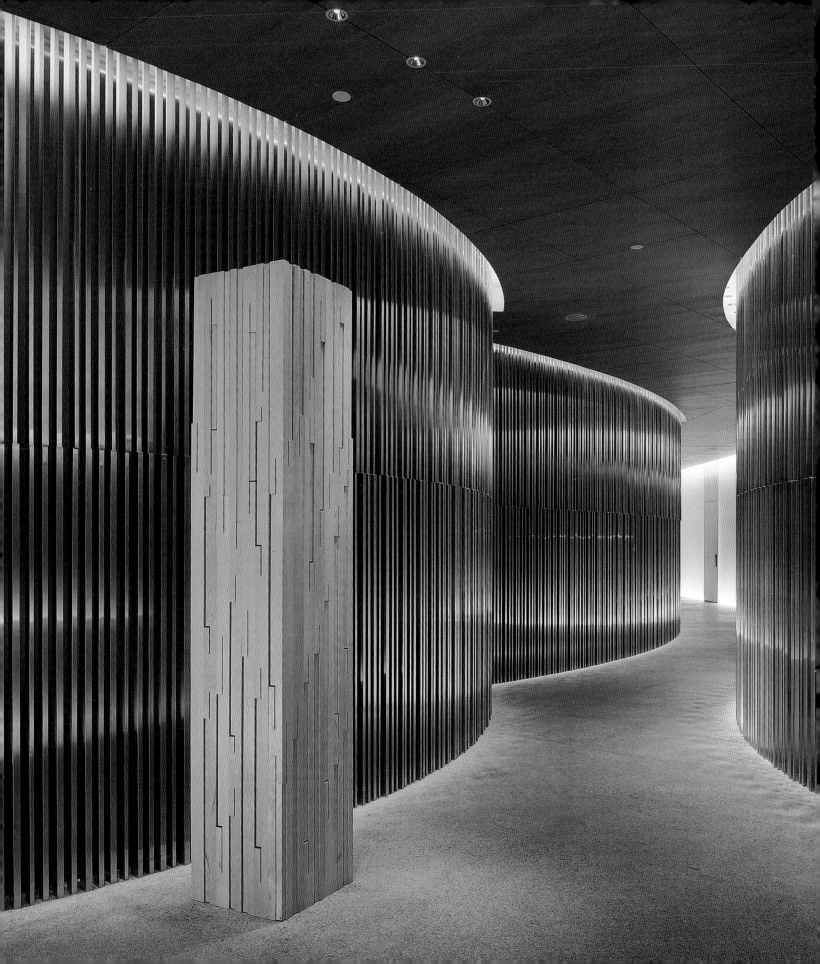

SUPER POTATO DESIGN

THE COMPLETE WORKS OF
TAKASHI SUGIMOTO
JAPAN'S LEADING INTERIOR DESIGNER

by Mira Locher
foreword by Tadao Ando
photographs by Yoshio Shiratori

TUTTLE Publishing

Tokyo | Rutland, Vermont | Singapore

Published by Tuttle Publishing, an imprint of
Periplus Editions (HK) Ltd

www.tuttlepublishing.com

Text copyright © 2023 Mira Locher
Photographs copyright © 2023 Yoshio Shiratori

Library of Congress Control Number
2006923590
Isbn: 978 0 8048 3737 8 (HC)
Isbn: 978 4 8053 1763 1 (PB)

Distributed by

North America, Latin America and Europe
Tuttle Publishing
364 Innovation Drive
North Clarendon, VT 05759-9436 U.S.A.
Tel: 1 (802) 773-8930
Fax: 1 (802) 773-6993
info@tuttlepublishing.com
www.tuttlepublishing.com

Japan
Tuttle Publishing
Yaekari Building, 3rd Floor
5-4-12 Osaki
Shinagawa-ku
Tokyo 141-0032
Tel: (81) 3 5437-0171
Fax: (81) 3 5437-0755
sales@tuttle.co.jp
www.tuttle.co.jp

Asia Pacific
Berkeley Books Pte. Ltd.
3 Kallang Sector #04-01
Singapore 349278
Tel: (65) 6741 2178
Fax: (65) 6741 2179
inquiries@periplus.com.sg
www.tuttlepublishing.com

HC 18 17 16 15 10 9 8 7 6 5
PB 26 25 24 23 6 5 4 3 2 1

Printed in China 2304EP

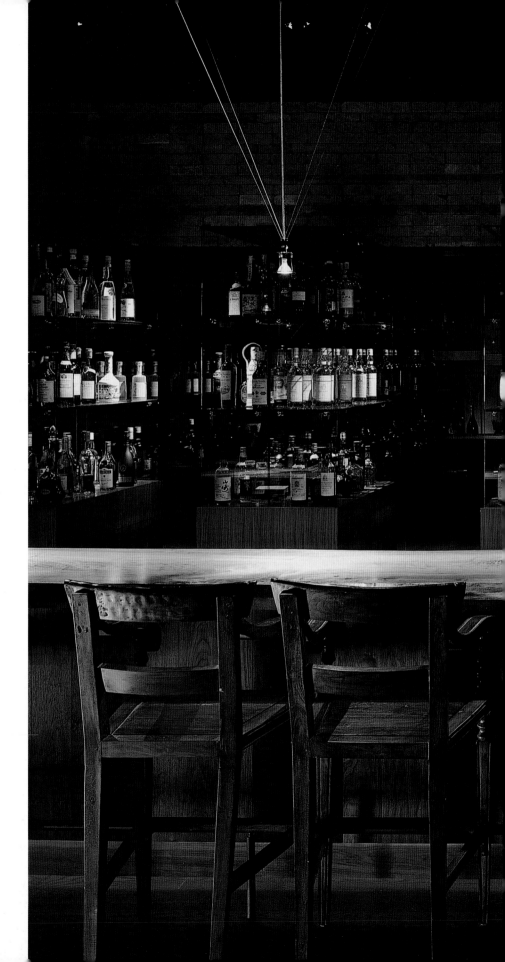

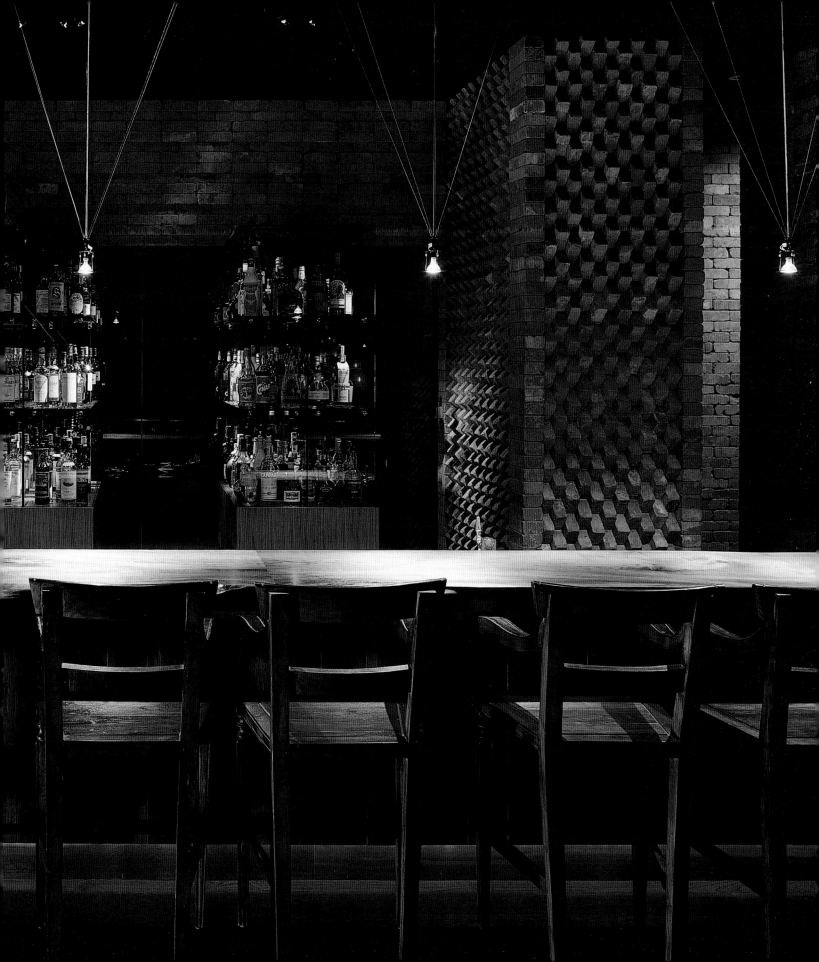

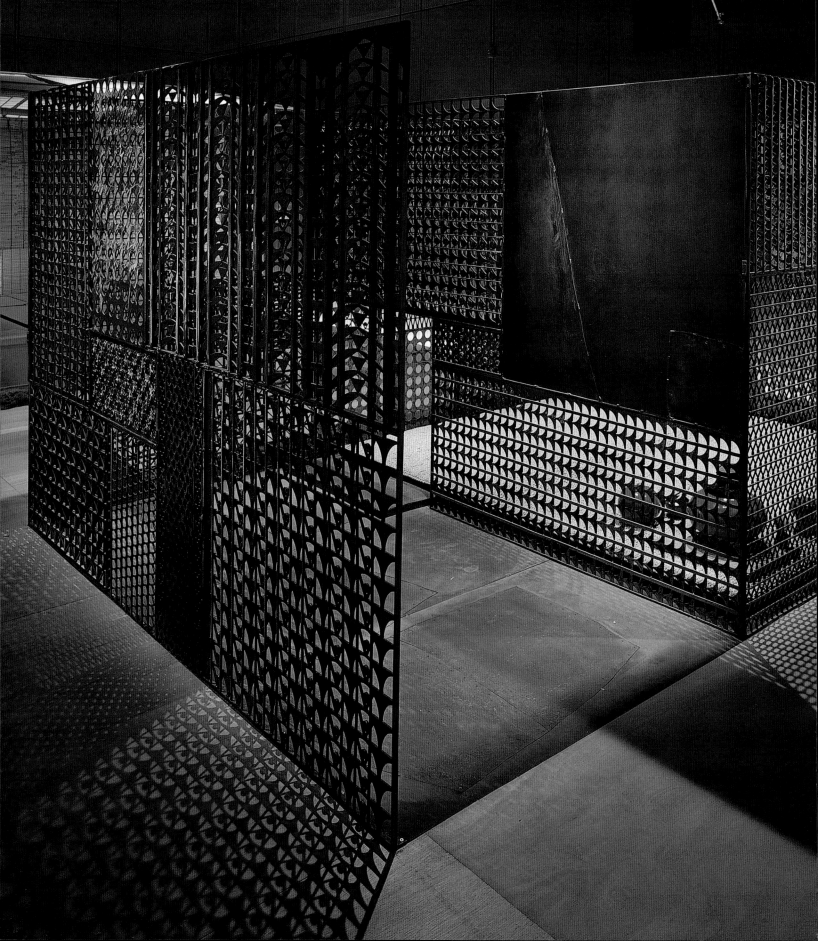

Contents

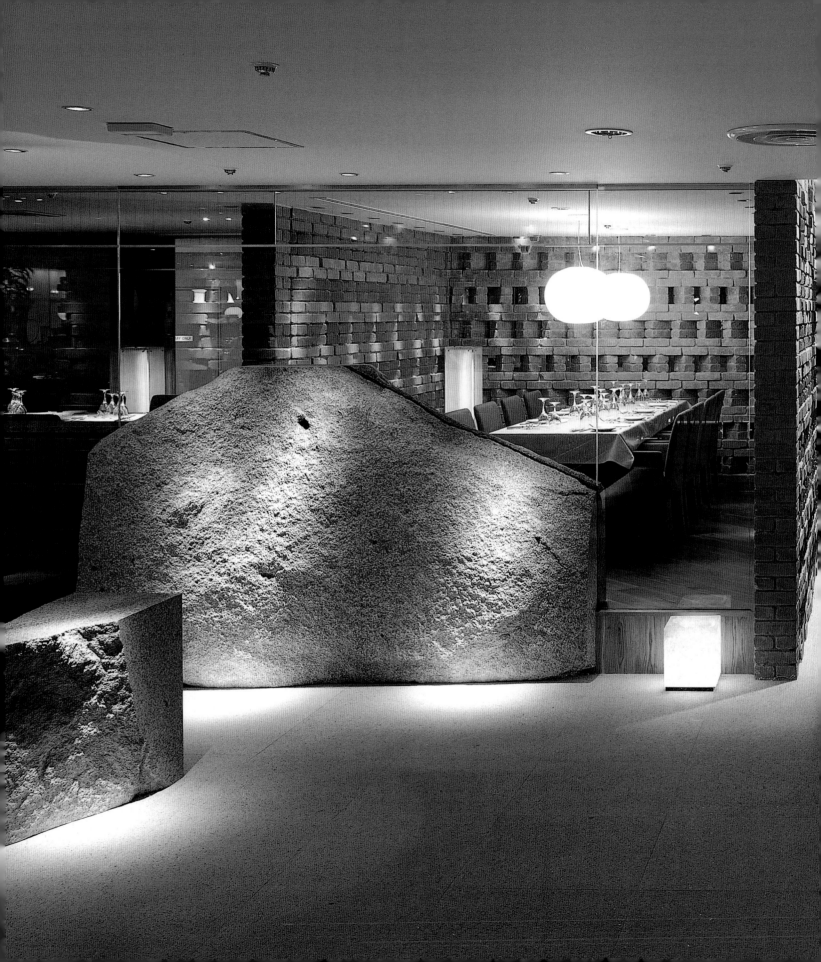

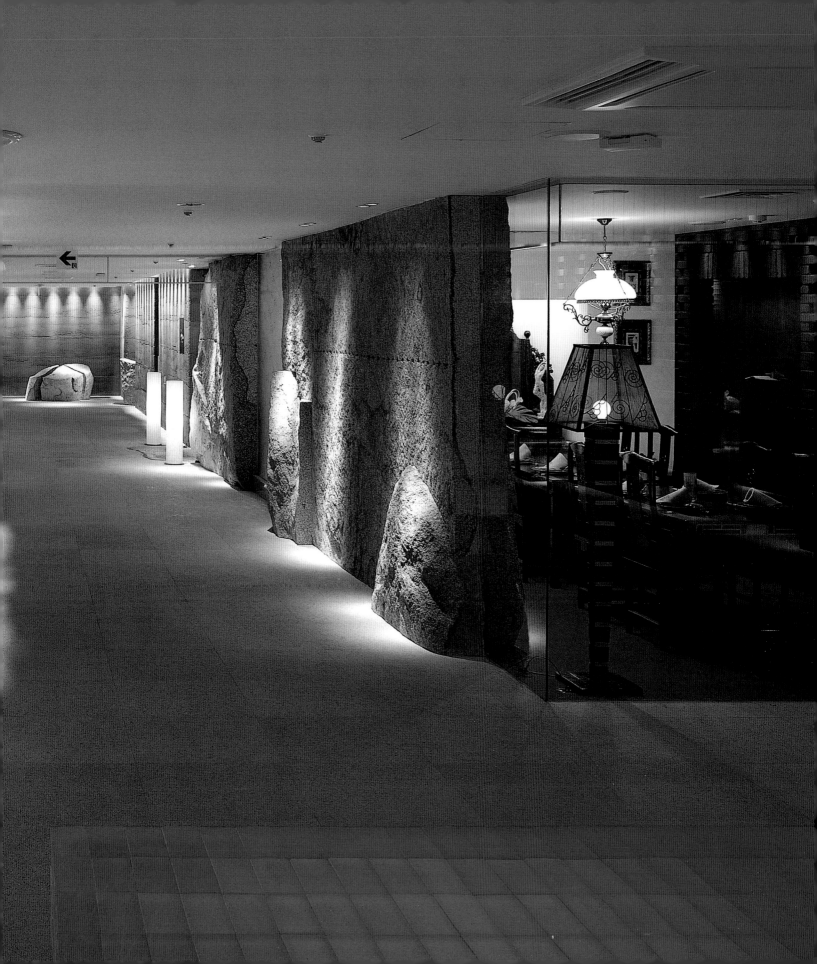

Beyond Layered Discontinuity

Rooms enclosed by massive blocks of *aji* granite,[1] enormous tables of granite and thick wooden planks, the sudden appearance of vast screens of bamboo and wood – such was the latest project I saw by Takashi Sugimoto of Super Potato inside a massive high-rise building in Tokyo. There, amidst works of other radical designers, each striving to develop magnificent futuristic spaces competing to achieve the greatest sense of lightness, Sugimoto's creation stood alone, as it formed a completely different atmosphere.

The materials Super Potato uses with an emphasis on stone, steel, and wood, impart scale and form beyond the customary. In the nonchalant ease of arrangement, logical harmony is unintended – the materials collide with each other, and in doing so each secures its respective place. The energy generated from that violent impact seizes the attention of people casually passing by and does not let go. Within the brilliant, fragile, artificial contemporary city overflowing with light, only Sugimoto can create a layered discontinuity that seems to summon an ancient spirit. Yet Sugimoto does not succumb to the conventional experience of old designs, and this is the result of his super power.

I cannot recall exactly when and where I first met Takashi Sugimoto. However, ours has been a very long friendship. I think perhaps we were introduced toward the end of the 1960s by the late Shiro Kuramata.[2] It was probably at Judd in Nogizaka, or some such place that Kuramata had designed. I was in my twenties and had not yet become an established architect. I still had not discovered my correct place in society, and all I had was courage and conviction, but I believed it was a time when society felt the hope and possibility that a path for the future would be revealed. I spent each day searching for creative stimulus, and was fortunate to meet many different people who influenced my path in life.

At that time, Kuramata had already acquired a reputation as a cutting-edge designer. When I occasionally visited from Osaka, he would always introduce me to someone interesting, such as Tadanori Yokoo[3] and the avant-garde artist Jiro Takamatsu.[4] Among the people I became acquainted with, Takashi Sugimoto stood out as an extremely idiosyncratic individual. Although he had only recently graduated from the Crafts Department of the Faculty of Fine Arts, Tokyo University of Fine Arts and Music, he already had a strong presence and made a significant impression on all he met. He was a man who drank *saké* animatedly and ate well. His expression of friendly innocence, mixed with a stubborn refusal to accept others' opinions, remains strongly etched in my mind. Since then, whenever I hear that a project has been completed by this man, four years my junior, I make a point of going to see it.

I think the first project I saw was the pub Maruhachi. Half of the ceiling and walls had been left as exposed concrete; the other half was covered with squares of steel, like louvers. From Sugimoto's personality, I expected a potent design, but the rusticity and power of this work was greater than I had imagined. Contrasting materials each transmitted a message, yet at the same time the space felt complete, and it had the persuasive power to put visitors at ease. Subsequently, I often visited another of Sugimoto's masterpieces, the bar Radio, originally made in 1971. I recall the attraction of the powerful space, which seemed to be generated from the dynamic immensity of industrial creation, but yet brought forth by human hands. There, rusted metal wall surfaces and a counter fashioned of thick boards of gnarly cherry wood created a mysterious harmony.

For people, including myself, who were more concerned with the expression of the time, the

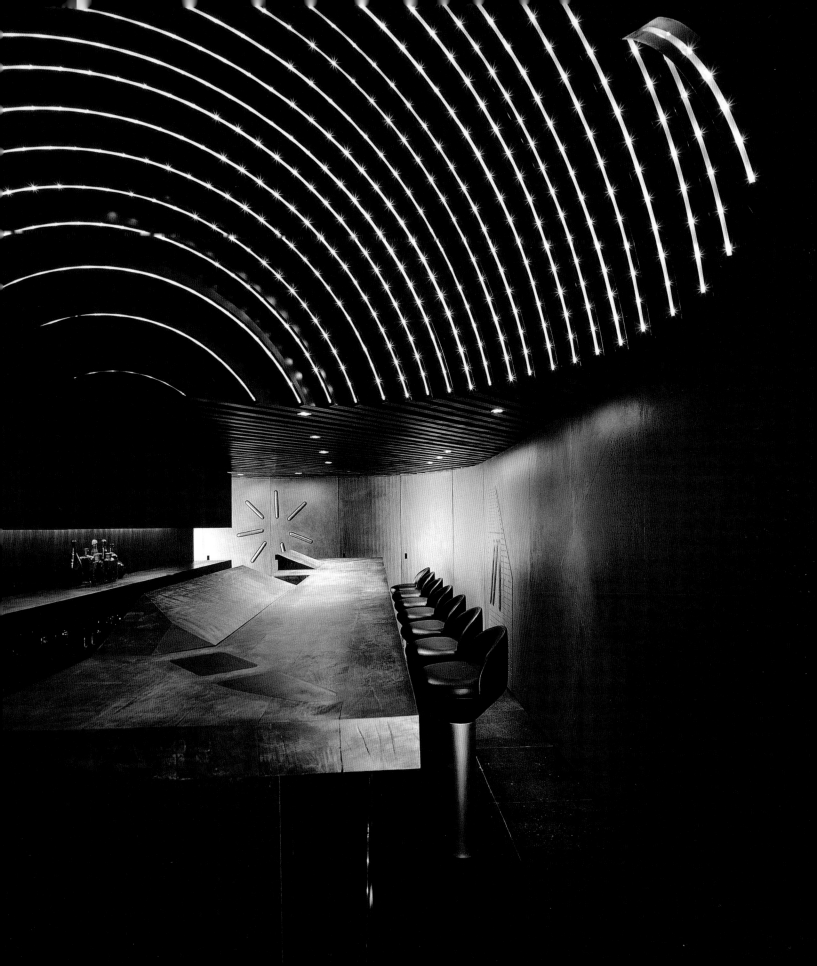

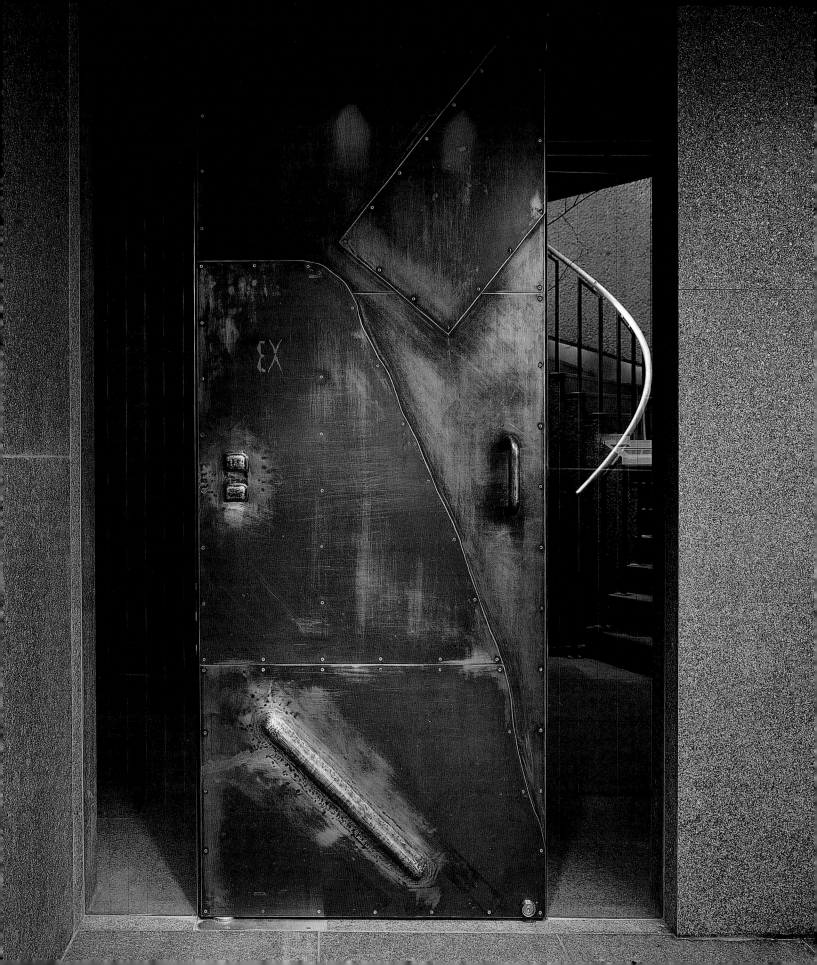

central focus was the modern design that flourished in the West. In my mind, we set forth from that place to discover our own self-expression. However, from there Sugimoto's work developed in an entirely different dimension, as if he were cultivating a novel world.

In direct opposition to this, Kuramata's work revealed exacting aesthetic considerations brought about by a keen design sensibility. Compared with the intense light which radiated from Kuramata's work – an abounding sense of transparency completely liberated from the force of gravity which seemed to negate the design's existence – Sugimoto's work was completely other, as though a creeping profound blackness was released. To speak without fear of being misunderstood, I believe it was just like comparing the refinement of the Yayoi culture[5] and that which takes root from the primeval life force of the Jōmon man.[6]

Of course, the essence of a composition is based on the formative language of the time. When reduced to line and plane, there emerges a design composition filled with an extreme feeling of tension. However, the essence starts from abstract existence, passes through Takashi Sugimoto's corporeal thinking and sensibility, and at the moment it is given tangible materiality and scale, a kind of discord is created. Each part of the composition has its own existence, at times in opposition to another, thereby uniting unstable atmospheres which begin to control place. Such primordial space can only be produced by Super Potato's Sugimoto from his own natural design approach. The industrial process is restrained to the utmost, materials are used in their natural state wherever possible, and the properties of diverse materials are exploited. Abutting stone, one very thick wood plank has its cross-section exposed. A bar counter is formed from one plank of roughly cut wood, its knots remaining. Sugimoto's eye for choosing materials is superb.

Abounding with contradiction, and in what could be called a fragmented state, the substance of such space is difficult to explain with recent design logic. Communication of the ideas through photographs, drawings, and other such media is similarly problematic. For more than thirty years, Sugimoto has continued this work, seemingly simple at first glance but yet difficult to understand. What amazes me, having seen his projects from the early days, is the consistency of thought that carries through his work. Of course, that expression changes freely according to the mood of the times, but always, in some way, an incongruous feeling of discontinuity emanates from it.

Logical evaluation is difficult: the world based on Sugimoto's individual physical sensibility is far removed from the so-called concept of universality. And as for today's society, in general, it can be called a closed existence. However, in that closed universe, Sugimoto alone is struggling to produce spaces which force us to consider the consciousness of existence, spaces which are rarely found in the present age. Materials one by one breathe, as though beginning a narrative of life phenomena throughout the entire space. That this life force can still be created is, I think, a miracle.

Recently, after a long time, I had the chance to speak with Sugimoto. His characteristic energy was as always: abruptly he began to describe the exciting festivals he happened upon during a visit to Bali. As I watched Sugimoto animatedly relate the rituals which expressed and reaffirmed the island people's traditional lifestyle – something which has become nearly lost in today's society – I was convinced that this "life force" is what Sugimoto himself reflected and wants to create through his work. In contrast to architecture, in interior design there is often a susceptibility to the fashion of the moment; and due to the swift cycle of the profession, interior design holds the power to end traditional life. Within this, Sugimoto contemplates the essential questions: What is existence? What is creation? What does it mean to give life to materials?

Through the subtle construction of suitable form and the skillful manipulation of scale and composition, new life is infused into his materials. Since his start in the late 1960s, Takashi Sugimoto has pursued this path – a world of his own – which has continuously evolved. While placing his body and soul in defiance to the continual flow and trends of the times, Sugimoto continues to make layered discontinuous spaces with an enduring force and tension that merits admiration. I want to continue to admire that quality forever.

Tadao Ando

[1] The *aji* stone, a type of granite used by Takashi Sugimoto, is quarried in Shikoku Island at the same quarry used by the late Japanese-American sculptor and designer Isamu Noguchi and his Japanese collaborator Masatoshi Izumi.

[2] Shiro Kuramata (1934–91) was one of the most influential avant-garde designers in twentieth-century Japan. Best known for his designs of furniture and interiors, Kuramata embodied the concepts of lightness and transparency in his carefully detailed and technically outstanding work.

[3] Tadanori Yokoo (b. 1936) is a vanguard graphic designer and painter based in Tokyo. Having first become known for his poster designs, which were influenced by the Japanese counterculture in the 1960s and 1970s, Yokoo continues to have a strong impact on Japanese visual arts.

[4] Jiro Takamatsu (1936–98) was active in the contemporary art scene in Japan from the 1960s and explored existential and metaphysical questions in his writing and mixed-media conceptual art and installations.

[5] The Yayoi culture flourished in Japan from 300 BC to AD 300. Greatly influenced by the civilizations of Korea and China, the era is distinguished by the advent of agriculture (wet-rice cultivation), advancements in ceramic work (hand-formed and decorated pottery), and the use of metal implements (iron and bronze tools and objects, presumably brought to Japan from the Asian mainland).

[6] The Jōmon culture in Japan (10000–300 BC) is characterized by nomadic hunter-gatherer tribes and pottery made from coils of clay and decorated with rope impressions. Based on the primitive yet bold and often highly sculptural forms of the Jōmon ceramics, the people of the era are considered to have embodied a robust primitive energy and an intrepid and audacious nature.

The Design Firm
Super Potato

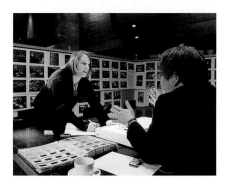

Super Potato. The words evoke a variety of images – but what an ostensibly odd name for a design firm! The choice of words seems entirely appropriate, however, after considering the qualities of the work of the firm and its founding principal and lead designer, Takashi Sugimoto. The work, like the lead designer, is indeed "super": super in the richly textured quality of the spaces, super in the determination to find a unique expression independent from the fads of the day, super in the creative energy apparent in both the design process and the completed works. As for "potato," the humble tuber has provided sustenance through times of hardship but rarely has been considered as a muse for serious design. What does it signify? The potato has an inherent history to which everyone can relate and from which it unassumingly gives forth information. This is also the case in Super Potato's designs. Used and salvaged materials add depth and layers of meaning to the designs. Alone, the potato is plain, simple, and humble yet with vast potential. Combined with the modifier "super," it becomes something never before imagined. The same can be said of the works of Super Potato: familiar yet never before imagined, richly exotic yet with a stark simplicity, original yet not disconnected from the past.

Takashi Sugimoto founded Super Potato in 1971, not long after he graduated from Tokyo University of Fine Arts and Music. His focus on metal sculpture as a student led him to the design of metal light fixtures, which in turn led to interior design. His continued exploration of the creation of meaningful spaces using textured materials and accentuated by finely tuned lighting has made him one of the most important and influential designers in Japan, with a body of work and an audience that spans three continents. His early project, the bar Radio, first completed in 1971 and renovated

in 1982, became a gathering place for the creative thinkers of the day, who were captivated by its space and materials. His ideas, such as the "theater kitchens" for his first great international success, the Mezza9 restaurant in Singapore from 1998, which exposed the action of the kitchen to the dining room to "entertain" the customers, are often emulated by other designers, especially throughout Asia where the bulk of Sugimoto's work can be found. However, the copies rarely come close to the level of complexity and elegance of the Super Potato originals.

What makes the work of Super Potato so distinctive, so intrinsically Japanese yet familiar to all who visit? What have been the influences on Takashi Sugimoto as he has refined his ideas regarding design? To begin with, from his university days, Sugimoto liked junkyards. He collected salvaged objects and materials for the images they gave of different ways of thinking and living of the people who had once used them. In the second year of his studies, he made a small structure for a school festival from a salvaged piece of rusted metal. This act of creation opened his eyes to the expressive potential of materials, old and new, and has remained in his mind. As a student in the 1960s, Sugimoto was interested in contemporary cultural trends, but he was shocked the first time he saw a work by Picasso and felt that he did not understand modern art. However, his desire to understand was strong, and he learned by drawing every day and carefully studying Cezanne's masterpieces. Through the process of drawing and learning to use drawing as a means of seeing and thinking, while looking at all types of design in Japan and abroad, Sugimoto began to build his creative vocabulary. He visited Europe, where many young Japanese designers of the time were turning for inspiration, and met with prominent European

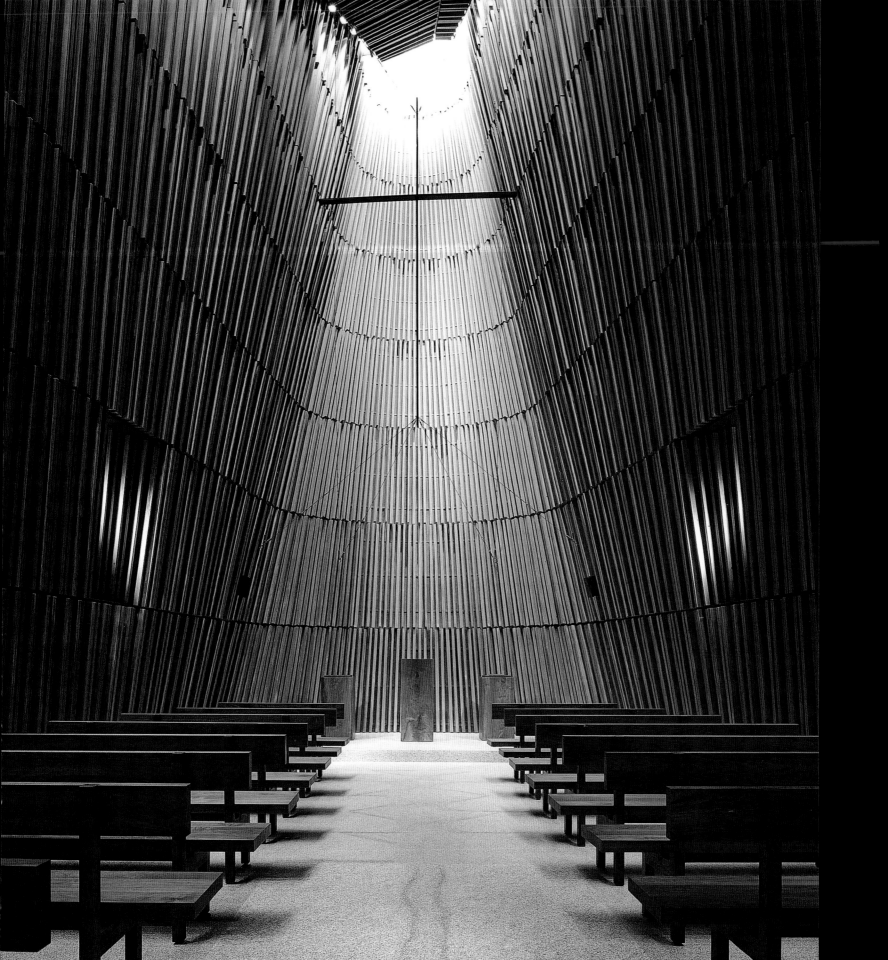

designers. He was particularly interested in Italian avant-garde design of the 1960s, especially the work of Super Studio. Founded in Florence, Italy, in 1966, as a critical and irreverent response to the pervasive ideas of Modernism in the twentieth century, the group questioned the roles of architecture and technology as forces for positive societal change and explored these ideas through the design of objects and exhibits and the creation of collages and films.[1] The influence of Super Studio is clearly apparent in Sugimoto's early projects, such as the 1976 design for café/bar Strawberry, as well as in his choice of "Super Potato" for the name of his own firm.

Despite the influence of European design on his work, when Sugimoto visited Europe he felt the vast difference between European style and that of his own country. He decided that, for his own future, he must develop a style appropriate for Japan, a style that would reflect Japan's contemporary culture more accurately than if it were based on a European model. For Sugimoto, coming of age as an independent thinker in the war-filled times of the 1960s and 1970s, it seemed that most young people had no specific objectives or goals. He felt that the era was marked by a changing idea of what was valuable in life. The Japanese culture was transforming from one of possessing *shisō uno kachi*, the "value of thought," to one of *sutekina kachikan*, a "sense of value in splendidness."

To understand these changes, Sugimoto deemed it necessary to find new values within Japanese culture. To investigate this concept in his projects, he started with the traditional tea ceremony, as it had developed in Japan in the sixteenth century. This style of tea, called *wabi-cha*, drew from the roots of tea as it related to Zen Buddhism and emphasized the ideal of beauty within imperfection. The strict rules and the aesthetic of refined rusticity of the tea ritual of that time have varied little since.[2]

Sugimoto understood the tea ceremony, or as he simply terms it, *ocha* ("tea"), as a creative activity conveying values of what he considered true Japanese style. This style is apparent in all aspects of *ocha*, such as space, light, clothing, implements, tea bowls, food, and flowers, yet their meaning is not fixed but changes for each ceremony according to the host's chosen theme. These themes are connected to the season, the invited guests, the time of the ceremony, and other such factors. For Sugimoto, *ocha* is much more than simply an expression of a style. It is a creative act, which requires the host alone to make all the preparations and consider every detail from the guest list to the tea confections as part of a greater cohesive experience. It is both ritual and entertainment. Sugimoto was attracted to the potential originality within the rigid structure of the tea ceremony, which allows for discovery and inspiration. He feels the practice of *ocha* has more value if it is done to the best of one's ability – with undivided attention and whole heart and soul, done sincerely even if only satisfactorily, rather than flawlessly following the ritual. Sugimoto also understood an inherent Japaneseness within the tea ceremony, which he sensed within himself and realized that he shared with his fellow countrymen.

While tea represented refined culture for Sugimoto, he was also strongly drawn to the seemingly opposite rough culture of the typical Japanese *izakaya* or pub, often found underneath train tracks or tucked away in dense city blocks. With just one small bar counter and half a dozen stools, customers relax in the informal atmosphere to enjoy a drink with friends and plates of food dished out from large bowls placed on the counter. Likewise, Sugimoto was drawn to the idea of the humble countryside restaurant, often with walls soiled from years of use and a regular clientele who appreciate the quality of the cooking and the homey atmosphere. He also recognized a collective idea of comfort in the rustic landscape, of good home cooking in a plain countryside restaurant or a hole-in-the-wall *izakaya*, or a cup of *saké* shared with friends in a primitive mountain hut. This tie to the countryside, to simple rustic nature, was one which Sugimoto felt was shared by the Japanese people and held considerable potential in his search to define value in his work and in the Japanese culture.

The combination of the creativity of *ocha* and the rustic plainness of the countryside proved to be Sugimoto's answer to the problem of lack of *kachi* in the Japanese culture of the late 1970s and 1980s, and is perhaps the most important design concept in his work. A project that well represents the convergence of these two ideas is the first in a series of associated restaurants, Shunju Akasaka, completed in 1990 and operating for just four years. The intentional super-softness of the flickering candle-like light gave the space of the Shunju

Looking out from the tearoom, the layers of space of the bar counter and garden are delineated and filtered by the perforated metal screen and hanging woven bamboo *sudare* blinds.

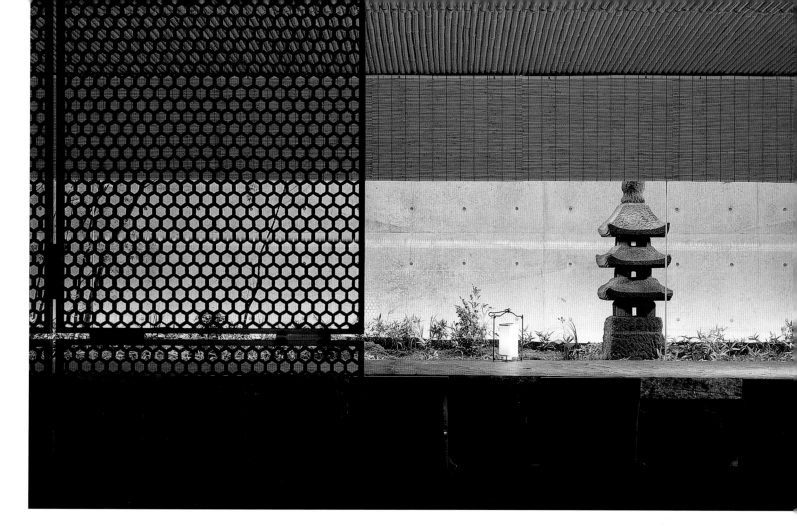

Akasaka restaurant a comfortable quality, like that found in an old-style *izakaya*, yet with an added sense of mystery. The light reflected off the varied materials, many roughly textured, at times seeming to absorb light and other times giving form to the light. The differing materials were carefully composed to allow each to express its individuality, sometimes outwardly in conflict with the others, and yet merge to form a calm, unified space.

The bar counter at Shunju Akasaka faced out to a raised courtyard garden, reminiscent of a tea garden with a large stone lantern as the focal point. The level of the ground was at the same height as that of the counter, thereby linking the outside space to the interior and offering a new viewpoint for the customers. A perforated metal screen separated the two spaces of the restaurant – the bar counter with less than a dozen seats and the wooden-floored *chashitsu* or tea ceremony room. Complete with a decorative *tokonoma* alcove and a recessed hearth, the room could be used for the tea ceremony but also served as a casual space for a group to share a meal.

In his explorations of bringing together the primitive energy of the *izakaya* and the sophisticated creativity of *ocha* to shape unified powerful spaces, Takashi Sugimoto has carefully explored and refined the way he uses materials and light to give meaning and form to space. He speaks about three main concepts for his designs, which he continually considers: *komyunikēshon* ("communication"), *shizenkan* ("sense of nature"), and *kuriēshon* ("creation"). Sugimoto constantly works toward the creation of a place for communication, which incorporates a sense of nature.

For Sugimoto, communication leads to inspiration, and inspiration – whether momentary or lasting – is the point of design. This communication is achieved through various means. The quality of light in a space, which he very carefully plans and controls, can communicate a feeling or mood. The size and shape of a space can promote quiet discussion or a lively exchange of ideas and can communicate a sense of romance, mystery, or playfulness. Most importantly in the work of Super Potato, materials can communicate a sense of

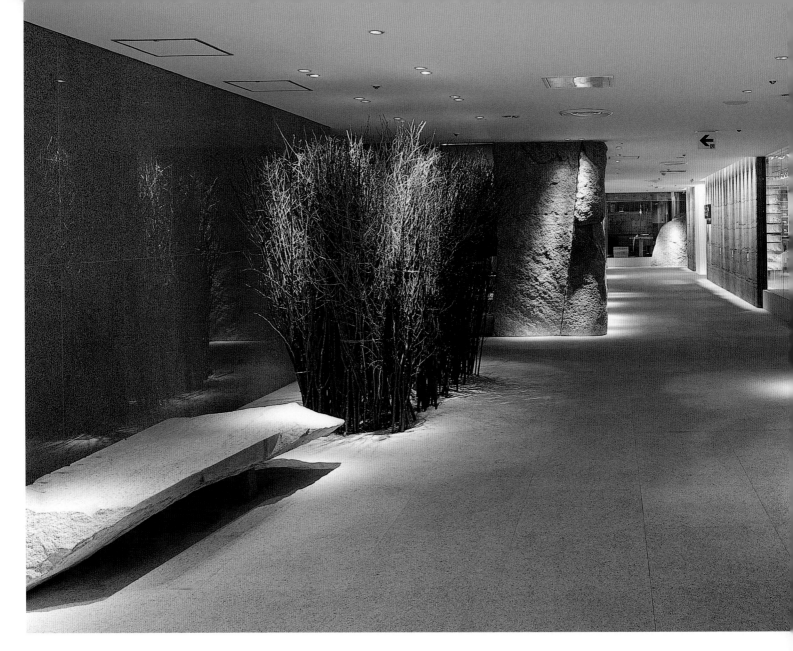

history, a link to a person or place, the details of which are unknown and unclear yet the connection is tacitly understood. Materials provide information, and Sugimoto sees his designs as a delicate web of information, conveyed through different materials, strong enough that anyone can feel it but light enough to provoke curiosity and further thought. This relates back to Sugimoto's understanding of the changing culture of Japan in the late 1970s. From that time, having designer clothes and a fancy apartment in a trendy neighborhood took priority over finding merit in subtle concepts and the provocation of thought, as Sugimoto still observes in the contemporary consumer culture of modern-day Japan.

This provocation of thought inherent in Super Potato's designs is emphasized by the use of salvaged materials, such as the metal screens in the Shunju Akasaka restaurant, the wooden timbers from an old school that gave structure to the space of the Pashu Labo showroom from 1983, or the intricate mosaics made of plastic hoses, strips of cardboard, and machine parts, which form the wall surfaces of the public spaces of Shunkan, two floors of restaurants in a Tokyo department store built in 2002. The specific history of these materials, which have been transformed by industry, may be unclear, but the power of their past is obvious. In the hands of Super Potato, they undergo another transformation, from insignificant to

ABOVE

Long views to and through the restaurants on the eighth-floor space of Shunkan are defined by walls of glass, wood, and stone. Sculpted stone objects accent the gallery-like public areas.

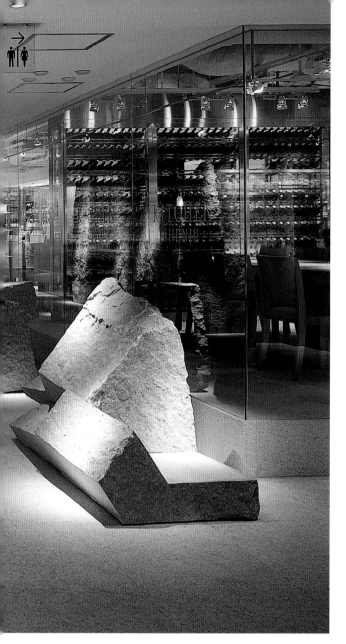

childhood or perhaps in a less specific yet equally suggestive way. Natural materials are also used to give power to a space, whether it is the strong juxtaposition of delicate bamboo and rusted metal or the astonishing power of massive walls of stone, like those in the restaurant Mezza9.

However, the reference to nature in Super Potato's designs goes beyond the obvious connection to the natural world through the use of materials like wood, bamboo, stone, and mud plasters or the implied spatial connections between the exterior and interior. Humankind is understood as an integral part of the natural world, in keeping with the traditional understanding of nature in Japanese culture, and therefore marks made by the human hand are marks of nature. The scratches on the wooden columns in Pashu Labo, the furrows from the adze in the surface of the roughly hewn bar counter in Shunju Akasaka, and the grooves from a drill in the surface of the stone walls in the Sensi restaurant, completed in 2004 – marks like these left on the materials by the human hand communicate another layer of history.

Creation, the third design concept, is energy or, as Sugimoto says, energy which gives inspiration. For Sugimoto, creation is the force essential for society, as well as Sugimoto himself, to evolve. He understands commerce as the result of creation within a specific era and the current conservative money-making attitude, which first emerged in Japan's economic boom of the 1980s, as lacking the energy and inspiration of creation necessary to change and to move forward. Sugimoto feels that 80 percent of the goods currently designed may appear beautiful, but they lack the power to transcend physical form. They miss the depth of meaning derived from inspiration, which Sugimoto believes is the mark of true beauty. In his mind, new creation alone often has too little meaning given the current state of contemporary society, but new creation in partnership with old produces the energy and inspiration needed for change.

In 1980, sponsored by the Seibu department store, Takashi Sugimoto teamed up with Kazuko Koike and Ikko Tanaka to create Mujirushi Ryohin, now known internationally simply as MUJI, a company producing and selling well-designed, good-quality, yet inexpensive goods for everyday life. The creative director and copywriter Kazuko Koike chose the Japanese character *so*, meaning "element" or "beginning," as the initial theme for

information-laden, from "plain" to "super," and thereby their value is rendered visible.

The second design concept, the sense of nature or *shizenkan*, is closely tied to Sugimoto's idea of the tea ceremony. Nature is an important element in the creative process of the design of a tea gathering, in which the host determines a theme based on the season and chooses the style of tea ceremony and other components, such as flowers and a scroll to adorn the *tokonoma* alcove, food and tea confections, and tea utensils and cups, to complement the theme. In Super Potato's work, the sight and touch of organic and mineral materials remind us of our connection to nature, possibly of a particular tree or of a forest of our

From the entrance
of MUJU Ayoama-
sanchome, the space
opens up for a long
view of shelves and
tables full of MUJI
goods. The exposed
ceiling adds another
level of information
and interest.

the company. The fashion of the time was pure spaces with beautiful clean lines, as embodied in the "lightness" revealed in the almost transparent furniture and slick interior designs of Shiro Kuramata, who creatively transformed everyday industrial materials, sheets of steel mesh or glass, aluminum or acrylic, into forms suggesting invisibility.[3] Despite the minimalist design trends of the day, the team wanted MUJI's expression to be "natural" and "unbranded," almost generic. The first independent shop, designed by Super Potato, opened in Tokyo in 1987. The simple labels on a cardboard brown background, which are still used today, were designed by graphic artist and creative director Ikko Tanaka, a designer and tea master who greatly influenced Takashi Sugimoto. Goods are displayed in woven wicker baskets on thick wooden plank shelves. The space has a homey, almost "undesigned" feeling, a "plain" background to show off the merchandise.

MUJI dishes, pens, and clothing have been popular in Japan since the "lifestyle" company's inception. The company has expanded in recent years to include a restaurant, Meal MUJI, designed by Super Potato in 2001, a prototype house, and even a campground. In the catalog produced for the 2003 "The Future and MUJI" exhibit in Milan, Italy,[4] Kazuko Koike states: "As a contribution to our modern life, MUJI advocates the use of those qualities which are integral to Japanese aesthetics: being Essential, Minimal, and Anonymous." Following in Ikko Tanaka's footsteps, current art director Kenya Hara, who created the sublimely haunting photographs for the "The Future and MUJI" catalog, writes: "MUJI is an enormously large vessel that accepts the sensitivities of anyone and everyone." Takashi Sugimoto adds: "Let me coin some terms: MUJI Journey, MUJI House, MUJI Car, MUJI Wine,"

MUJI continues to move toward the future with slow deliberate steps, carefully trying to avoid the path of fleeting fashion in favor of timeless style. In the Yurakucho MUJI store in Tokyo from 2001, nothing is hidden. The steel structure of the building, the ventilation ducts, the shelves full of merchandise in neat stacks, the ingredients for the Meal MUJI lunch of the day – Super Potato designed the space to allow each of these elements to express its separate power yet within a unified whole. This is not unlike the power of the exposed heavy timbers of a traditional *minka* farmhouse,

which convey the strength and history of the structure. Multiple generations of a family typically occupied the *minka*, each leaving behind the marks of their occupation, adding a layer of history to the space.[5] Similarly, MUJI has necessarily changed over time, but in its 25-year existence, MUJI has maintained its ties to the past, to the traditions of Japan.

Takashi Sugimoto often looks to the power of tradition – traditional materials and traditional methods of working materials – to give a sense of strength to his creative work, as well as to make a visual and experiential link to history. However, he is careful to emphasize that his interest is in utilizing traditional materials to create new design not traditional design, and he is equally fascinated by contemporary culture and design.

Sugimoto's goal is to make space for inspiration, *kandō*. To continue to find inspiration for his work, he is constantly searching for new things to experience, to taste, to savor – in his words, *ajiwau*. Sugimoto's influences and interests, such as food, music, and travel, are many and varied. He wants his designs to be *futsu kedo futsu janai*, "ordinary yet not ordinary," and he walks the streets of Tokyo or wherever he may be to get a feeling for the place, to be inspired by the ordinariness he finds. He is constantly looking, always with the themes of his design in his head. For Sugimoto, design is not about beautiful proportion or form but about what is felt and experienced. Although he believes that the idea of beauty – like the idea of value – changed significantly in the twentieth century from a profound concept to one more superficial, and that "beauty" is a key word for the twenty-first century, Sugimoto does not design for the sake of outward beauty. He finds beauty in the process, again making a connection to the way of tea. *Irona koto kasanette oishi*, "many things superposed are full of flavor" – but design is more than just about taste, it is also about sensation, mood, information, the passing of time, and the moment of energy in which all of it is experienced instantly. The power of the moment of understanding is vital, but Sugimoto sees design as *yukkuri ninshiki shiteiku mono*, "something that is slowly perceived."

For Takashi Sugimoto and Super Potato, time is always present in their work, whether it is the vitality of the moment, when first witnessing the powerful juxtaposition of an expanse of rough

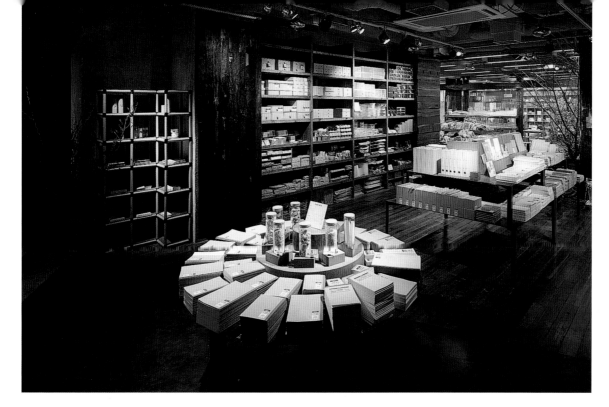

stone joined with a delicate sheet of glass, or the ephemeral nature of passing time present in the marks of history left indelibly in the surface of a sheet of salvaged metal. Sugimoto talks about the influence of French philosopher Gaston Bachelard, whose writings examine the significance of space and memory, on his conception of the experience of time; and he relates Bachelard's ideas to concepts of Zen Buddhism that developed in Japan.[6] The transient nature of time, which Sugimoto describes as seeming to change a middle school girl to a grandmother in an instant, is that which connects Sugimoto, and his design work, through Bachelard back to his own cultural history. It is also the transient nature of time which connects Super Potato's recent works to the future. Sugimoto emphasizes that even if a project has a short life, as is so often the case with interior design, it can still generate a strong influence on future design.

Takashi Sugimoto is concerned with the future. As a designer and a teacher, he wants his students and the staff of Super Potato to find their own way for their own time, just as he works toward in his designs. Sugimoto feels it is imperative to consider continually the future and how creative acts of today can affect what is yet to come, although he stresses that one cannot design for the future but only leave something tangible behind to influence future generations.

As contemporary culture places increasingly less significance on the value of thought, *shisō*

no kachi, and more on "splendidness," *sutekina kachikan*, continuing the trend started in the late 1970s and 1980s, Takashi Sugimoto finds greater need to give meaning to space and life. For his conception of design, found and salvaged materials must be used, not because they are cheap, but because they contain information accumulated over time or "truth" and provide an important contrast with new materials, which are generally considered "beautiful" but lack any connection to the past. Sugimoto believes the collision of old and new is the historical basis for the evolution of creation and thus the basis for future creation.

For Takashi Sugimoto and Super Potato, the future of design is more international and more open than ever. It is not unusual to overhear a staff member on the telephone discussing a project in Korean or English. The majority of their projects are overseas, throughout Asia as well as in Europe and the United States. Super Potato's office is housed in a quiet minimalist concrete building adjacent to busy railroad tracks in a dense residential neighborhood of Tokyo. The building is filled with found objects and in-progress material explorations. It is not unlike Super Potato's designs with its juxtaposition of calm elegance and active harmonious discord. There is a constant buzz of activity in the office. In the background, a sense of urgency underlies the calm exterior, as does a sense of camaraderie in the act of creative exploration of both the plain and the super.

[1] The Super Studio collective was founded by architects Adolfo Natalini and Cristiano Toraldo di Francia, who were later joined by Alessandro Magris, Roberto Magris, and Alessandro Poli. Although the collective disbanded in 1978, the individual designers continued to explore these issues in their work.

[2] In the late fifteenth century, tea gatherings flourished as lively parties, displays of wealth and power during which affluent merchants would show off their treasured Chinese tea utensils. By the sixteenth century a merchant from Sakai, Takeno Jō-ō, and his pupil, Sen no Rikyū (who became the most influential tea master in the history of tea in Japan), developed the style of *wabi-cha*, distinguished by its strict rituals and particular aesthetic.

[3] Shiro Kuramata (1934–91) was one of the most influential vanguard designers in twentieth-century Japan. Kuramata, who first appeared on the international stage in the 1980s, studied woodcraft in a polytechnic high school and design at the Kuwasawa Design School in Tokyo.

[4] Published by Ryohin Keikaku Corporation (Tokyo, 2003).

[5] The Japanese *minka* vary from region to region depending on the climate, environment, and locally available building materials. In general, *minka* are constructed using heavy wooden posts and beams, which are exposed on the interior of the space, giving a clear sense of the construction and weight of the structure.

[6] French philosopher Gaston Bachelard (1884–1962) began his career teaching natural sciences but later concentrated on philosophy, which he also taught at the university level. His writings have been translated into many languages and have had influence on designers worldwide, especially those of Sugimoto's generation.

Strawberry
Café and bar / Shibuya, Tokyo / 1976

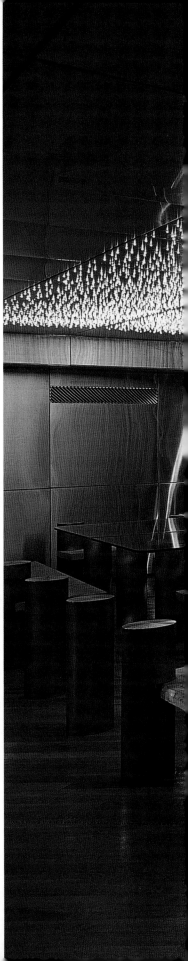

The first design by Super Potato to receive wide recognition in Japan, Strawberry broke away from the typical 1970s Japanese café and bar design by conveying an up-to-the-minute image using simple forms, reflective materials, and dramatic lighting. The influence of Italian radical design, focusing on geometric forms and industrial materials rather than function or comfort, was clearly apparent in the wide, cylindrical, stainless steel pipe supports for the expansive glass tables and wood benches, and in the stainless steel-covered walls and ceiling. The glass tables seemed to float above the steel cylinders, while the wood plank benches – in stark contrast to the sleek industrial materials – were cantilevered from the steel supports, appearing to have only a tenuous connection to the cylinders. Several thousand tiny lights punctured the ceiling plane and reflected off the stainless steel and glass, like a galaxy of stars hovering overhead.

Taking advantage of its bustling central Tokyo location in Shibuya, Strawberry added a new experience to the already popular café and bar scene. Low windows cut into one wall allowed a glimpse of street life beyond a narrow garden edged with shrubs. The distant movement of the city outside played out as if on a dim movie screen, in strong contrast to the slick high-energy interior.

The contemporary design of Strawberry moved away from the dark interiors typical of coffee houses and bars at the time. The oversized glass tables accommodated multiple groups of people simultaneously and, together with the reflective surfaces and unusual lighting, created an animated atmosphere for convivial conversation rather than quiet contemplation. Only the wood flooring and the benches – made of thick planks of pine with the knots and cracks exposed – gave a momentary visual and tactile connection back to the familiar materials of the day.

RIGHT

The long horizontol opening was placed low in the wall to look out to the street activity from sitting height and to give a view of the narrow garden from standing height.

BELOW

The steel cylinders supporting the tables and benches were placed at equal intervals within the space.

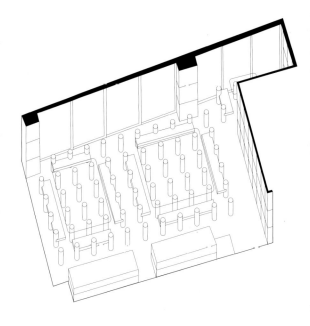

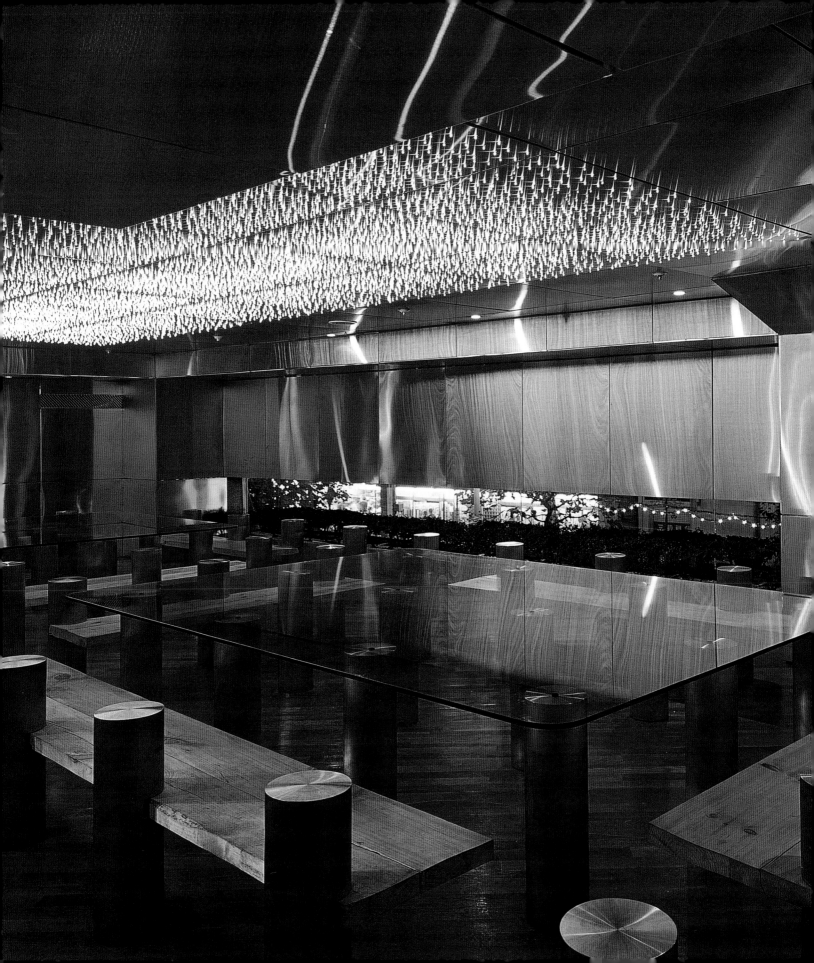

Maruhachi
Bar / Shibuya, Tokyo / 1978

Located in Shibuya, the same bustling, densely packed urban area in downtown Tokyo as Strawberry, Maruhachi was designed two years later and represented two years of new thought and a turning point in Super Potato's design work. It was a time of economic growth for Japan, before the inflated "bubble" economy of the 1980s, but at a point when the country was just starting to transform into an economic power.

Takashi Sugimoto wanted to express a commonly held Japanese sensibility, born from a culture intrinsically tied to nature, and also wanted to incorporate new ideas formed on his trips to Europe. Maruhachi was an expression of this shared sense of "Japaneseness" combined with influences from abroad. It merged contemporary design with the simplicity and comfort of *izakaya*, small drinking establishments typically found under the elevated railroad tracks and in the Golden Gai district in Tokyo.

Sugimoto exposed the raw concrete ceiling and walls of the space – an unprecedented design move which was a great surprise to the design community – and further emphasized them by incorporating recycled metal pipe, utilized like diagonal louvers to cover part of the wall surface.

Sugimoto recognized the beauty of the previously used materials and their inherent suggestion of history. He brought out the character and comfort of their everyday quality by combining them with new materials and simple but dramatic lighting. Industrial spotlights were intermixed with lights set in strongly geometric metal frames hung from the ceiling. The lights were mirrored in the reflective surfaces of the floors of the two-level space, drawing out the pattern of the louver-like metal pipes on the walls. The lights focused attention on the wooden tables and benches, while the reflection gave a sense of depth to the space despite the low ceilings.

The upper part of the space featured large round tables and benches, while the lower level, five steps below, accommodated long rectangular tables and benches, which emphasized the length of the room. Takashi Sugimoto hand-picked the wood for the tables and benches in the northern city of Morioka and used it in a manner which expressed its natural beauty. The seating arrangement encouraged a sense of community in the bar, not unlike that found in the *izakaya*, while the bi-level design and lighting allowed for privacy within the space.

LEFT

The weight and strength of the exposed concrete ceiling complemented the natural beauty of the wood tables and benches and contrasted with the polished surface of the floors.

RIGHT

Two level changes gave a sense of separation, while allowing the space to flow.

Radio
Bar / Harajuku / 1971, renovated 1982

Takashi Sugimoto considers Radio to be his most important early work, and it was very popular among his contemporaries as well as younger designers. Sugimoto understood design to be not simply a motif but to have an intangible character. He wanted the design of Radio to be essentially Japanese in character, based on the traditions and customs of the locale, but combined with new design ideas he had conceived during his travels to Europe. Although Sugimoto knew that the space must create the ambience, he was deeply concerned about the loss of character of the space that often occurs when it is expressed in drawing, which is necessary for construction. In order to find a method which would allow for the expression of the character of a shared cultural "life force," he began his studies for the project by asking the renowned sculpture Isamu Wakabayashi to make 300 sketches to serve as inspiration.

Sugimoto was familiar with Wakabayashi's work from his time as a student of sculpture at Tokyo University of Fine Arts. For Sugimoto, Wakabayashi's work expressed a mentality common to all Japanese people and represented a shared cultural continuity. Sugimoto's desire to express that which is inherently Japanese led him to ask Wakabayashi to spend a year making sketches, unrelated to the specific design of Radio but which would trigger the imagination. The result was a new kind of collaboration, one in which the originator of the images worked completely independently from the designer and then passed on the responsibility for the communication and expression of the ideas.

In Wakabayashi's sketches, forms gingerly emerged from the page, always subtly suggesting a shape or a pattern but never quite coming to completion. Sugimoto's choice of materials reflected his desire to express a similar ambiguous beauty, one that is steeped in the traditions of Japanese aesthetics, where beauty is found in irregularity and imperfection. The dominant element of the space, the bar counter, which seated only seven, was a thick slab of cherry wood, full of knots and cracks. Rusted iron, a new material in the palette of interior design, covered the walls and also showed beauty in the aging of the material and in its visible history of use.

In order to keep pace with the changing times, Radio was renovated by Super Potato eleven years after it first opened. The arched pattern of delicate overhead lights was a reminder of the arches of the original design. The rusted pipes and cherry counter continued to express the Japanese character which initially inspired the design.

ABOVE

The simple floor plan of Radio, with the bar counter as the central focus of the tiny space, allowed the textures of the walls and counter to generate the atmosphere.

RIGHT

Arched lighting highlighted the intimate ambience created by the wood bar and the rusted metal walls accented with forms inspired by Isamu Wakabayashi's sketches.

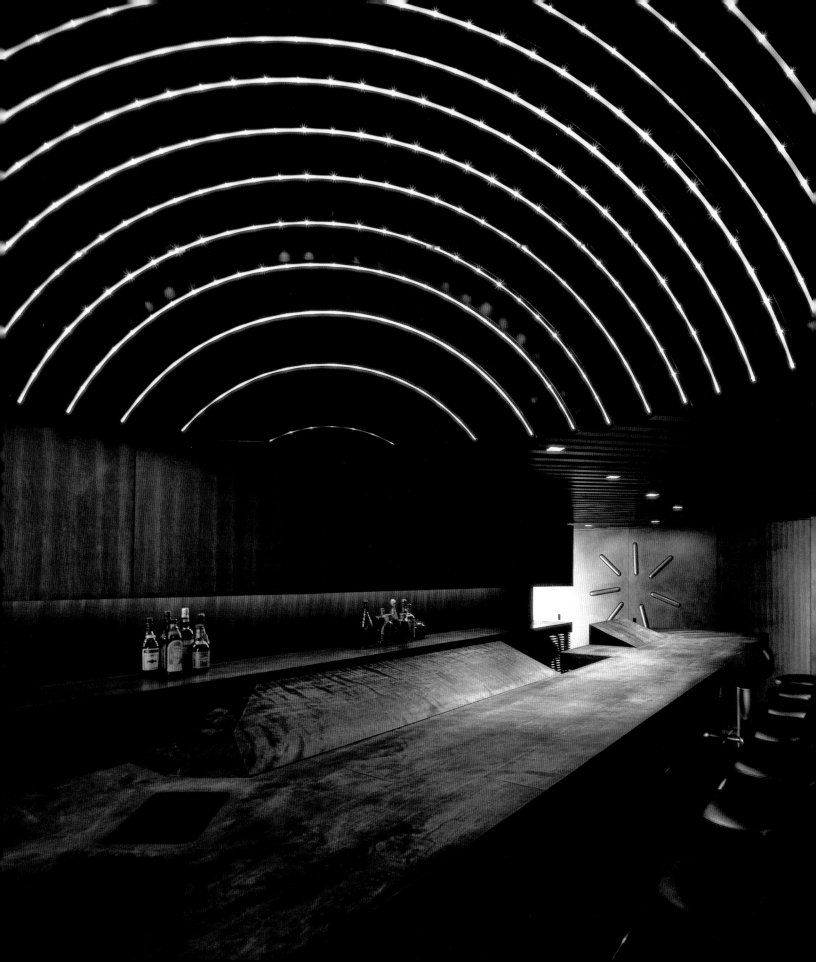

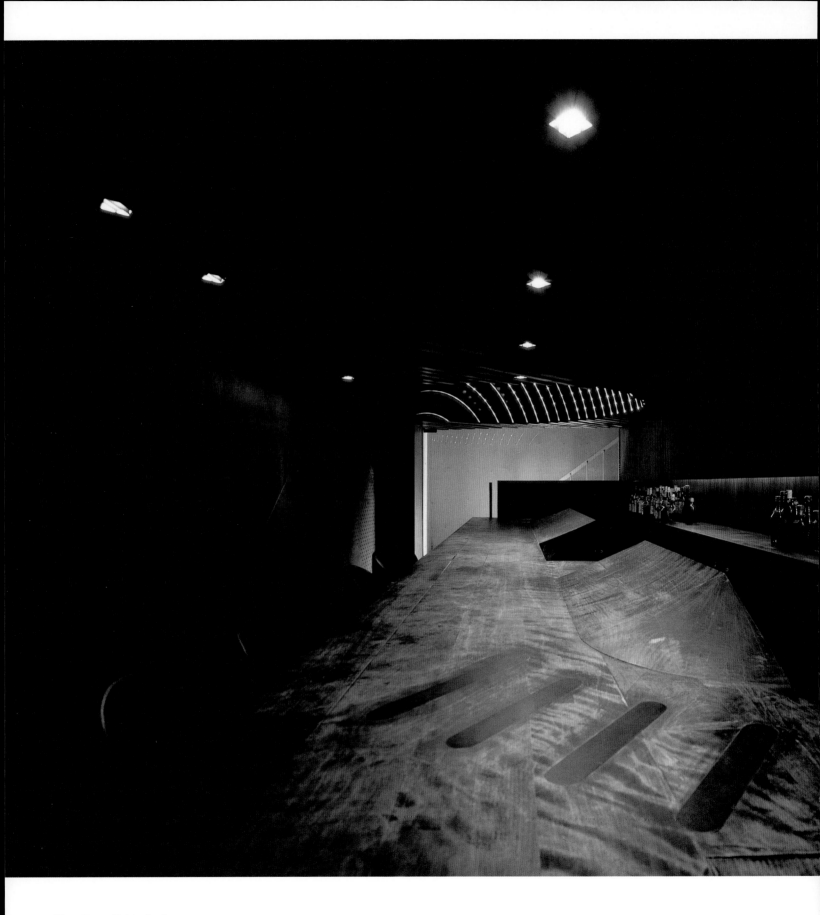

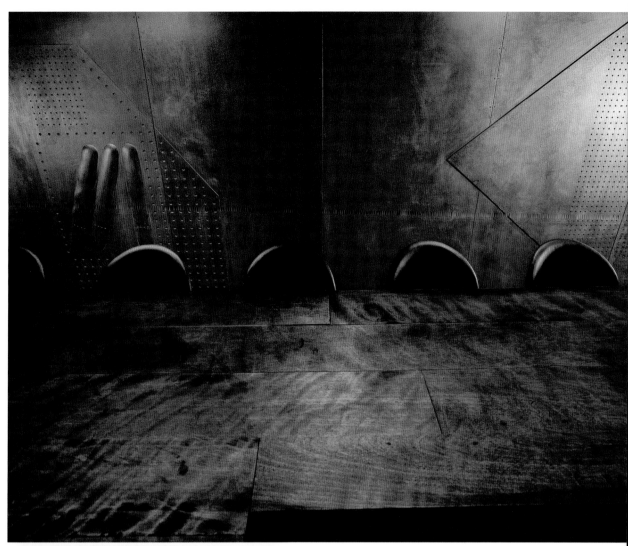

OPPOSITE

The long, sculpted wood bar gave a solid, permanent feel to the space. The roughly textured surface was inlaid with wood in a pattern relating to the forms on the metal walls.

LEFT

Forms and patterns from intuitive sketches drawn by Isamu Waka-bayashi, like this one on the metal panel wall, mysteriously appeared on different surfaces throughout Radio.

ABOVE

The soft light seemed to be absorbed into the warmth of the cherry wood bar and gently revealed the abstract forms slowly emerging from the rusted metal wall panels.

Pashu Labo
Boutique showroom / Nogizaka, Tokyo / 1983

A boutique showroom for a high fashion clothing manufacturer, the design of Pashu Labo expressed much more than simply the quality and idea of the brand through a specific theme; the intention was to suggest the accumulation of time. Super Potato utilized only previously used salvaged materials in the construction of the space. The texture and patina of the rusted metal and weathered wood gave a sense of the history of the materials' use, but the ways in which the materials were put together achieved a sense of the present and spoke to the future.

The space was a simple rectangle, and Super Potato's design emphasized the shape of the space by building out the walls with shelves and closets. Prominent objects set within the space caught the eye and emphasized the void between the walls. The exposed ceiling was a maze of ducts and pipes, and subtle downlights drew the eye away from the ceiling to the areas where the clothes were displayed. Twelve rough wooden columns from an old schoolhouse, painted white, stood in the center of the space as a focal point as well as a display area. The floor was also made of wood from the old school. The planks were split and stained and had visible holes, but when they were lined up next to each other, the patterns suggested a new way of looking at and understanding the material.

The shelves which were built into the walls were constructed from rusted and cracked sheets of iron from a shipyard, which also covered the surface of the walls. The large sheets were cut into smaller pieces which were then welded together in random patterns to show off the variations in the patina. In order that the clothing would not be in direct contact with the rusted surfaces, the shelves were treated with zinc in a process that bleached out the rust and left the metal a mottled silver color, with the scratches and marks of time intact. In addition to the display area created from the wood columns, a grouping of blocks of solid metal punctuated the central void space. The metal blocks were forged and beaten to soften their edges and give them the appearance and feeling of clay. They were placed as sculptural objects in the space, objects with a mysterious past, lending a sense of the continuum of time to the space.

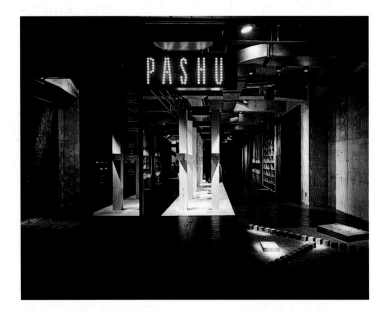

LEFT

Set within the existing structure and exposed ducts of the building, new elements created a space filled with color and texture, highlighted by dramatic lighting.

RIGHT

The abstract geometry of the metal block installation and the simplicity of the salvaged timber frame and textured metal walls combined to give the boutique a gallery-like quality.

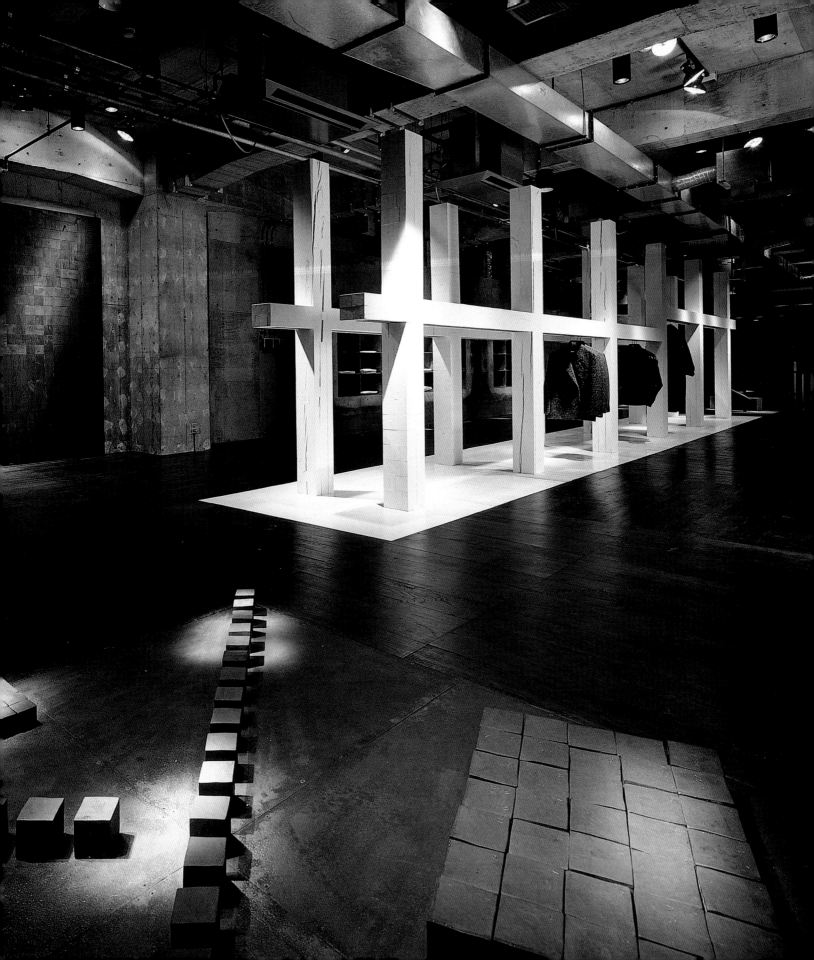

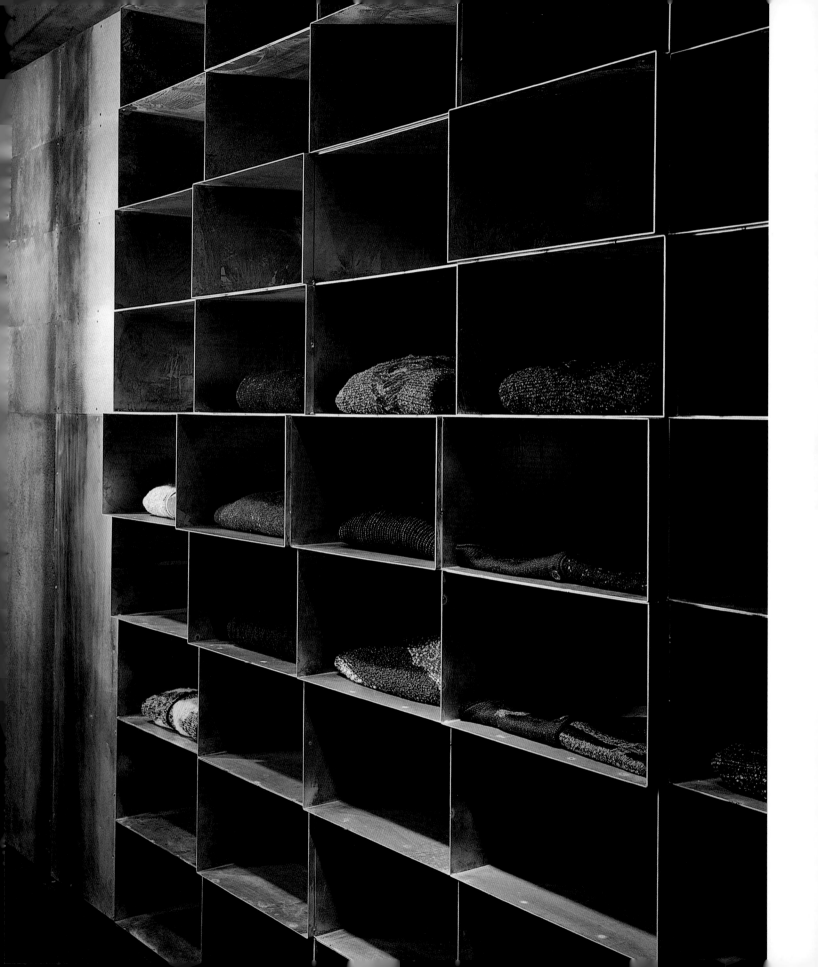

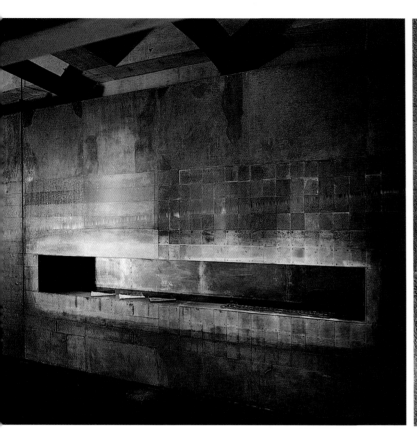

LEFT ..

Salvaged metal boxes were arranged in irregular stacks to create undulating wall shelves.

ABOVE LEFT

A niche displayed merchandise in a textured wall composed of salvaged metal pieces.

ABOVE RIGHT

The patchwork configuration combined zinc-treated pieces of salvaged metal with those having a rusty patina and rough texture.

RIGHT

The length of the public showroom was emphasized by a long timber frame in the center of the space. The private functions were located in flanking spaces.

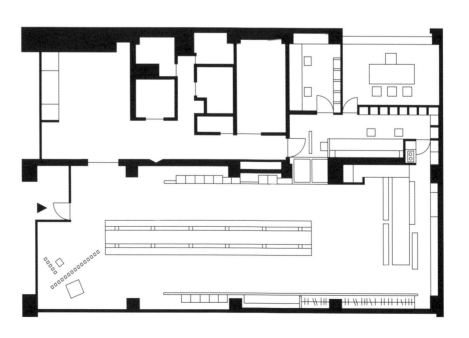

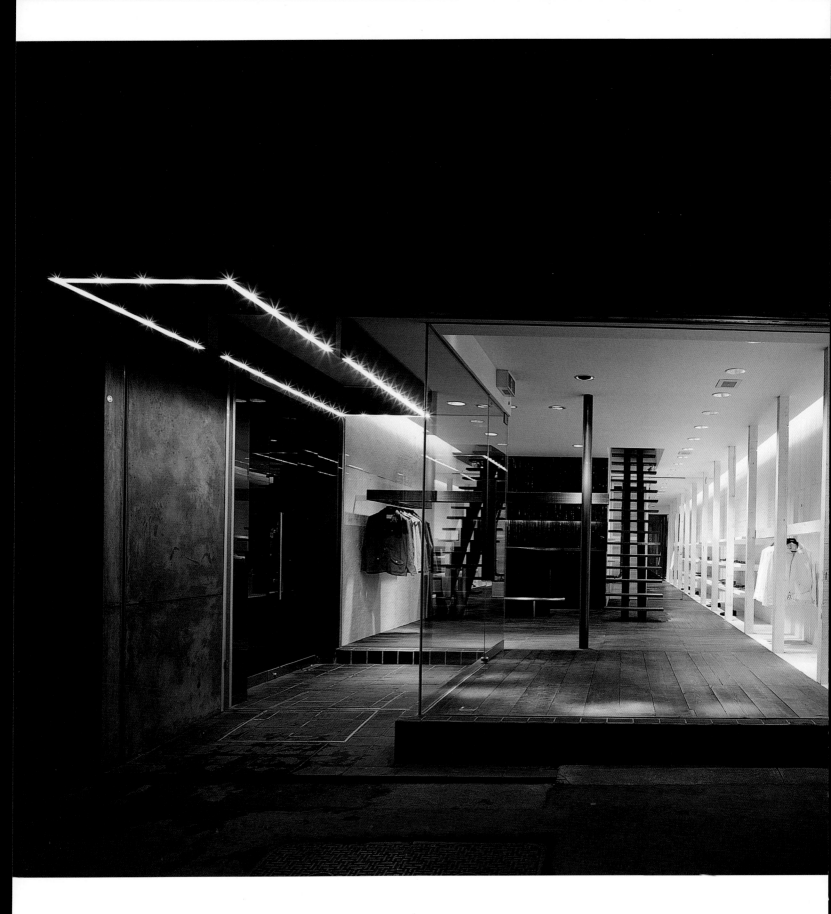

Pashu
Retail boutique / Sapporo / 1983

One of close to sixty retail outlets for the Pashu brand of clothing, the design of the Pashu Sapporo boutique followed the same theme as Pasho Labo: the expression of history and the understanding of an amassing of time in the space. The designer's goal was to give the space a character which took advantage of the age and patina of the materials and spoke of that history rather than simply expressing texture. Super Potato scavenged materials from demolished old houses or found them in junkyards. The materials showed the marks of their previous uses but were arranged in patterns that gave them new life while allowing their history to be revealed. Some of the salvaged wood and metal was painted white to hide the patina, as well as to protect the clothing on display, but the character of the material was not completely hidden and hinted at a past use.

On the walls and floor, Super Potato lined up, piece by piece, wood from several old Hokkaido houses, the scratches and cracks of time apparent in their surfaces. The wood was of all the same species, but the differences in aging gave varied patterns and textures which added to the character of the space. Steel found in junkyards was also arranged in patterns which showed off textural and color differences within pieces made from the same material.

Unlike contemporary materials which are fabricated to remain new looking for as long as possible, Super Potato chose materials which showed the history of their use and would continue to age and change over time. The materials created a space expressing this continuum of time, from a past that can only be imagined to a future that is inherently implied.

LEFT

A cantilever roof, outlined in lights, led to the entry. Frames of old house timbers, some painted white to subtly hide the marks of time, defined the spaces and displayed the clothing.

RIGHT

The boutique featured a sculptural stair leading to the upper private area that separated the L-shaped display area and a small bar from the long display space defined by a timber frame.

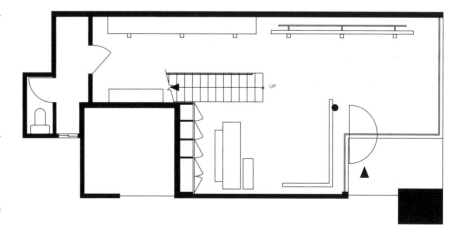

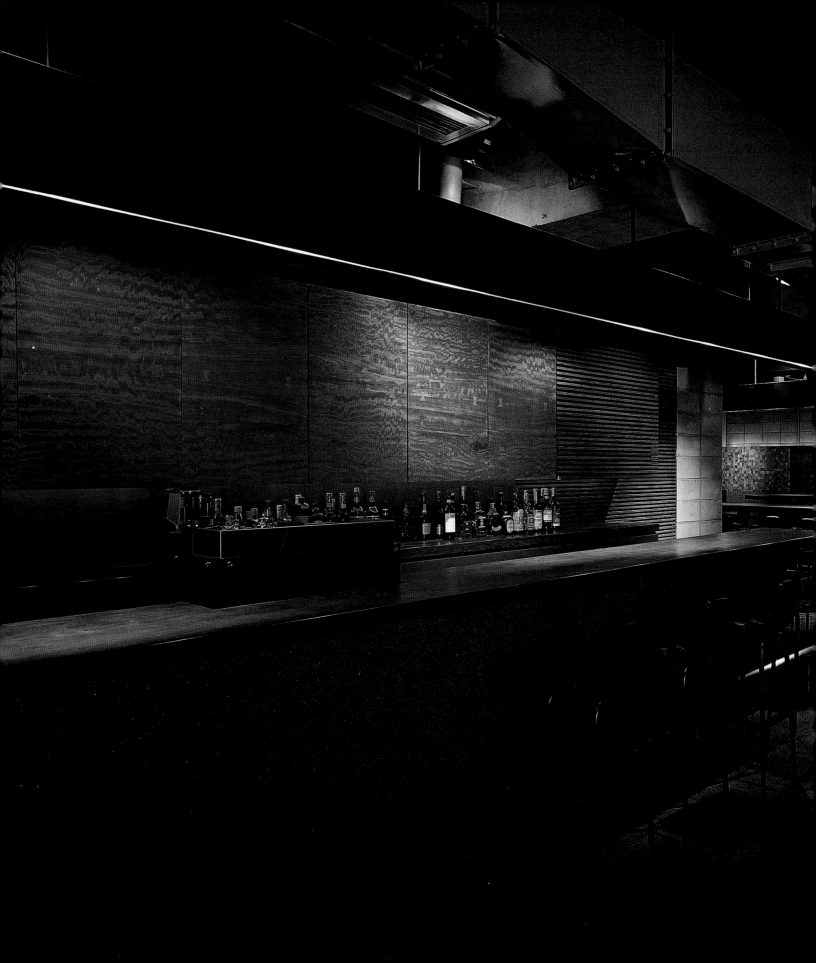

Old-New
Café and bar / Ikebukuro, Tokyo / 1983

LEFT
..............................

The smooth surface and simple lines of the long bar counter, highlighted by the continuous light fixture above it, emphasize the horizontality of the space.

In the early 1980s, Takashi Sugimoto recognized that the changes that were taking place in the Japanese economy marked a potential for change in the design world. For the design of the bar Old-New, Sugimoto proposed expressing the skeleton of the space by exposing the ceiling and all its ductwork, pipes, and wiring as well as part of the concrete block walls. For the lower part of the walls, to a height of about 1.8 meters, Sugimoto planned to cover the surface with scrap metal from found objects. The client for the project, a well-established department store chain, was reluctant to accept Super Potato's proposed design. Takashi Sugimoto was convinced that such a design would attract customers and took full responsibility for its success. On its second day of operation, over a hundred people lined up at the entrance, proving the bar's popularity. Sugimoto's prediction had been correct: the Japanese people were ready to embrace new ideas.

The dimly but precisely illuminated L-shaped space features subtle material changes that give the space a sense of mystery. The floor surface changes several times, shifting from wood flooring at the entry to matte finish metal plate to a collage of wood of multiple shapes and sizes and then back to metal. Tile-like pieces of metal, some formed from rusted copper sheets, some from aluminum cans which had been pounded flat, and others from steel cut out of old truck beds, line the lower part of the walls, wrapping the space with a horizontal band of muted color. Panels of metal slats, attached to the wall horizontally like louvers, occasionally interrupt the pattern of the metal tiles. In a seemingly random arrangement,

the metal shimmers mysteriously in the low light, as though the rough concrete block walls are lined with precious materials which serve to contain the space and make it suitable for human activity.

The metal wall stops short of the wood bar counter, exposing the existing concrete block wall which contrasts with the warmth of the polished wood of the counter and the cabinets lining the back of the bar. The bar counter turns the corner of the space, and its smoothly finished wood surface is highlighted by soft spotlights. An overhead fixture of black metal holds the spotlights and is the only designed element that occurs at ceiling height. Large round tables and rounded benches are also made from thick slabs of wood and finished to a smooth surface that seems to absorb the light. They fill the space, and their strong geometry complements the subtle color variations of the walls and floor.

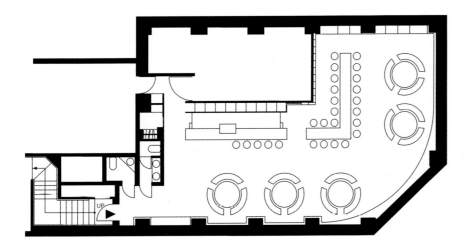

ABOVE

The floor plan shows the simple spatial configuration, with the bar counter wrapping around the kitchen and round tables and benches following the outer wall.

RIGHT

The "old" concrete block walls and ductwork of Old-New contrast with the "new" wall, a patchwork of salvaged metal, which envelops the space at sitting height.

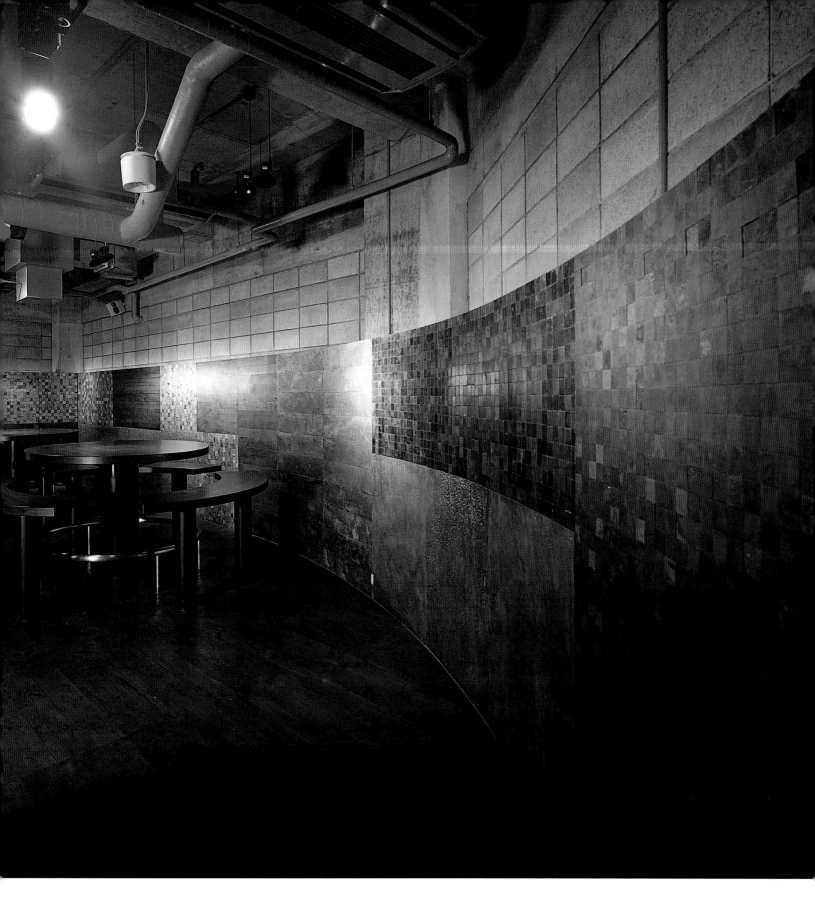

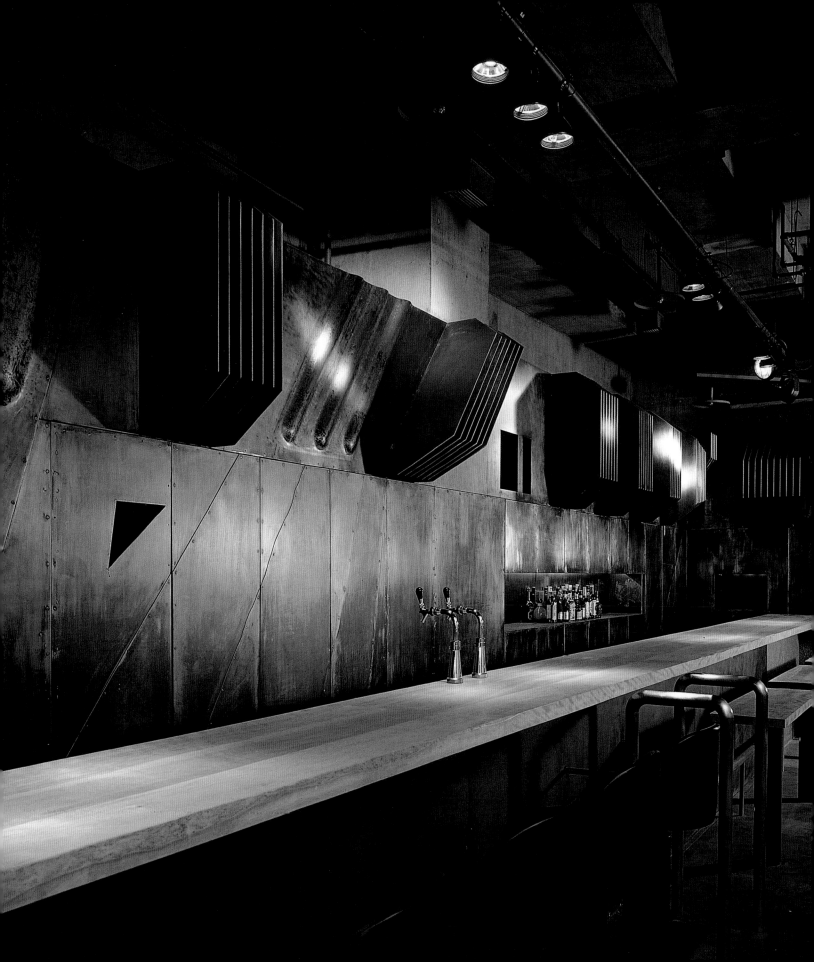

Brasserie-EX
Café and bar / Shibuya, Tokyo / 1984

Located in the busy student area of Shibuya in Tokyo, Brasserie-EX was built in a large high-ceilinged space that was partially underground. Sugimoto's intention for the design was to create a new kind of café atmosphere, where many different parts made up the whole and provided varied spaces for different sized groups of customers. The entrance to the space extended from a central staircase, and Takashi Sugimoto took advantage of this natural division of the space in his design, as the first step to make the large space feel more comfortable. The intentionally chaotic scheme featured two kinds of space: a casual quiet space and an active installation-like space. The idea of the space was to understand it not from its physical form but from the information it gave and received – like changing the channel on an old radio: both familiar and new at the same time, with a bit of static in between.

The active space featured banners of patterned fabric, inspired by the configurations of repetitive shapes of the French abstract painter Claude Viallat. The banners were interspersed with walls of tile mosaics, some black, some white. The tiles, salvaged from a tile factory, had been damaged during manufacture and had already broken into pieces. Assembled randomly, the tiles covered the walls, floor, and tabletops in Brasserie-EX. Separated into black and white zones to further divide the large space, the surfaces of the tiles contrasted strongly with the colorful fabric banners. Large round tables and benches provided seating for groups of 8–10 people within the lively atmosphere. New theater-style spotlights with colored filters hung from the high ceiling and highlighted the surfaces of the tiled tables, perhaps the first such use for that type of spotlight in an interior design.

In contrast to the active tile work and vibrant banners, the quiet section of Brasserie-EX had long rectangular wood counters, tables, and benches. The warmth of the wood was offset by the sculptural metal found objects installed on the walls.

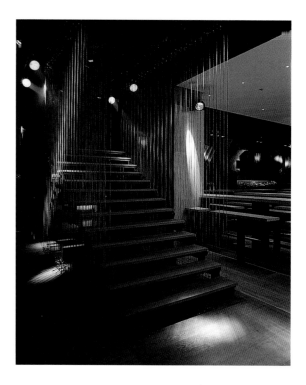

OPPOSITE

In the calm side of Brasserie-EX, the long wood counter with simple wood benches wrapped the corner, continuously facing the mysterious sculptural metal wall.

ABOVE

The wooden treads of the entrance stair seemed to float between many thin strands of metal rod, which delicately separated the space of the stair from the adjacent bar area.

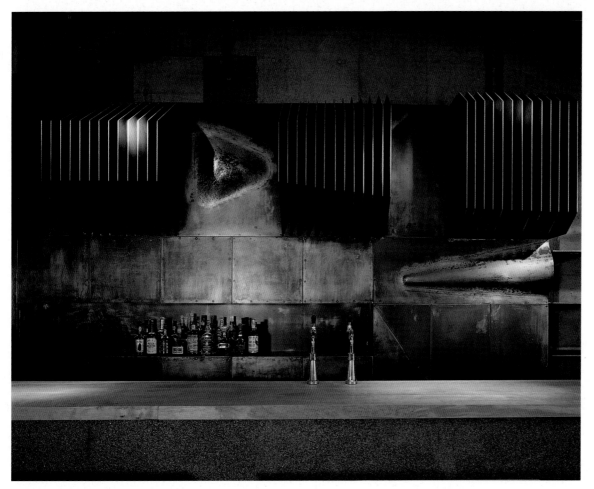

LEFT

The smooth wood counter contrasted with the sculptural wall behind the bar. Old machine parts emerged abstractly from the metal panels, while a shallow niche held bottles.

RIGHT

Playful lighting accentuated the lively side, where circular tables with curved benches and fabric banners in colorful patterns were interspersed with mosaic tile wall panels.

BELOW

The upper floor plan (below right) shows the long entry hall to the stair, which descended and divided Brasserie-EX into two distinct spaces (below left).

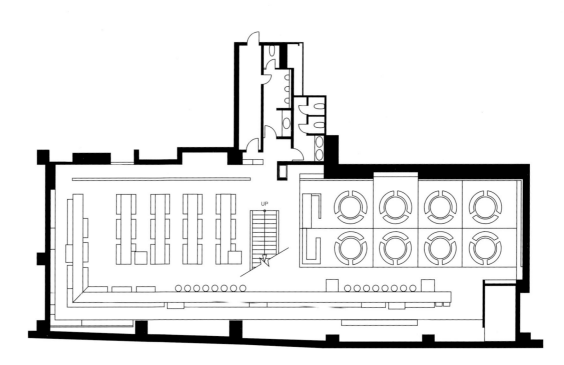

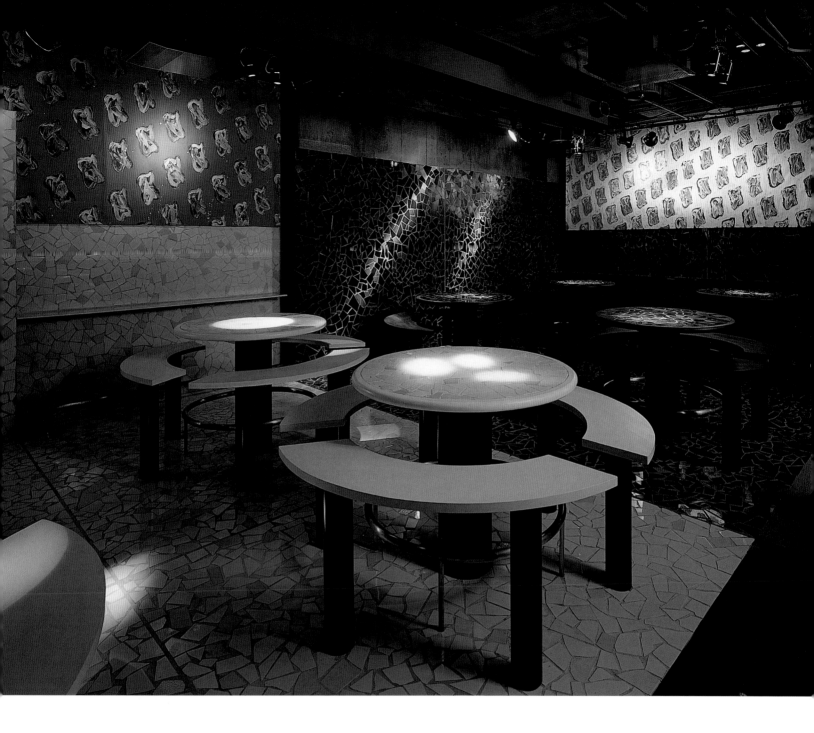

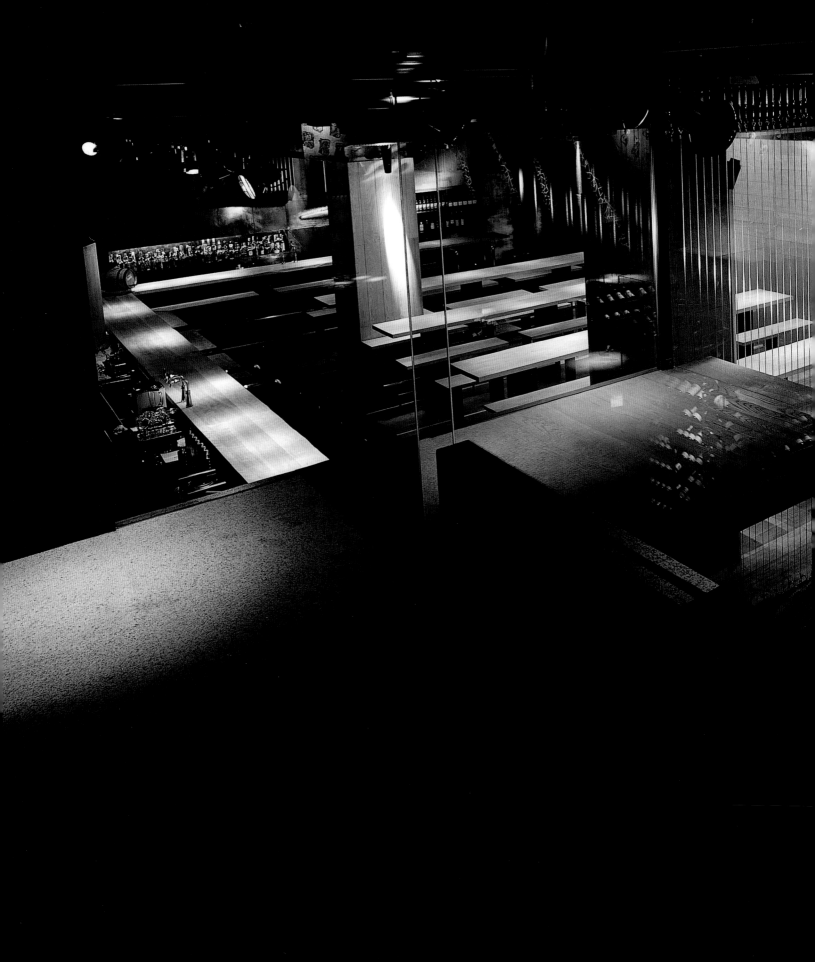

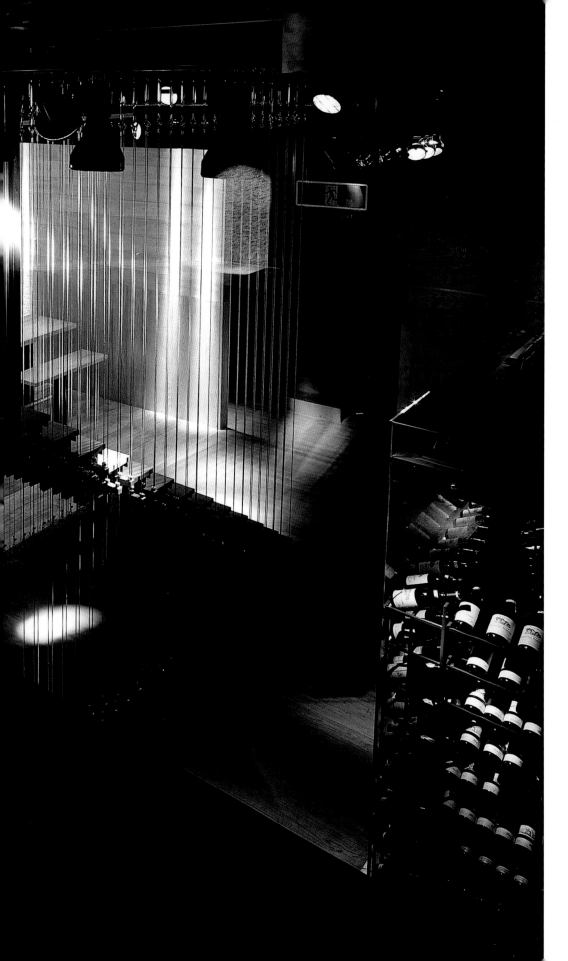

LEFT

The upper entrance hall was enclosed entirely by glass, allowing views of the "floating" stair and the two spaces it separated, one calm and the other lively.

Be-in
Café and bar / Shinsaibashi, Osaka / 1984

Constructed in a renovated warehouse in Osaka, café/bar Be-in was one of Super Potato's more experimental early projects, in which Takashi Sugimoto wanted to explore the possibility of designing a space like a picture. Unlike previous projects which had emphasized the texture and character of the materials used, the materials in this design were presented in an intentionally ambiguous manner. When the construction was 80 percent complete, Sugimoto asked the contractor to stop. Working with the staff of Super Potato and the sculptor Isamu Wakabayashi (who had made the sketches which inspired the design for the bar Radio), Sugimoto spent a week experimenting with finishes and completing the project.

They painted the walls and most of the surfaces white, using a method that applied the color unevenly to give it depth and a mist-like appearance. Sugimoto then used a thick pencil to draw large blocks of gray color on sections of the wall and punctured the wall in arcing and straight lines in order to insert rods containing tiny lights into the holes. The lines of rods and blocks of gray added additional layers and points of interest to the mist-like white walls.

The main space was on a lower level, with a sculptural staircase that led to a special "bar within a bar" on the mezzanine. The furniture – simple counters with benches or chairs – floated in the space, and only the carefully illuminated outline of the stair projected strongly. On the upper level, the counter, set in the center of the long, tight, rectangular space, bent slightly near its midpoint and appeared to be anchored at both ends by sculptural blocks which protruded from its surface. The overall effect of the abstract design created a calm and tranquil atmosphere, a space of indistinct layers momentarily accentuated and clarified by points of light and sculptural elements.

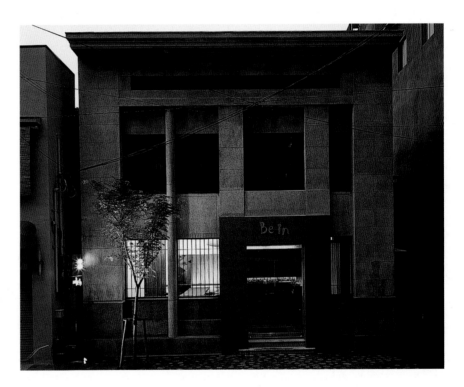

ABOVE

A simple geometric frame set in front of the renovated warehouse clearly marked the entrance to Be-in while playing off the strong lines of the building.

RIGHT

Bold geometry defined the lower level. Vertical planes of contrasting materials pulled away from the walls to frame the space and balance the horizontality of the wood tables.

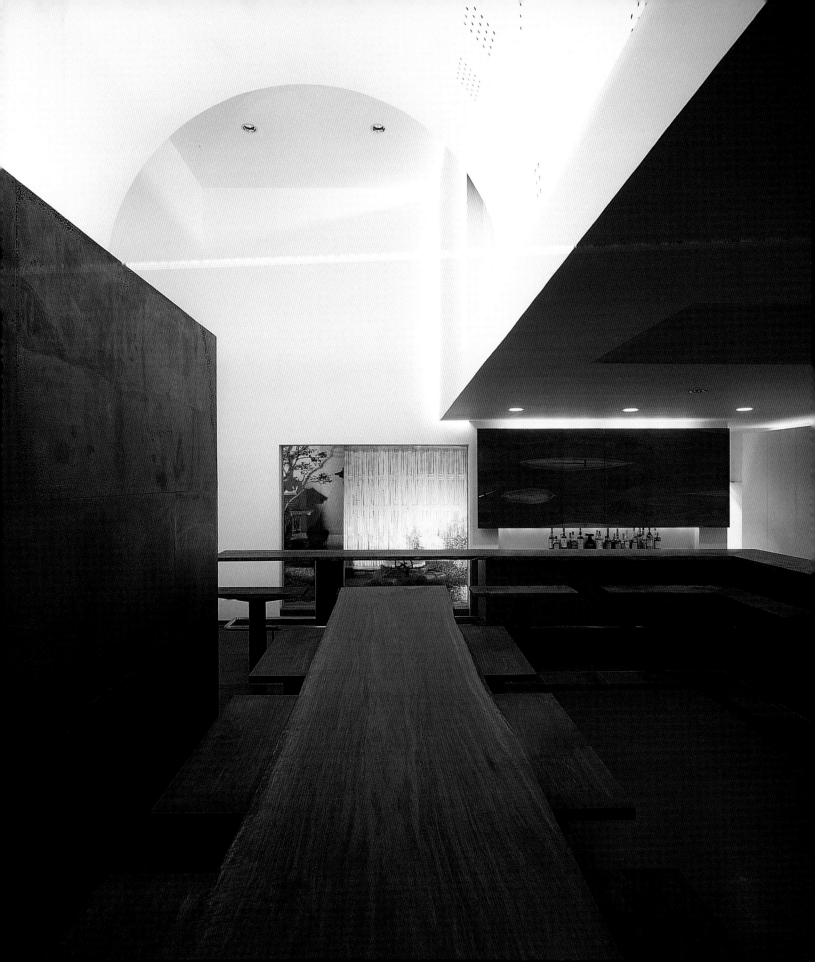

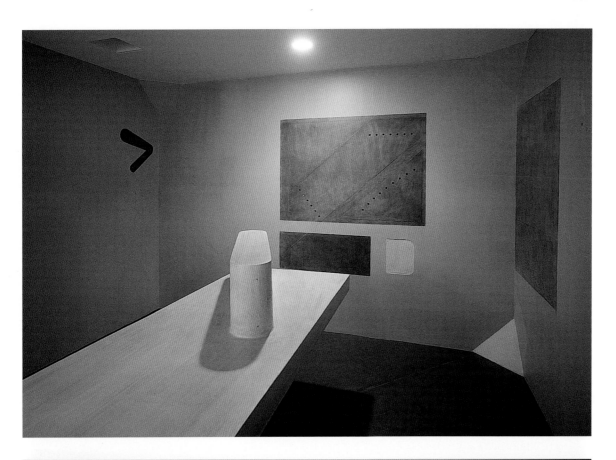

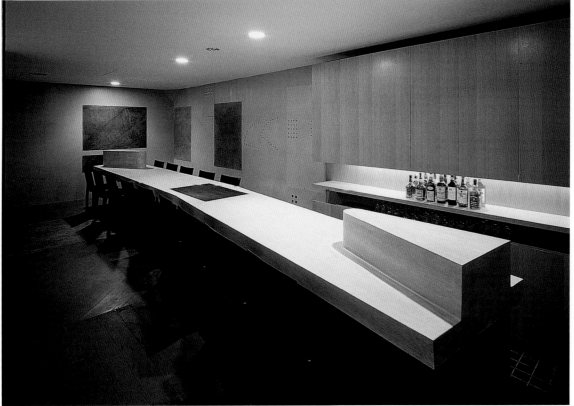

ABOVE

The upper level was conceived as an abstract space with surfaces layered in white paint and shapes drawn in graphite on the walls and accented with lines of small lights.

LEFT

The cool grays and whites of the walls, floor, and sculptural counter on the upper level were set off at one end by the warmth of the wood cabinets and bar counter.

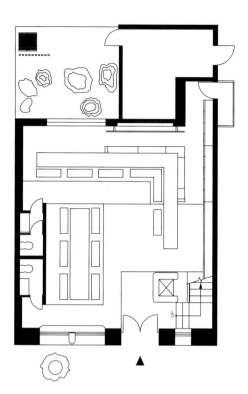

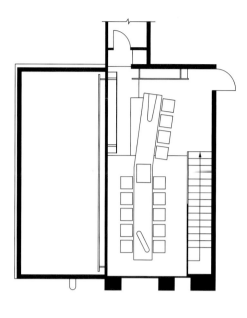

LEFT

The lower floor (far left) focused on a large window with a view to a small garden. The counter ran past the window and turned the corner, stopping where the stair began (left).

BELOW

The stair was designed as a single folded white plane, which appeared to float in the space. Only the edge of the stair was lighted, emphasizing its figurative quality.

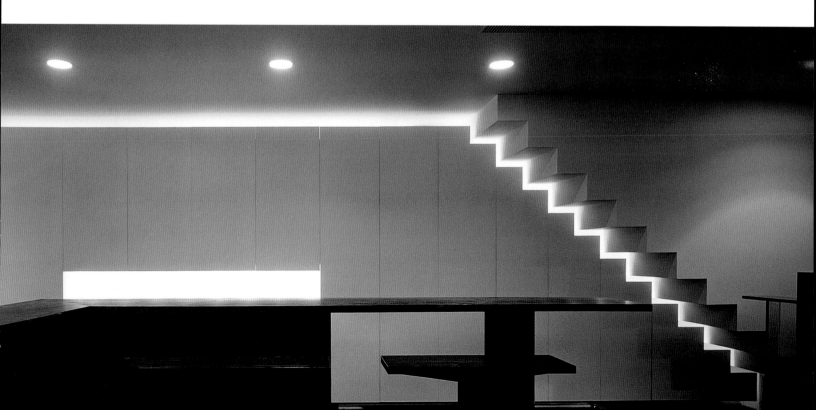

Kiyoshi Sey Takeyama
Talks with Takashi Sugimoto

March 15, 2005, at Super Potato

Mira Locher (M): Takeyama, from the 1980s you have been very familiar with Sugimoto's work. What was your initial impression? What attracted you to it?

Kiyoshi Sey Takeyama (T): I believe that design, especially space design, has the interesting quality of "cutting." It is continually being cut. That aspect of cutting makes space quiver, creates space. Before Sugimoto there was the designer Shirō Kuramata, who created erotic yet extremely beautiful designs, sharply composed and constructed. Kuramata's work was finely polished with sandpaper. The finishes were very beautiful. But Sugimoto cut materials roughly with a hatchet – "How's that?" – and placed them with a bang. There, just like that, space can be made…. That was very shocking to me.

M: Sugimoto, you were influenced by Kuramata, weren't you?

Takashi Sugimoto (S): Overwhelmingly. I didn't try to imitate him; it was more from his presence, I suppose. While I was a university student, I came across Kuramata's work. At that time, I was not especially interested in design. I was more interested in fine arts, but I began to want to do that sort of thing myself….

While I was working in metal, I hit upon design in a very intense way. The very first I came across was Italian design. Initially I learned of it from books, then I became aware of this being that was Kuramata. I think it was during my third year of university. The restaurant Cazador had been completed in Shinjuku … at the moment I saw the space, I thought it was

incredible. Kuramata's early work in particular had an overwhelming intensity. What Takeyama referred to was the work like the chair with roses set in it [Miss Blanche, 1988], as well as his later work; but to be frank, I was not so interested in them. To borrow Takeyama's words, Kuramata's work was more than art. There was the sensation that he had cut his point of view with a blade. That's the part that radically influenced me.

M: As you said, Takeyama, compared with Kuramata's meticulously finished work, Sugimoto creates appealing spaces from a casual accumulation of roughly finished materials. I believe that he was the first designer in Japan to use this technique … to my eye it has a very Japanese quality.

T: Kuramata's work was fantastic design, but it was based on European geometry – that is, beauty based on the square or the circle. This is universally perceived. But Sugimoto's geometry is warped, isn't it? (laughing) Radio was a relatively early work, as was Bc in, the bar in Shinsaibashi in Osaka. There was a segment of a perfect circle that formed part of a beautiful light fixture … so it isn't that Sugimoto doesn't use geometry. On top of fully understanding the power held by geometry, he says "What d'ya think of this – get it?" While he respects geometry, he also daringly brings in irrational form, and this creates the expression of a very different kind of beauty. I think that Sugimoto was the first to use this technique.

M: At that time designers tended to look primarily at "universally" beautiful things, didn't they? It must have been shocking to see the beauty that Sugimoto pursued.

T: It can be thought of in the same way as [tea master] Sen no Rikyu's small tea ceremony hut. The mud plaster walls, for example, and other so-called "dirty" things which he brought in for their *mitate*-like [an unexpected sight which triggers awareness] beauty. Sugimoto brought in contradictory materials, such as wood and earth – vernacular materials. The things that were made from these, however, were not folk crafts but just the opposite. If they are said to be Japanese, I believe they are intrinsically Japanese. However, it is not the sense of delving into Japanese tradition just as it is – Sugimoto didn't have the slightest intention of that…. If it's done poorly, it becomes like a folk style. That said, I believe he brought a completely different Japanese sense into play.

M: And yet Sugimoto's technique is born from Japan, isn't it?

T: Sugimoto is Japan, yet he is not Japan. Sugimoto is from Kōchi on Shikoku Island, right? The people from the area near Shikoku's Inland Sea nearly suppressed the country of Japan. Also, the area of Shikoku near the Pacific Ocean was part of Japan yet not part of Japan. The alleged reformed Japan always started from that area…. After the war, the American army prohibited *kendō*, *jūdō*, and similar ancient Japanese martial arts. And yet Sugimoto is a *kendō* master, even though ordinarily that was prohibited….

S: It was forbidden to teach *kendō* in schools, but it was practiced in the towns, and the police were allowed to do it.

T: *Kendō* was originally done using a

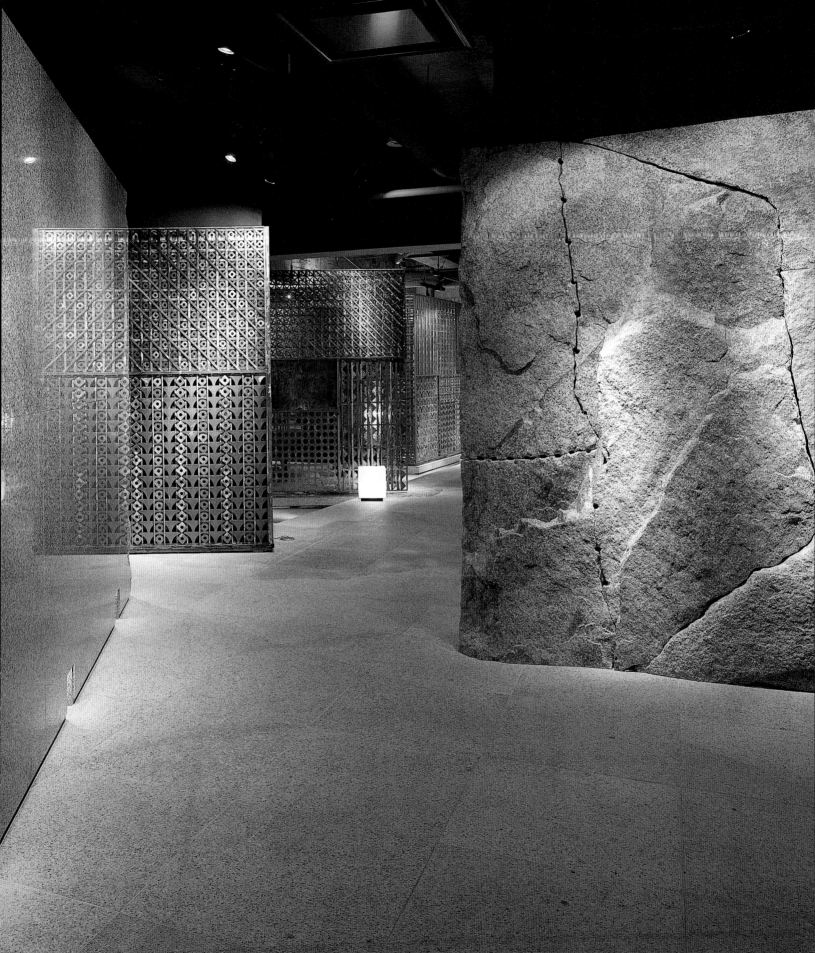

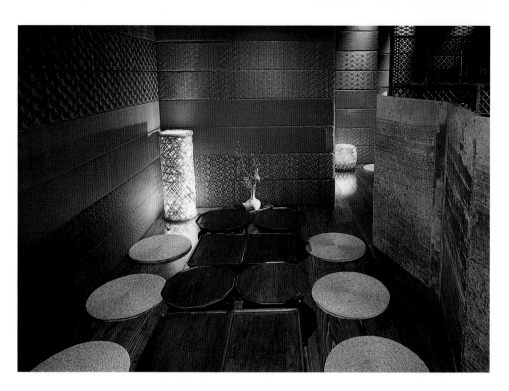

PAGE 52

Kiyoshi Sey Takeyama is an award-winning architect and author, who started AMORPHE, his office, in 1979. He has been teaching at Kyoto University since 1992.

PAGE 53

A polished stone wall and an angled wall of precisely fit rough stone together frame a view to the perforated salvaged metal screens which separate the private dining spaces in Zipangu.

RIGHT

A patchwork of materials, textures, and shapes form a serene private dining room in the Yooan Japanese restaurant in the bustling Tokyo neighborhood of Shinjuku.

Japanese sword. It came into existence through the medium of martial arts. Now it is a kind of sport done with a bamboo stick. By the way, the first time I met Sugimoto there was one more thing that was very surprising. He could use the paper cover of disposable chopsticks to cut the chopsticks – to cut wood with paper.

S: I can't do it now, but then I could.

T: That was truly remarkable! I saw immediately in Sugimoto's early work a hatchet cut sharpness. That sharpness is not mere metaphor. We had been drinking *saké*. He said, "I'll show you a little something." I held the chopsticks. Sugimoto held the paper cover. The chopsticks didn't break, they were sliced! I was amazed. After that, I tried to do it but couldn't. You think there's some trick, don't you? But Sugimoto persistently says it's the speed – the speed at the instant it hits. Acuity supported by that kind of physical ability; imagination supported by the strength to actually incite movement, seeping into every corner of design. I saw that scene of cutting wood with that paper, and it appealed to me in a very real way.... Naturally, Sugimoto will only explain scientifically, "It's simply the speed." He won't say it's a Japanese mentality. Merely because he practiced *kendō*, he won't simply reason that it's Japanese culture.

On the surface, Japanese culture is something that is at times very tranquil, at times mellow, at times quiet – but as though it has a violent impulse at its very core. That's what's at the depth of Sugimoto's well-sharpened power, I believe.

S: That's a great anecdote.... Essentially, all the time I've been practicing interior design, it's one of the things within myself that has become apparent.... For example, a long time ago when Rikyu made his teahouse, by no means did he consider it necessary that teahouses be comfortable, I think. To borrow your words, there is some kind of violent component.... For about ten or twenty years, that point – in an undefined state, however – has been continuously inside me. Design, especially the case of interior design, is by no means just stylish or beautiful. That's not the point. It's something essential, something forceful. For example, when I am skiing, in a way it's violent. My legs ache, and I perceive bodily danger. If I were to relax, I would fly. In my case, when I cry out while I'm just barely staying up on my skis, it could be called a sense of tension, I suppose. In the case of interior design, good design causes tension. It embodies a sense of tension. To create that, one must precisely possess energy.... It's not a simple matter like making beautiful or stylish

things. Architecture too, although the dimension may be different, probably has a similar situation, doesn't it?

T: Interior design has the characteristic of very thoroughly investigating one side of architecture. Architecture includes studying the whole – the transcendental and the intrinsic. Because space can be made so precisely in Japanese interior design, it contains the thoroughly investigated intensity of the immanent, the intrinsic. For example, as Sugimoto just said, when skiing, the surroundings are blown by the wind, the field of vision disappears, and the situation changes at every moment. To ski at a very fast speed cuts and separates space, as if one creates space oneself.... Some time ago Sugimoto favored motorcycles. Because with motorcycles, too, the point is that the surroundings change moment to moment and continuously create space that is cut and separated.... And take the example of *kendō*. As a sport *kendō* now is one on one. However, when [royalist military leader] Musashi Miyamoto defeated Yoshioka Ichimon, Kyoto's top *kendō* group, his opponent was not one person.... He was surrounded and forced to cut open his own path and escape. In the end, design is cutting open a path, isn't it, just like physically using the body to do it? Sugimoto's method of making is to cut and tear space.

S: That's true. For instance, take Angkor Wat.... Ten or twenty years before the construction of Angkor Wat, it was as if they had made a small scale model of it at Phimai [in Thailand].... In recent years the Thai government has excavated and is reconstructing it. That reconstruction is not done accurately as it would be done in Japan. It looks like they put it together up to the point they know. But because it isn't accurate, there is a strong sense of reality. It's quite extraordinary, you know. One stylistic motif starts from the left, but after about fifteen meters, it changes to a completely different style. It makes you wonder! There's one relief of a procession, probably the relief of a specific legend. Suddenly it changes into something quite different. At the point where it changes, there is one geometric pattern. Another geometric pattern enters in, and from there it changes to another style. Furthermore, it changes above and below. Looking at the whole generally, a narrative becomes apparent.... As another example, take an old Japanese picture scroll and continually unroll it and look at it. It's not made up of just one story. One narrative begins, suddenly a different narrative starts. At the end, the four or so narratives come together in one story.

Confusion, what we now call confusion, has no logic. If the logic is not complete, then it leads to confusion. At that time, it wasn't that way. You could say that it started from a logical place. Society is fundamentally logical. Within that logicality, there is something like a force of rotation at the grand scale, for example, something like the Buddhist cross. To grasp the idea reciprocally, you feel a strange method of recognition. In my mind, design is by no means rational. Logically speaking, from about the end of the twentieth century, there was the well-known audio company Bang & Olufsen. Now, together with various lighting fixtures and stationary, their products are installed in the Museum of Modern Art. But that's boring, isn't it? I think what is uninteresting is that they are too logically regulated. For example, in the world of furniture, there is the *salone* in Milan.... At the *salone* there are a number of furniture makers, including the very best, but frankly it's not very interesting. That's

because design has gone as far as it can go. It's excellent but doesn't attract interest.... But go to China – seeing Chinese furniture makes the heart pound! And then go to Spain. Looking at antique Spanish furniture or at Asian colonial-style furniture is somehow more interesting. There was confusion then. Probably now that is reversed. The confusing way is perhaps normal. I have become aware, for about ten years now, that my theme has been how in the midst of confusion – to perceive something like existence.

T: With architecture, even if it's disagreeable, we study logic. At first we can think only about Bauhaus-like composition. From that kind of compositional technique, it's as if Sugimoto was able to find a way to a completely free place. Compositional method, in one sense, if you call it strong, it's strong; if you call it easy, it's easy.... When expressing certain transcendental things, Europe or China inevitably rely on symmetry. Japan is in a marginal place and therefore broke down the symmetry of the temples that came in from China.... I believe that is due to the instinctive sense of incongruity that Japanese people possess. Confusion, as it is, is made intrinsic. A little while ago, Sugimoto said, "This is not logic." However, that logic came from a method that exists in the depths of Japan's culture. Before arriving at logic, by using the physical sense to intentionally exclude logic, it is as though Sugimoto instinctively designs transcendent uncomposed compositions, like parts colliding with each other....

S: To my mind, in the last half of the twentieth century design became stifled, whether it was cars, clothing, or product design – also space and interior design, as well as architecture. To consider how that happened.... Probably the things we need are made many times – many tens of times – too much. By making things, circumstances became comfortable, and there was something like overconfidence. Partly it was proper, partly it was detrimental. For example, if we look at Japan, it is said that there are many thousands of curtain samples. Furniture upholstery and carpet, too – there are many thousands of kinds. Even though they exist,

there isn't a need for them. In the same way, there are electric vacuum cleaners, rice cookers, televisions, and other electrical appliances, including personal computers, each with multiple varieties. By expanding the varieties, in some cases industry was created. Overproduction sustains the current era.... To say that overproduction gave us affluence, it didn't at all. Most products are simply moving through the cycle of creation and destruction. But we haven't given up. Whether a restaurant or a boutique, I think it's necessary to collide with something like reality. The role of design ... is not to make beautiful things. To take a stance, returning to the previous discussion, we become consumed with how to explain things like the concept of the design.... There is a consciousness – a so-called "tea-flower" sense – regarding arranging flowers for the tea ceremony, how to take flowers from the garden and hang them on the wall. The only condition is to cut the flowers oneself.... Even if I search for appropriate flowers, they are not for sale. I have to go somewhere and cut them myself. That is an iron-clad rule of the tea ceremony. In truth it's the same for *kaiseki* [the light meal served before the tea ceremony]. Now it's very difficult because no one cooks that way anymore, so we have the food delivered or hire a caterer. Originally, preparing the food oneself was a fundamental rule. The taste and aesthetic sense from that time changed in the latter half of the twentieth century, from about the 1960s. Because more and more things were made, steadily more and more were sold.

In this respect, architecture is a bit different. From about the 1970s, the designs of our interior designers became industrialized. Selling design became linked with the process of designing. There were some good aspects too, but seventy or eighty percent were bad. The designs of young designers today do not seem very appealing. That is because the aesthetic sense, as with tea ceremony flower arranging, is fundamentally lacking. Therefore, with industrialization everything was produced, as was the way to sell it. When something sold up to a point, it was finished....

The reason I utilize scrap materials is

that I don't want to forsake that kind of consciousness. You could say I recycle things that have been used. At the very least I go on valuing the previous use. But their structure or function has a slightly different sense than that of architecture with its governing principles. With interior design, because it's done in a building where the structure is already completed, the governing principles aren't there.

T: For example, radios – not the bar Radio but the radios that became scrap material. When arranged in rows on the wall, their function as radios is discarded. They are dead bodies but become recycled, and there is a beauty in them that couldn't be seen when they functioned. The point is whether that is discovered or not.

S: On the subject of beauty, in a way there is something like the aura of the energy from when they functioned, and people felt some sort of value in them.

M: Regarding value in recycled materials, for you, Sugimoto, the idea that materials possess information is significant, isn't it?

S: Stone is that way, wood too, but not all wood is the same. For example, with old materials, some are warped, some may have scratches on them. Some manufactured materials may have had things buried in them ... we use things which have accumulated a range of information.... From the time Edo houses are built until they become scrap material, the wood accumulates information. Several hundred people must have lived in the surroundings.... If that wood was here, it would emit information, I think. To me, wood is not merely a lifeless substance, there's a sort of information that it discharges. As for stone, some percent is fossilized. For example, there are fossils from ancient marine plants and fossils from other plants. Inside are insects, or they contain fish or shells.... And to speak of metal ... there is steel that has just been manufactured at a factory, but the steel that I often use has been used once before. It is full of energy, like an "air battery." I want to make use of things like that. More than from the real physical space, space is given meaning through

information that drifts through. I think that's invaluable....

T: The point is in some way to change things into information, change them into narrative, perhaps to put foremost the character of the material itself, something like the texture of wood or a knot. Sugimoto's design is not made of jewels. It has a different way of attaching value.

M: Information in Sugimoto's designs has value as a catalyst for communication. Takeyama, how do you sense the expression of this in Sugimoto's work?

T: Through its expression, a message is conveyed. While materials themselves are silent, they speak. In the process of making things, many different things are considered – some with forms which can't be put into words. And space is not for one person, completely closed in on itself. Spaces for communicating with other are common, pubs, for example, and bars, restaurants, hotels. They express some kind of humanity that Sugimoto himself possesses. The expression itself is communication with people....

S: I think about it a bit more simply. I think the role of interior design is ostensibly something in between architecture and fashion design. To talk about the role of design ... finishes alone are not design. It's the same with product design. It's not as if using things that the product designer makes will bring happiness.... The important role of design today – for those who agree with that way of thinking – is the point of how many people can be brought together ... it's the same with the space we make.... Pubs and restaurants, now I do many hotels.... I design in order to bring together people who want to stay at that hotel.

T: Before Radio ... Maruhachi, wasn't it? The form seemed to exceed the boundaries. All the finishes were peeled off. In a place where there seemed to be nothing, furniture was plunked down. Self-important businessmen won't go to that kind of place. But people with an idiosyncrasy or two would gather there. It's due to Sugimoto's design that a pub can be

made where this kind of company is cultivated. In that way, space calls out to people.... Probably everyone who communicates through the medium of space believes it somewhere in their hearts.... We believe that space chooses people. We set about making that kind of space.

S: People create space, but space cannot create people.... Concerning appeal, it is said very lightly, that design is consumed and destroyed. It is especially true of interior design. Many people believe that if they hire a famous designer, they will be able to sell their product. Architecture has also become such an object....

T: The first time I met Sugimoto was at a time when Japanese interior design was very vigorous. I thought it was far more interesting than architecture. What I felt at that time was, in architecture, there were many people behind the big organizations and society, and very few people who opposed and fought dangerous commercial capital. In that regard, there was a very interesting school of thought in interior design. What was interesting about interior design was that an individual, independently, could fight against society – like a kind of Don Quixote-like lone horseman.... That independence was impressive, and in that it altered society, it aided society. A noteworthy point about Japanese society in regard to independent people who seem to have few eccentricities. People duly follow them, and significantly, markets open up....

Because it regretfully belongs to the establishment, architecture – in terms of its main trajectory – is conservative. Within that, there are independently minded people.... Sugimoto successfully associates with business people and with individuals who are not associated with business. No matter their capability, Sugimoto opens his heart wide and guides them. In consideration of that, what I personally learned from Sugimoto – in regard to the individual who follows in his footsteps – is the mental attitude of having ammunition, confronting the enemy, and communicating strategy. Sugimoto, as an individual – as an independent person – must have made his way by considering how to cut open culture....

S: Many treatises on Japanese society say it is like a group system. In one sense this is true, but as an organization, as a system, to say that it is sound ... actually it is full of holes.... Go to a business enterprise, and you'll understand. In reality, only a handful of people are running the organization. The others are doing nothing. But to be within a loose Japanese-style collective body is reassuring. In truth, because there are such loose collective bodies, it is possible to do certain things. From within there are people who, little by little, move toward an independent direction. There are also people who act very independently. For those who act independently, there is a facet of, in a way, being shown respect by the organization. It is said that in Japan not every face in a group can be seen, but on one hand there are remarkable cases of it not being like that.

Also, there is a strong sense of Japan in my space design. That is because eighty percent of my work is abroad now ... in Asia. Also in America and Europe ... probably about twenty places. There are completed projects and also there are quite a lot of offers, especially in China and Korea, mostly in Asia. To say why that is so ... everyone senses Japan in my work, you know. The Japan sensed at that time is not the tourist Japan. It's a Japanese sense of value that, until now, has not been presented to the world, an element that has not been appeased by modernism. For the people who pursue it, when they come across something Japanese-like, it appears fresh. Therefore we have an awareness of our design having been introduced as Japanese. This has international value. We must teach it to the current younger generation. Japan is famous in the design world. However, the teachers who are instructing the current students have a design sense that came primarily from Europe. Ninety percent of the designers of our generation rehashed European design. What's more, there is much that looks similar, and no one from abroad values it. There weren't things like those we have made; consequently, there is value in them. How to connect that to the current younger crowd ... I believe that is my theme. That is, however, a very difficult problem, isn't it?

ABOVE

Shadows revealed the textures of the sculpted metal handle and rough wood door of Shunju Akasaka. The candle-lit entry was visible through the adjoining window.

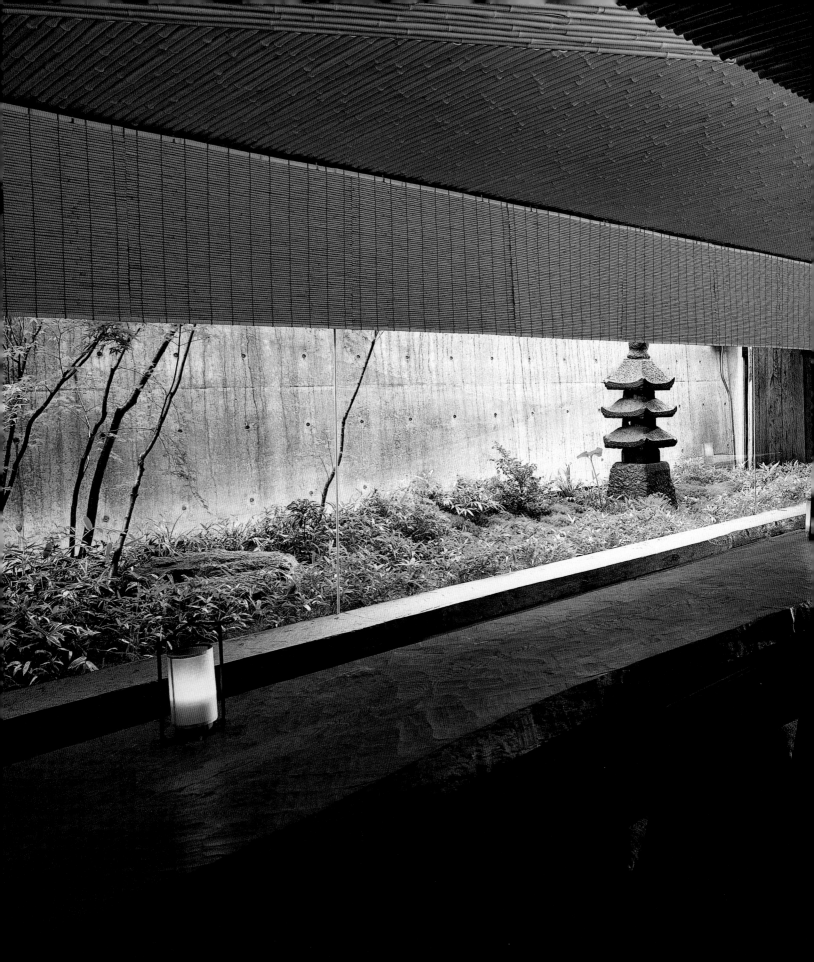

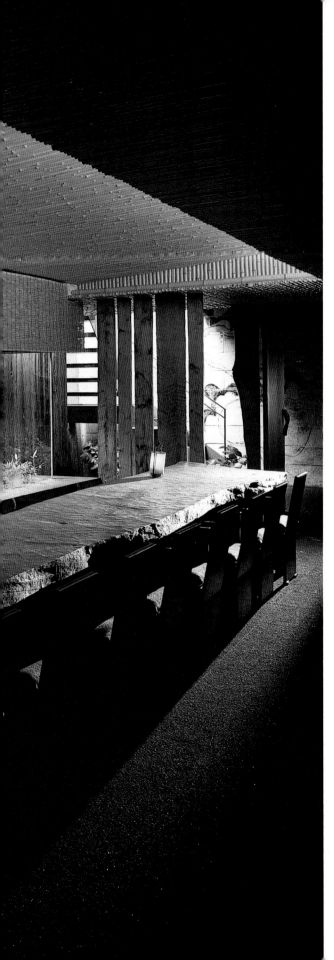

Shunju Akasaka
Restaurant / Akasaka, Tokyo / 1990

As a deliberate departure from the showy design typical of interiors of the late 1980s, Takashi Sugimoto created a calm space for the first Shunju restaurant, built in the Akasaka section of Tokyo in 1990. Sugimoto understood that point of time as dominated by scattered images and fragmented information. To create a place where the image of the space could be identified and shared by all, he chose nature as the theme for the restaurant, reasoning that all people of a certain time period have a shared image and memory of nature. Considering the function of the space, Sugimoto emphasized, "taste is not simply a sensory matter for the human palate, but is the memory of an experience that also includes that moment in time and environment."

To arouse the senses and thus the memory, Sugimoto used a range of diverse materials: wood, bamboo, paper, glass, steel, brick, and tile. Some materials had the patina of age, others contrasted with shiny newness. The materials retained their individual characteristics yet worked in concert to define volumes of space that had weight and depth. Very low lighting levels and softly flickering candle-like lights brought forth an emotional response and allowed darkness to define the boundaries between spaces.

The restaurant was recessed a few steps below ground level, and Sugimoto took advantage of this by creating a garden viewed from the counter seating, with the ground level of the garden at almost the same height as the countertop. Natural-feeling in its simplicity, the garden was bounded by an indirectly lit concrete wall, which set off the few plants and the 1000-year-old stone pagoda sculpture. The unusual height relationship between the garden and the counter allowed customers to feel as if they were part of the garden rather than viewing it objectively from above.

Super Potato gathered together highly skilled craftsmen to work the wood, tile, stone, and metal in the project. The solid wood counter was finished in the difficult *honchōna* style, a rough finish which

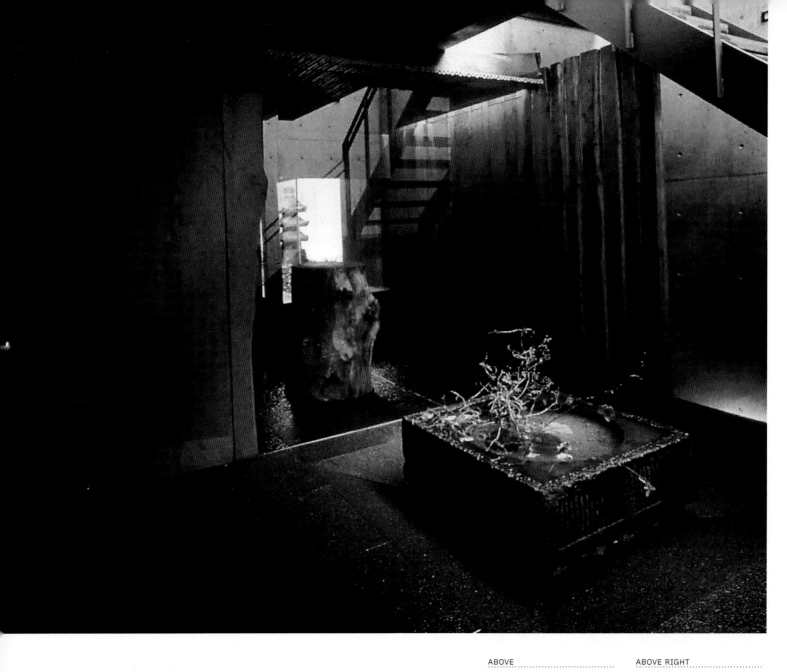

ABOVE

Stairs led down to the entry area, with walls of textured wood and smooth glass. The continuous stone flooring guided the eye through the restaurant to the garden beyond.

LEFT

The section drawing highlights the play of floor levels and ceiling heights. The ceiling over the bar was sloped to emphasize the view of the garden.

ABOVE RIGHT

The garden and adjacent bar were visible from the entry area but separated from the private room by metal screens.

RIGHT

Light played off the uneven surface of the bar counter and the smoothly polished chairs, while the soft illumination in the private room glowed through the perforated metal screen.

brings out the luster in the wood and had rarely been used in such an application. A skilled ceramicist created a wall mural of tiles depicting turnips, which appeared as if they had been painted with a brush on the wall. The geometric simplicity of early twentieth-century iron screens rescued from an English junkyard played in contrast to the layered bamboo ceilings and wooden patchwork walls. The screens separated the main seating area, only eleven chairs at the long wood counter, from a more private tearoom-like space featuring an *irori*, or sunken hearth, used for charcoal grilling.

The small size and limited seating created a sense of community but turned out to be the restaurant's downfall. Although this Shunju, the first in a series, lasted only four years, the memory of the place and its expression of the continuity of time continued on in Super Potato's designs for the subsequent Shunju restaurants.

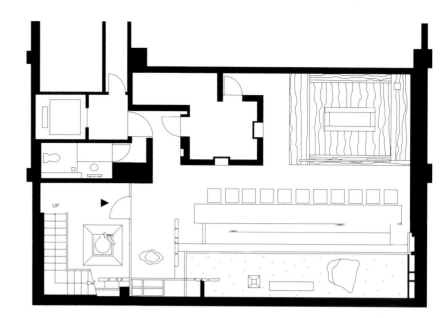

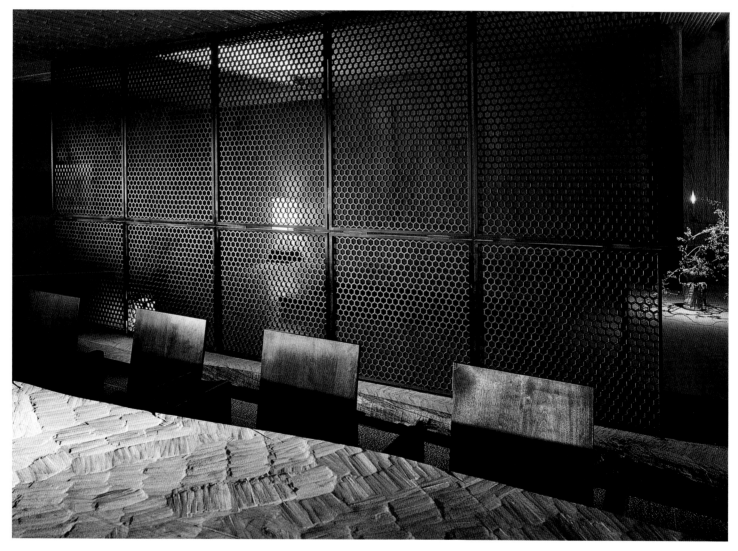

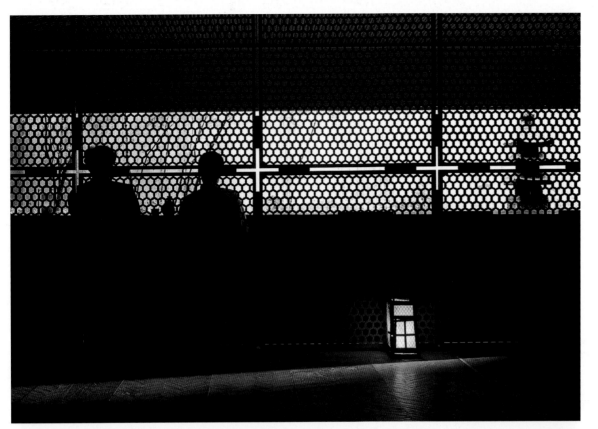

LEFT

A salvaged metal screen gave privacy to the private dining room, yet allowed a filtered view of the bar counter and garden beyond.

BELOW

The raised wooden floor of the private room was softly illuminated by lantern-like paper light fixtures and the glowing charcoal of the traditional *irori* hearth.

RIGHT

Old wood timbers, cut and pieced together to form a geometric composition, covered a wall of the private dining room with hints of information and ideas from times past.

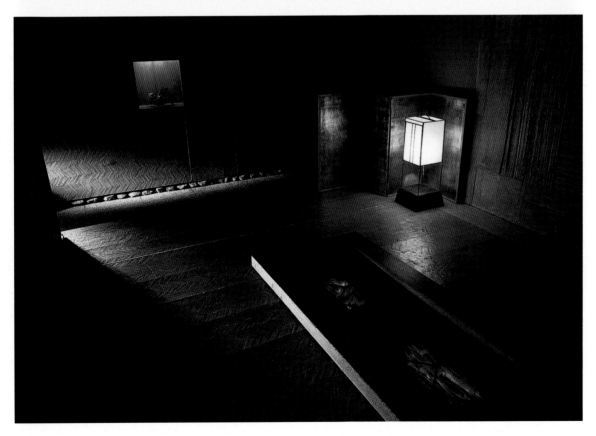

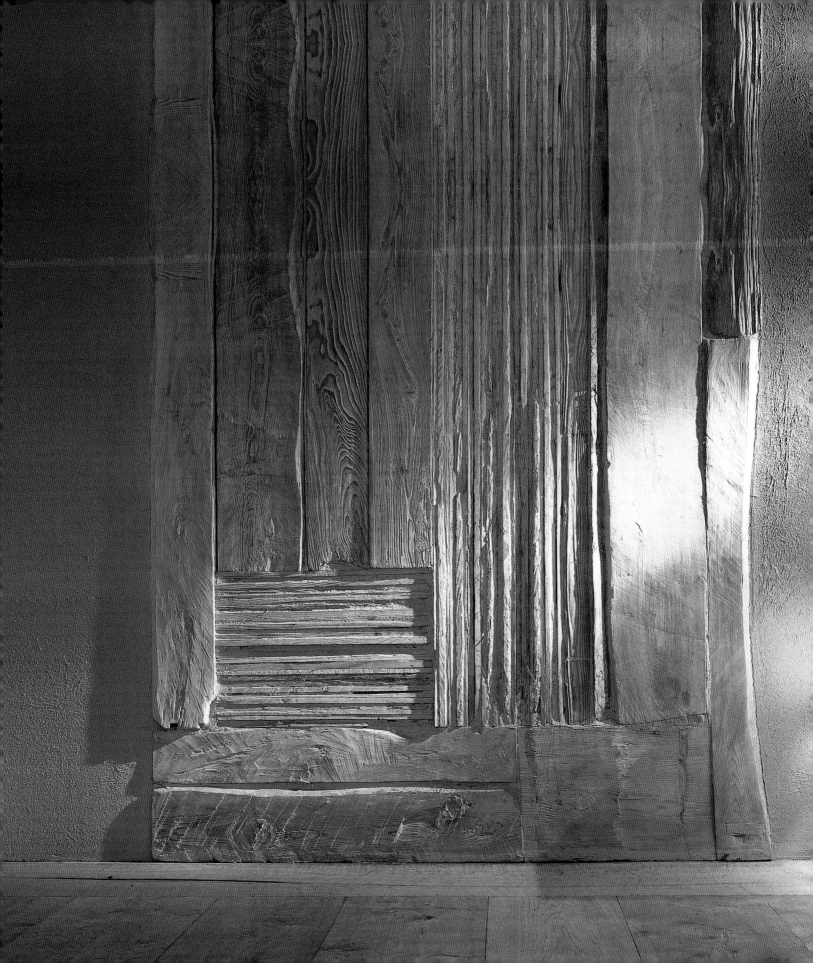

Shunju Tameike Sanno
Restaurant / Tameike Sanno, Tokyo / 2000

Located on the 27th floor of a commercial building, the Shunju Tameike Sanno restaurant is a calm oasis in a surprising spot in bustling downtown Tokyo. Taking advantage of the L-shaped floor plan, Super Potato created a separate bar area with a walk-in wine cellar and a cigar lounge. The smoothly polished surface of the wood bar counter with its naturally undulating edge contrasts well with the geometric precision of the rough brick used on the back bar wall. Cozy tables line the window wall for long night-time views over the city.

The restaurant wraps around the corner of the building, and the open kitchen, set at a 45-degree angle to the corner, is the focal point from the entrance. Only the kitchen has a dropped ceiling. In other spaces the ceiling is left exposed, simply painted black and sprinkled with a constellation of small spotlights. Semi-private seating areas toward the back of the restaurant follow the diagonal orientation of the kitchen, while the table seating near the front mediates between the two geometries. Partitions of vertical and horizontal wooden louvers separate the tables in the semi-private dining area, each seating 4–12 people on cushions on the wooden floor with a recessed leg space. The louvers give a sense of seclusion while allowing views through the space. Thick handmade paper baffles hung from the ceiling are back-lit with spotlights, giving a soft visual emphasis to each space.

A private 41/2-mat *tatami* tearoom at the far end of the restaurant is a surprise; the delicate *tatami* mats juxtapose copper- and steel-covered walls. The space remaining between the right angle of the building walls and the skewed geometry of the *tatami* room becomes a private stone garden, imparting the sense of a view to nature. Other "left-over" spaces between the pre-existing geometry of the building and Super Potato's imposed geometry are also designed as gardens. The large pieces of

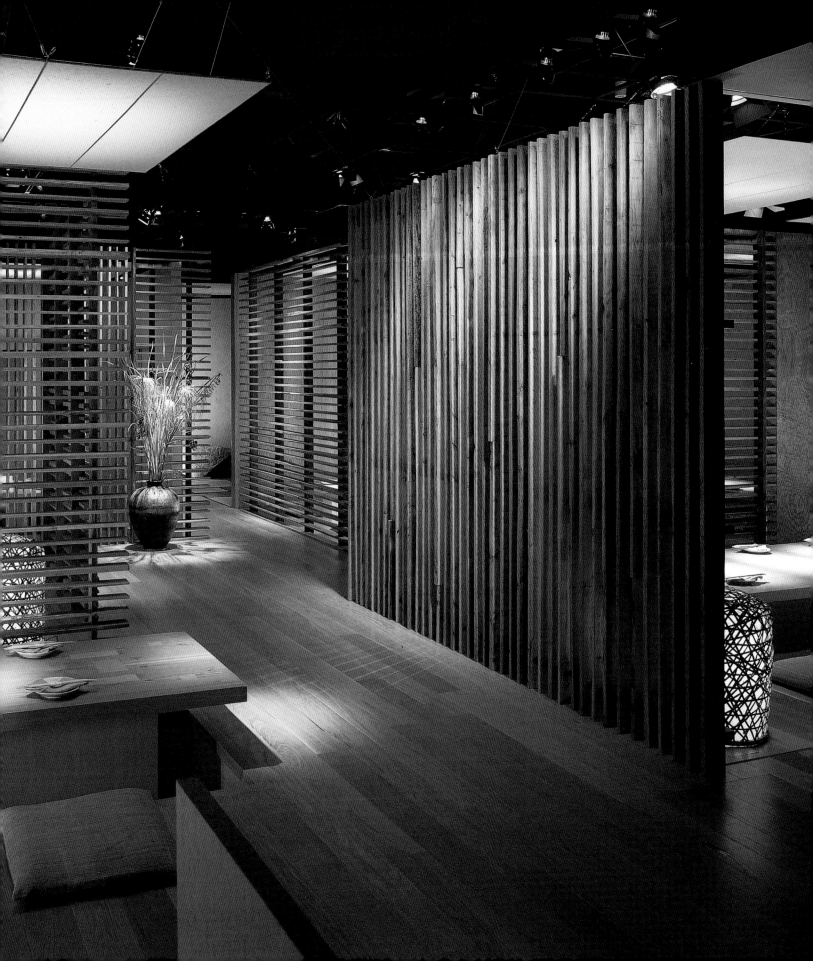

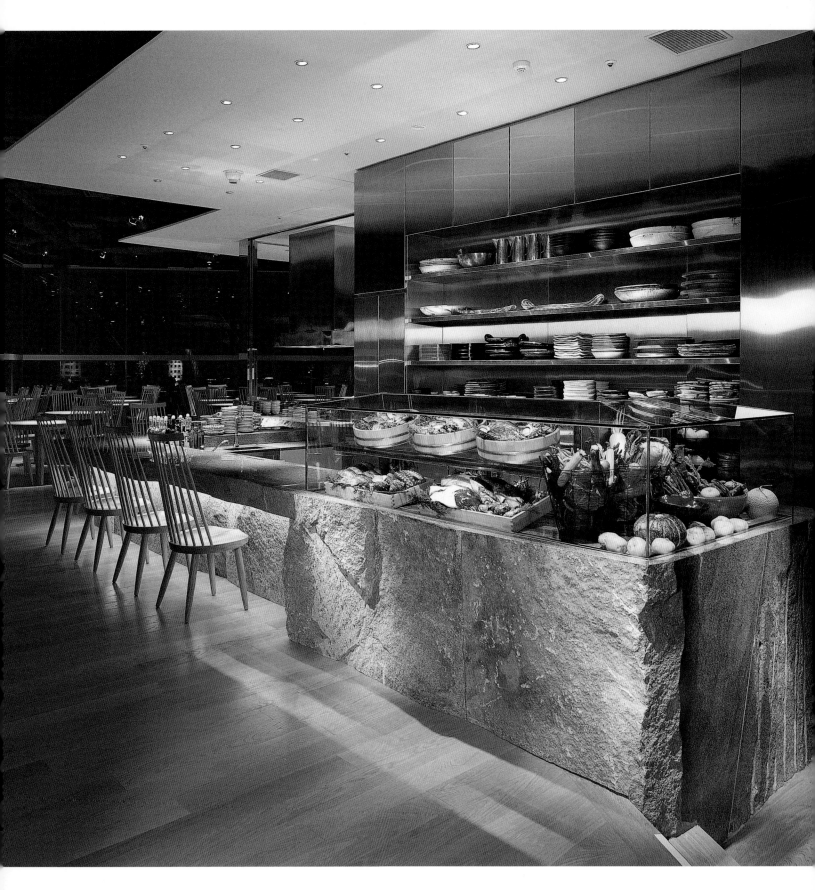

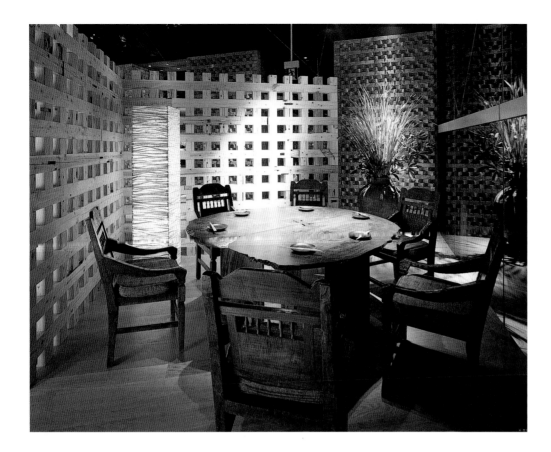

granite are left unpolished, with the drill marks from the quarry readily apparent.

The same granite, similarly rough and "unfinished," is used on a wall at the entrance, as well as under the polished stone counter which separates the open kitchen and the seating area. The rough texture and obvious weight of the stone contrasts with the other materials used in the design: the regularity of the brick at the entry and the bar, used primarily on the diagonal, similar to a traditional French farmhouse method; the shining stainless steel of the kitchen counters; the fragility of the paper light baffles; the precision of the wooden louvered partitions; the handmade quality of the Balinese chairs; and the temporality of the changing counter display of vegetables and other ingredients used in the preparation of the food. The stone is symbolic of the strength of nature and is meant to be viewed not as sculpture but rather as object. As such, it engages the customers' imaginations and suggests an understanding of a design process rooted in nature and simplicity rather than high design.

OPPOSITE
Two steps up from the entry area, a heavy block of granite supports a delicate glass display case and marks the end of the thick stone counter that faces the open kitchen.

TOP
Wide wood lattice screens create a cozy space for the single round table, which has views over the city as well as back to the textured brick wall near the entry.

ABOVE
The L-shaped space is divided between the bar and the restaurant, with its three distinct areas: private rooms toward one end, tables near the windows, and counter seating at the open kitchen.

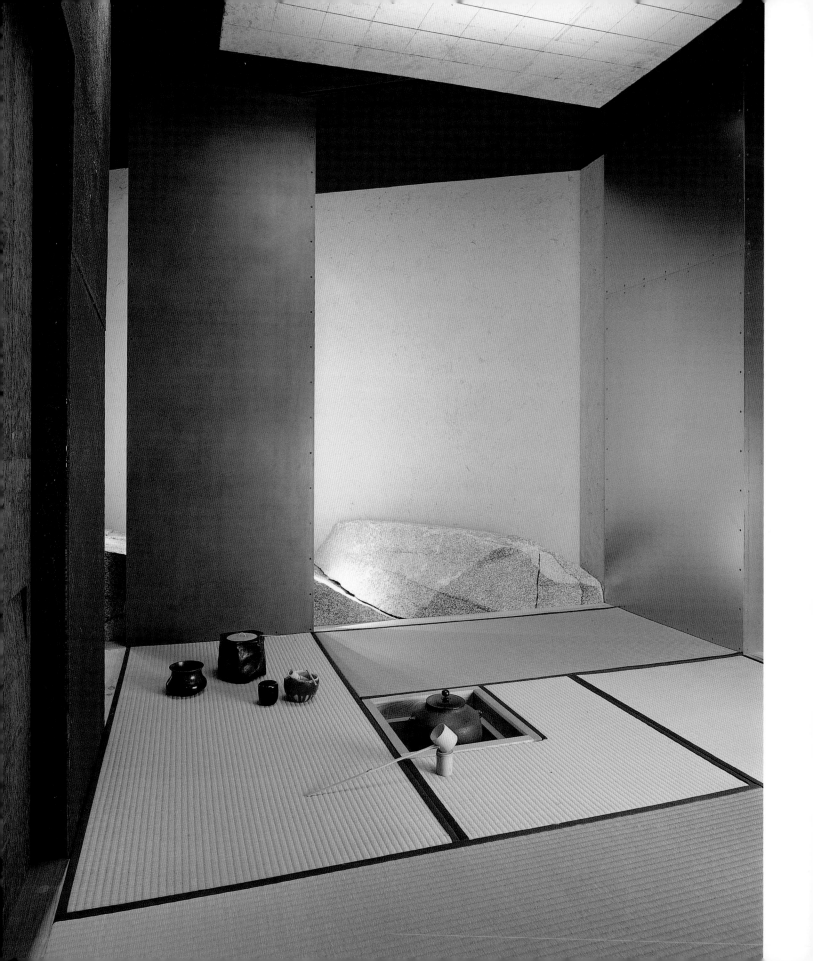

Tucked away at the far end of the restaurant, a tearoom space with traditional *tatami* mats and sunken hearth was designed with its own private "garden" of boldly abstract wedges of granite.

Planes of varying materials – wood slats, handmade paper, and wood boards – define a private dining space with a long wood table and *horigotatsu* style sunken seating.

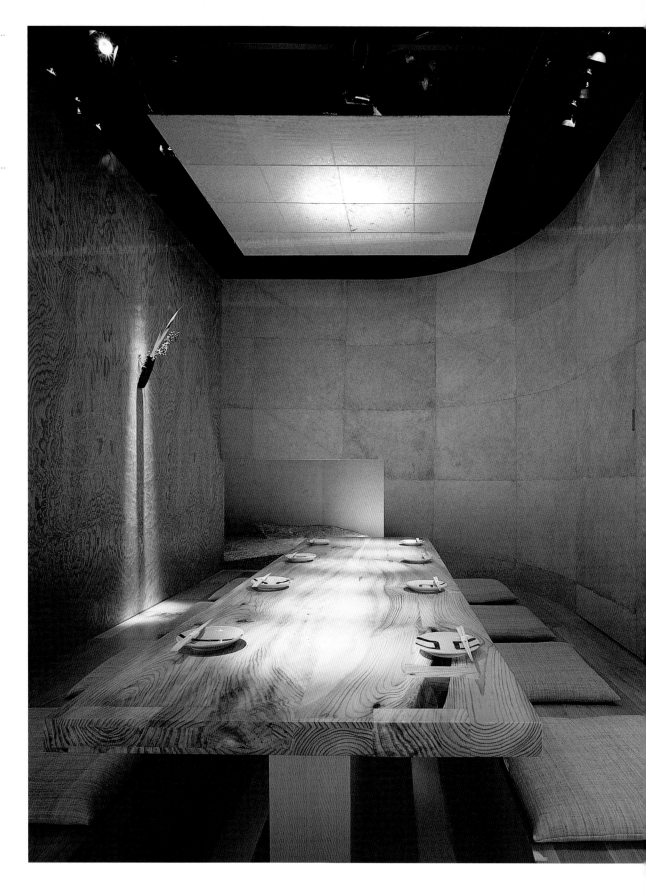

ABOVE

The private cigar lounge
is set off at one end of
the bar area by simple
glass partitions. Heavy
furniture contrasts with
the delicately patterned
brick walls and lighted
cigar case.

RIGHT

Table seating takes
advantage of the long
views from the expansive
glass wall. The high bar
counter leads the eye
to the texture of the
patterned brick wall at
the far end of the space.

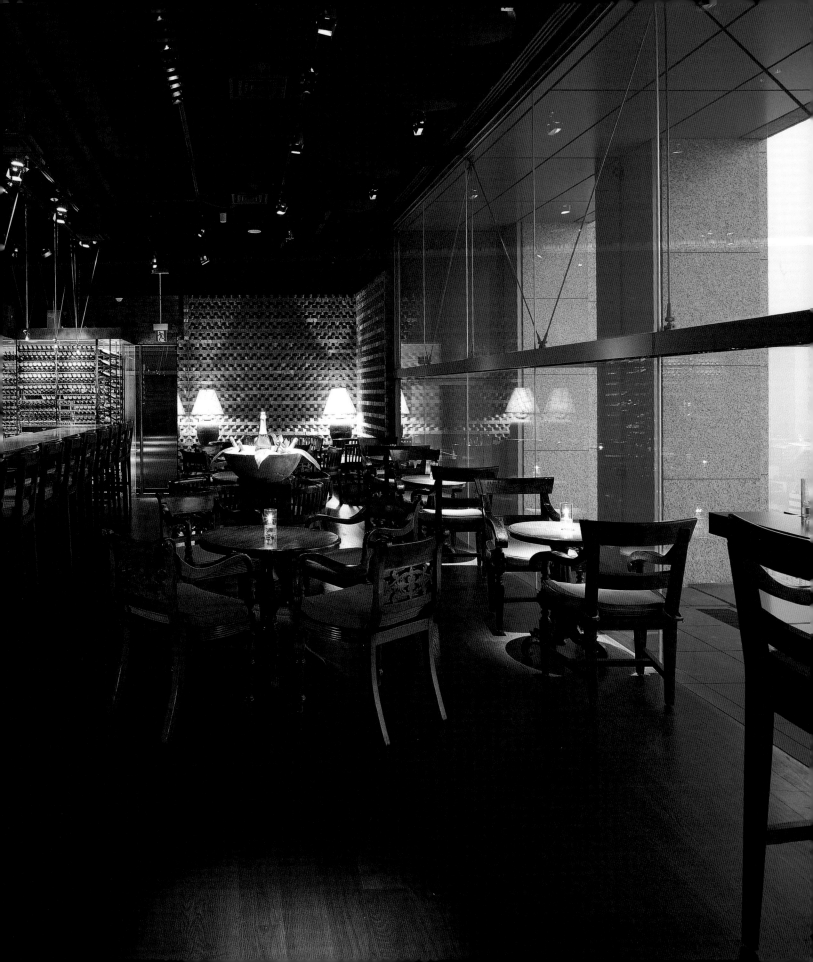

Kitchen Shunju
Restaurant / Shinjuku, Tokyo / 2002

Part of a two-floor complex of restaurants in a department store within the busy Shinjuku train and subway station, Kitchen Shunju is akin to a calm place to rest on a winding garden path. Similar to the other restaurants in the complex, Kitchen Shunju has no windows or views from its eighth-floor location to the bustling commercial area of Shinjuku outside. To give the sense of distance and vista, Super Potato designed Kitchen Shunju to allow views within and through the interior of the restaurant. Seating is arranged in many different configurations – large tables, small tables, counters, private rooms – to provide variety and subtle spatial divisions. The existing low ceiling, painted a light color and left exposed, gives continuity throughout the entire restaurant.

Different materials and methods are used to create the divisions of space. In the individual room area, wood partitions and columns define the space around each table and provide privacy without completely enclosing each space. A temperature controlled wine cellar, entirely encased in glass, is used as a semi-transparent wall between two different seating areas. Other walls are covered with glass shelves packed with stacks of glasses and wooden shelves with stacks of pottery in different shapes. Large bottles, filled with fruit

RIGHT

A long row of walls filled with stacks of glasses and ceramic dishes in a spectrum of transparent to white to gray creates an active backdrop to the opening space of Kitchen Shunju.

BELOW

Textures and patterns define the spaces of Kitchen Shunju, starting from the entry between a rough plaster wall with horizontal striations and glowing translucent glass.

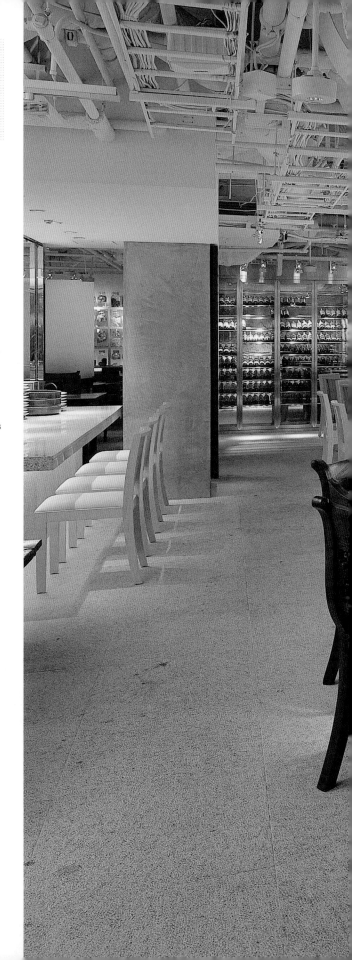

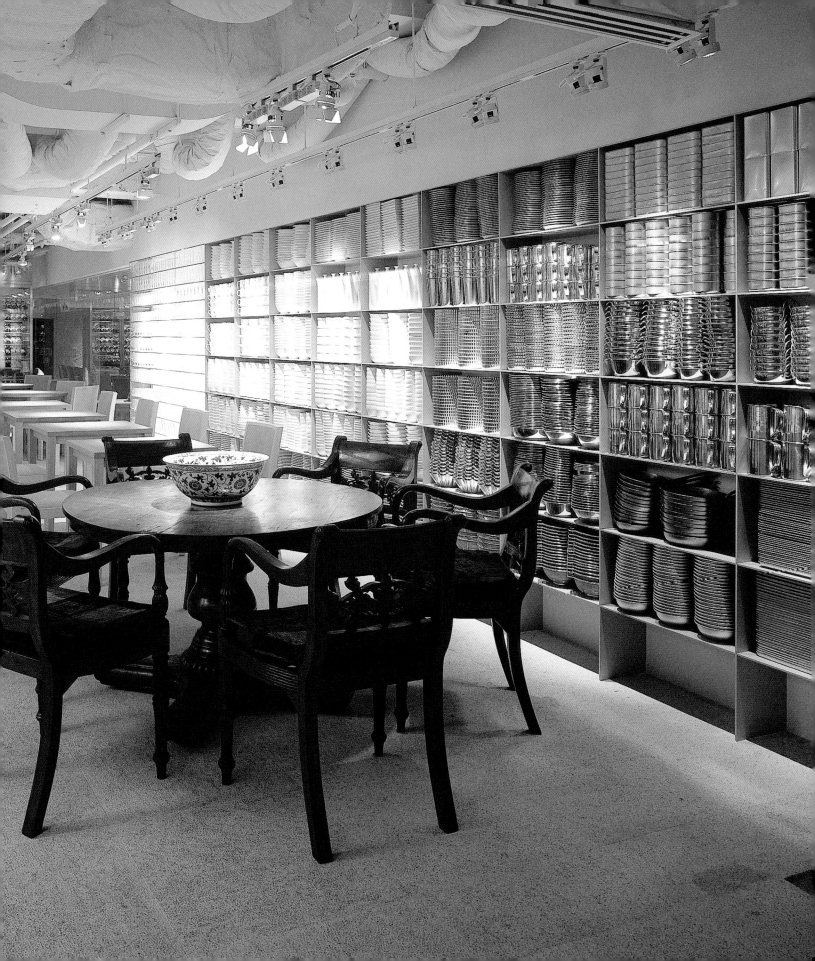

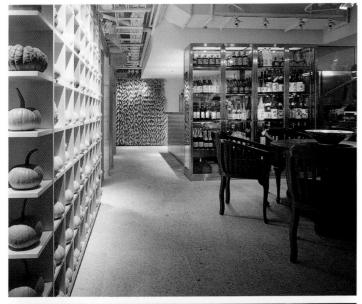

LEFT

Looking back toward the corncob wall, a dining space is defined by a wall of wood shelves filled with dozens of small gourds and a tall glass case holding bottles of saké.

RIGHT

A playful wall covered with corncobs is juxtaposed with the textured stone floor and the knotted timber structures, which frame views of the space throughout the restaurant.

in clear liquor and dramatically back-lit, line one wall, while another wall is surfaced with transparent panels holding thousands of dried chili peppers, curls of pasta, and bay leaves. Yet another wall is completely covered with corncobs, playfully jutting out perpendicular to the wall. These everyday objects are presented not so much as beautiful design but more as patterns and symbols, which give the customer the opportunity to reflect on the source of the food and its role in Japanese society. Similarly, fabric from Bali covers some chairs in a manner which allows the customer to consider the origin of the fabric more deeply. The staff of Super Potato chose different patterns of inexpensive Balinese fabric and worked with the local craftspeople to cut the fabric into small squares. The squares were divided into piles of similar colors and then were sewn together randomly. The resulting pattern is an expression of creativity, rather than high design. It possesses a kind of information, available to those who truly look and ponder the production of the furniture coverings. The effect of both the entire design and the details, like the fabric coverings for the chairs and the corncob wall, is playful yet serious, creating a space that is simultaneously usual and unusual, familiar and unfamiliar.

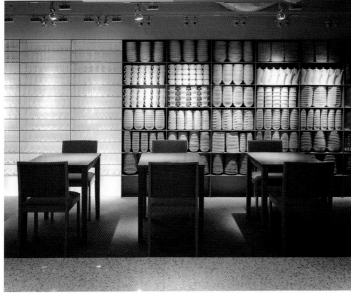

ABOVE

Downlights accentuate a wall with a split personality: one part comprises glass shelves holding glassware and the other half wood shelves holding stacks of white ceramic dishes.

RIGHT

The kitchens, some open with counter seating, line most of one wall of the restaurant, while tables of different sizes and shapes are spread throughout the space.

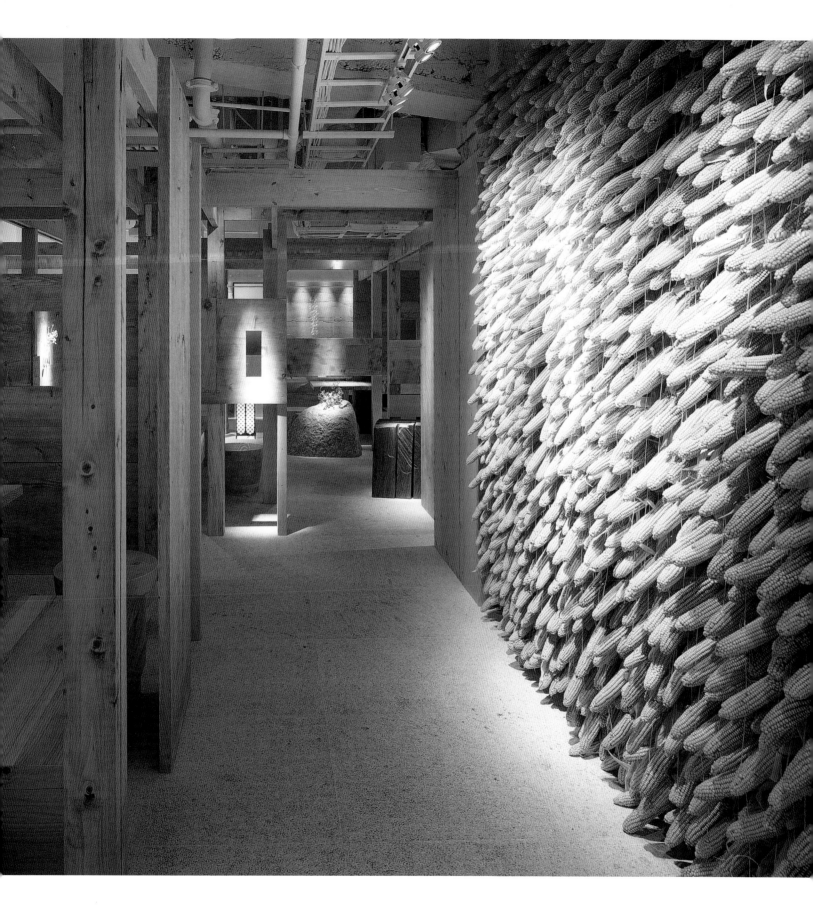

Shunju Tsugihagi
Restaurant / Hibiya, Tokyo / 2005

In the basement of a corner office building in an established commercial district in central Tokyo, the seventh Shunju restaurant, Tsugihagi, lies in wait with its heart pounding. Takashi Sugimoto's idea was to capture the activity and reflection of life that is present in the bartering and jumble of goods in old marketplaces. To his eyes, markets – being full of information – are spaces for communication. Tsugihagi, designed as a communication space, brings that abundance of activity and information to its staid Tokyo location.

Opening the door to the restaurant is like opening a door into a magical world. The name Tsugihagi means "patched and darned," and the space at first appears like a three-dimensional patchwork – as though layer upon layer of every imaginable material had somehow found its way into the restaurant. The spaces and views overlap each other in a richly constructed composition

RIGHT

True to its name, Tsugihagi is a patchwork of materials and forms. Partitions of salvaged metal and wood offer enticing views of the overlapping spaces of the restaurant.

BELOW

Stairs lead down to the reception area, which opens into the maze-like dining room filled with a variety of seating arrangements. Private rooms and service areas line the perimeter.

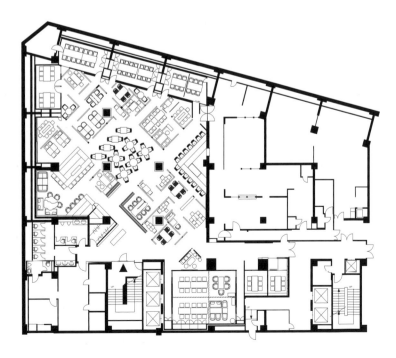

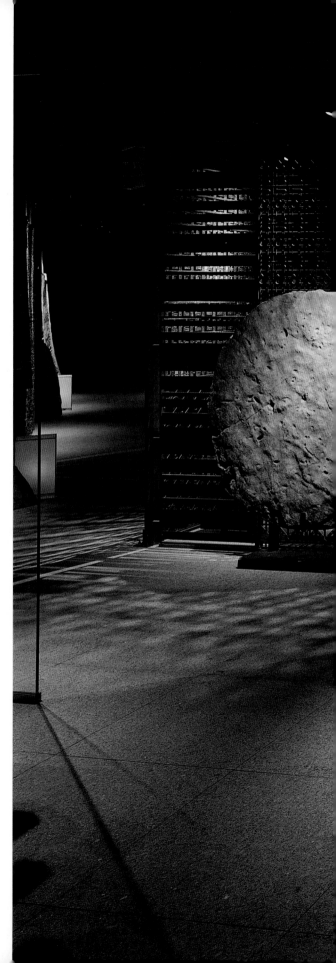

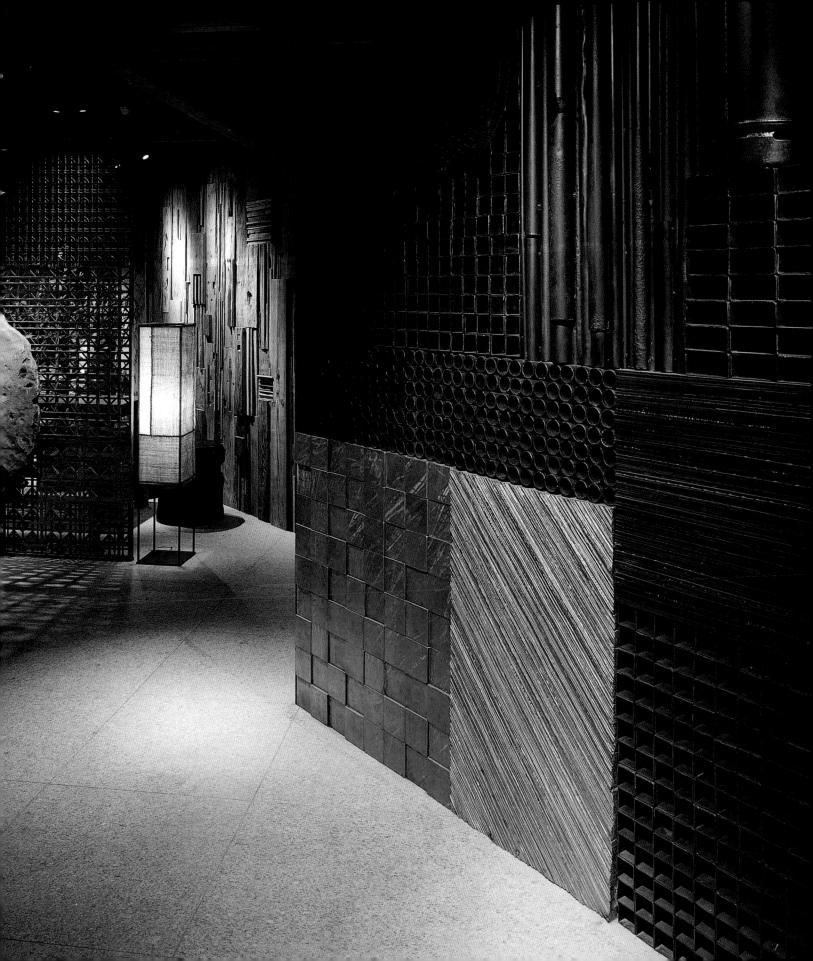

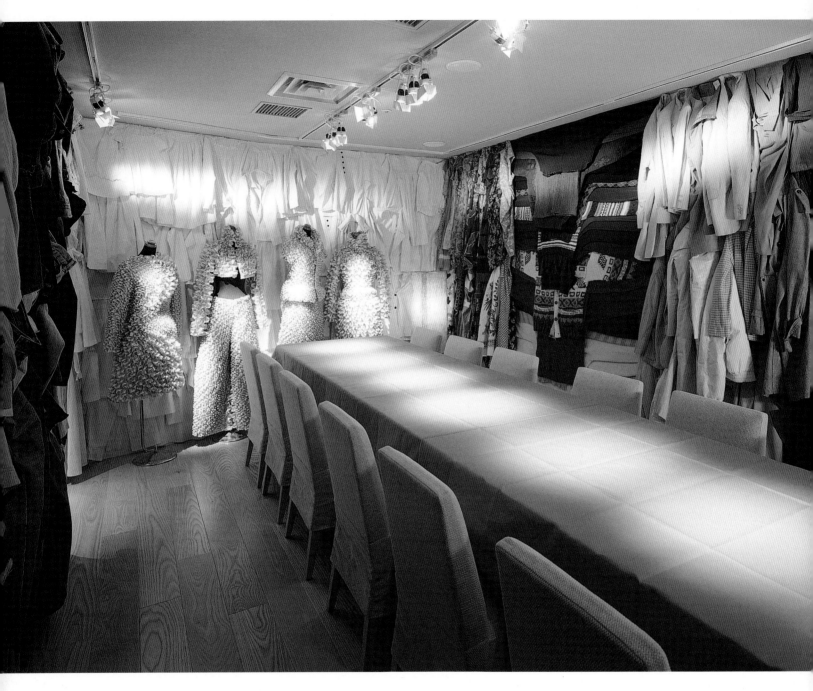

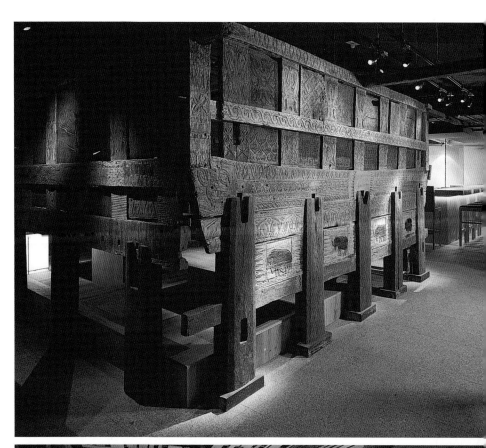

of collisions, defined by abundant energy and
calm serenity, complex collages of materials and
simple objects. The whole is awe-inspiring and out-
rageous. Then, suddenly, the eye focuses on one
wonderful wall constructed of parts of an old Indo-
nesian Toraja longhouse, or a glimpse through a
metal screen revealing a glowing wall of glass bot-
tles, or a long view down a blonde wood-paneled
corridor, like an abstract garden path, leading to
a tea ceremony room.

Private rooms – some serene with simple ma-
terials and quiet lighting, others themed and active
with walls covered with layers of clothing or not-
quite-balanced stacks of books – are tucked away
at the perimeter of the restaurant, hugging the
walls of the building. The remainder of the res-
taurant is turned 45 degrees, creating a sense of
tension, with smaller semi-private spaces, the bar
and lounge, and two open kitchens (a sushi counter
and a charcoal grill) toward the edges, and open
seating areas in the center.

The spaces are ingeniously separated in a
myriad of ways. Metal and wood louvered ceiling
panels define certain sections; raised floor areas
suggest separation for others. Walls and screens
are made of many different materials: collages of
old wood, salvaged roof tiles, scrap metal, heavy
masses of stone, a patchwork of fabric pieces in
varied shades of red, or thick embossed handmade
paper. Light flows gently through thin wood lattice
screens and complex layers of salvaged metal
strips. Fiberglass partitions are impressed with the
shapes of street gratings, and clear acrylic panels
contain old circular gauges, which seem to float
within them. Carefully placed objects – old pottery
jars, a crystal chandelier, a simple ceramic bowl,
or a grouping of old cylindrical wood columns
resembling a gathering of people – are emphasized
by dramatic lighting and punctuate the "landscape"
of the restaurant. Each material and each space
offers its own information and communicates its
own story within the multi-faceted yet unified
patchwork that is Tsugihagi.

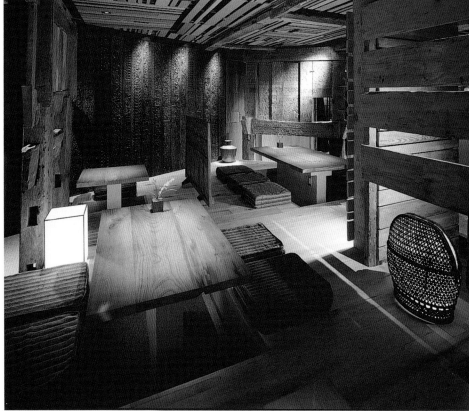

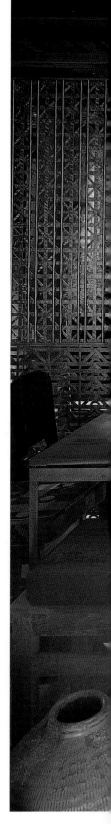

LEFT

Colorfully patterned and embossed sheets of handmade paper hang from partitions dividing the dining spaces. The wood slat ceiling continues from the dining area to the bar.

BELOW

An antique crystal chandelier casts a soft glow in the lounge area adjacent to the bar. The space is defined by a wall faced entirely with stacks of old books.

RIGHT

Despite the abundance of patterns and objects, especially the different configurations of the perforated screens and the varied materials, the dining spaces are serene and comfortable.

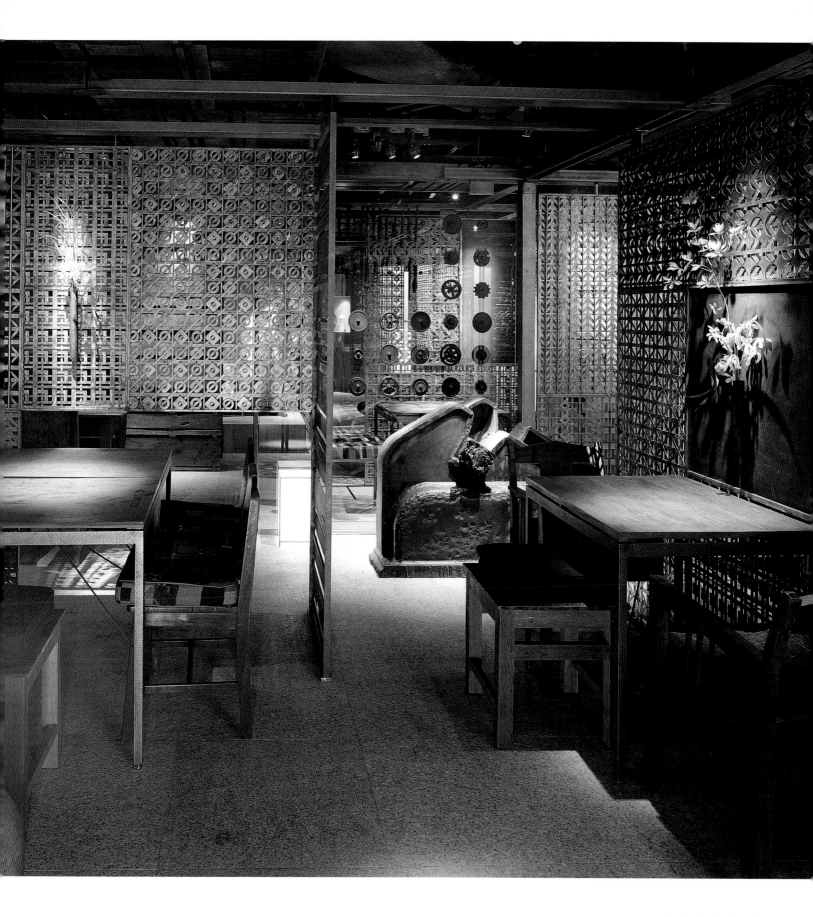

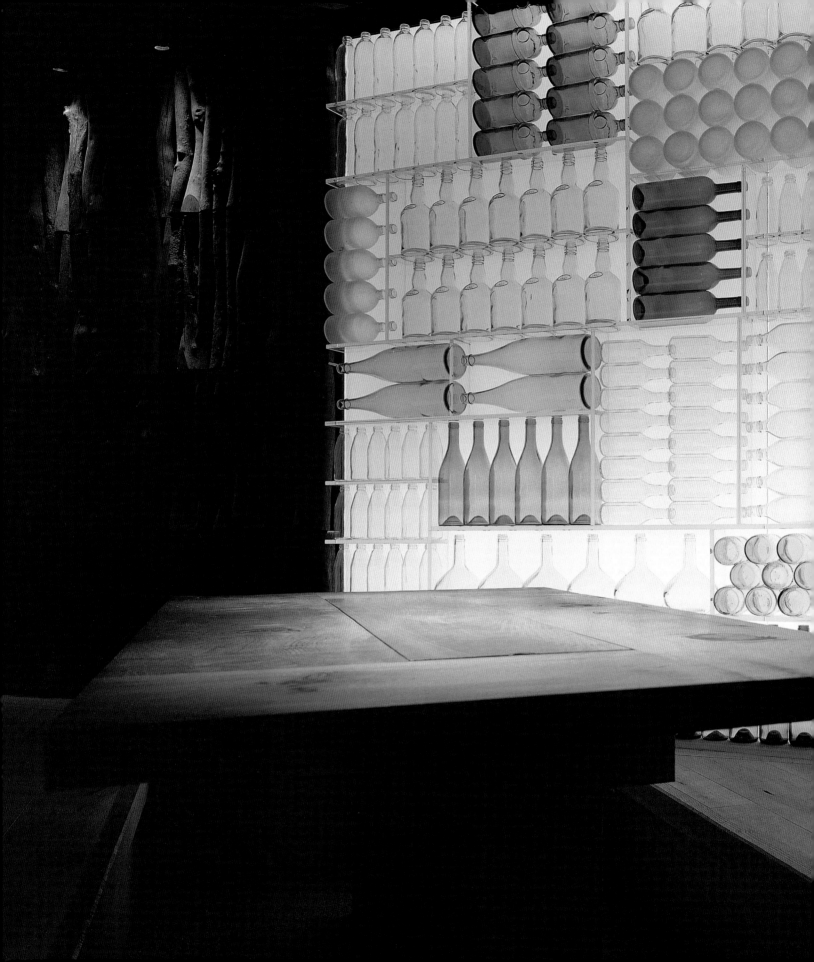

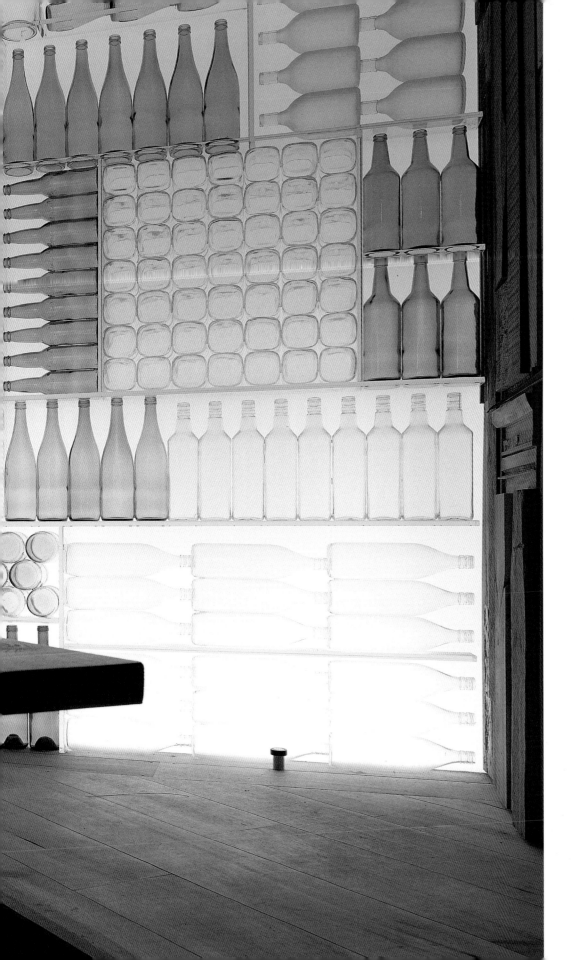

LEFT

A wall covered with sections of tree branches stacked vertically flanks a glowing wall composition of glass shelves holding glass bottles of different colors and shapes.

Shunsui
Restaurant and department store restaurant floor / Umeda, Osaka / 2000

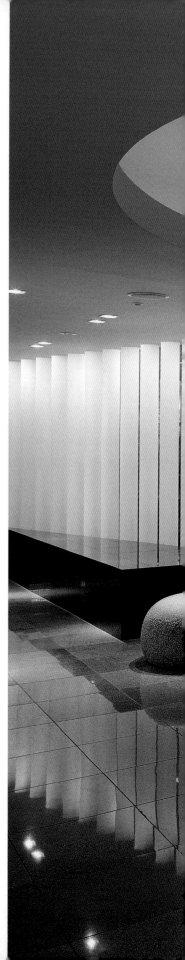

The escalators of the Hanshin department store near Umeda Station in Osaka lead quickly to the top floor, the tenth floor, featuring branches of seven different well-known restaurants from the area. Customers arrive in an open space punctuated with round stones, sized large enough to sit on and placed upon smooth stone floors. The stones, some polished and some left rough, starkly contrast a raised platform of polished black stone. The stone platform is incised with round holes, which seem as if they were carved by swift whirlpools of water. The space is bounded by glass; water gently flowing over the surface of the glass blurs the view through it in some places, and walls alternate between stripes of transparent and translucent glass in others. Views from this open public space into and through the restaurants are important in the design.

The transparency allows the floor to be understood as one large space, with each restaurant being a smaller, more intimate space within it.

Rather than designing specific entry points for each of the restaurants, as is common for this type of department store restaurant floor, Super Potato's goal for the renovation of the floor was to create a feeling of extended space with a contemporary yet familiar design. Takashi Sugimoto describes the design as "hidden Japanese." The subtle references to traditional Japanese design make the space appealing for older customers, yet the contemporary feel of the design also attracts a younger set.

The ceiling lighting in the central space varies in intensity during the course of the day, mimicking the cycle of the sun as it changes from warm yellow to cool blue. The calm atmosphere contrasts with the lively interiors of the various restaurants, like Shunsui designed by Super Potato, with wood floors and louvered partitions that draw people into the warm interiors.

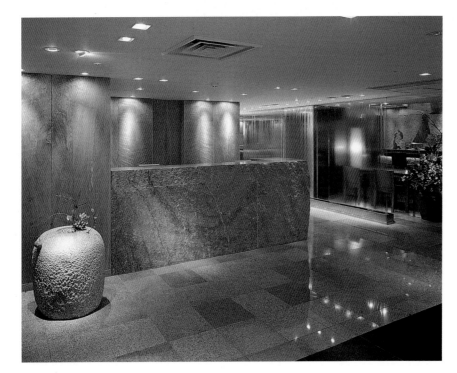

LEFT

The variegated colors and surfaces of roughly hewn wood and textured stone contrast with the polished geometry of the stone floor at the entrance to Shunsui.

RIGHT

The eye-catching circle inset in the ceiling demarcates the open public space. Round stones and polished stone slabs contrast with the glowing glass tubes and provide seating.

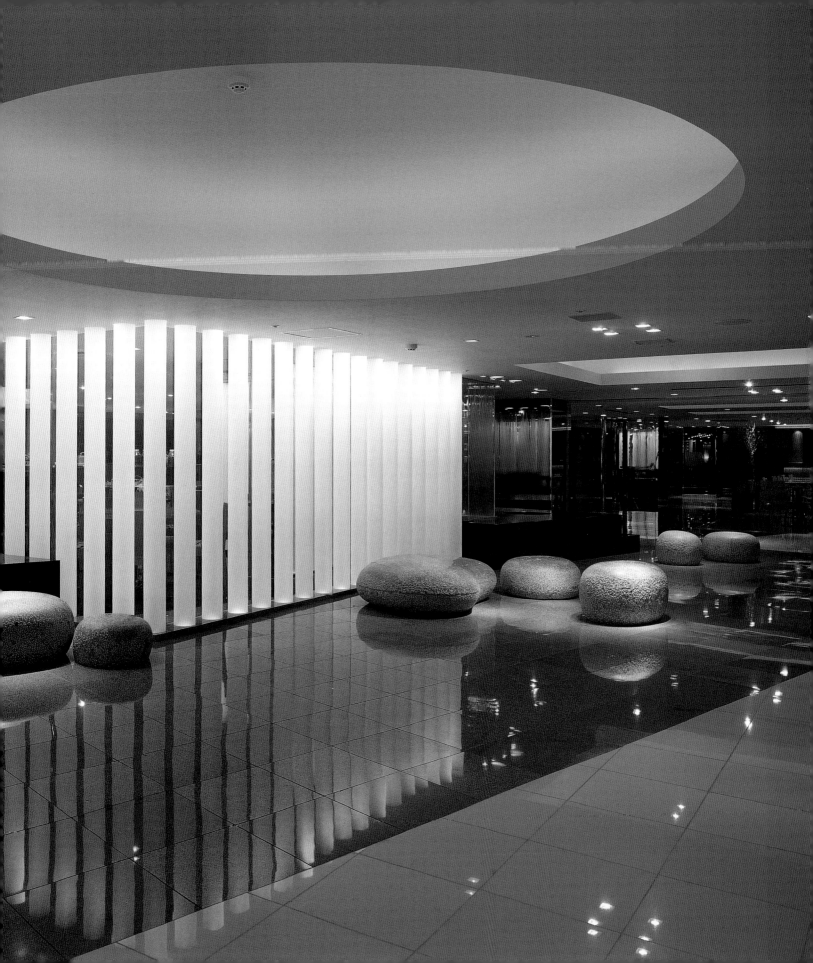

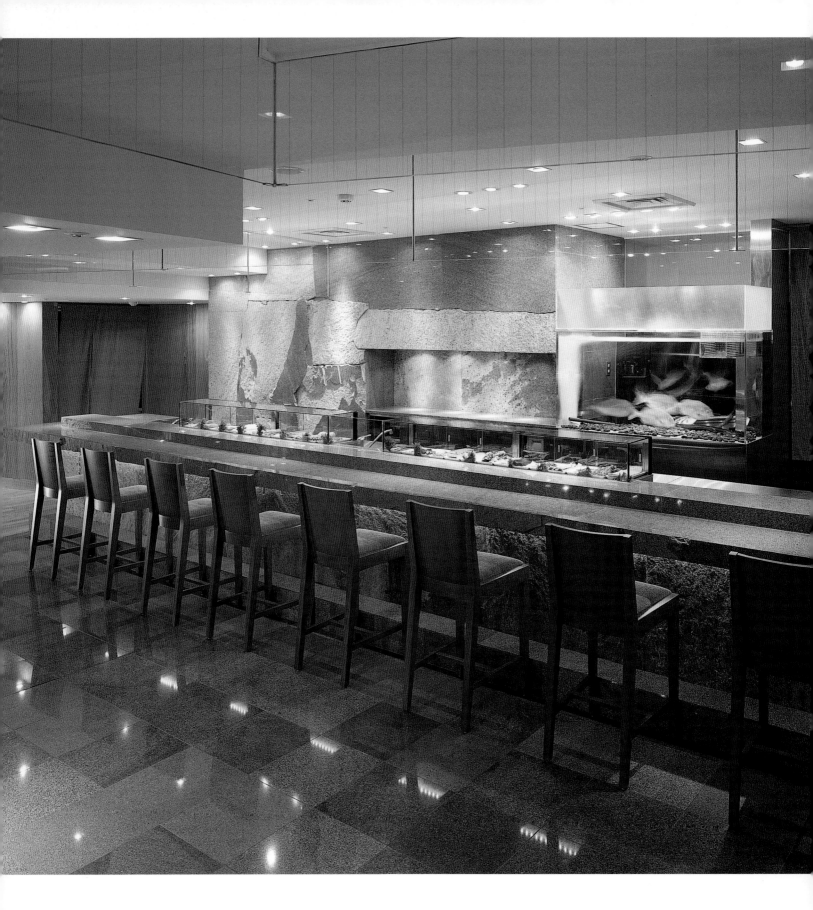

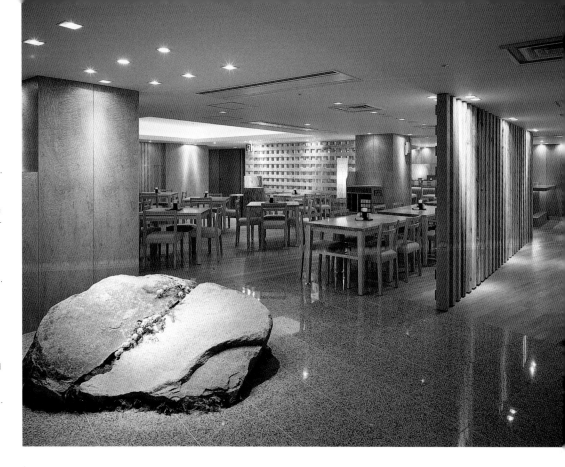

LEFT

The smooth stone sushi counter of Shunsui restaurant looks onto a fish tank cleverly incorporated into a wall composed of irregularly shaped slabs of stone.

RIGHT

A cracked slab of rough granite marks the entry to the main dining area, finished completely in wood and separated from other spaces by lattice screens and solid wood partitions.

BELOW

Restaurants line the perimeter of the central open space of the department store restaurant floor. Shunsui shifts off the building grid and opens onto the central space.

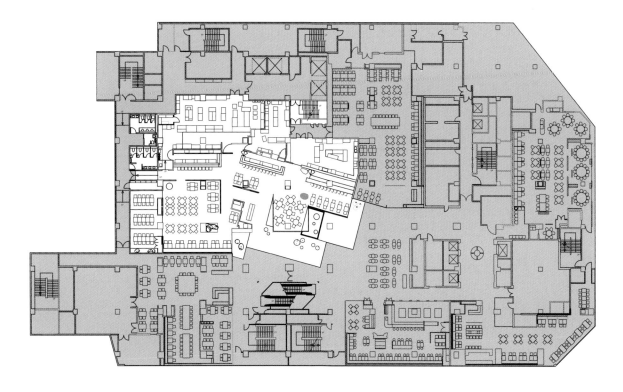

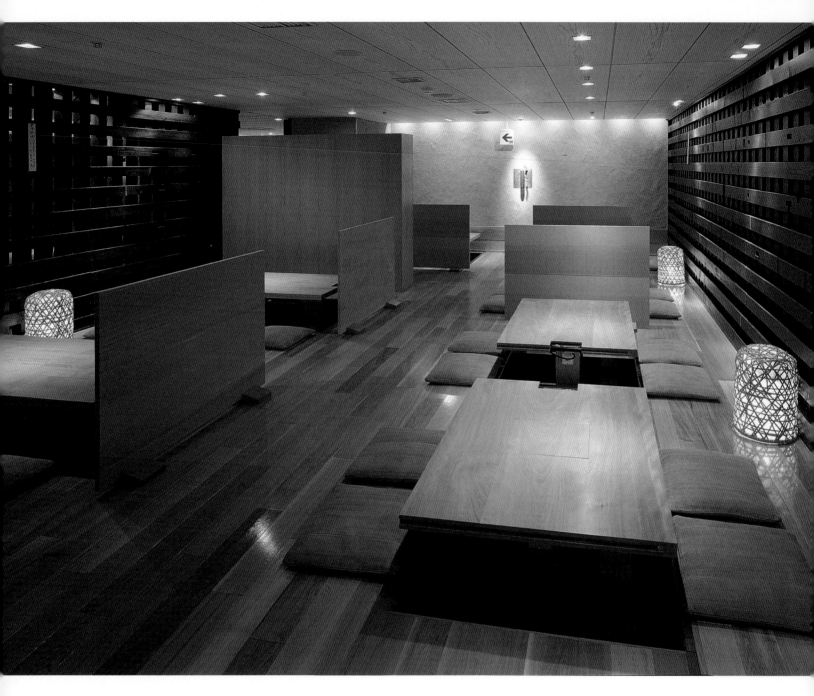

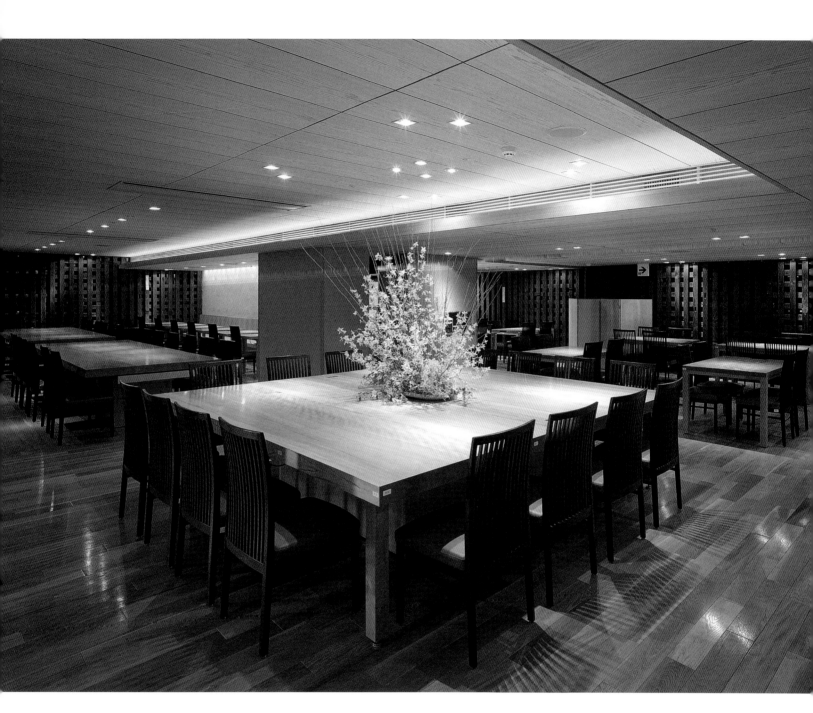

ABOVE

The dark wood of the chairs and thick lattice screens are set off by the blond wood tables and floor and ceiling surfaces. A central large wood table provides a space for groups of diners.

Shunkan

Department store restaurant floors / Shinjuku, Tokyo / 2002

Shunkan is located at the top two floors of a lively department store in bustling Shinjuku Station, one of the busiest train and subway stations in Tokyo. Because of the constant activity in the station, Super Potato conceived of the design of Shunkan as a space focused toward the future, rather than fixed at a point in time. The materials and design ideas throughout both floors of restaurants further this concept through their variety and energy. Even the name of the area – Shunkan – allows different interpretations: based on its pronunciation, it could mean a moment in time or it could refer to the notion of season.

The overall design concept of the public spaces of both floors, as well as one of the 22 restaurants, Kitchen Shunju, was established by Super Potato. Interior designers, chosen by Sugimoto for their abilities to create spaces with strong character, which would not get lost in the overall design, created the other restaurants. The two floors have different concepts, but both build on the identity of Shinjuku. The seventh floor is considered "Shinjuku town" and is lively, like a street festival. The eighth floor is quieter and more formal, approximating a stroll through a garden.

The theme of the seventh floor was inspired by walking through East Shinjuku during the day and night. The design reflects Shinjuku as a place with history, with active commercial streets and an active pleasure quarter, with dark and dangerous-seeming back streets and bright family-oriented main streets. This metaphorical contrast of light and shadow is apparent in the distinction between the fun and funky restaurant designs and the collages of found materials which cover the walls of the public areas. The people and companies in Shinjuku that collect used materials for recycling and reuse inspired the collages. In Shunkan, the materials are organized and displayed in patterns on the walls. At first glance, the objects appear only as patterns, but closer inspection reveals their former functions. Cardboard completely covers one wall. It is cut into strips, stacked in a random wave-like pattern, and painted bright red. Dramatic lighting adds to the artistic effect. Other walls are covered with empty bottles, parts of machinery, or

LEFT

Escalators arrive to the seventh floor under a galaxy of tiny lights suspended from the ceiling. A mosaic of odd-shaped pieces of plastic pipe fits puzzle-like on one wall.

RIGHT

A variety of lighting accentuates the changing textures of the patterned brick walls, which are carefully positioned to lead the eye through the shared spaces on the eighth floor.

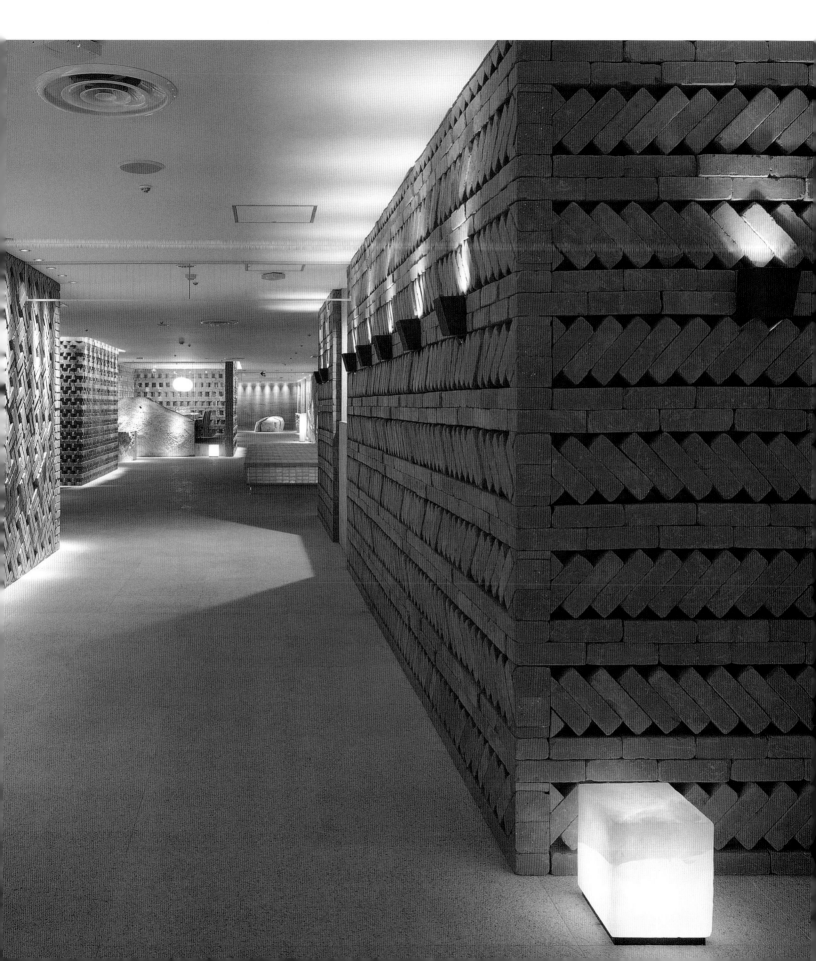

bits of acrylic behind transparent panels. As occurs in the crowded bustle of Shinjuku, from a distance the individual parts lose their identity and combine to form something totally different; but when viewed up close, the individuality of each part is clearly apparent.

The design concept for the eighth floor was to express the combination of small traditional *izakaya* drinking establishments with the strong presence of the big international hotels and Tokyo City Hall found in West Shinjuku. Takashi Sugimoto conceived of the public spaces as a garden path, with the restaurants as places to stop along the route. He wanted to use water in the design, but the building, scheduled to be rebuilt ten years later, was not designed to handle the extra weight. Instead, Sugimoto used mirrors and light to create the sense of water. The path winds between walls of stone, brick, and glass, subtly lit with paper lanterns and small flickering candle-like electric lights set into niches in the walls. Blocks of stone, left rough and showing the marks of the quarrying process, are interspersed throughout the space. The blocks contrast with the planes of the walls and the fragility of the paper lanterns and provide an element of surprise and discovery, like the sudden view of a beautiful stone along the garden path.

RIGHT

Clever compositions of everyday materials, like this rubber tubing, tightly coiled, stacked, and painted an even gray, provide a visual surprise throughout the seventh floor.

BELOW

The seventh floor common space (upper plan) is designed as a continuous loop, whereas the eighth floor (lower plan) is conceived as a winding garden path.

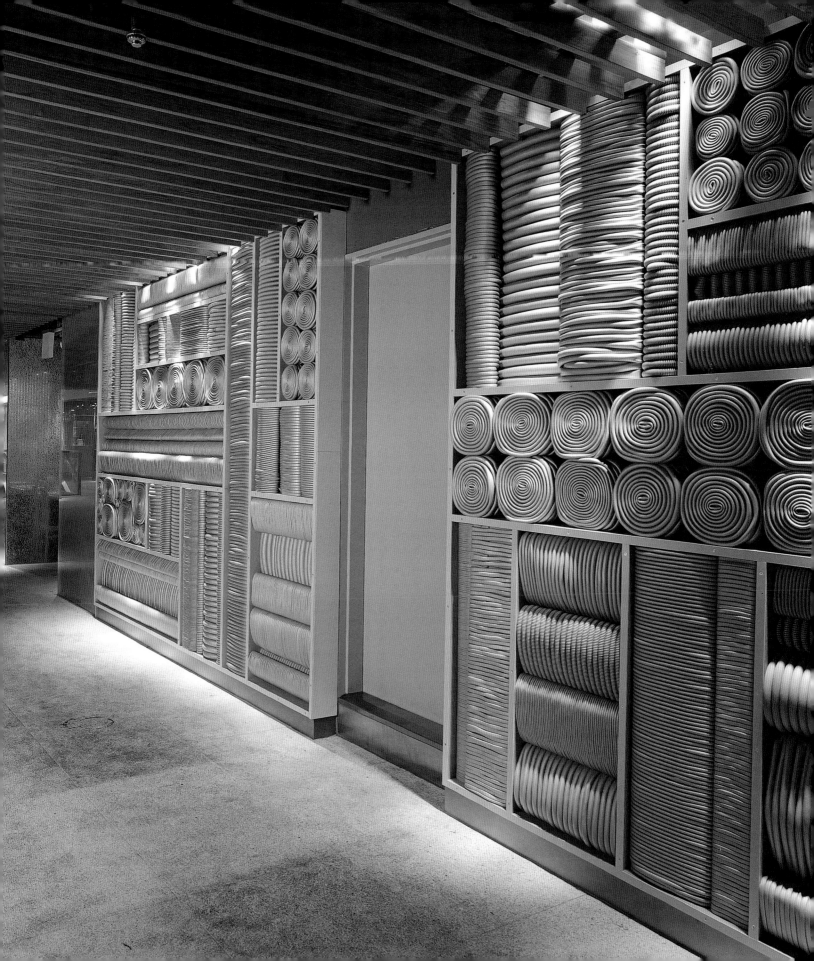

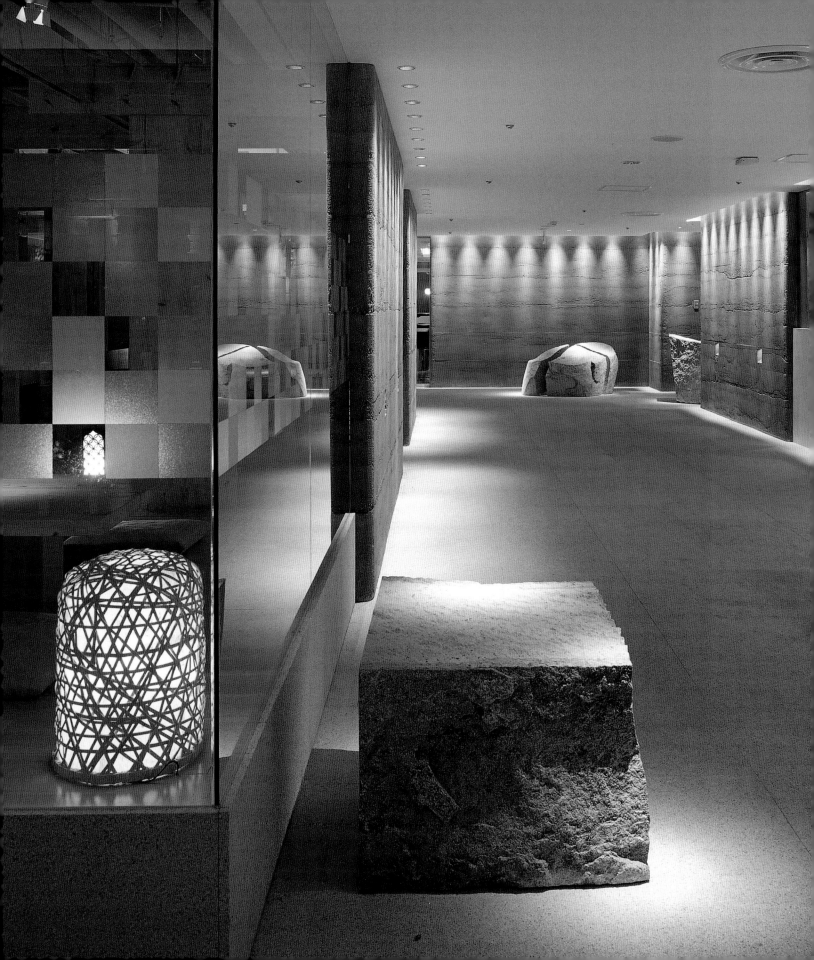

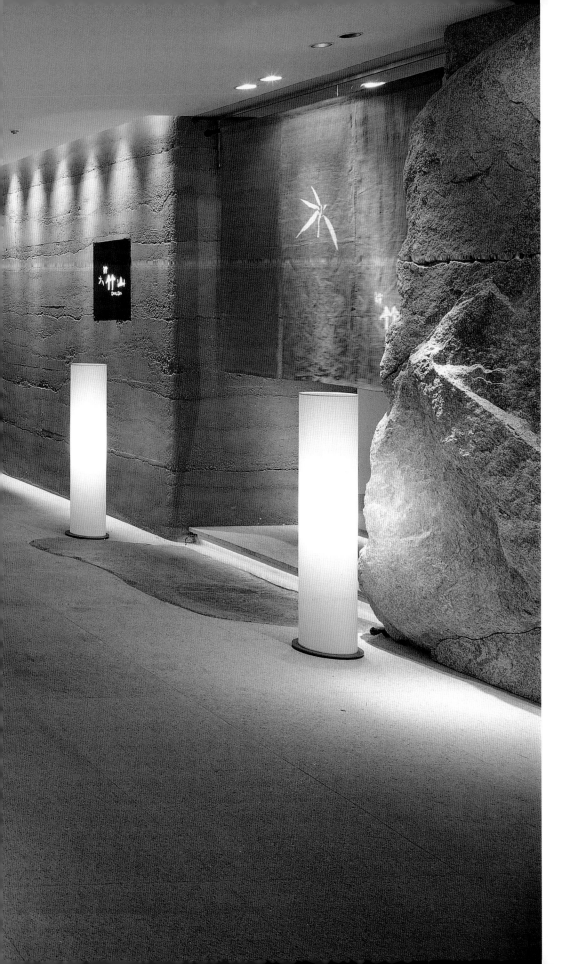

LEFT

Glowing light fixtures
and heavy blocks of
granite punctuate the
space of the eighth-floor
path and complement
the horizontal layers
of the plaster walls.

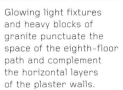

RIGHT

Old machine parts —
gauges, ducts, casings,
and pipes — all painted
steel gray, create an
unexpected three-
dimensional composition
that emits "information"
about their past use.

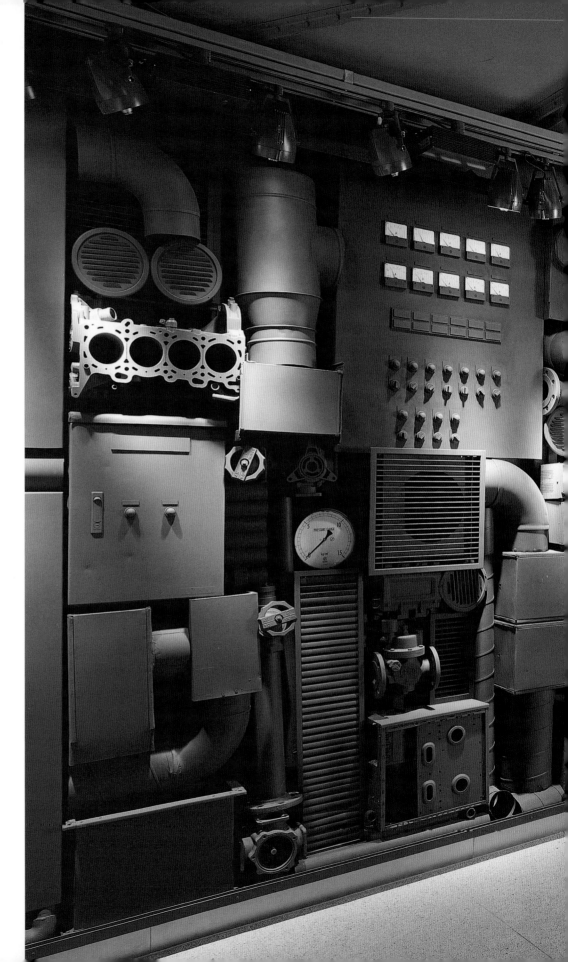

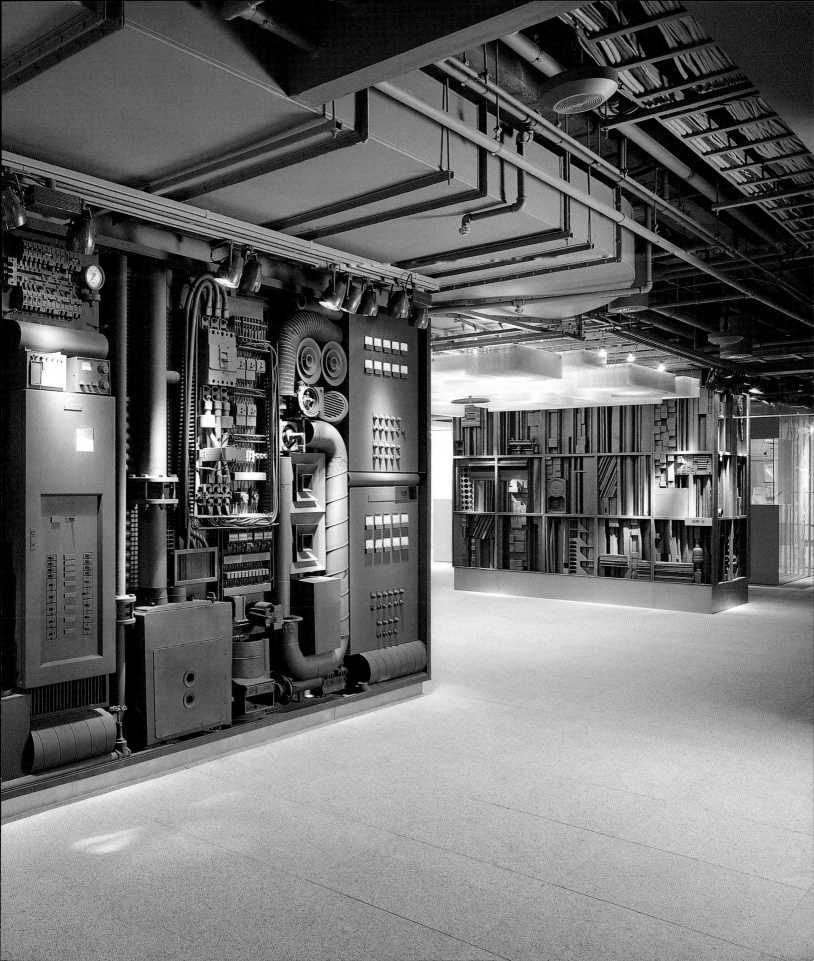

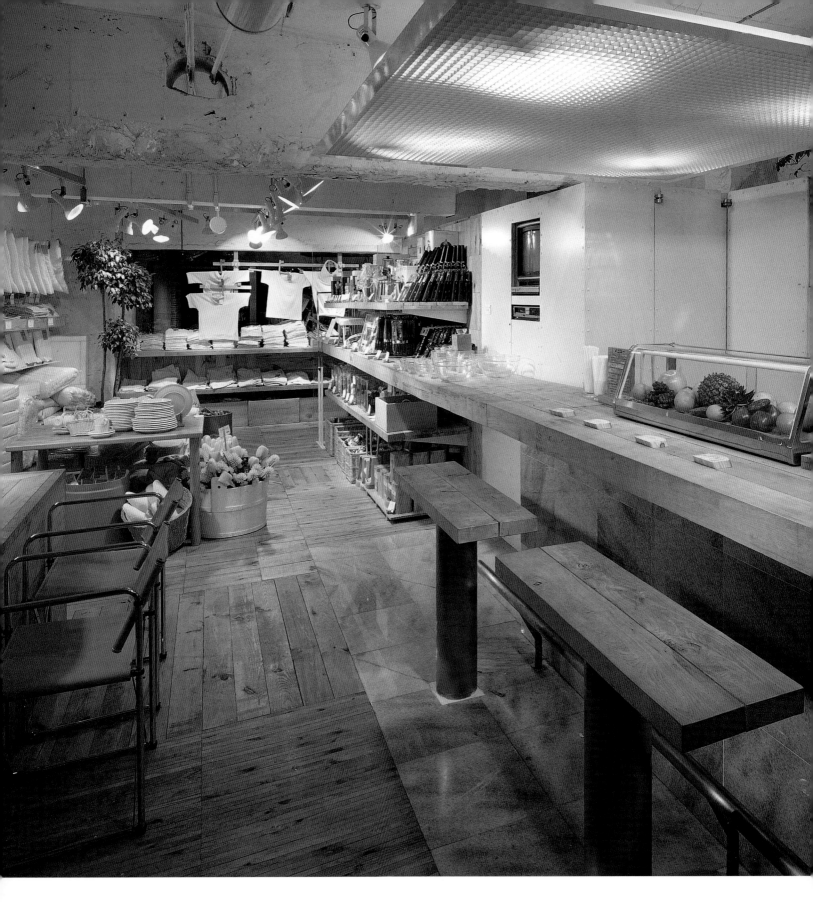

MUJI Aoyama
Retail shop / Aoyama, Tokyo / 1983

The idea of Mujirushi Ryohin (literally "no-brand quality goods," known outside of Japan simply as "MUJI") started in the early 1980s during the oil crisis. It was a time when people in Japan refused to spend money for certain things but still wanted to shop. The idea of Mujirushi Ryohin was conceived by a team of three designers: Ikko Tanaka, Kazuko Koike, and Takashi Sugimoto. MUJI was developed to have a designed yet homey image, selling high-quality goods at reasonable prices. Simple, almost generic, labels and packaging became the hallmark of the "no-brand" brand. This attitude toward frugality without compromising quality combined with well-designed packaging and thoughtful advertising caught the eye of the Japanese people. Within a short time, MUJI was booming. Initially with only 30–40 items, such as packaged foods, stationary, and T-shirts, and just a few shelves displaying MUJI merchandise within the Seiyu department store, MUJI outgrew its first home and an independent shop was planned.

The first MUJI store, in the busy Aoyama area in downtown Tokyo, was designed not simply as another boutique but as a lifestyle shop considering total design. In a time when supermarkets were designed differently from boutiques which were also very different from nightclubs, the design of the first MUJI store was unusual. Takashi Sugimoto's idea was not to create simply a beautiful place for shopping but rather a place that reflected both nature and the lively activity of a country market: warm, basic, and not merchandise-specific. The same kind of shelves could be used for food or for clothing, and if the merchandise was removed, the space could be used for a bar or a boutique.

The façade of the Aoyama shop emphasizes the textures of the different materials used: brick with thick mortar joints expressed, smooth curving double-height glass, and rough adze-finished wood

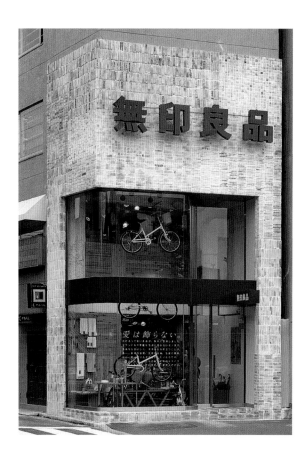

OPPOSITE

The exposed concrete structure is painted white. Wood shelves and flooring, cut in assorted lengths and laid in different directions, accentuate the space of the upper level.

ABOVE

The characters for Mujirushi Ryohin pop off the brick facade of the original MUJI shop. Bicycles hang behind the curved glass storefront in the two-story entry space.

planks. The two-story space of the shop was designed to have slightly different characteristics on each floor. The street-level space is open with rough stone columns. The columns contrast with the large glass shop window while supporting heavy stone beams, from which hang dozens of shirts, pants, and skirts. The exposed ceiling is painted a light color to add to the open feeling of the space. The second floor has the crowded feel of a country market, with wooden shelves and woven baskets packed with merchandise. A small café counter was part of the initial design but was removed when the store underwent a renovation. The space of the café is now filled with metal MUJI shelves holding a myriad of MUJI merchandise, as the number of products under the brand now numbers more than 2000, and the number of shops and outlets selling MUJI merchandise has grown to over 300 worldwide.

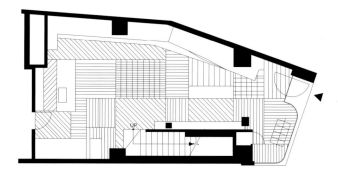

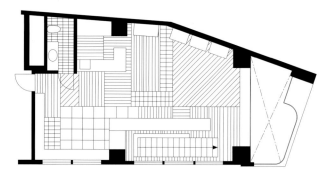

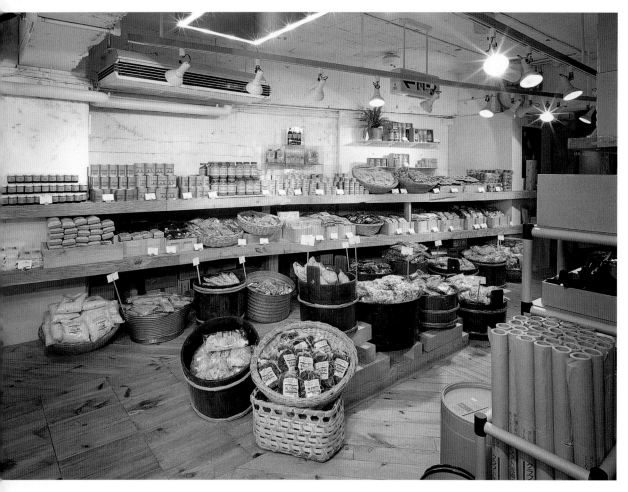

ABOVE

The glass façade curves in at the entrance (top plan), which opens into the double-height space. The stair starts from the middle of the space and ascends toward the front.

LEFT

Although filled with a wide assortment of goods, the entry level is unified through color — the signature MUJI cardboard brown of the labels and paper tube shelving.

RIGHT

Brick tiles in two sizes cover part of the floor and run up the wall, relating to the brick exterior of the shop. Thick wood shelves display a great variety of merchandise.

MUJI Aoyama-sanchome
Retail shop / Aoyama, Tokyo / 1993

The entrance of the MUJI retail shop in the trendy Aoyama-sanchome neighborhood in Tokyo is marked simply by the company's logo of the four Japanese characters which read "Mujirushi Ryohin." The characters are repeated in white on each of the tall clear glass panels at the entry, an understated expression of the company's desire for simple yet well-designed high-quality goods. Stone flooring continues from outside the doors into the store, creating a raised platform with steps leading down to the level of the shop floor. The smooth surface of the stone steps changes first to the rich patina of aged metal and then to the warmth of wood in varied shades of brown. This shifting of the material palette occurs not only on the floor surface but on all surfaces, in all dimensions, throughout the space from the entry to the back of the store.

The entrance area is gallery-like, with a carefully down-lit alcove backed by a patchwork of rough and smooth metal panels and a strategically placed circular wood table with an eye-catching exhibit of goods. The open plan allows space to flow around displays of merchandise, carefully piled on tables and shelves or in MUJI containers. Super Potato's design concept was to display everything, thus everything from the concrete structure of the building to the ventilation ducts and lighting tracks is exposed. The exposed structure and ductwork are meant to give strength and power to the space, and the detailed connections and use of varied materials communicate information and offer the opportunity to consider their meanings.

Old materials, fully expressing their long lives, are combined with new. Planks of salvaged wood, scarred and uneven from years of use, alternate with polished new wood shelves to cover one wall. Shiny metal shelves set against the exposed concrete cover another wall, while the concrete turns the corner and then gives way to back-lit translucent glass panels. Heavy timber columns from an old wooden building dominate the center of the store and support thick wood shelves full of every kind of merchandise imaginable.

Although the materials and forms that shape and fill the space vary greatly in color and texture, the feeling of the space is calm and harmonious.

LEFT

The floor at the entrance to the MUJI Ayoama-sanchome shop changes subtly from stone to metal to wood, and the textured walls are highlighted with dramatic lighting.

RIGHT

Brushed metal panels and shelves give a feeling of lightness and contrast the dark wood plank flooring. MUJI shelving in both wood and metal is used to display merchandise.

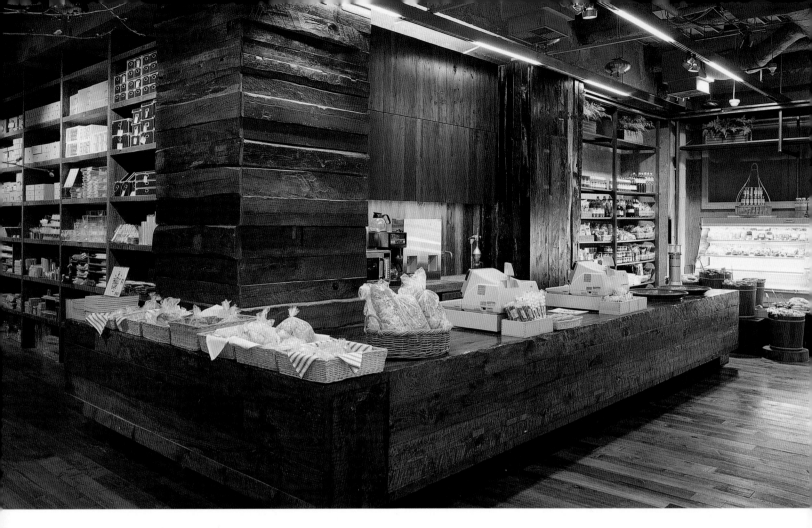

ABOVE

Old wood planks show-
ing the marks of years
of use form the long
cashier counter and are
used horizontally and
vertically as texture
on the walls.

LEFT

Floor surfaces change
from the stone and metal
of the entry, set in from
the curved glass façade
(far left), to directional
wood flooring.

RIGHT

In the center of the
space, a framework of
heavy salvaged timbers
supports wide wooden
shelves holding stacks
of glassware.

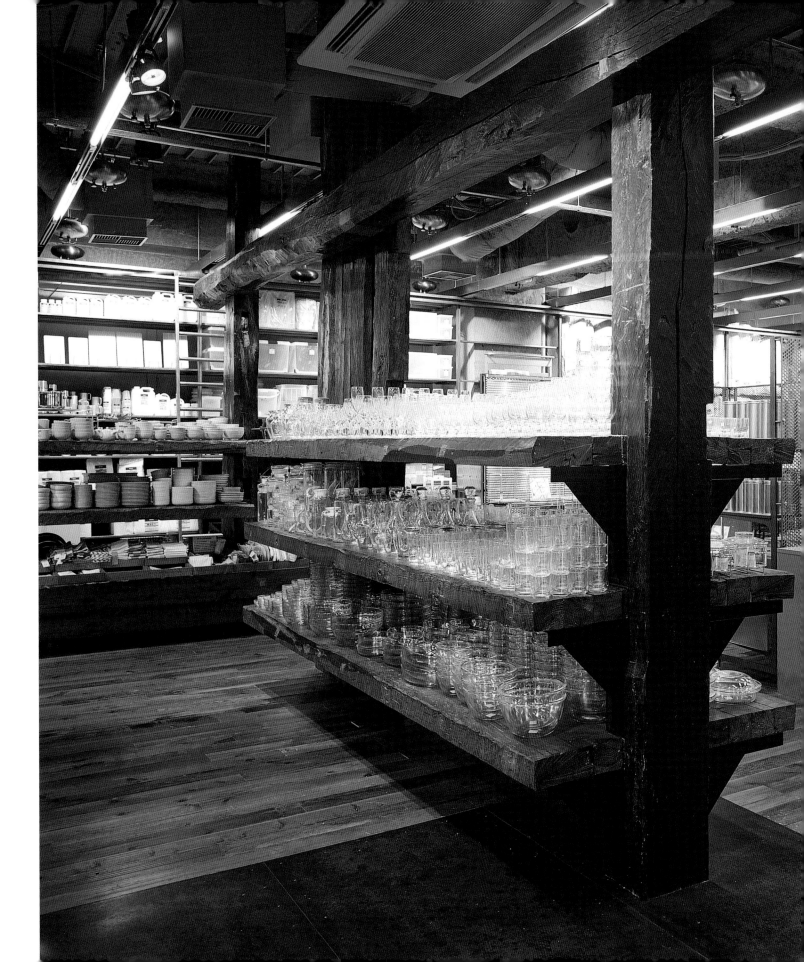

The Future and MUJI
Exhibitions / Tokyo and Milan, Italy / 2003

The first international exhibition of the design concepts and lifestyle products of Mujirushi Ryohin took place in an old steel factory in Milan, Italy. Entitled "The Future and MUJI," the exhibit introduced MUJI merchandise, as single objects as well as part of a total way of life, and suggested how MUJI can adapt to future lifestyle trends. A similar exhibit, the first by MUJI in Japan, titled simply "Mujirushi Ryohin," was held at Gallery MA in Tokyo following the show in Italy.

In Milan, the two main walls of the long narrow space displayed MUJI goods, type by type, with short explanations. Seven varieties of strainers, three kinds of graters, five sizes of dishes, one ricer cooker, one refrigerator, notebooks, pens, clothing, a bicycle – all were among the objects hung gallery-style on the wall, highlighting design over function. In subtle hues of black, gray, and blue, enormous photographs of the horizon, concept photos used in MUJI advertisements, filled the adjacent wall space. The sheer size and subtle variations of the expansive horizons signified the impending future – at once both clear and ambiguous in their magnitude and simplicity.

The exhibition space in Tokyo included an outdoor gallery, which was transformed by the same long photographs of the horizon, moving from the outside space into the lower level of the bi-level indoor gallery. Throughout the space of the lower gallery, as in Milan, MUJI goods were presented as both art piece and functional object. Mounted on the walls and hung from the ceiling, jackets, shirts, lamps, plastic bottles, and even a bicycle were shown in a suspended state, their explicit uses implied yet overshadowed by the simple beauty of their designs.

A model MUJI apartment set up in the upper gallery space evoked a lifestyle filled with the simple beauty of clean lines and quality materials. Each piece, such as the rectangular white bathtub and the simple gray table with kitchen sink and electric cooktop, fit well with every other and still could stand alone beautifully.

RIGHT

Vast photographs of serene horizon scenes, used for MUJI advertisements, moved from the outside gallery area into the lower floor of the two-story interior gallery space.

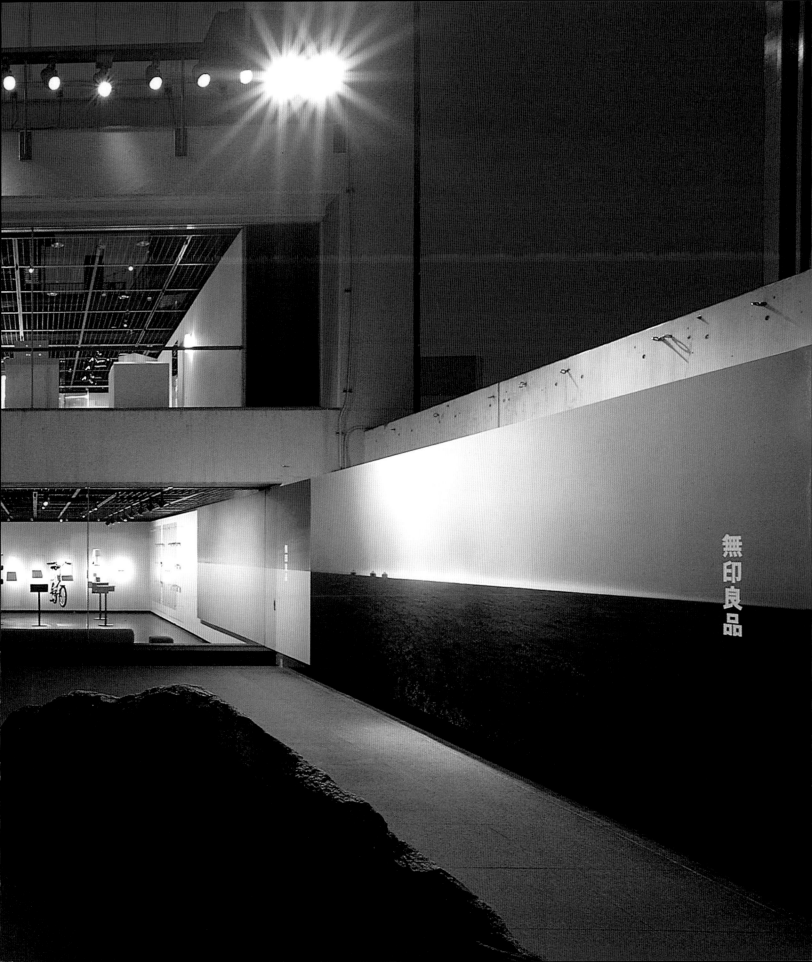

無印良品

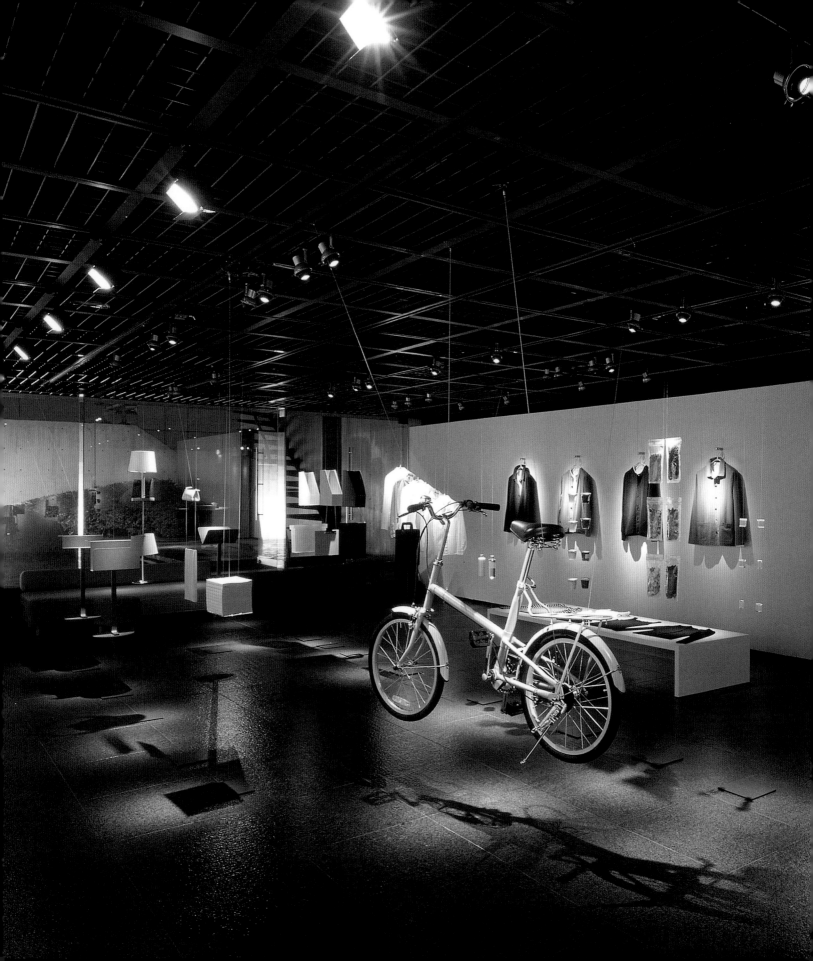

LEFT ·····················

Suspended by thin wires from the ceiling and mounted carefully against white walls, MUJI goods became floating art objects exhibited in the lower gallery space.

ABOVE RIGHT ·····················

The upper floor of Gallery MA was set up like an apartment filled with MUJI furniture and kitchen and living acces-sories, demonstrating the total MUJI lifestyle experience.

RIGHT ·····················

A modular kitchen table, complete with sink and range top, represented the MUJI attitude toward simple well-designed multi-functional objects for everyday use.

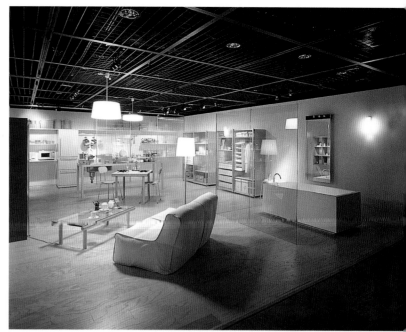

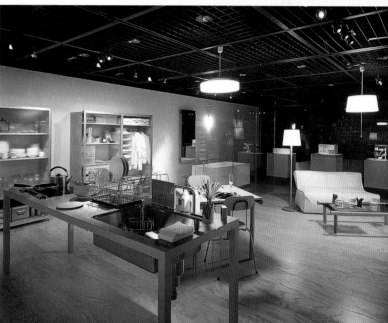

The exhibition catalog, produced for the Milan show, featured the horizon photographs used in the exhibit, overlaid with short quotes about MUJI from well-known designers. Architect Tadao Ando states: "MUJI's succinct design reveals a Japanese aesthetic, which values sustaining simplicity by completely discarding all worthless decoration." The exhibits clearly revealed that simplicity, rely-ing on just the photographs and the MUJI goods to inspire a future where an intrinsic beauty is found when function and form are inherently integrated.

Ryurei
Transportable tea ceremony room / 1992

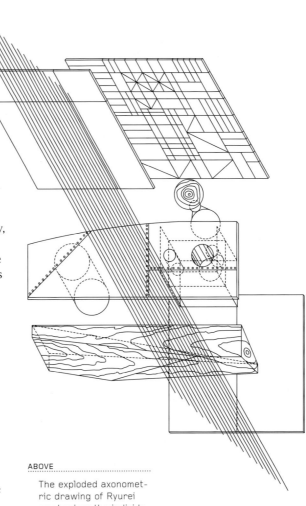

For his first design of a space for the tea ceremony, Takashi Sugimoto drew from his long experience of practicing the tea ceremony and his belief in the inherent beauty of materials. He used simple forms and expressed the richness of the space with materials left over from industrial processes and other salvaged materials. Their surfaces are not refined but have the patina of age and marks of use that convey what Sugimoto refers to as "information" – a strong link to the past which can suggest history and trigger memory.

Designed for a tea ceremony performed with a table and bench rather than on *tatami* mats on the floor, as is more common, the overall form of the tearoom is implied rather than obviously demarcated. The quality and atmosphere of the space come from the combination of forms and materials. A metal partition, partly made from one sheet of metal with a polished surface and partly of small pieces of rusted iron collaged together, marks the back edge of the space. An enormous square wooden beam from an old farmhouse hovers slightly above the floor to mark the front edge of the space. A thick plate of solid copper serves as the tabletop. A single hole is cut out of the copper plate for the brazier, used to heat the tea water. Two hourglass-shaped stools and a delicate screen of thin metal cables, stretched vertically from the floor to overhead, complete the richly textured composition, which seems simultaneously to float and to be grounded.

ABOVE

The exploded axonometric drawing of Ryurei emphasizes the individual characteristics of the different pieces which come together to form the tea ceremony room.

RIGHT

Centered on the copper table and heavy wood bench, the tea space is defined by planes, both solid and implied, like the metal partition behind and the vertical rods at the front.

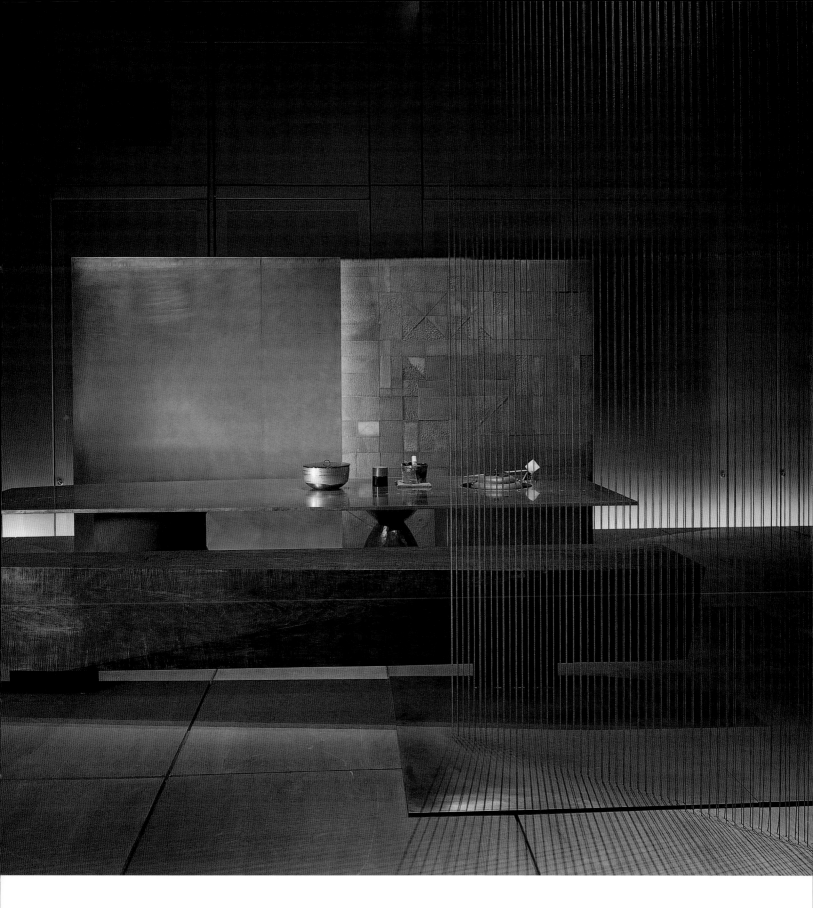

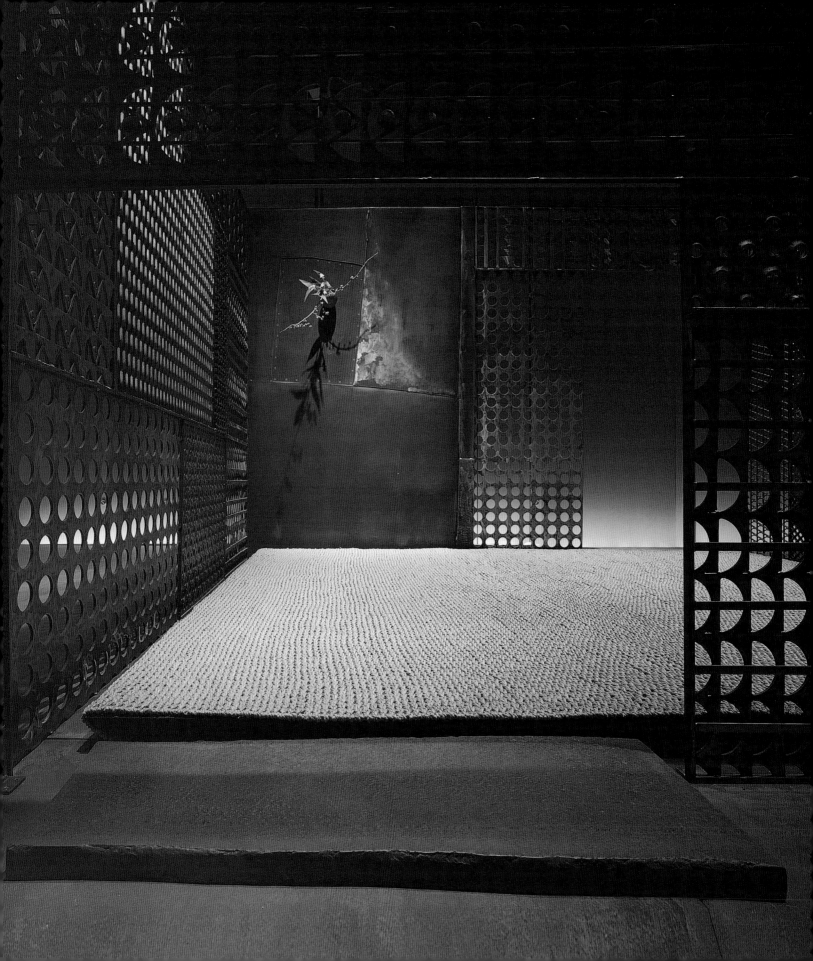

Komatori
Transportable tea ceremony room / 1993

Komatori teahouse was not designed for a specific site but rather to be portable; the walls break down into pieces which can be crated for shipping. Therefore, rather than reference one particular place, Takashi Sugimoto designed it to create a sense of place wherever it is assembled. Sugimoto chose to use salvaged metal as the primary material, because metal can take on many different forms, and the patina of the used material suggests a tie to history and memory, incorporating the element of time. Sugimoto visited a factory which used a computer-guided laser to cut shapes out of metal sheets. The leftover sheets, systematically perforated with holes where the pieces were removed, created interesting patterns. Assisted by an ironworker, Sugimoto gave form to the scrap metal. They reinforced the metal where necessary and combined the pieces into a patchwork of screens and solid panels with a mysterious lightness and transparency that defines the boundaries of the teahouse.

The teahouse is divided into two spaces, the entry and the tearoom. The entrance area has a floor of rough metal panels. One small panel creates a subtle step at the transition point between the entry and the tearoom. The opening in the metal screen wall between the entrance area and the tearoom is a square, about one meter on a side, a direct reference to the low *nijiriguchi* entrance of a traditional Japanese teahouse. Sugimoto's tearoom is an abstraction of the traditional. Instead of ceiling planes of varying heights, Komatori has no ceiling. In place of the decorative *tokonoma* alcove, Sugimoto hangs a flower arrangement on a solid metal wall panel. Rather than filtered light through paper screens, the perforated metal walls filter the light and view. And replacing the strict geometry of a *tatami* mat floor, Sugimoto uses one large woven *goza* mat, custom-made by a craftsman in Okayama. The subtle references to tradition combined with the delicate quality of the salvaged industrial materials create a space of restraint and understated complexity.

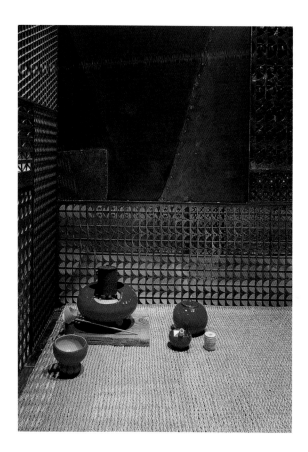

OPPOSITE

In place of a path through a carefully tended garden, the approach to the traditionally low entry in Komatori is adorned by the play of light and shadow filtered through the metal screens.

ABOVE

Utensils for the traditional Japanese tea ceremony are set up in a corner of the space that is defined by the roughly woven *goza* mat and the salvaged metal screens.

Tea Utensils
Hikari / 2000 and Touboe

Hikari: water jar (layered glass), 2000

To accentuate the darkness of the typical tea cere-mony space, Takashi Sugimoto designed a glass *mizusashi*, a water jar, which would also function as a light fixture. The latest technology was used to laminate a layer of special paper within three layers of cast glass. When a low amount of electric-ity is applied, the paper emits light, and the glass glows softly.

A black lacquered wooden lid highlights the glowing sides of the jar. Its sharp edges and squared corners contrast with the amorphous glow of the glass. The thick sides of the jar are tapered slightly, thereby emphasizing the perfectly square opening.

Touboe: water jar (salvaged steel), date unknown

The name Touboe means the "mournful howl of a dog," a reference to the lonely quality of the shapeless, rough water jar. Touboe is made from the bodies of old fire extinguishers, salvaged from a pile of scrap metal. The amorphous form of the container gives way to a perfectly circular opening at the top. The simple wooden lid fits down into the container, sitting slightly lower than the lip of the jar, maintaining the pure geometry but acknowledging the strength of the thick metal surrounding it.

The inside surface of the water jar is coated with layers of dark lacquer. The lacquer protects the metal from the water and reflects light in its glossy finish, just as light is reflected in water. The juxtaposition of the smooth lacquer coating and the rough metal surface adds an element of the unexpected to the design.

The pure geometry of the black lacquer lid accentuates the form of the water container, and its polished surface heightens the glow emanating from the translucent layered glass.

Created from assorted pieces of used metal, the rough organic form of Touboe (shown with other tea utensils in a typical setting) is juxtaposed with the perfect circle of the wood lid.

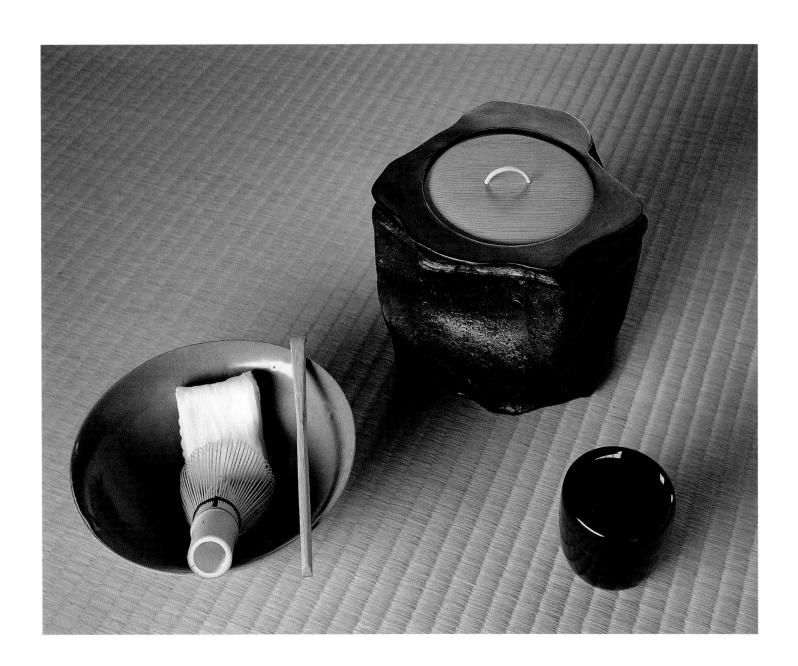

Kenya Hara Talks
with Takashi Sugimoto

March 16, 2005, at Super Potato

Mira Locher (M): Let's start with something ambiguous.... What is design?

Kenya Hara (H): Start with something difficult, you mean? (laughing) The fact is that each and every thing has been designed. Design is the awareness of that, isn't it? I also think design is about continuing to consider the variety of everyday things, for example, a table. What is a table? What is a chair? What is a cup? Before being able to understand, we must continually ask ourselves this. Typically, we don't think innovatively about what is a table, a telephone, clothing. To continue to consider this, is design, I think.

Takashi Sugimoto (S): Generally, there is this presumption that Kenya Hara surely will say something like "design is communication." There was a time when design was thought of as an aesthetic. And there was a time when it was thought of as a technique. That was not entirely a mistake, but looking over different intervals of time, you represent the belief that "design is communication"....

H: My specialty is communication, but the concept of design is not only communication. Beyond consuming design, we make use of it.... To use design for some purpose, even if people aren't aware of it, means they come to understand something, or they begin to gather at a certain place or to buy certain products. The power to explicitly generate that kind of response ... I am continually contemplating the secret of that power.

S: In a sense, the concept of communica-

tion is just that – we must take another look. For example, there are many different department stores, which are in themselves communication brought to perfect form. However, as with the space of a department store, our work is often called commercial space. The question, "What is design?" for us is similar to "What is commercial space?" Setting aside the notion of space, the question becomes "What is commerce?" This is very interesting. In the book known from the third century, *Gishiwajinden* ["An Account of the People of Wa (Japan)"], the scene of a market in Japan is described. *Gishiwajinden* is thought to be the first written record of Japan's commerce. After that, commerce is depicted in picture scrolls and other documents. Then, in about the eighth century the expression of commerce became like a form of speech. To simply say what a market is, trade is just a small part – communication is the core. For example, at ancient market places, people did things like have religious gatherings and theatrical performances, diagnose diseases, and have discussions about prehistory. Commerce was just one small part. In the era when the monetary economy was still uncommon, people engaged in bartering. In that way, little by little Japan moved toward an abundance of goods. The challenge up to that point had been agriculture, but agriculture is not why Japan became prosperous. With the act of buying and selling agricultural products, exchange began. And because exchange began, thought evolved. In a certain sense, commerce is one catalyst of society's trends and movements....

A big turning point was when the Mitsukoshi Department Store was established. In the thirtieth year of the Meiji

period [1898], the then Mitsukoshi Dry Goods Store issued a public advertisement announcing the first department store. The same year, Japan's industrial production exceeded agricultural production. That meant that citizens with the social standing of townspeople had increased.

In that way, just before the time when an era seemed to be evolving, commerce was there as a kind of energy. To my mind, in a certain sense, design should have been strongly situated – like lubricating oil for communication. However, now commerce is declining. Still things that sell are selling, but leave them alone, and they stop selling. In order to sell, there must be an incentive. That has also become a role of design. There's the sense that salability and design are in collusion. It is possible to see brand intention and the like – that kind of inducement has become synonymous with design aesthetic. Now design aesthetic is trying to change. The point where we direct our attention to what kinds of things will be necessary in the next era, that's where the vanguard of design is, isn't it?....

For example, on the way up the staircase of this office, there is a wooden column. It is *umoregi* [lignite], a fossil.... It's an object that was not affected by any aesthetic up to the twentieth century nor by the twentieth-century model of communication.... Salable things are not pleasing to me. I don't want people to think of design as salable. That's a reverse phenomenon, I suppose, but I want things to have value other than salability. Because Hara is also a person at the vanguard of design, how he organizes the things that he chooses to possess in terms of value is very important, I believe.

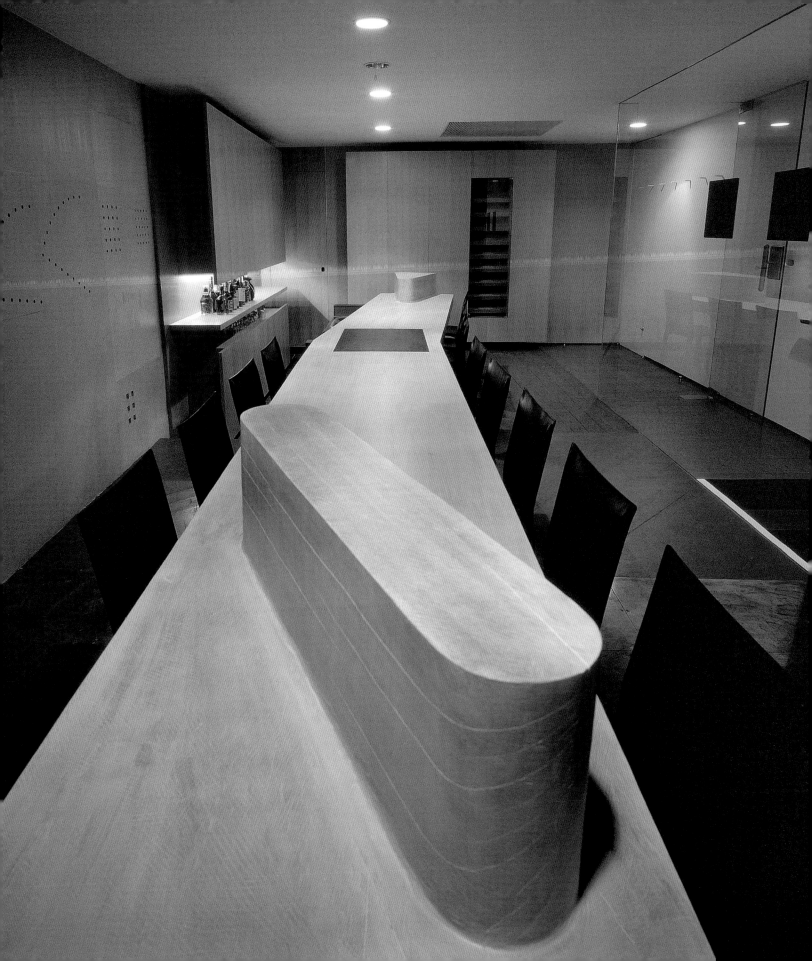

H: It's expressed in my book [*Exformation*, 2004], but I consider design to be "the education of desire." Regarding our earlier discussion of the economy and markets, new "unknown" things sometimes appear before one's eyes; and as one becomes aware of the things one didn't know, the senses are aroused and give birth to the desire for a more interesting lifestyle. Something is activated that should initiate a market or economy.... We are getting to the point of considering how we can make the things that will be desired in the next lifestyle. It's not just about wanting what's in the department stores ... a slightly newer desire must be born. That's where design must work.

Design is related to culture. Presently we are in a global era. But culture is basically a local phenomenon. Therefore, the consideration of how to raise the standard of desire in the local marketplace is also important. Inquiry into future design is that kind of fundamental and essential problem, I think. It's not throwing on chemical fertilizer to produce splendid fruit the following year, but to ensure a continuously stabilized good crop. As with properly cultivating the basic field, if there is an awareness of exercising influence over all domains used every day, design works as an extremely beneficial resource, I think. For example, to touch on the products of Mujirushi Ryohin [the retail establishment MUJI], they're not expensive brand-name goods. Many Japanese people now want to be able to buy simple but good things.... In the case of pursuing foreign markets – a product generated from that kind of aesthetic consciousness ... because it is unique, can possess its own force of influence.

Designers exist also in order to give appeal to products. The attitude of managing product appeal in the short term is spreading, but on one hand there is also the attitude of surveying the whole more. Being aware that design is taking a wide view is very important for communication.

M: The concept of communication is fundamental in the work you both do ... so is the idea of nature. I find the role of nature in contemporary life to be an important notion in your design approach, Sugimoto. How are you considering that?

S: The projects that we undertake are in the genre of space design. In that case nature – natural – is not being in harmony with earth in a broad sense. I use it in the sense of materiality or as scenery. In our situation, it's a very necessary element. To explain using the example of a residence.... Imagine the residences of the past 300 or 400 years ... the townscapes in Tokyo or in Kyoto, also the townscapes in the countryside, were attractive, I think. It's not that the people's sense of form was superior or their creative ability was above the average. Probably their imagination and skills were within a certain range, and they lived by adapting themselves to nature. As people live, little by little different ideas emerge and techniques are disseminated; thereby perhaps each individual's level was raised. The range of food spread out, the types of clothing increased, and people began to use all sorts of furniture. If that kind of factor increases ... houses lose their attractiveness. In that regard, now is the worst time, isn't it? There is the company that sells the most houses in Japan – their house sales have surpassed one billion several hundred million yen. Every year they add 200 new employees, just graduated from university. In today's Japan, that kind of company is rare. In order to recruit new employees, the directors of the company came to my university. When we were talking, I suddenly thought to say to one of the directors, "It is possible to see many houses from here. Which ones are your company's houses?" And he didn't know. This is a top company in Japan, and the executives don't know their own company's product. This is a bit of a problem. Beer companies know. Clothing companies probably also know. It should not be odd for housing companies to know theirs. It's one part of being a vanguard industry. Just the other day, regarding another matter, I dined with the chairman of that housing company. When I mentioned my earlier discussion – he is aware of my involvement with Mujirushi and had obliged me by visiting the Mujirushi house at the Yurakucho branch – he said, "If Mujirushi is as good as Sugimoto says, why can't I recognize that in the MUJI house?" I think that is an honest statement. He probably doesn't understand. Materials, science, size, cost – he only looks at that kind of thing. With dwellings, there is slightly different information. This is what I most wanted to say today. After all, we live and also eat and do work ... human life is composed of many things. Present-day Japan can only make things exceedingly materialistically.... While being conscious of continuing to live, there is the matter of what we consider to have value. That kind of consciousness is now suddenly missing.

There is a painting, a Japanese national treasure called *Yūgao tana nōryōzu* ["Enjoying the evening cool under the bottle-gourd trellis"]. It's a folding screen painted in ink with the scene of a couple and a small child enjoying the cool of the evening underneath a gourd trellis. This is an overwhelmingly popular painting among the Japanese. The scene is very pleasant, and it is technically superb. If you look at the painting, it can bring tears to your eyes. In the past there was attachment to the kind of lifestyle in that painting – that sense of value was the core of what the populace liked. It's not like that nowadays. Brand-name goods are becoming the core. (laughing) Therefore, when you look at the housing companies' houses, there is no core value compared with looking at that painting.

To go back to today's discussion – what is "communication"? The meaning of communication is not the physical products made until now, but something just coming into being. In the Mujirushi house, the focus turned a bit in that direction. It's not that the space is magnificent or the ceiling high or the entrance splendid or that kind of thing. How you feel when living in the house – that is the point. I believe this is very important.

H: When designing, one is absorbed with the form of something or the color. Many designs, in fact, startle us with their form or color. On the other hand, it's not about that. There is also the method of designing the awareness of a "way to consciousness." Sugimoto explained "nature" – nature is the earth or the oceans or the ground. But nature is not unrelated to humans. Human beings are also nature. Humans have an extremely finely tuned sensibility. In the human way of sensing

and within the territory we are able to sense, there are still many undeveloped areas. In venturing into the interior of the human being's way of sensing, perhaps things akin to the once still-undiscovered American continent can be discovered. That is to say, the course of design until now has focused on thinking only about being surprised by the outer world, without looking at the nature inside humans. However, now considering "how to make one conscious" remains as the territory of communication. Looking at Sugimoto's space, I think he aims precisely in that direction. It's not that there is surprising form, it's merely the case that there is a stone, a stone which is packed full of an extraordinary amount of information.

Not so long ago I went with Sugimoto to Bali. I hadn't been to Bali for fifteen years. Since then many grand resort hotels have been built. But Sugimoto said, "Hara, since it wouldn't be interesting for you to stay in one of those resort hotels, let's stay in an old hotel," and he guided me to a hotel with cottages on a large plot of land. There were stone pavers, and everyone walked on the stones with bare feet. Since people walk on them frequent-

ly and repeatedly, the stones had been worn down. I thought that was a very pleasant feeling and contained a great amount of information. If I were to input this quantity of information into my computer, it would probably freeze immediately. The human brain likes that kind of condition in which information is abundant. There are times when suddenly one becomes aware of it. The present age is said to be an era of "excess information." In fact, that is not the case. It's an era of fragmentary, seemingly broken information wafting abundantly, randomly, through various media. Information of substance is limited.

Consider the way people live, a dwelling.... If one enters a room ... the human brain and senses are caught up in what quantity of information – in a world full of information – can produce the sensation of a pleasant feeling. Today's housing is probably not thought of in that way. Mujirushi's house, as Sugimoto explained, although simple contains a great deal of information. For one thing, materials are used to generate as pleasant a feeling as possible. Japanese housing manufacturers probably can't comprehend this standard

of quality as a form of measurement. When I enter a bar designed by Sugimoto, what is remarkable is the amount of information contained by the whole space. Within that vast quantity of information, we are made to feel good.

To return to the discussion of Bali ... it is a very pleasant place. To say why it's pleasant, partly it's the stone paving, but there is also a scent in the air. That scent is sometimes a fruit fragrance. Sometimes the smell of incense wafts by. It's not a simple scent – it has a complex fragrance. There's very little sound, but if you strain your ears, you can hear the music of the gamelan mingled with other soft sounds. The hotel's wooden walls have become aged antiques.... There is a richness of space that is completely different from plain, very new things ... like the latest Japanese high-rise buildings. My clients like new things. Elevators and the like in enormous buildings have a plain and balanced feel. Carpets and walls and ceilings, too, are inorganic substances. The people in those buildings can endure that kind of artificiality well.... But for me, if there's not enough information, it's intolerable.

Recently I have been using the word

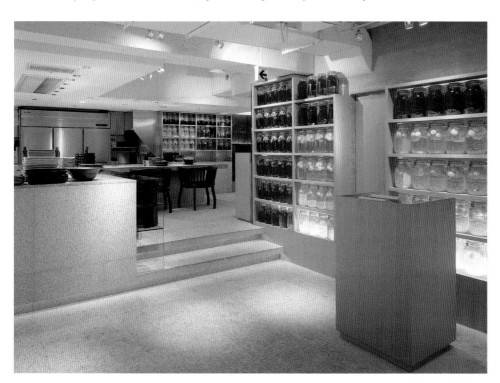

PAGE 118

Internationally acclaimed graphic designer Kenya Hara runs the Hara Design Institute, as well as serving on the board of MUJI and teaching at Musashino Art University.

PAGE 119

The upper level of Be-in café and bar was conceived as an abstract space with surfaces layered in white paint and shapes drawn in graphite on the walls.

LEFT

In front of a wall of jars filled with colored fruit liquors, the reception desk at Kitchen Shunju Ginza sits on a stone floor, which seems to wrap the stairs and counter of the adjoining dining space.

"haptic" quite a lot, but hapticity is not merely a characteristic of the tactile sense. To perceive things, human beings use all their very delicate sensors and fully open the pores of their five senses. To say still more, referring to the delicate brain and sensors, I use "haptic" as a motto for the movement of consciously acting to serve through design.

M: In that sense the spaces that Sugimoto makes are haptic, aren't they?... Within the concept of information is the idea of the beauty of information. Sugimoto, how do you consider that in your design work?

S: Information – the word "information" is very easy to comprehend – but the essence of information goes beyond that, doesn't it? To use a different form of expression, for a long time I have thought that our work is very similar to poetry or *tanka* [Japanese verse of thirty-one syllables]. Sometimes I read or recite poems.... By repeating them over and over, it's very similar to experiencing space. That is also information. Superb *tanka* can be felt more strongly if they do not express one's own idea as such. There is something like a trigger. Saigyō Hōshi has that kind of quality. Ishikawa Takuboku and others do too. If you read Takuboku's book, there are many poems that cause tears to well up inside you ... they're a bit melancholy, you think "that guy must've been so sad." No matter how hard he worked in his life, it didn't get any easier, you know. He went here and there, but nothing came his way. His was not an abundantly ripening life, but that's what is recounted. That is something like "information," as we have been discussing it. The act of creating space is somehow very similar to that. Among the superb poems is Kakinomoto Hitomaru's *Higashi no no ni kagiro, hi no tatsumiete, kaeri mi sureba, tsuki katabukinu* ["In the eastern fields as far as possible, I see the sunrise, looking back, the moon leans"]. The east became bright, and the day broke. You turned around, the moon was already waning. It's only expressing an ordinary thing in an ordinary way, but there's great scale. You sense the grandeur of nature – it's a wonderful poem ... a poem from a thousand years ago handed down to the present.

I think the value of space lies in that aspect. In one sense, I think it is the act of creating an opportunity that must not become arbitrary. Modern design has achieved extremely difficult things. The information coming from the designs is excessively and intentionally arranged. To make something modern, half of the effort goes toward the minimum. At the same time, it is empty. It is difficult to convey that successfully. For example, the well-known electronic products of B & O [Bang and Olufsen] are an example of beautiful objects that were created in the twentieth century. At the same time, I find them blank. To be blank is – I can't say unconditionally – to have such refinement, such eroticism, and such a high degree of perfection that it is impossible to see what lies beyond. The depths aren't visible. It's not like a piece of tattered fabric that I saw in a countryside antique shop. It was an everyday kimono worn long ago by a farmer, yet it was rich, you know. You could sense the warmth of hands and body heat. Not only one person had worn it. You could tell that grandpa's kimono had been worn many times after being sewn, modified, mended, patched, and mended again. That sort of thing possesses a kind of richness, which I believe is necessary in space. Information is something that I think should not be defined with words. Take a tree, for example. Wood possesses information, you know. Not just the variety and size of trees. The wood from a dismantled old house or school ... for several decades or several hundred years it watched over the people who went back and forth, gazed out, and perhaps it was soiled and had holes made in it or nails driven into it. It possesses that kind of information. Paintings and sculpture are the same, also stone and ironwork. If you use materials like that, information flows out. That is the essence of information within space.

H: The question "What is information?" is difficult. To me, the power of information – to relate to the discussion of human sensibility – is that human sensibility can't at all times be considered to be sensitive. At some moment, for some reason, it suddenly can become sensitive. That

is, in any given moment it will not always be constantly sensitive in all directions. For example, in Japanese *tanka* or *haiku* [Japanese verse of seventeen syllables], there's something remarkable that someone has discovered, arranged in an orderly way, and put into easily understood information architecture – not so as to present to someone, but only to indicate "I think this is really great, but how about it?" "How about it?" The person who is asked momentarily focuses in the indicated direction, on that one phenomenon, and becomes very sensitive to it. From that sensitivity, an enormous amount of information is taken in. After all, in Japanese poetry and literature it is not the case that all the answers lie within the text itself. It's designing the information so as to somehow become sensitive in the indicated direction.

As for the way to grasp information, look at today's information and ask a young Japanese person, "Do you know this?" For example, if you ask, ... "Do you know Le Corbusier?" "I know, I know." However, no discussion of Le Corbusier follows. They know because they saw it in a magazine. That has become the goal of communication. Since the role of information is to set the brain in motion, this situation is far from the essence of information, isn't it? In that sense, the condition that "they understand what they don't know" can be thought of as a way to a deeper understanding.... In that sense, in regard to information, I've been considering the concept of "exformation." Exformation is a method of putting out information "to make one understand how much one knows."

For example, think of a guidebook for New York.... The guidebook is jampacked, swollen with information.... That's one use of information. Perhaps sightseeing is to see the things that one wants to see in the expected manner. However, there must also be a way to become free of that conventional route and get to know New York. Becoming aware of how much one did not know about New York probably has more strength than a guidebook. In that way, while continuing to consider what information is, I believe that the essence of information will become apparent.

Exformation ... possesses the capability to express many different things. It is a model of one process of thinking.... Design that brings about a new feeling is interesting. When I enter one of Sugimoto's spaces, I have that kind of feeling. Even if there is stone, I don't feel that "this is how stone is" or the stone's splendor is being interpreted. Rather, it is the awareness of not having known that stone is a certain kind of thing. I have the impression that the substance of that unknown space is being quietly revealed ... design provides the opportunity to become sensitive. In that way, I think one is being made aware of "information."

M: The concept of awareness is an important point – awareness as a way of seeing and awareness as memory. For example, when reusing materials, even if the specific history of the material is unknown, there are phenomena that become apparent from the memory of the material and cause us to see it in a new way.

H: The unknown or "ex-form" is one power in Sugimoto's design, and simultaneously degeneration or chaos is included. Usually the process of making things ... proceeds from chaos to generation. That process toward generation is like the image of B & O's ideal, flawless form being completed. And yet, completed things become rusty or decayed, they weather and so forth, returning once more to chaos. From things that become soiled, beautiful things arise. After they are completed, again they rust and return a second time to being soiled. Objects continue to exist in that kind of cycle of generation and degeneration.... Sugimoto doesn't look just at the generation part. He also sees beauty in degeneration. That's his way of looking at things. The act of seeing beauty in decaying things, in degenerating things, is extremely significant in Sugimoto's design work. Beauty is not modifying the "plus" in people's awareness; beauty is the power to awaken one's senses, that is, in both the "plus" and the "minus." Sugimoto employs that power precisely as the "power" of interior design. It's entirely different when people are aware of that than when they are not aware of it, isn't it?

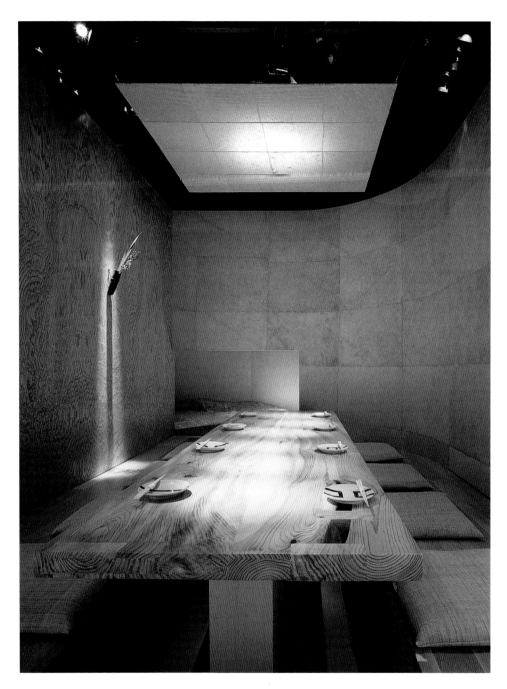

The private dining room in Shunju Tameike Sanno is a quiet composition of wood, paper, and plaster. The table, a thick wood plank with sunken seating, is the focus.

Recent Projects

Niki Club

Hotel / Nasu Shiobara, Tochigi / 1997

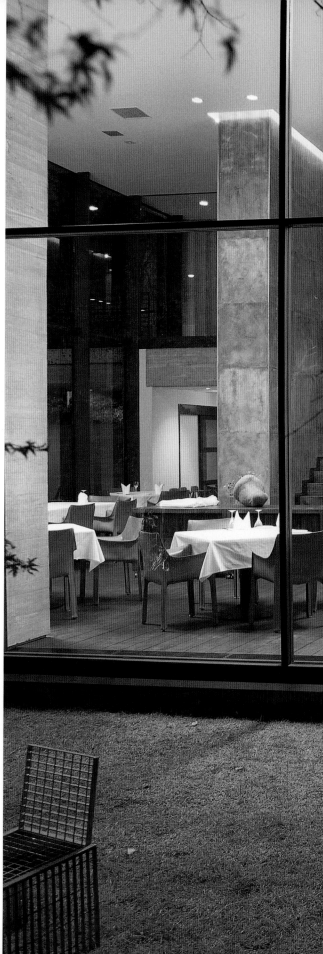

Designed to make the most of its location in a beautiful natural setting, the Niki Club resort features buildings housing different functions scattered throughout the site and connected by paths, providing a sense of closeness to nature. Rather than designing the entire site as a garden, most of it was left untouched. Only a few flowering trees were added to enhance the seasonal changes visible in nature. The master plan of the resort, as well as the basic design of the buildings, was done by architect Akira Watanabe. Super Potato designed the interior of the restaurant, bar, and fourteen guest rooms, which were added after the resort outgrew the original six guest rooms designed by Watanabe.

The restaurant is located on the lower floor of a two-story building, which houses the reception area and bar above. From the entrance on the upper level, a staircase of heavy dark wood descends against a wall covered with panels of rough bronze. The wall is cut away just above the

RIGHT

The two-story space of the restaurant is shaped by the thick bronze-paneled wall and the wide stair. The bar floats above, with one corner entirely enclosed by glass.

BELOW

In the upper level, shelves filled with photos and books and richly hued wood paneling and furniture create a comfortable living room-like space — with a surprise view to the treetops from the bar counter.

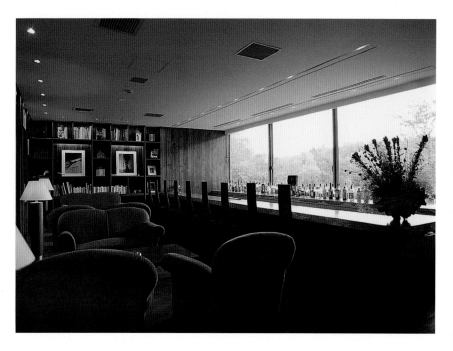

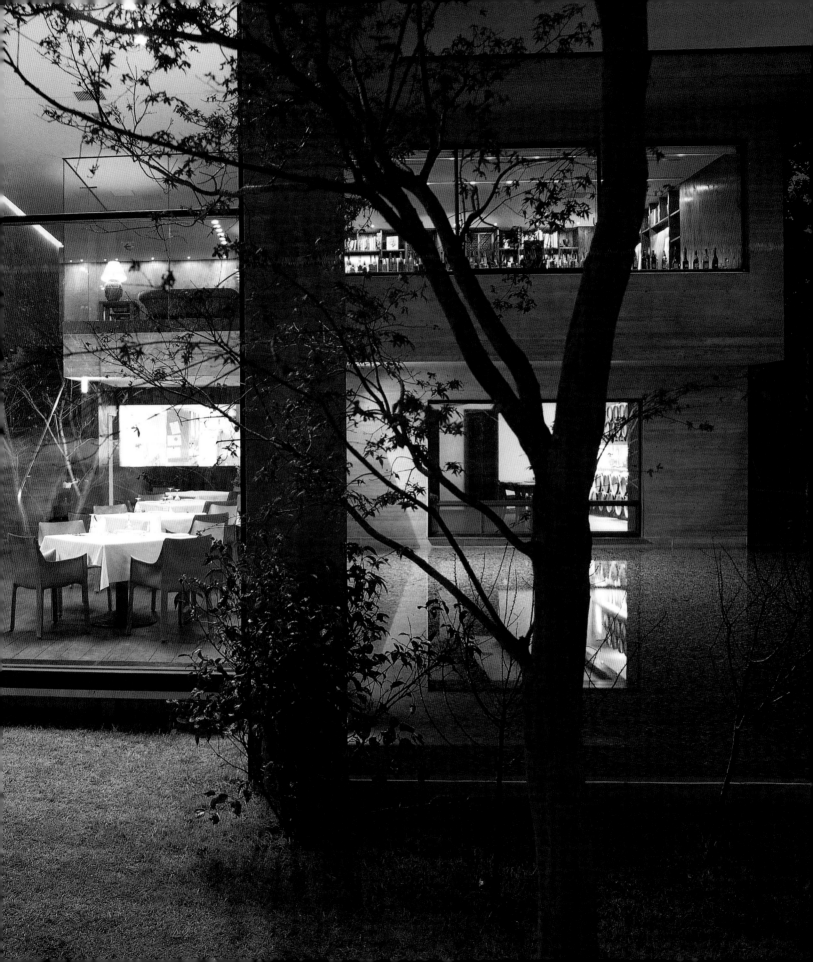

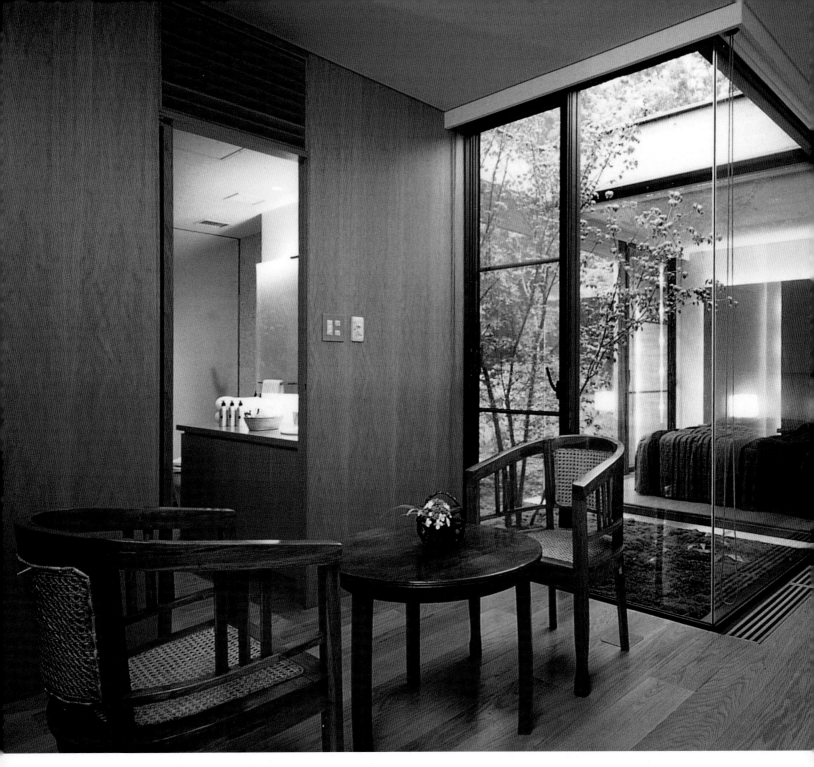

ABOVE

Nature is brought into a
guest room with a small
glassed-in court garden
planted with a flowering
tree. Wood furniture,
flooring, and wall panel-
ing enhance the tie to
nature.

RIGHT

The site plan shows the
concept of the hotel as
a complex of buildings
in nature, with the res-
taurant on the right and
the guest rooms spread
through the landscape.

staircase, mimicking the stairs' zigzag form. This creates a reveal for soft downlights, which emphasize the stairs within the open space. The bronze panels have a rough, almost stone-like surface, expressing the natural quality of the material in juxtaposition to the smooth, exposed concrete structure of the building. Takashi Sugimoto designed the restaurant to open out into nature, with solid concrete walls framing large openings of glass that run from floor to ceiling in the double height space. Simple wood chairs and tables covered with bright white cloths form a pattern on the contrasting dark wood floor. A glass wall separates the kitchen from the dining area, allowing the customers to view the preparation of their food.

The metal-paneled wall continues as a feature in the upper level, serving as the backdrop to the fireplace, which is a favorite gathering spot in the winter. Nearby windows are designed for views out into nature, and special exterior lighting emphasizes the falling snow. The upper-level space continues into the bar area, with a softly lit intimate atmosphere. Decorative metal grates cover the windows and gently filter the view while adding to the warm ambience. The bar, with its curving wood counter and dark wood-paneled walls, is one of

Sugimoto's favorite spaces. It affords views attuned to the seasonal changes of nature: the new greenery in the spring and the bright leaves of autumn.

Exterior paths run alongside two shallow pools of water which reflect the sky and connect the restaurant building to the guest rooms. Each of the fourteen guest rooms is different, but all are designed with the same close connection to nature. The rooms are compact and cozy, with just enough space to be comfortable but not claustrophobic. Wood floors and plaster walls in warm colors add to the sense of the closeness of nature. Windows offer long views into the forest and shorter views into carefully designed courtyard gardens.

Many of the guest rooms have an attached room designed for tea ceremonies, with floors of traditional *tatami* mats and walls covered with rough handmade paper or mud plaster mixed with straw. *Shoji* screens (wood lattices covered with translucent white paper) filter the light, and ceilings of thin bamboo add to the traditional feeling of the rooms. Walls covered with roughly textured panels of bronze and metal lattice grates over windows provide a contemporary interpretation of the traditional space. These intimate spaces are designed as a microcosm of the nature just outside.

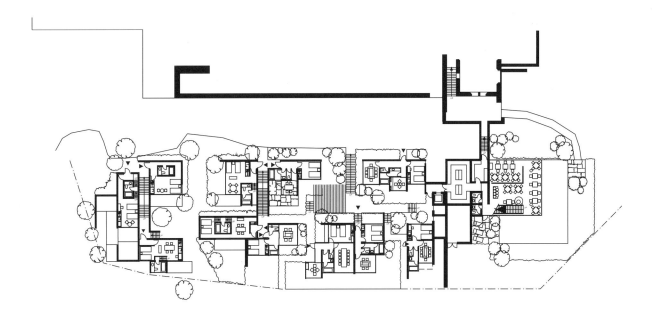

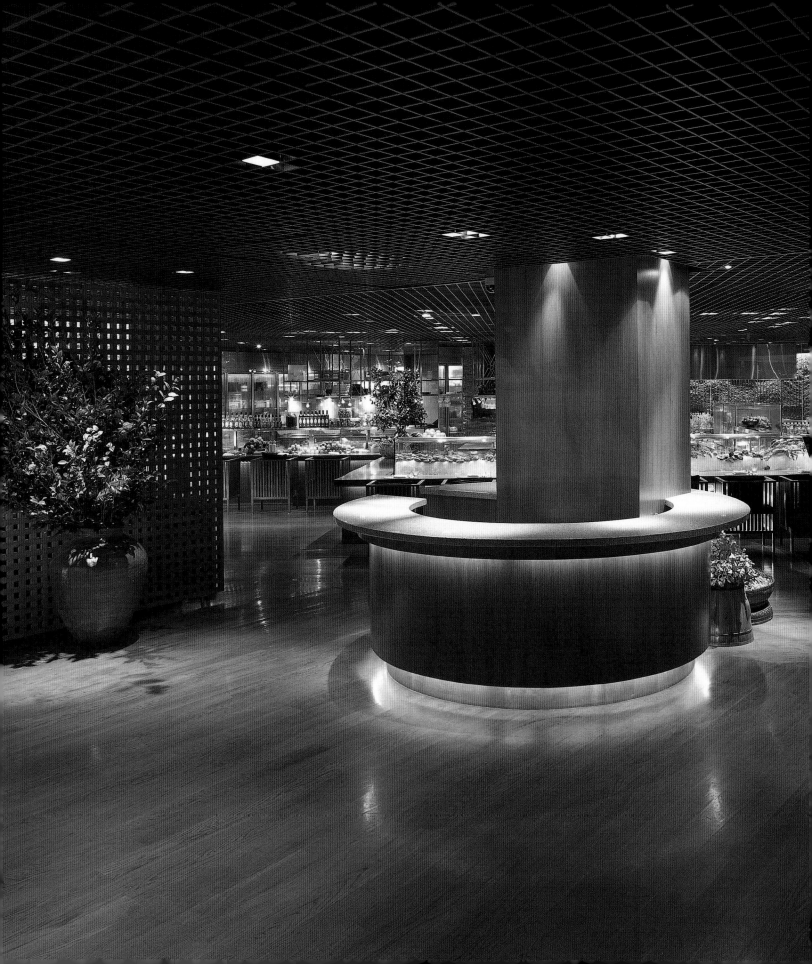

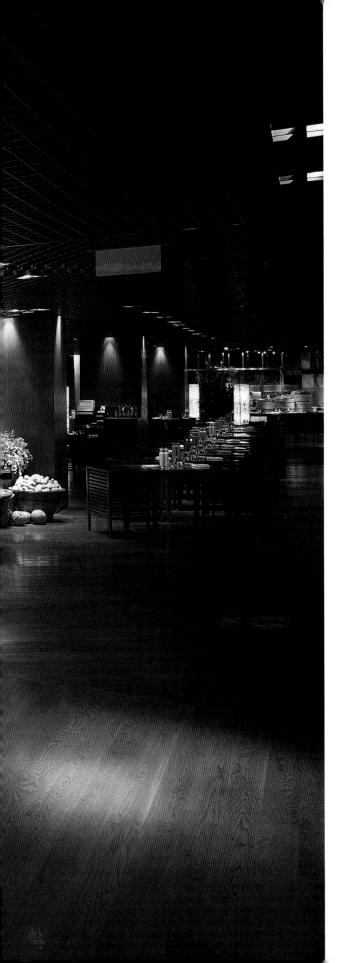

Mezza9

Restaurant / Grand Hyatt Hotel /
Singapore / 1998

LEFT

Views of several of the
open kitchens greet
customers from the
restaurant reception
counter, which curves
around one of the over-
sized columns that give
rhythm to the open
space.

When the Hyatt Hotel in Singapore decided to
upgrade to Grand Hyatt status, they wanted a
designer who could create an atmosphere that
would attract many people to the hotel, not just
hotel guests but people from the city and visitors
as well. To this end, Super Potato was asked to
renovate the lobby, restaurant floor, Club level
office and lounges, and the basement bar. For
Super Potato, the opportunity to work outside
of Japan was exciting – they could discover and
utilize the skills of the local craftspeople. The
design of the hotel's Mezza9 restaurant, with its
much-copied "theater kitchens," gave Super Potato
international name recognition.

The restaurant's name, "Mezza9," playfully
refers to its location on a mezzanine level over-
looking the hotel's front lobby, combined with the
number of kitchens contained within the space –
nine. Previously, the floor had housed several sepa-
rate restaurants. Super Potato chose to use the
entire space and reference Singapore's famous
food courts, creating an upscale version, to attract
people from all over the world to enjoy many dif-
ferent types of food. Super Potato's design concept
was the "theater restaurant," with open kitchens
scattered throughout the space. Customers can
see their food being prepared and are entertained
by the chef's skill and intensity while working.

Seating areas are interspersed among the
kitchens, with tables of varying sizes, counter seat-
ing with close views of the kitchens, and private
rooms for groups. Patrons can sit anywhere and
order from any of the kitchens. Each specializes
in a certain kind of food, including popular items
such as seafood, sushi, and Chinese favorites.
Customers can also sit at the bar, next to one of
the wine cellars, or in the cigar salon, or they can
visit the shop for takeaway sweets and souvenirs.
The seating areas were planned to feel intimate
yet part of an extended space. Tanks of live fish
and counters covered with iced seafood and other
ingredients divide the space. From all vantage
points, the area of the restaurant opens up, and

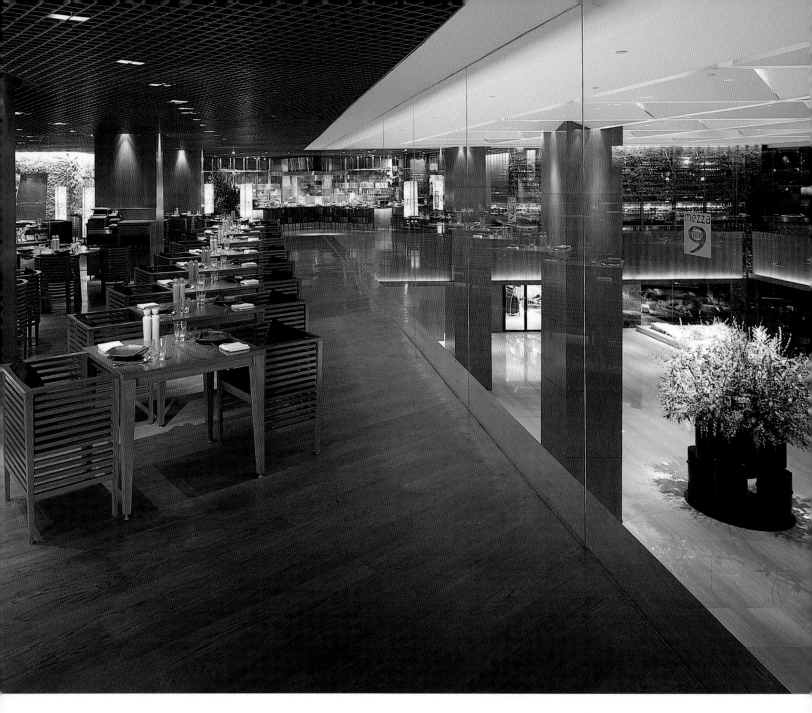

ABOVE

Overlooking the lobby atrium, with its origami-like folded ceiling, the main dining spaces look through the atrium and down into the lobby, separated only by a simple glass partition.

ABOVE RIGHT

The dramatically lit underside of the stair-case accentuates the sculptural quality of the stair in the tall space of the lobby and empha-sizes the connection to the restaurant above.

RIGHT

The restaurant and bar wrap the upper space of the lobby atrium, with the open kitchens and counter seating set at an angle and the private dining rooms tucked into the corner spaces.

accented by the continuous latticework ceiling, views extend across the restaurant and through the glass walls down to the lobby below.

Super Potato integrated contrasting materials in the design: smooth high-tech materials for the sleek kitchens and textured "high-touch" materials in the areas for the customers. The kitchens gleam with stainless steel and glass, while the seating areas have walls of rough stone, wooden floors, columns wrapped in wood, and tables and chairs in warm wood hues. The intimate bar area features a wall of collaged pieces of reused metal and metal screens brought from Japan, the remains of thick sheet metal after pieces had been removed for other purposes. The private rooms use materials such as rough handmade paper and mud plaster on the walls, woven strips of thin cedar wood for ceilings, and paper light fixtures. One wall is covered with old Chinese carved wood panels. Like elsewhere in the restaurant, the private rooms provide a feeling of intimacy while still being connected. Views emerge through small courtyard garden-like spaces filled with stones into the larger restaurant space and beyond.

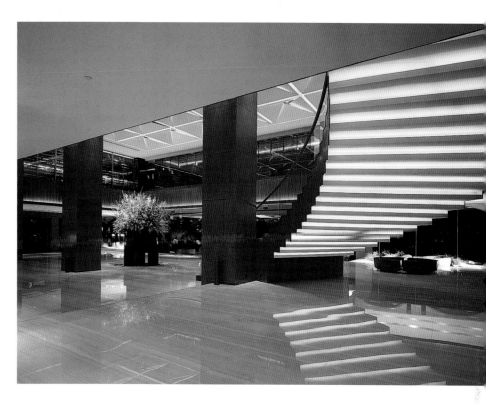

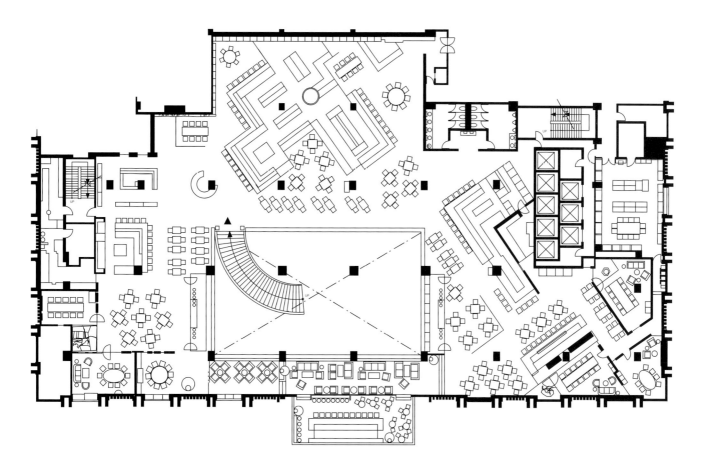

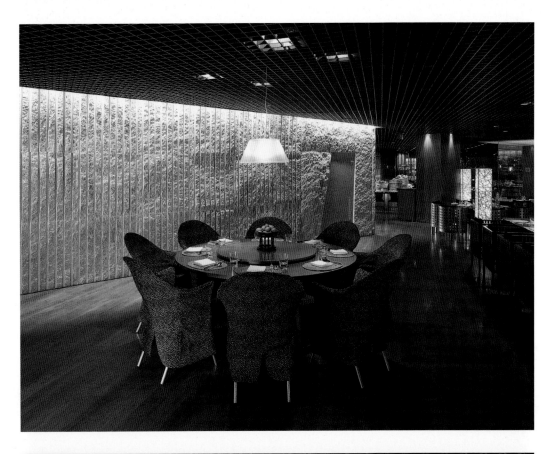

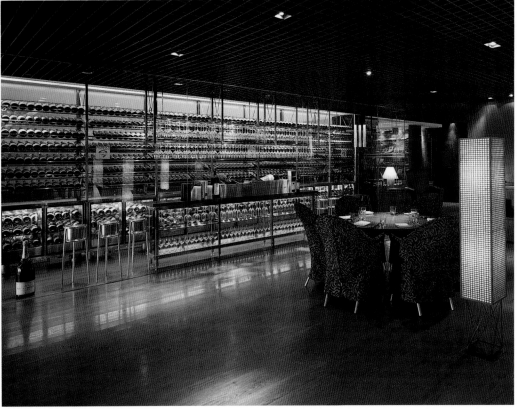

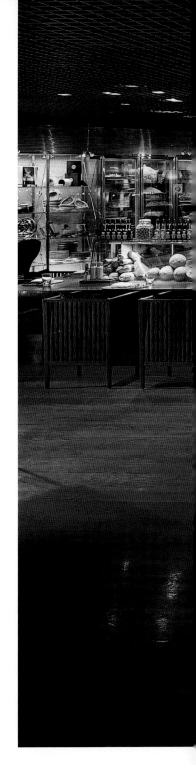

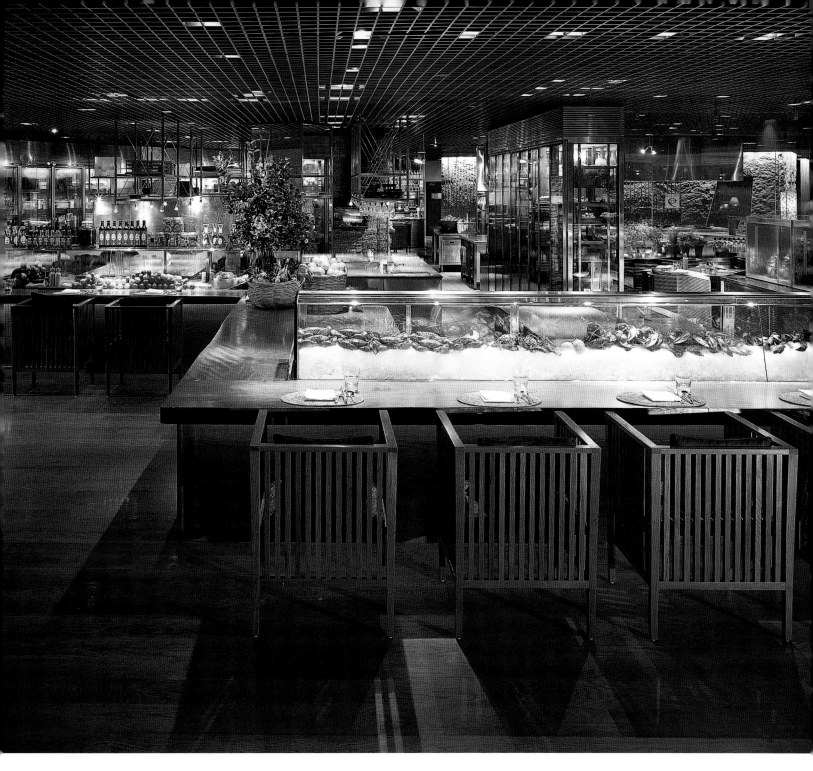

A glass-encased wine cellar holding hundreds of bottles defines an edge of the open dining area. Tall floor lamps covered with handmade paper accent the space.

The dining space flows into the open "theater kitchens." The wood counters, wrapped around glass cases full of fresh food, create the only separation.

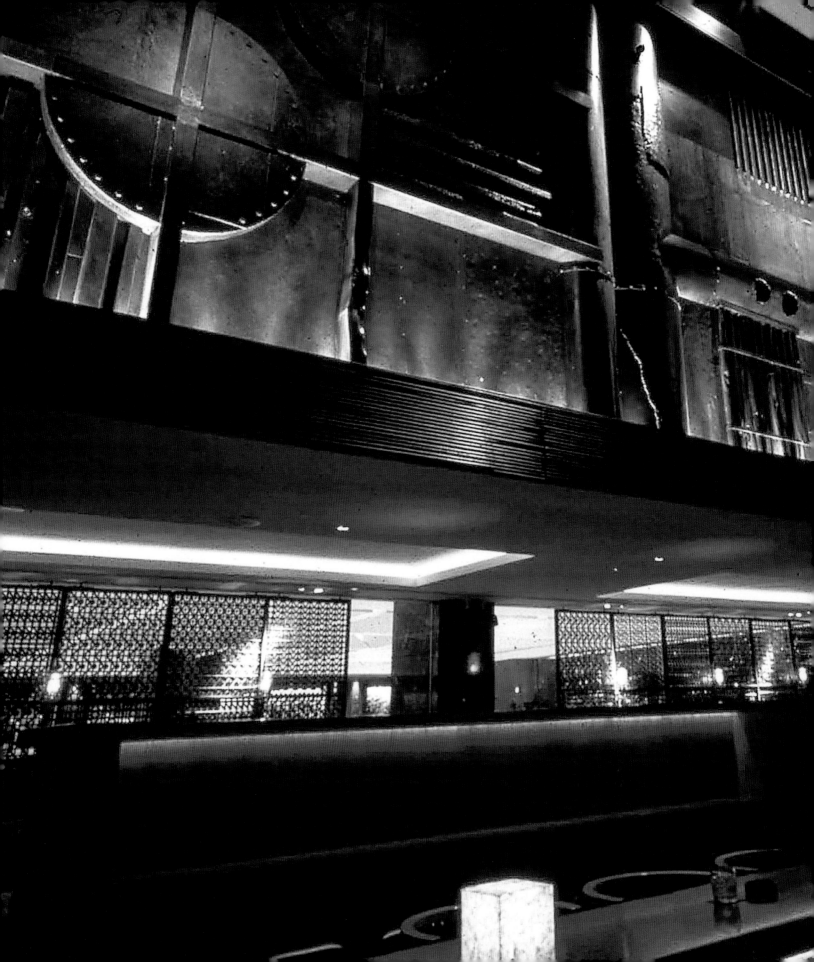

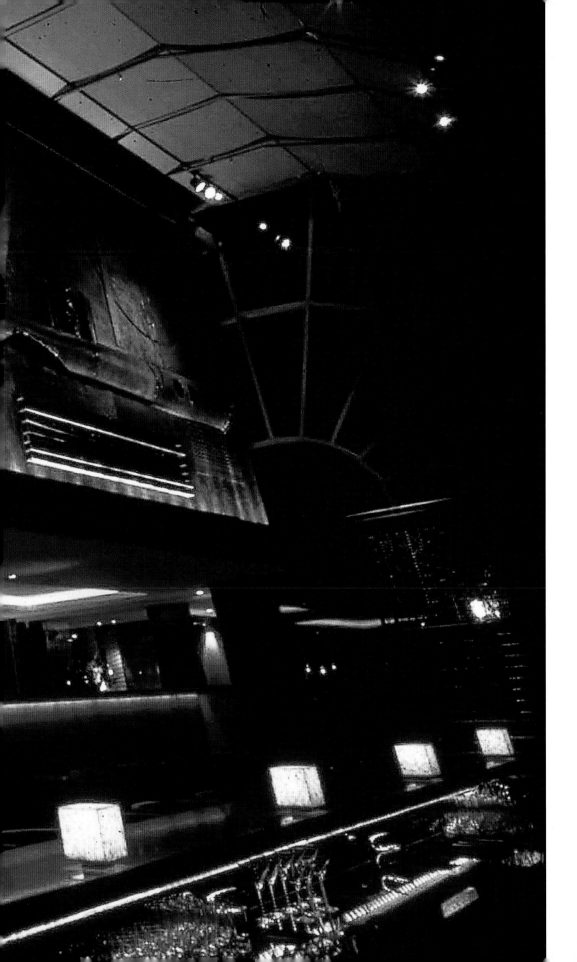

Salvaged metal accents
the bar area. The wall
above the bar counter
is a composition created
from pieces of used
metal. Metal screens
separate the bar from
the lobby atrium space.

Brix

Bar / Grand Hyatt Hotel /
Singapore / 1998

An exterior staircase located near the main en-
trance to the Grand Hyatt Hotel Singapore leads
to the large underground bar, Brix. The name of
the bar refers to the most prevalent building ma-
terial employed in the design – bricks. To create
a strong relationship with the city, Super Potato
referenced the façades of old Singapore buildings
by using a locally made brick as a covering for all
the vertical surfaces. But rather than using brick in
the conventional way, Super Potato shows the great
versatility of the material. Columns are wrapped
in brick set on the diagonal. Arched alcove seating
areas are built from stacked brick. Walls are cov-
ered with a variety of textured brick patterns, akin
to a three-dimensional patchwork – some solid
and some perforated like delicate screens through
which light and views pass.

In contrast to the weight of the brick, the
floors, furniture, wine cellar, and bar counters use

RIGHT

Gleaming glass and
stainless steel shelves
float over the bar.
Spotlights highlight
the texture of the sleek
wood counter and
three-dimensionally
patterned brick walls.

BELOW

At the entrance to Brix
bar, light plays over the
muted brick walls and
rough metal of the door,
marked by the Brix logo,
creating deep shadows
that set the mood for
the interior.

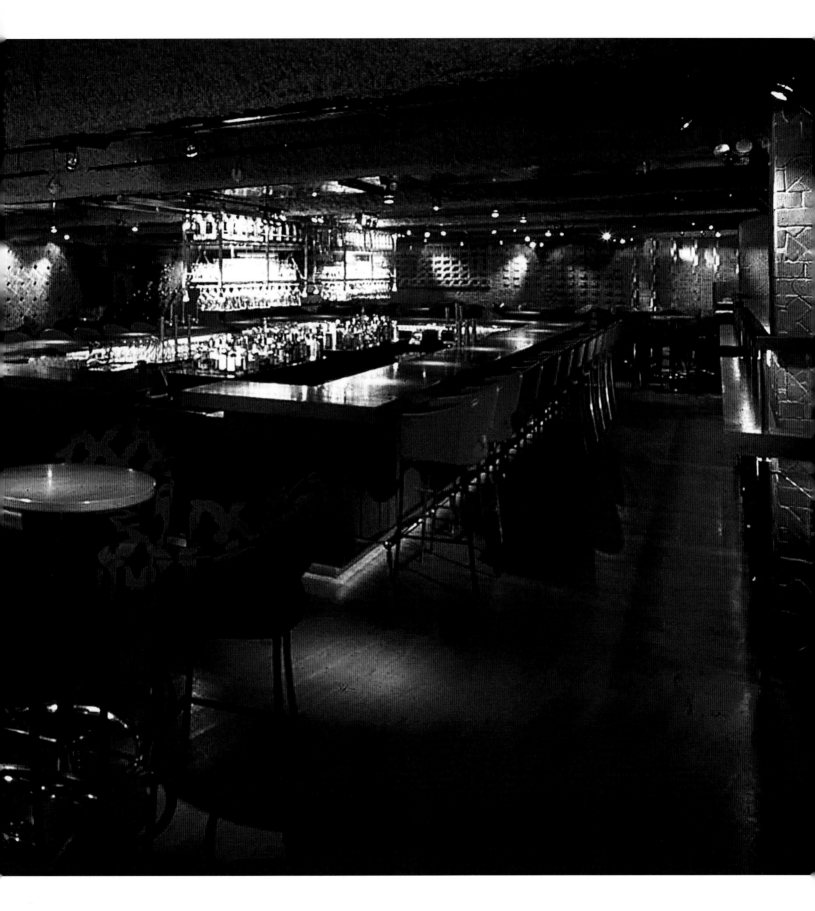

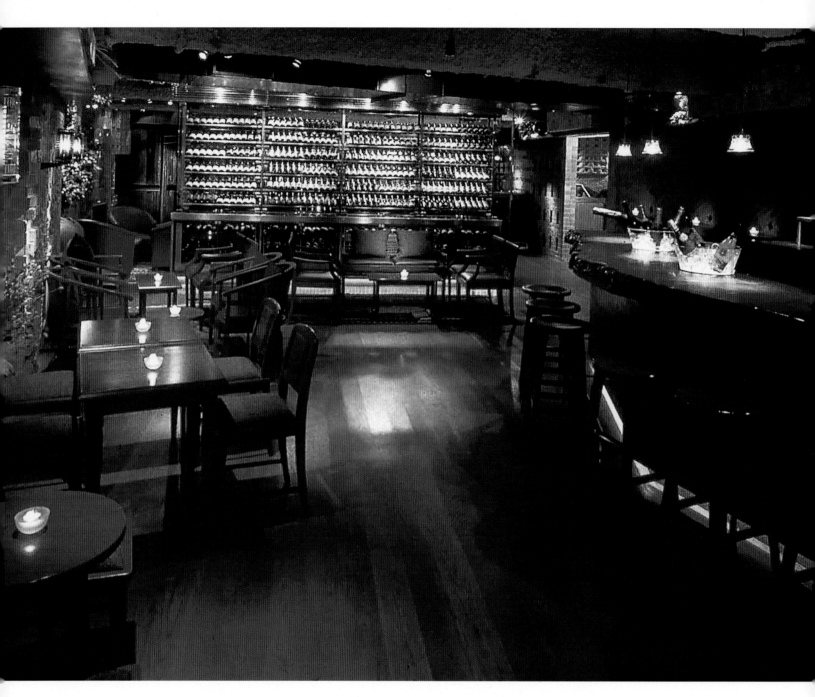

metal, glass, and wood for a lighter, contemporary feeling. Some of the chairs are upholstered in bright fabrics with eye-catching patterns, adding points of color and motion. The ceilings are left open, with the ductwork exposed, to give the space as much height as possible.

Brix is divided into two main areas which flow into each other and take advantage of the varied methods of using brick to create different seating areas. The lively larger main bar space features a long wood counter wrapping around the central bar and a stage for musical performances. Alcove seating at the edges of the room gives a sense of privacy and enhances the acoustic quality. Separated by a perforated brick wall, the more intimate side of Brix houses a wine bar with a glass-encased wine cellar and a cigar salon and whiskey bar with a wall composed of pieces of salvaged metal which serves as a backdrop. Designed to give customers choice, the variety of sitting areas and ambience of Brix ranges from active to intimate, yet the space remains united by the texture and pattern of brick.

ABOVE

The quiet ambience of the wine bar is accented by the luminous glass-enclosed wine cellar, which also serves to separate the cellar from the cigar salon and whiskey bar.

RIGHT

Polished wood tables
and chairs in bold geo-
metric shapes contrast
with the flowing three-
dimensionality of the
varied patterns of the
brick walls.

BELOW

The central main bar
counter parallels the
lines of the existing
building, while the brick
walls defining the space
are rotated off the axis
to create intriguing
spatial tension.

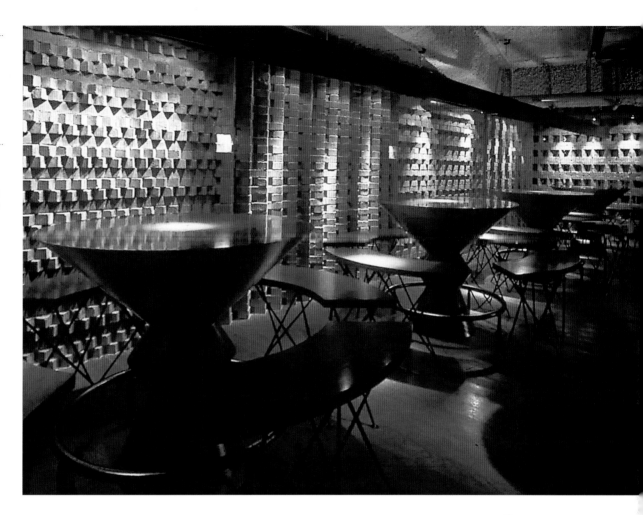

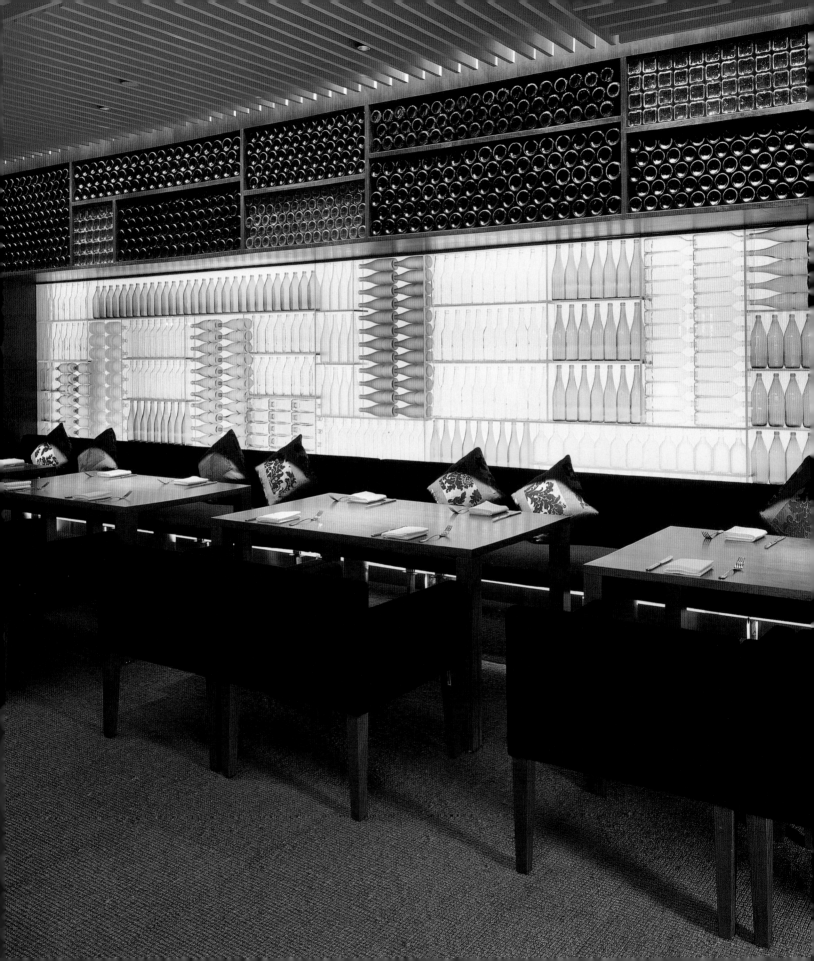

Straits Kitchen
Restaurant / Grand Hyatt Hotel /
Singapore / 2004

LEFT

A wall composed of
bottles lines one edge
of the dining area. The
glowing composition of
glass is capped by wood
shelves filled with dark
bottles, stacked to show
their round and square
bases.

The casual Straits Kitchen restaurant adds a playful mix of transparency and opacity and a clever blend of materials and textures to the rear lobby of the Grand Hyatt Hotel Singapore. The 2004 renovation changed a dark under-used space into a brightly colored, lively sensory experience, with Singapore itself as the design concept. The bold lobby space features long walls covered with mosaics of salvaged local wood painted metallic gray and is accentuated by columns covered in layers of salvaged wood, stacked horizontally to create deep shadows.

The restaurant is separated from the lobby by ingenious screens of black and white photographs of Singaporean food floating in a transparent wall, and partitions of vertical wooden louvers inlaid with spots of colorful acrylic. Visitors are treated to filtered views through the restaurant to its teeming buffet tables.

A glowing translucent glass counter marks the restaurant entrance, where customers are greeted with a dynamic experience of sights, smells, and sounds. First in view is the beverage counter, featuring a glass case full of fresh fruit on ice, dramatically lit from within. Glass shelves hanging above the counter hold myriad jars of preserved fruit in a rainbow of colors. Just beyond are the open kitchens, where chefs serve freshly made Asian specialities like Malaysian satay, Chinese chicken rice, and Indian tandoori, reflecting the varied ethnicities of the citizens of Singapore. Everything is on display in Straits Kitchen: colorful salads in large bowls sit on stone counters, shelves of plates and bowls fill the space under the counters, arrays of tempting desserts line glass cases, and chefs cook up noodles to order, while chatting with customers. Even the ingredients add to the ambience: bottles of fish sauce are stacked on glass shelves overhead, and jars of spices line the walls behind the kitchens.

Wood tables of various shapes and sizes are grouped along the edges of the restaurant space, with views to the open kitchens and buffet counters and out to the lobby beyond. Structural columns, cleverly hidden behind layers of wooden shelves filled with tiny ceramic teapots, punctuate the active space. Walls of the dining areas are lively compositions of common materials rendered uncommon by Super Potato. Gray dishes completely cover one part of a wall, white dishes another. Glass shelves glow dramatically with stacks of bottles in green, clear, and blue glass. Blocks of salvaged wood face a section of one wall; others are covered with back-lit strips of acrylic in shades of cool green and yet others with ordered patterns of ceramic tile. Each segment of the wall, like each element of the restaurant design, is carefully composed to engage the senses and playfully create a sense of order within the active space.

LEFT

Open kitchens are interspersed with a variety of seating areas, taking advantage of the zigzag edge between the restaurant and the back lobby of the hotel.

BELOW

A variety of textures defines the spaces of the restaurant. Mosaics of salvaged materials cover walls, wood shelves wrap structural columns, and louvers create ceiling planes.

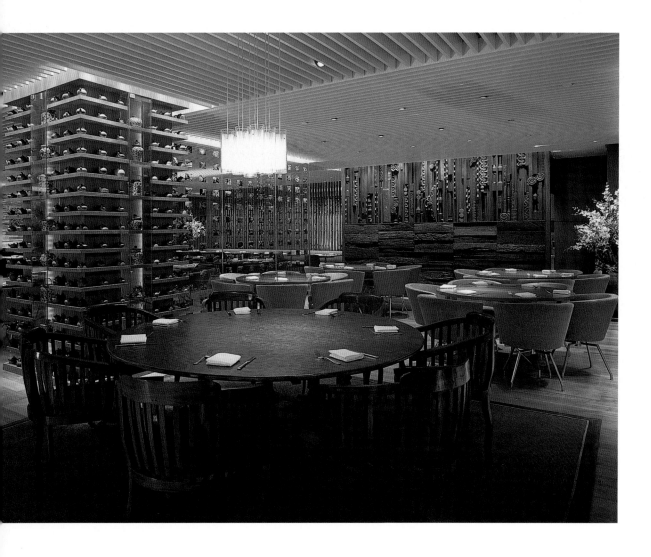

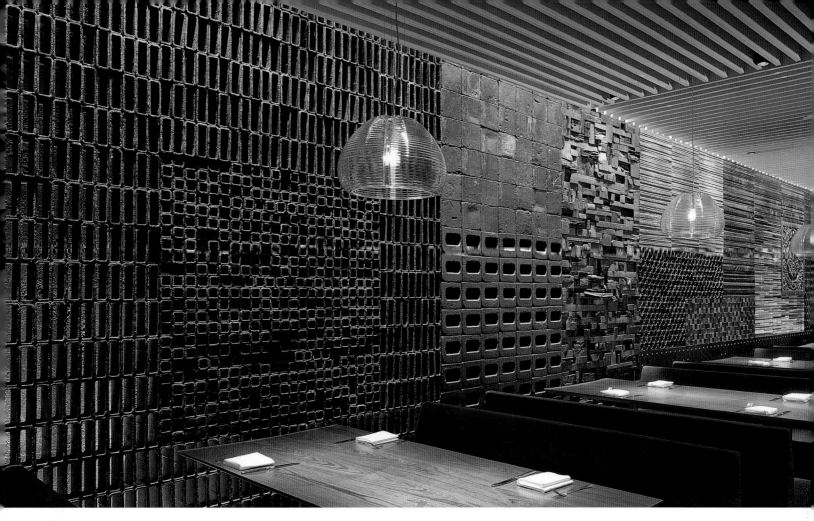

A patterned wall covered with ceramic tiles in many shapes and sizes reflects and refracts the light, showing off the subtle variations in color and surface texture.

LEFT

Hundreds of irregularly shaped pieces of salvaged wood, painted charcoal gray, are arranged mosaic-like to cover the wall between the front and rear lobbies.

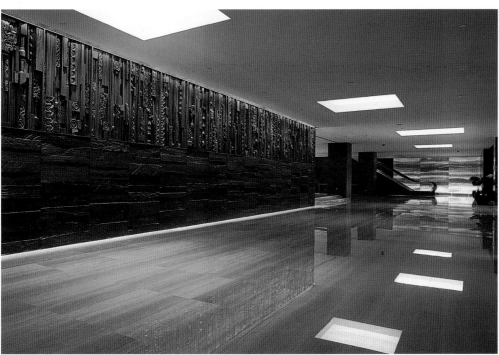

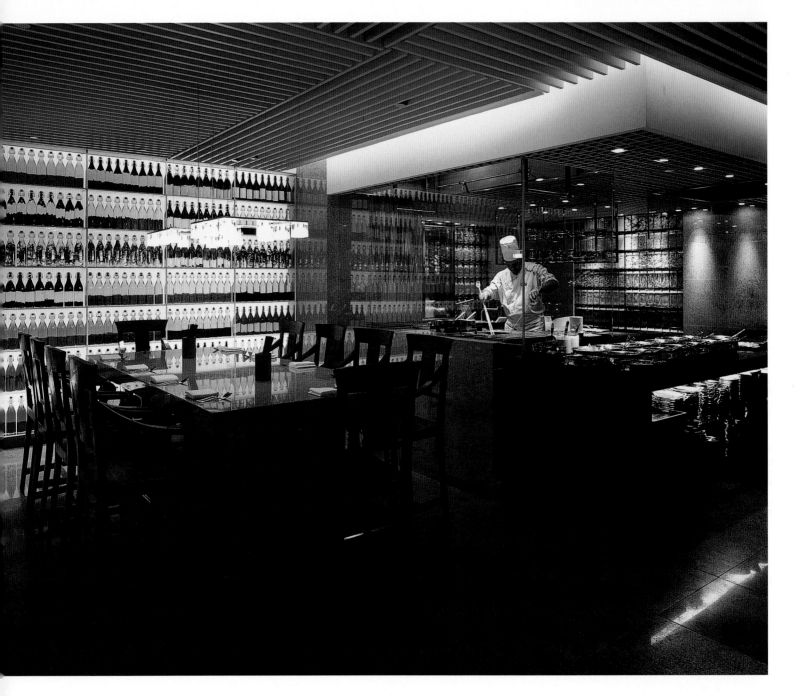

Back-lit bottles of con-
diments line the glass
shelves beside and
behind the tandoori
kitchen. Diners have
a front-row view of the
lively kitchen action.

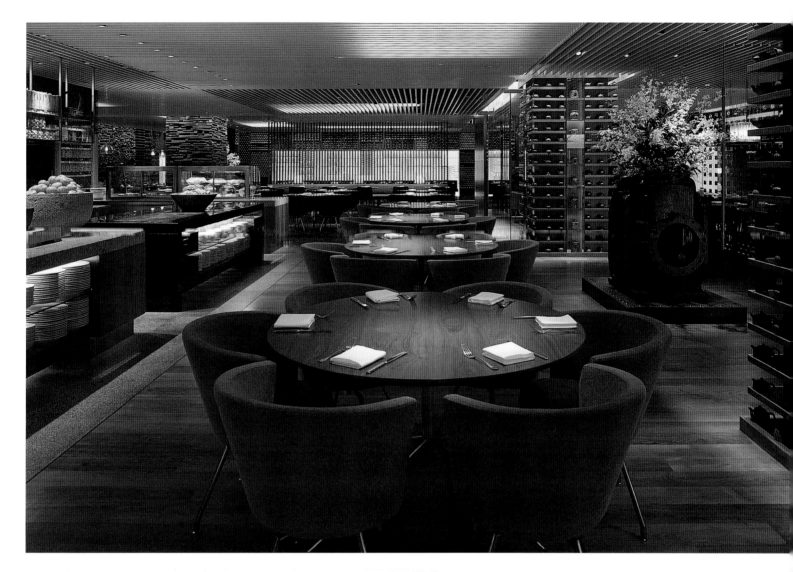

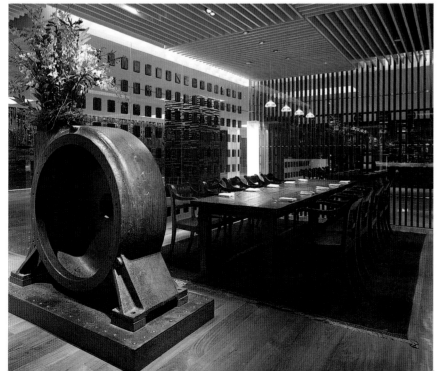

ABOVE

Circular wood tables
are arranged between
the counters of the
open kitchens. The
structural columns,
wrapped with wood
shelves, hold dozens
of tiny ceramic teapots.

LEFT

Part of a salvaged
metal machine acts as
sculpture, surrounded
by semi-transparent
partition walls and lou-
vered ceilings, which
seem to float within
the continuous space.

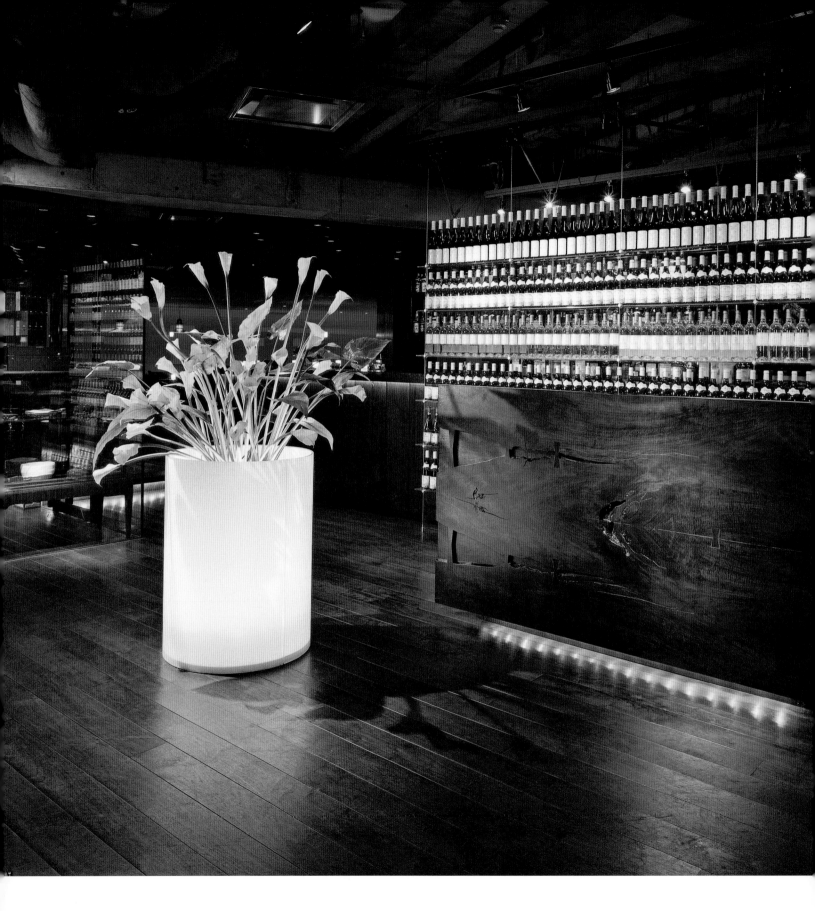

Zipangu
Restaurant / Akasaka, Tokyo / 2000

The long narrow space of the Zipangu restaurant previously had been the home to several other restaurants, but despite the location in the active Akasaka area of Tokyo, none of them were successful in the 100-meter-long, low-ceilinged corridor-like room. However, Super Potato cleverly skewed the floor plan to create a zigzag path that draws customers through the long space. This design, combined with the strength of the well-known Japanese restaurant Nadaman, has resulted in the restaurant being a popular destination.

The zigzag path is a surprise and a delight and is not immediately obvious when one enters the fourteenth-floor restaurant. The elevator opens into a formal lobby, where 6000 bottles of wine line the walls. The reception desk is set at an angle to the lobby – a hint of the zigzag to come. The bar and lounge area, which open up to the left side of the reception desk, are plushly furnished and dramatically lit, glowing with deep shades of red and purple. Columns are wrapped in wood, and the furniture is finished in wood, leather, and velvet. The bi-level lounge space is classic and comfortable yet has a contemporary feel with the use of bold color.

In contrast to the brightly colored bar area, the richness of the restaurant area comes from the textures of the materials and the variety of views through the space, created by the inspired reference to a meandering garden path. Super Potato's image for the design was the active townscape of old-time Akasaka. There, streets are full of people and *izakaya* – small places to eat and drink. Working on the design shortly after having completed the Mezza9 restaurant in the Singapore Grand Hyatt Hotel, Takashi Sugimoto chose to use a similar open kitchen scheme. Customers can sit anywhere and order from any of the kitchens, each of which prepares a different type of food.

Moving down a gentle slope from the reception desk into the dining area, customers are led past a series of small private dining rooms. The rooms are set at an angle to the path and separated from it by metal lattice screens and shallow pools of water. Glowing cast glass blocks, like large chunks of ice, light the way through the garden-like space, and heavy rough stone walls intermittently stand out against the perforated metal screens. The rooms have low tables topped with thick stone slabs, some with low wooden chairs and others with the floor carved out underneath, *horigotatsu*-style, for comfortable seating. The floors are covered with wood planks and stone.

The path then opens up into the main dining area, with five separate open kitchens one side and seating along the opposite window wall. Stone and wood counters separate the cooking from the dining spaces. The kitchens are set one step below the seating areas so that the chefs can talk easily with the seated customers. Wood lattice partitions and walls covered with thick handmade paper – which is also used on some of the light fixtures – gently divide the space yet emphasize the continuous zigzag form.

LEFT

The open space of the lobby, with a distinctive gnarled wood counter, is backed by a glowing wall of wine bottles and a view into the richly colored bar area.

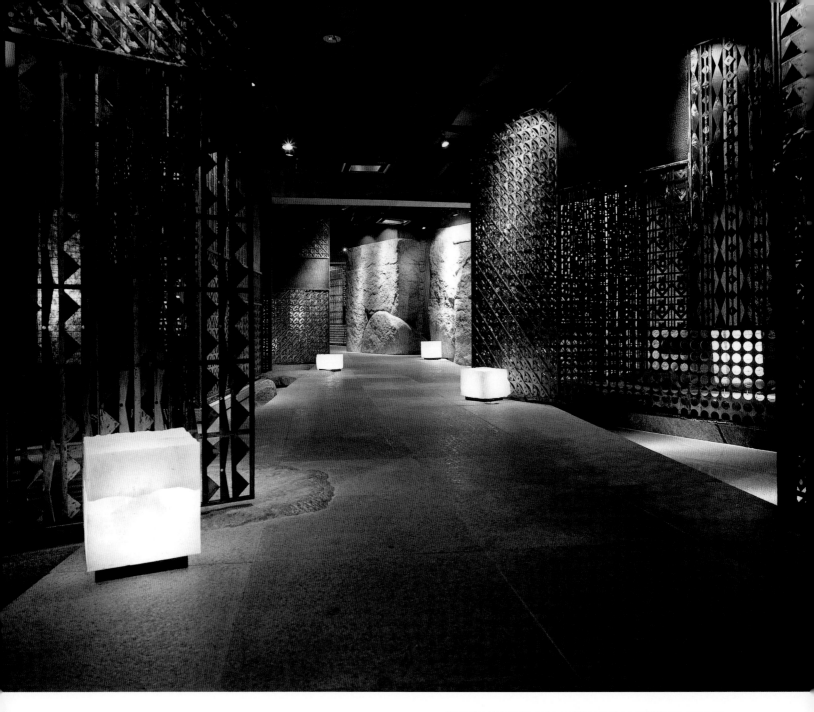

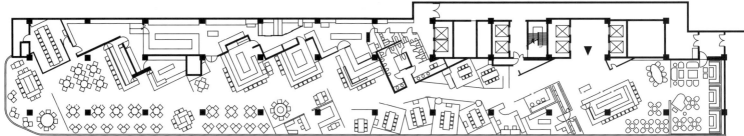

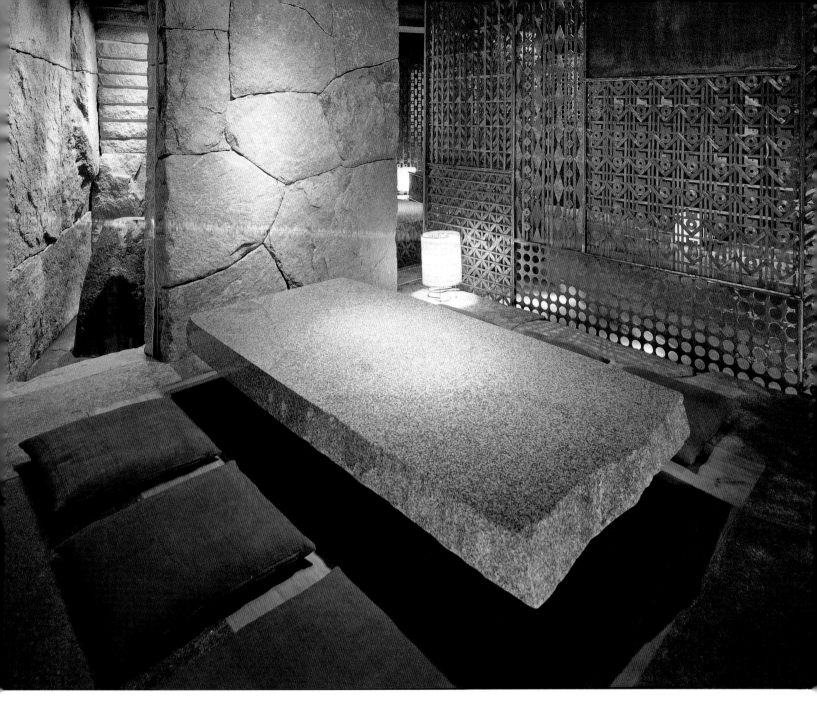

ABOVE LEFT

Screens created from salvaged metal line the stone path that wanders through the restaurant and offer glimpses into the adjacent dining spaces as well as a sense of mystery.

LEFT

The open kitchens and cozy dining areas are shifted off the axis of the long, narrow space and hug the walls. The path zigzags between them, drawing diners through the restaurant.

ABOVE

A private room features a table made from a single slab of granite and *horigotatsu*-style seating. Heavy stone walls and perforated metal screens give texture and definition to the space.

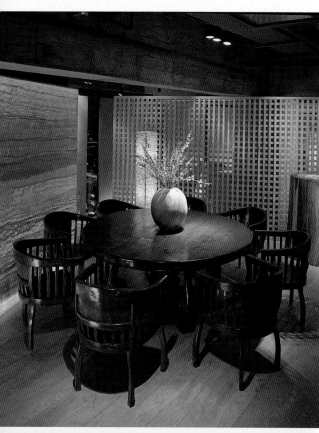

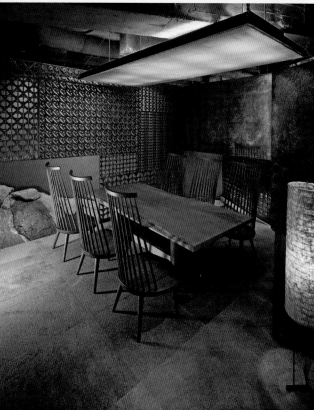

LEFT

In a nook off the zigzag path, a glimpse of the city is offered between a wood lattice screen and a back-lit partition wall of handmade paper sandwiched between glass.

BELOW

Handmade paper lamps create a soft glow in this private dining space with its own corner rock garden backed by patterned screens of salvaged metal.

RIGHT

Looking back to the lobby space, the upper bar area is accented by heavy Balinese wood furniture and defined by a wall sheathed with shelves of wine bottles.

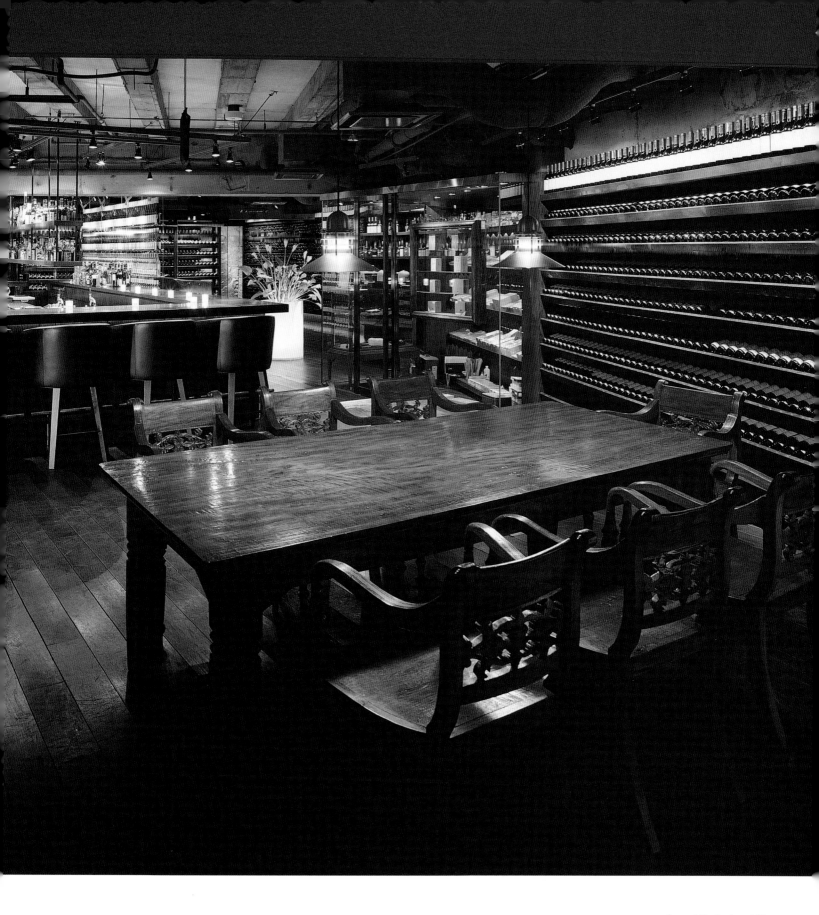

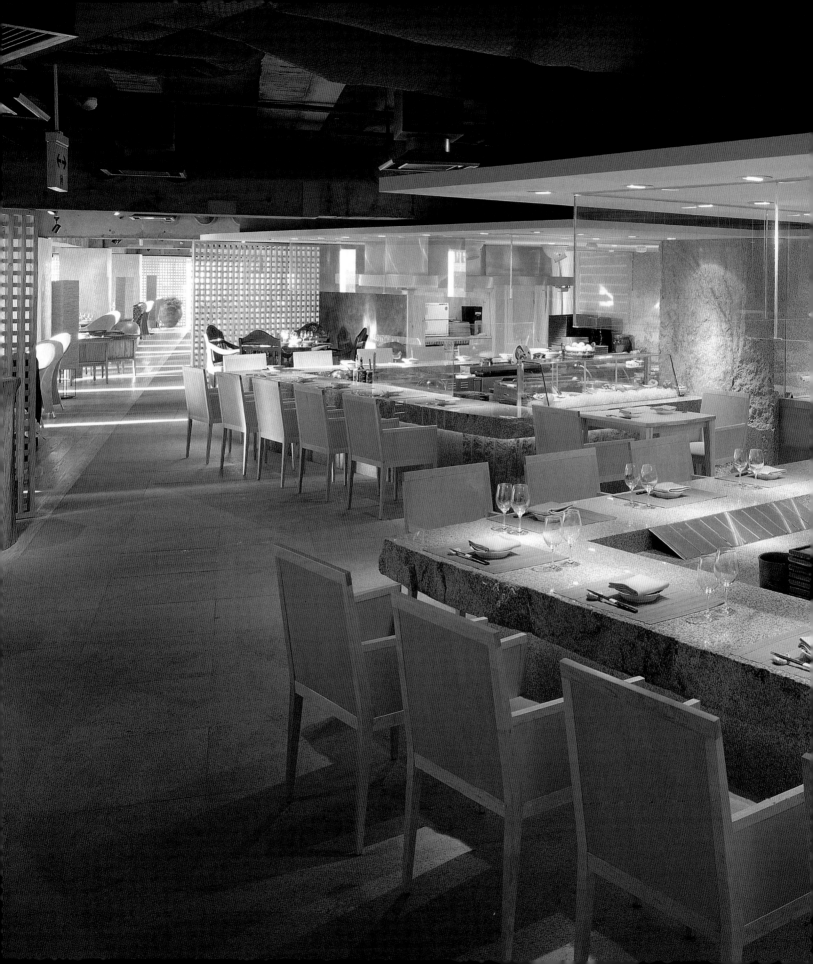

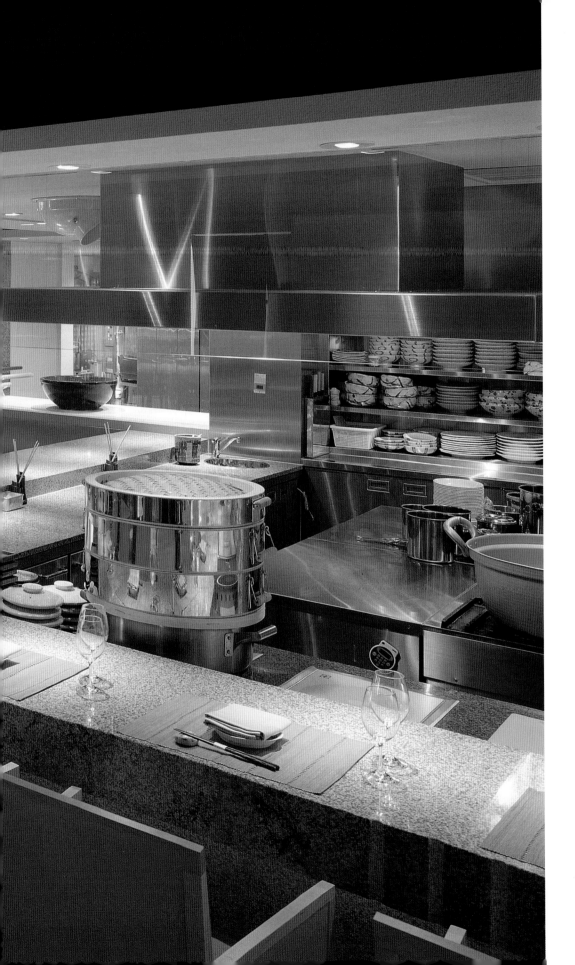

LEFT

The space of the restaurant opens up to thick stone counters bounding open "theater" kitchens and filtered views through the restaurant to the dining areas beyond.

Café TOO
Restaurant / Shangri-La Hotel / Hong Kong / 2001

Set within a classic Hong Kong hotel, a mix of conservative European and Chinese styles, the Café TOO restaurant is bright, vibrant, and surprisingly contemporary. The entrance expresses bold formal geometry: a perfect circle carved out of the ceiling and an almost square opening framed in wood within a dramatically lit white wall. This gives way to a more casual and colorful interior space with a lively atmosphere that is a mix of Chinese restaurant, European bakery and delicatessen, and Asian spice market.

From the compressed space of the reception area, the wine cellar, with over 1500 bottles displayed behind a long glass wall, leads into the expansive restaurant. Food is visible everywhere. Counters of polished marble or glowing translucent glass are covered with dishes full of exotic and familiar foods. Bamboo baskets of dim sum steam, and chefs prepare big bowls of noodles and pull tandoori dishes from the oven. The walls are also covered with food: colorful spices, dried pasta, coffee beans, tea leaves, and other natural ingredients sit behind transparent panels. Clear refrigerated cases full of fruits and vegetables arouse the senses and whet the appetite. In order to serve over 1000 people per day and cater to many different tastes, Café TOO has five buffet counters featuring salads, seafood and sushi, desserts, noodles, and Asian specialties, as well as a bar area and open kitchens where customers can see dishes being prepared and talk to the chefs.

The large space, with its curving wall of windows looking onto the hotel garden, flows easily from seating area to buffet counter to kitchen and is divided by two lines of glowing translucent columns. Tables of different sizes and shapes and assorted chairs covered with colored fabrics add to the variety within the space. Floor surfaces shift from wood to roughly finished marble to glowing frosted glass. The glass is lit from below to highlight the buffet areas and give the heavy stone counters the appearance of floating. The ceiling is left exposed but painted white and partly hidden behind suspended metal louvers set on the diagonal. The louvers lead the eye from one end of the restaurant to the other, uniting the space.

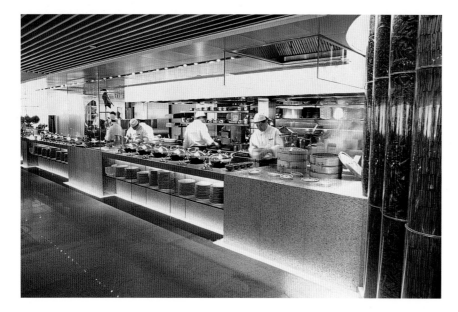

LEFT

The activity of the kitchen is always on view as chefs work behind buffet counters of solid stone, which alternate with wood counters and glass shelves holding stacks of plates.

RIGHT

The dramatic entrance, colorful and boldly geometric, frames a view of the reception counter backed by a curved wall of glass shelves lined with jars of preserved foods.

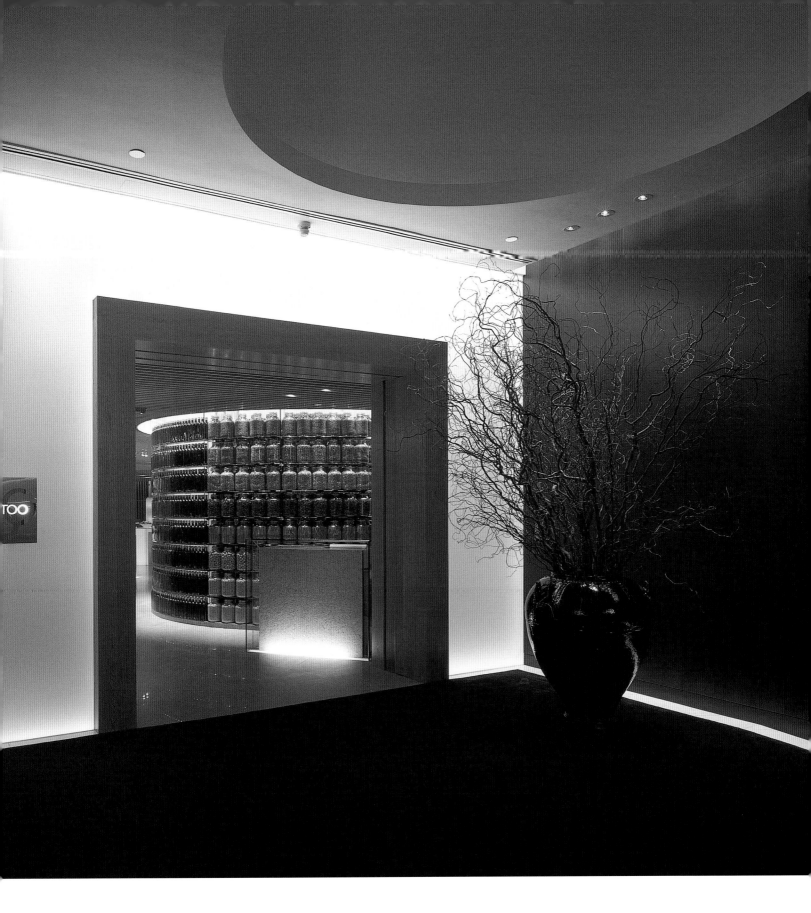

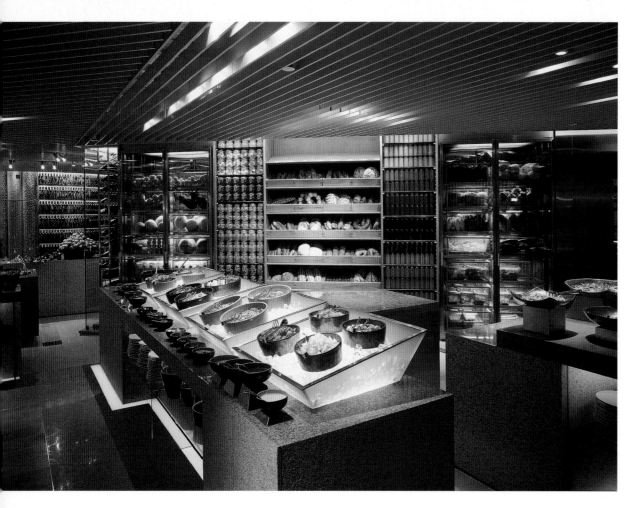

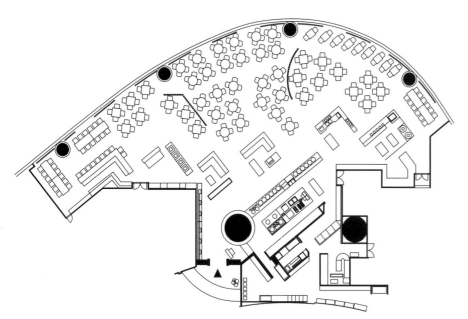

ABOVE

Food is always on display in Café TOO. Lit from below, glass boxes set into stone counters hold iced dishes of prepared foods. Beyond, wood shelves display breads and teas.

LEFT

Seating is concentrated near the curved glass wall overlooking the garden. Throughout the open plan are island-like open kitchens with buffet counters.

RIGHT

A dropped ceiling and stone floor define the space of one of the seven open kitchens, with displays of food and spices on the counters and walls creating a colorful contrast.

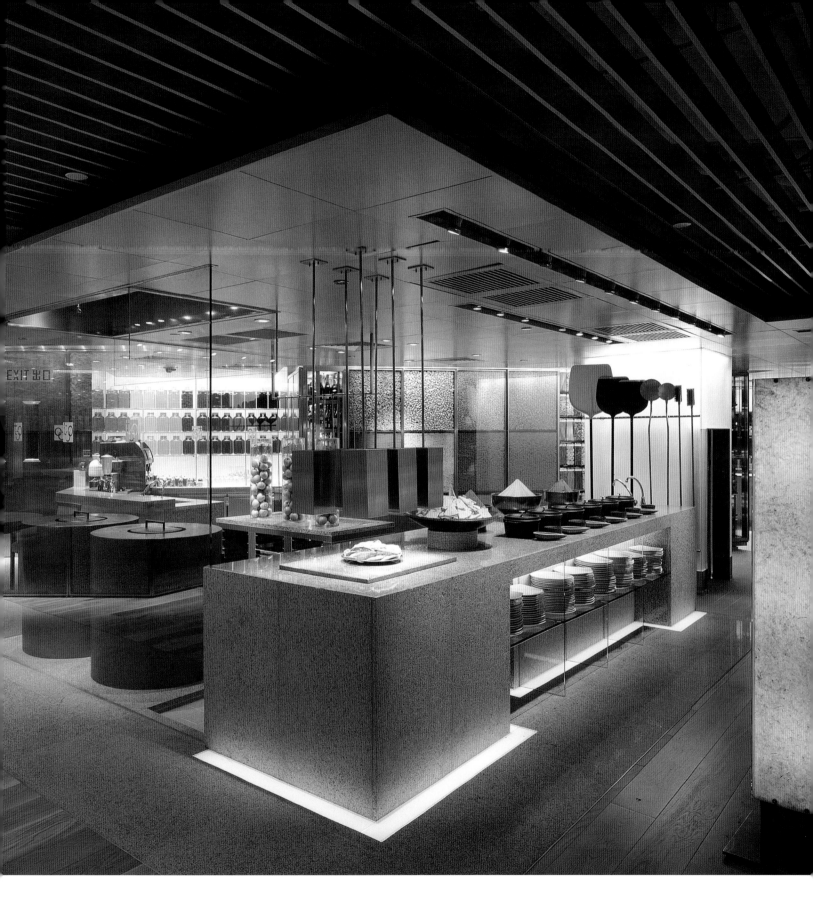

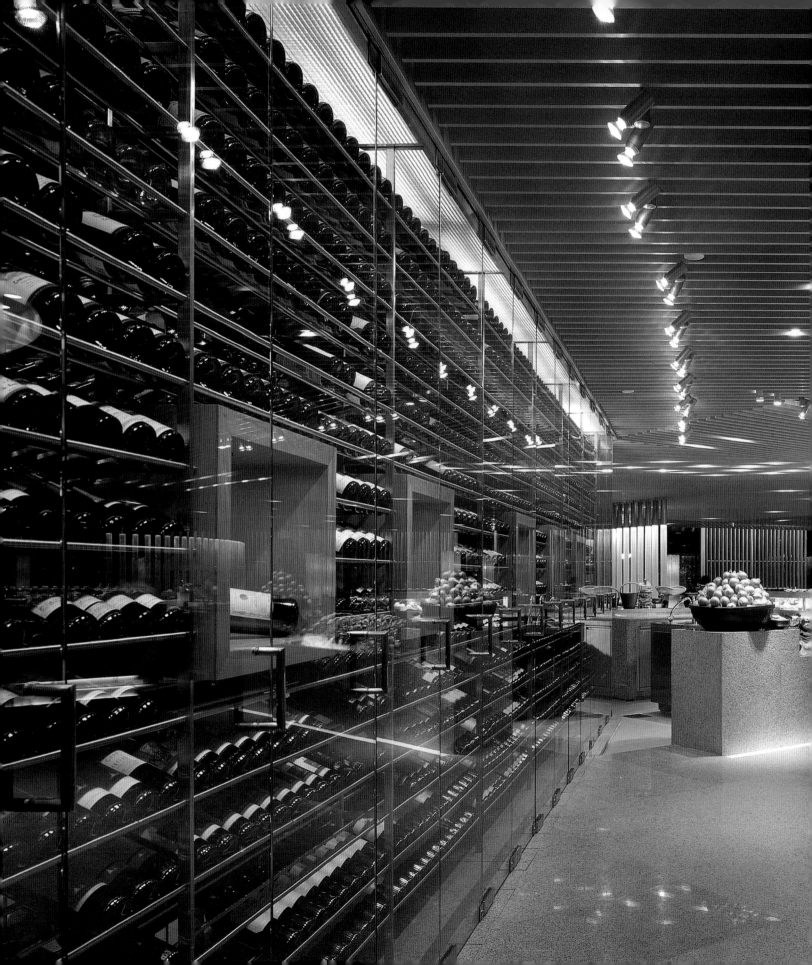

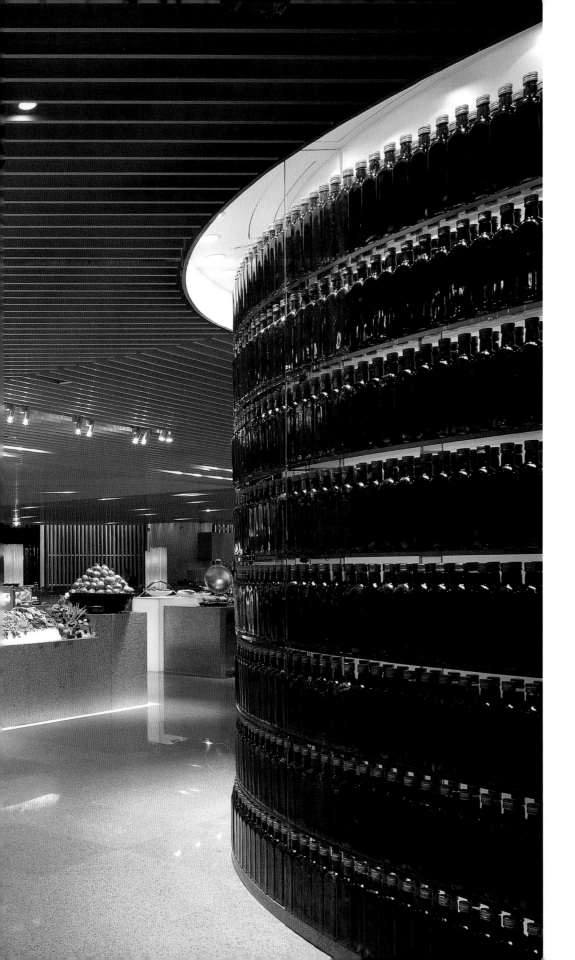

LEFT

From the entry area, the space of the restaurant is slowly — and dramatically — revealed between the glass-encased wine cellar and the curving glass shelves holding hundreds of bottles.

Hibiki

Restaurant / Marunouchi, Tokyo / 2001

Hibiki restaurant, in the busy Tokyo commercial center of Marunouchi, is marked simply by a sign with the name of the restaurant in Roman letters. The simplicity continues inside the restaurant, where the design focus is on stone and light. The stone represents ideas of the past, and light signifies the future – other materials are rendered expressionless. The rough stone is understood to have existed over a long period of time and connects to the past. Yet the mark of the human hand, where the stone has been cut and polished, speaks of the present. The combination of stone and glowing translucent panels – materials that are at once familiar and new – gives a sense of the future and an occasion to reconsider the meaning of the materials and the design.

The main space features a bar and a central open kitchen. Heavy blocks of rough stone define both areas and support polished stone countertops or are themselves precisely cut and polished to form counters. The rough stone also serves as a base for glass cases filled with fresh vegetables and other ingredients. Translucent panels hide the kitchen ventilation hoods; and columns, covered with mirrors, seem to disappear. The bright colors of the vegetables draw the eye to the kitchen area and maintain the emphasis on food.

LEFT

The entrance is marked simply by the name of the restaurant and opens up to a long view past the reception counter to the space of the central glass-encased kitchen.

RIGHT

Two heavy pieces of granite anchor the corner of the polished stone counters, which have seating looking onto the activity of the stainless steel and glass kitchen.

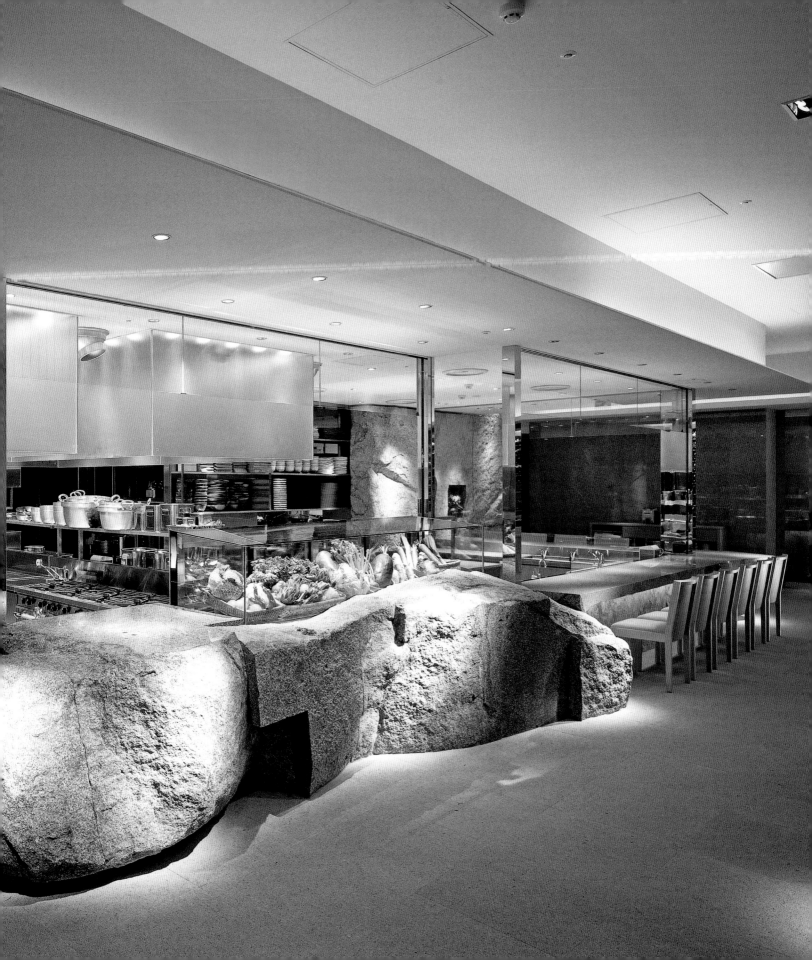

The building structure is carefully hidden to emphasize the weight and power of the stone. Columns are wrapped in translucent acrylic panels and softly lit from within, like glowing pillars of light rising from the wood and stone floors. Some walls are covered with stone and serve as a backdrop to the dining space, while other walls are covered with back-lit translucent panels, seemingly liberated from the attributes of solidity.

A large private room next to the main dining area is separated only by racks of wine bottles encased in glass: a wall, yet not a wall. Small private rooms are more secluded and contrast with the open feel of the main dining space. Walls are covered with mud plaster or rough handmade *washi* paper, and traditional low *horigotatsu*-style tables have openings in the floor allow customers to sit comfortably. Both the private and open dining spaces achieve Super Potato's goal to create a place for communication, with a tie to nature in the use of natural materials yet with the understanding of the mark of the human hand, with materials that speak of the past yet point toward the future.

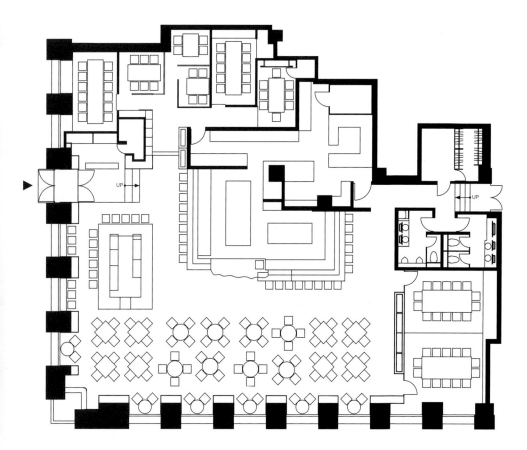

ABOVE

Back-lit translucent panels frame the space of the windows, creating an atmosphere of calm and serenity in contrast to the bustling activity of the street beyond.

LEFT

Private dining rooms are tucked away at the edges of the floor plan, with the open kitchen and bar as the central focus from the entrance and the dining area.

RIGHT

A glass wall separates the glowing glass and stone bar from the stone steps at the entrance. Glass shelves hung from metal rods float above the thick glass counter of the bar.

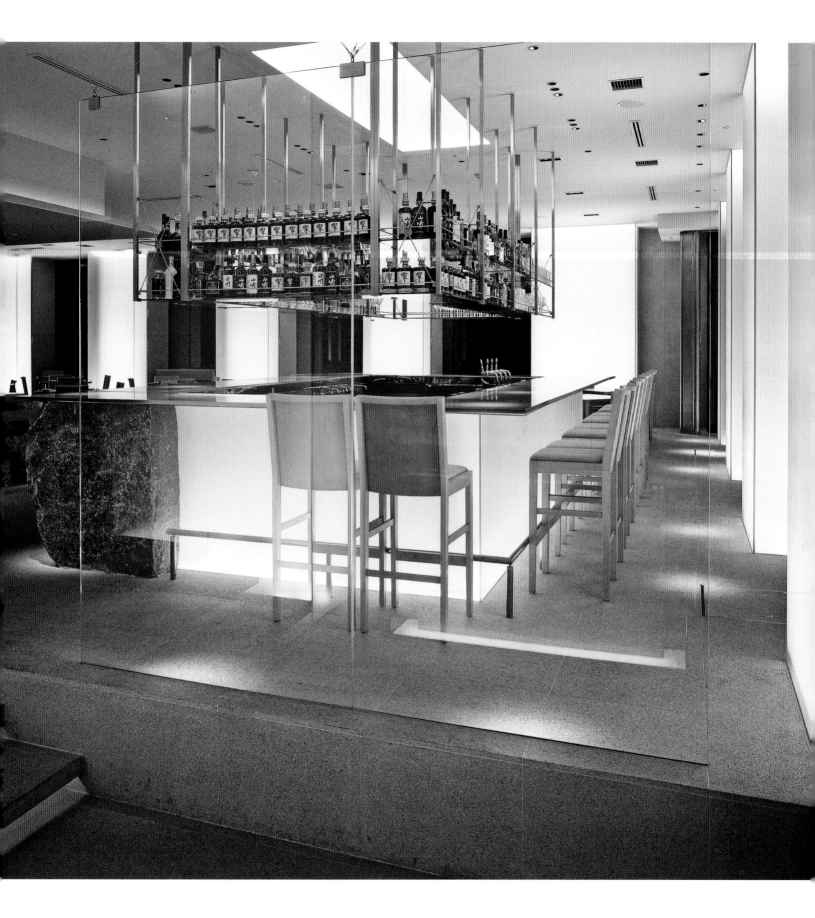

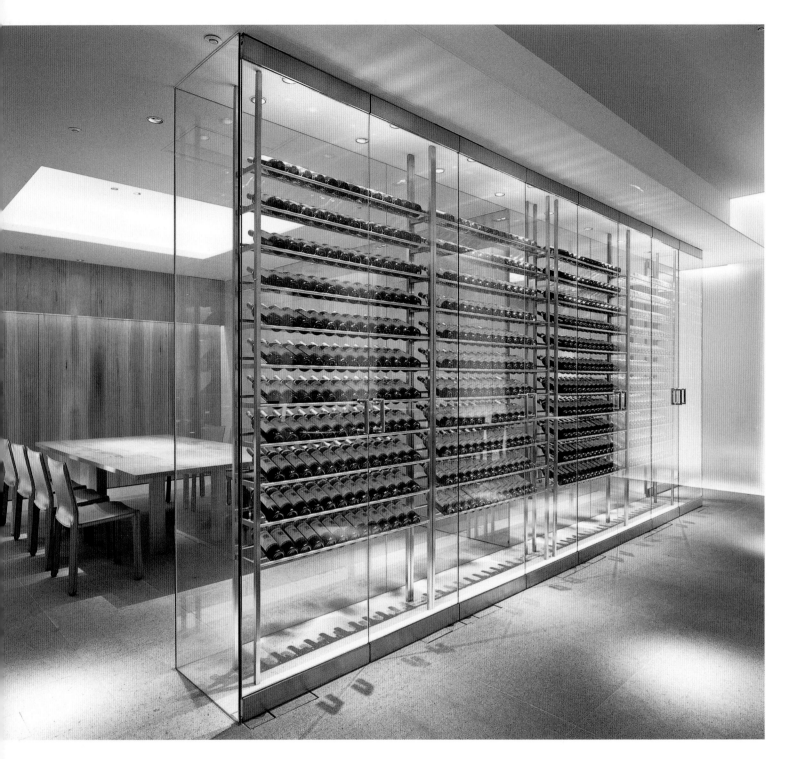

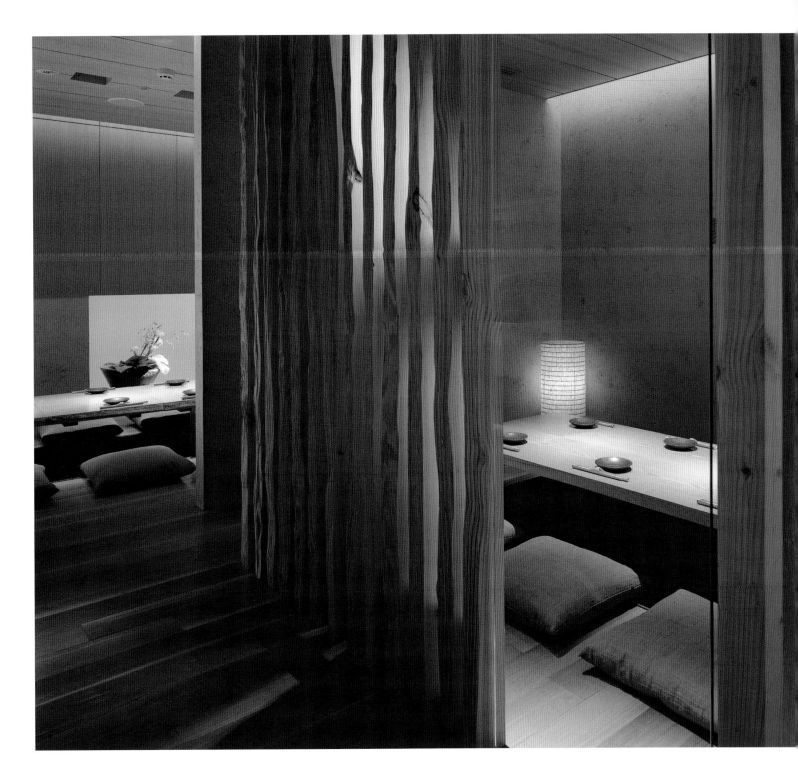

Rough wood louvers separate small private dining rooms, with soft lighting and simple wood tables with *horigotatsu*-style seating, from the main restaurant space.

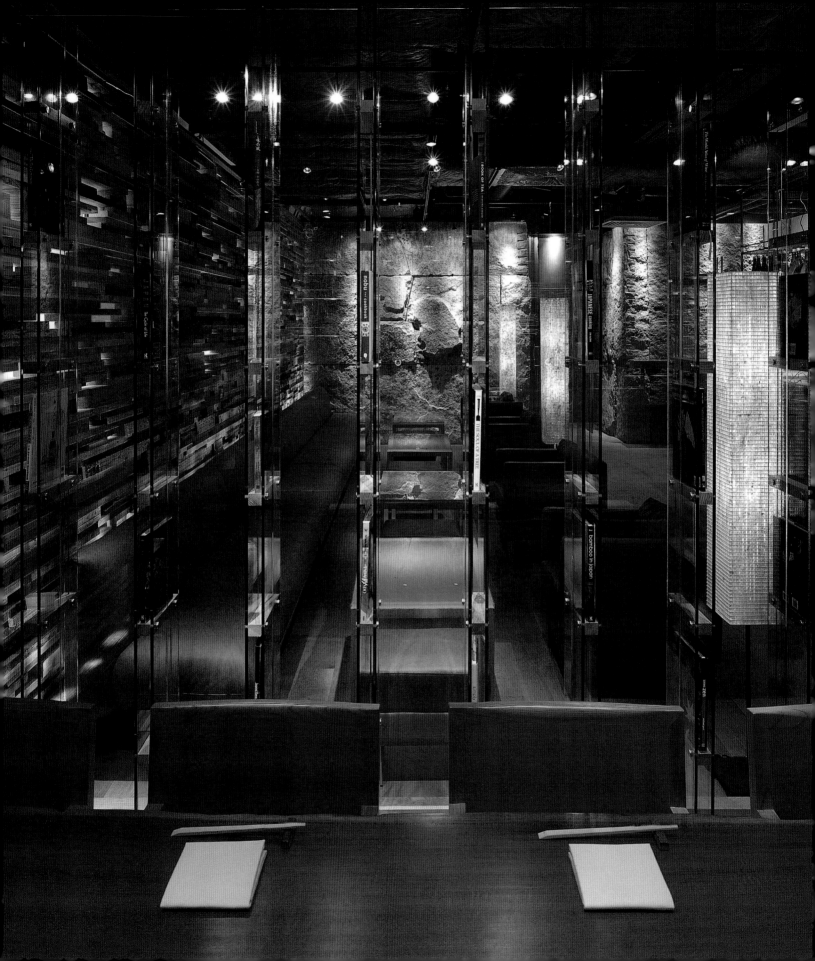

Zuma
Restaurant / London / 2002

Chef Rainer Becker describes Zuma as a "destination restaurant" with a "surprise factor." Although the restaurant is located directly across the street from the famous Harrod's department store in a bustling neighborhood of downtown London, the entrance is concealed on a quiet back street, provoking an impression of discovery. It was precisely the desire to create a surprise, the introduction of a different kind of contemporary restaurant design suggestive of a new local identity for London, which led Becker to Super Potato. Takashi Sugimoto describes this new identity "like smoke rising," subtle but apparent. The subtlety starts at the entrance. The heavy wood door, set into a wall of glass, opens into a reception area marked by a counter of smooth stone and glass, which allows a peek into the adjacent bar area and the restaurant beyond. Materials and lighting shift slightly from space to space, giving each area a distinct yet complementary ambience. Only the stone floor and exposed ceiling, painted a dark gray to disappear overhead, are continuous. First in view is the space of the bar, outlined by heavy blocks of roughly hewn stone interspersed with luminous panels of translucent glass and supporting a delicate, thin glass countertop. Glass shelves suspended from the ceiling are lined with hundreds of bottles of *saké* from all over Japan.

To one side of the bar counter is a lounge area with low tables and comfortable seats, defined by

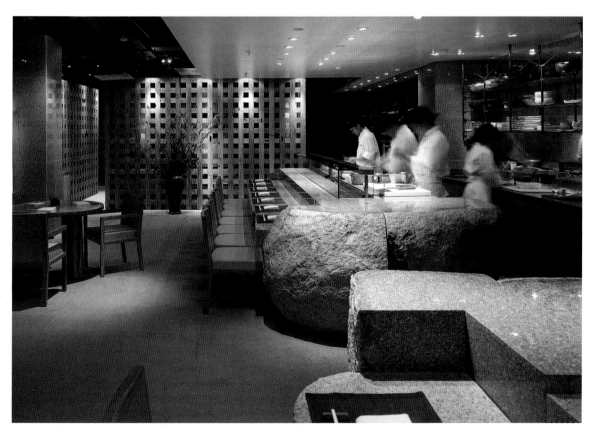

OPPOSITE

Books sandwiched between translucent panels divide the dining space and the lounge, with its solid wall of heavy stone and light wall composed of pieces of salvaged wood.

LEFT

Large blocks of granite, some roughly textured, others polished to a smooth finish, define the area of the open kitchen. Counter seating provides close views of the kitchen activity.

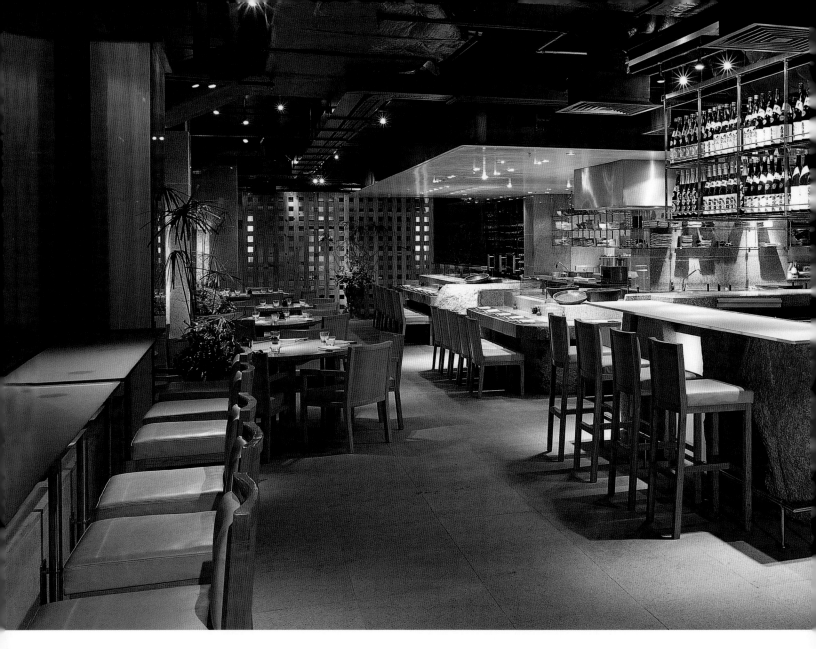

one wall of heavy stone and another of wood slats placed in front of a glass wall. Pieces of previously used wood, laid one atop another with gaps in between, create a lively composition while allowing glimpses through to a small outside garden. The wood slat wall is continuous from the lounge area to the dining room. The division between the two spaces is merely implied by means of an almost invisible book rack fabricated from metal cables and transparent acrylic panels.

The dining space surrounds the open kitchen, distinguished by thick stone counters set on heavy stone bases and a dropped ceiling dotted with downlights. The perimeter of the kitchen is further delineated by glass cases full of seafood on ice,

large earthenware bowls filled with fresh vegetables, and stacks of ceramic dishes in various shapes, sizes, and colors. The colors and shapes of the food and dishes draw the eye to the activity of the kitchen. Wood chairs from Bali line the counter for a close view of the action in the kitchen, while circular wood tables and chairs fill the dining room. The warm glow of paper floor lamps accentuates the space and complements a luminous wall of handmade paper sandwiched between glass. A thick wood lattice screen at the back of the dining area separates two private rooms from the main restaurant. The screen provides another discreet contrast within the rough yet refined character – the subtle identity – of the restaurant.

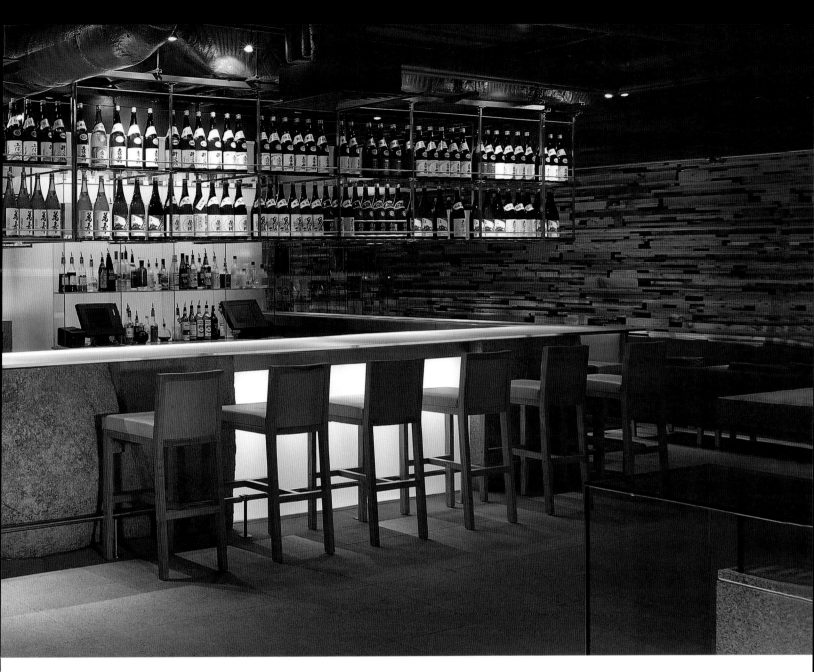

ABOVE

Varied wall textures and ceiling treatments delineate different spaces within the open plan, allowing both a sense of intimacy and a connection to the whole space.

LEFT

The entrance opens into the bar and adjacent lounge area. Counter seating borders two open kitchens, with the main dining area at one side and private rooms tucked away in the back.

The Grand Chapel
Grand Hyatt Hotel / Roppongi, Tokyo / 2003

Part of the extensive Roppongi Hills complex, the Grand Hyatt Hotel Tokyo is integrated into the complex, yet stands alone as a self-contained building. With a strong history of designing interiors for Hyatt hotels, Super Potato was retained to design the chapel, Shinto shrine, fitness center and spa, and two restaurants. Super Potato's designs, which are contemporary in feel but draw from traditional Japanese ideas, help to foster the hotel's international atmosphere.

For Super Potato's first chapel design, Takashi Sugimoto studied many European churches as well as churches in Japan designed by Tadao Ando. Influenced most by one of Le Corbusier's early churches, Sugimoto appreciated its simplicity and the way natural light entered the space from above. During the two-year design period for the chapel – a much longer time than is typical for interiors – Sugimoto worked to make the chapel seem as "undesigned" as possible, including only what was necessary and nothing more.

Sugimoto collaborated with the building designers to create enough height for the tall, angled ceiling, and his design emphasizes the height through the use of materials and light. The walls, which taper inward slightly as they move toward the altar, are covered with shifting slats of wood, oriented vertically and left with a slightly rough finish. Wooden slats also form the ceiling which hovers over the space. Simple wood benches rest on the slightly textured stone floors. Three boxy wood podiums mark the altar, with a floor of the same stone, located one step above the main floor level. A simple, thin metal cross hangs overhead. The space of the chapel angles gently toward the altar and then pushes back and away, creating an opening at the highest point between the walls and ceiling where light enters, just above the altar. Light comes through mostly at this highest point but also seeps around the edges of the ceiling. It washes down the wood slat walls, emphasizing the three-dimensionality of the wall surfaces with the play of light and shadow in the dramatic space.

BELOW

The floor plan (above) shows the angled walls of the chapel surrounded by service spaces. The section (below) highlights the changing height from the low entry to the altar.

RIGHT

Accentuated by the angled walls and ceiling faced with vertical wood slats, the space of the chapel soars dramatically upward to a glowing aperture above the hanging cross.

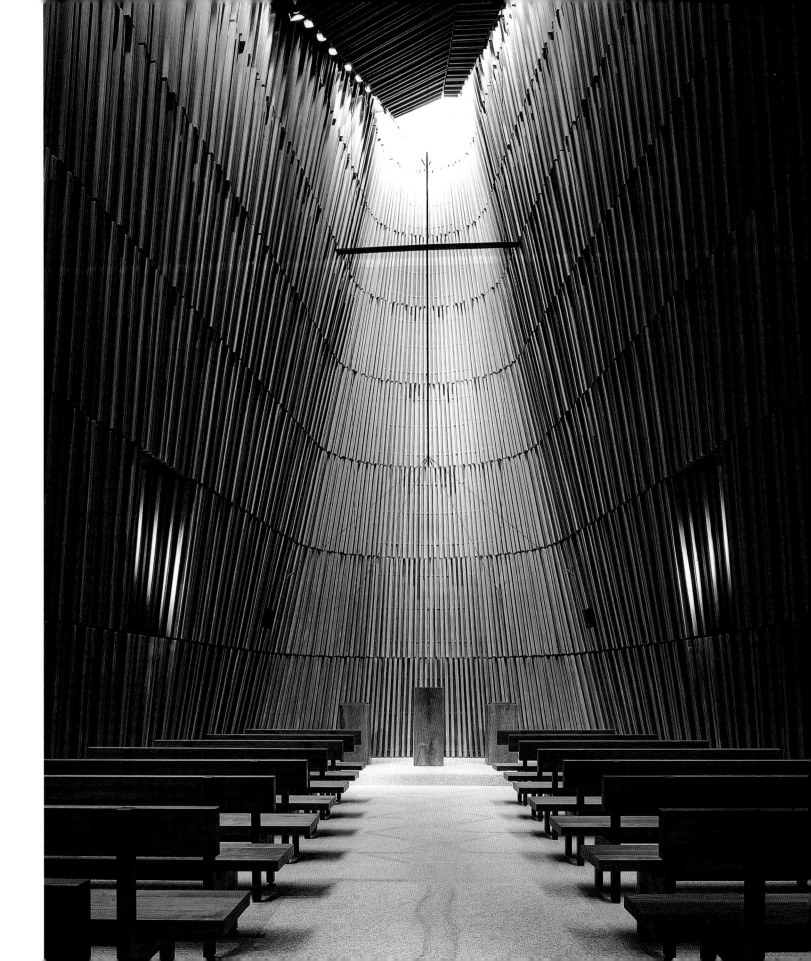

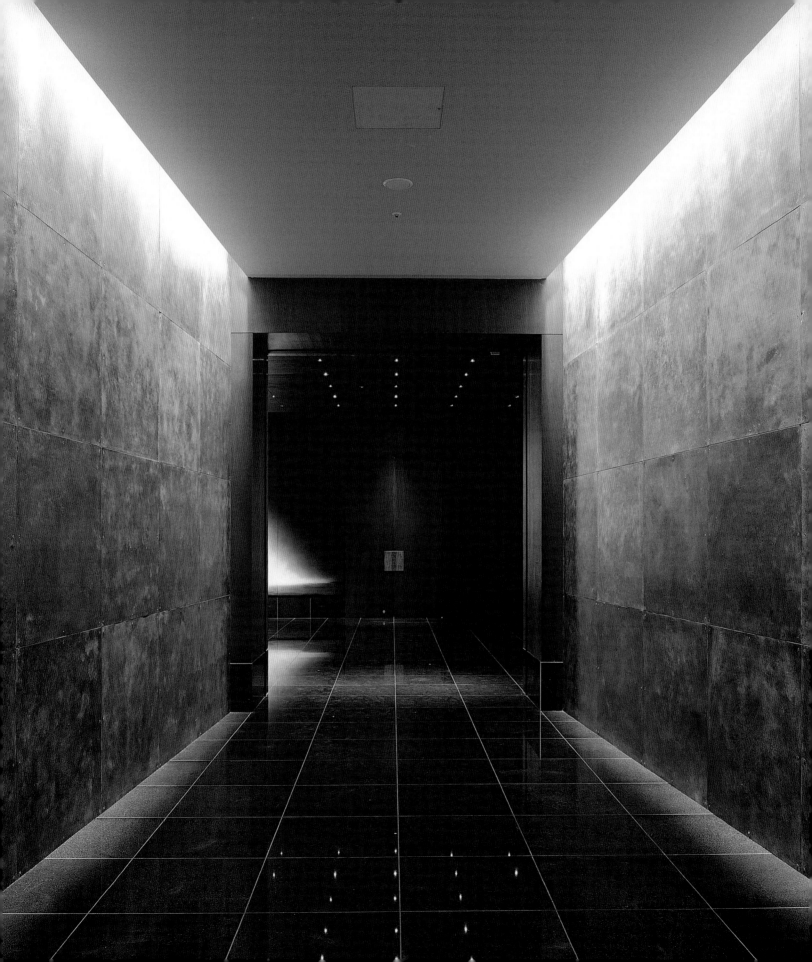

The Shinto Shrine
Grand Hyatt Hotel / Roppongi, Tokyo / 2003

Carefully choreographed as a vivid and striking
sequence of three distinctly textured spaces, the
Shinto shrine in the Grand Hyatt Tokyo Hotel is
a compelling composition of darkness and light.
Used primarily for the traditional Shinto wedding
ceremony, the spaces are by no means traditional
in the typical sense but retain a feeling of tradition
while being wholly contemporary. Each space leads
into the next with a high sense of drama but also
with a strong sense of human scale.

The sequence begins as a passage through a
shadowy tunnel-like space with dark stone floors.
The walls are covered with panels of bronze, with
a distressed texture, as if they had been left out
of doors to weather naturally. Light comes from
reveals between the ceiling, walls, and floor, giving
the ceiling and walls the appearance of floating
planes. The tunnel leads into a dark waiting room.
The walls are covered with atmospheric paintings
of misty waterfalls, done in white on black, by
the artist Hiroshi Senju. The faint light from tiny
ceiling lamps picks up the streaks of white in the
paintings, giving the room a mysterious glow.

Two large doors open from the dark anteroom
into the unexpectedly vibrant main chamber, which
at first appears to be made of wood and glass and
brightly lit with natural light. In actuality, the room
is a lattice shell of beautifully finished cypress
wood, which is pulled away from the lime plaster
walls and ceiling. Lights set into the back side of
the cypress timbers reflect off the walls and ceil-
ing, giving the room an intense glow as if sun-lit.
Wide wood planks line the floor and lead the eye
to the altar: a thin cypress table backed by glow-
ing strips of acrylic louvers. The top-lit acrylic
louvers run vertically from floor to ceiling and
are transparent except for their thin edges, which
are sanded to a rough finish that reflects the light
and creates their luminous appearance.

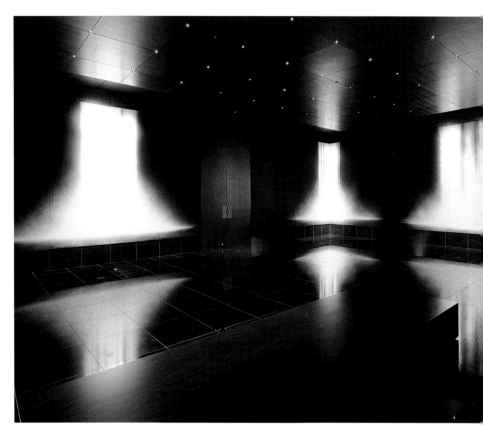

OPPOSITE

The uneven finish of the
bronze wall panels in the
entrance tunnel seems
to absorb the light. The
joints in the polished
stone floor lead the eye
into the dimly lit waiting
space.

ABOVE

Careful lighting accentu-
ates the mist-like quality
of Hiroshi Senju's mag-
nificent wall paintings,
which reflect clearly in
the smoothly polished
stone waiting room
floor. Tiny lamps set in-
to the corners of the
ceiling panels glow like
stars overhead.

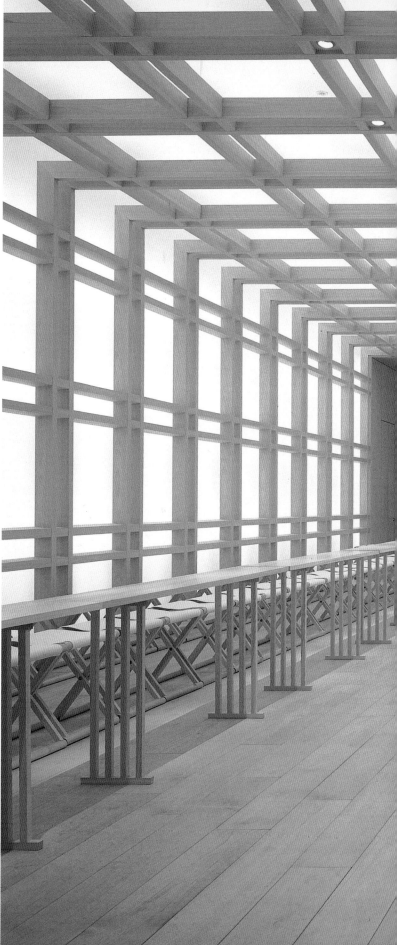

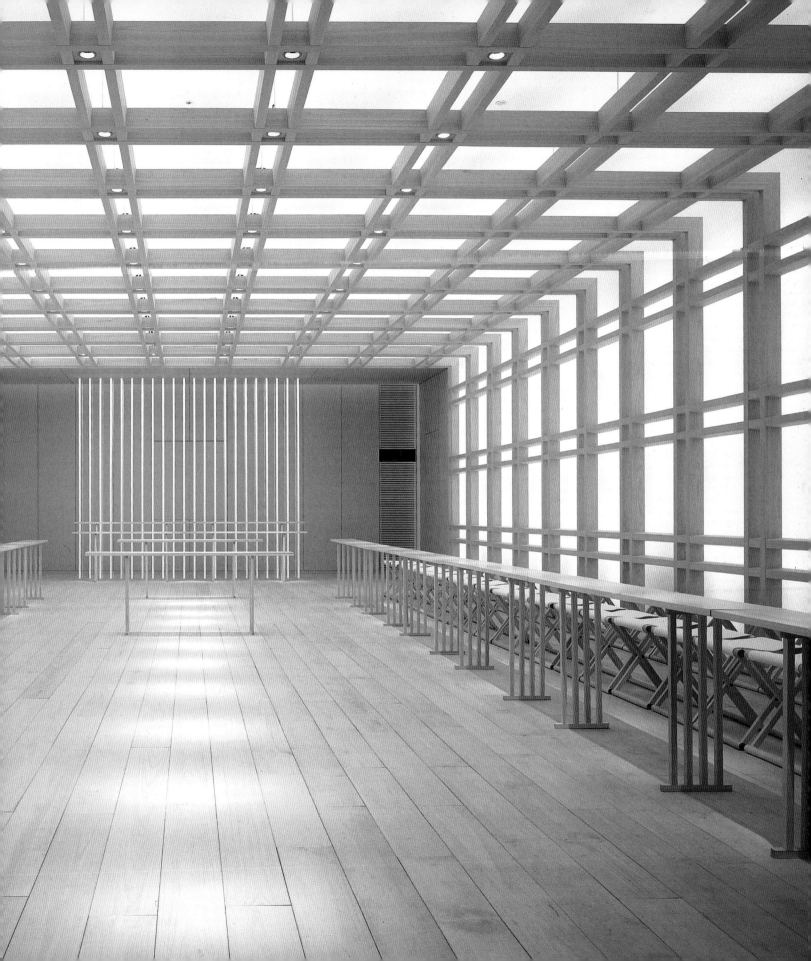

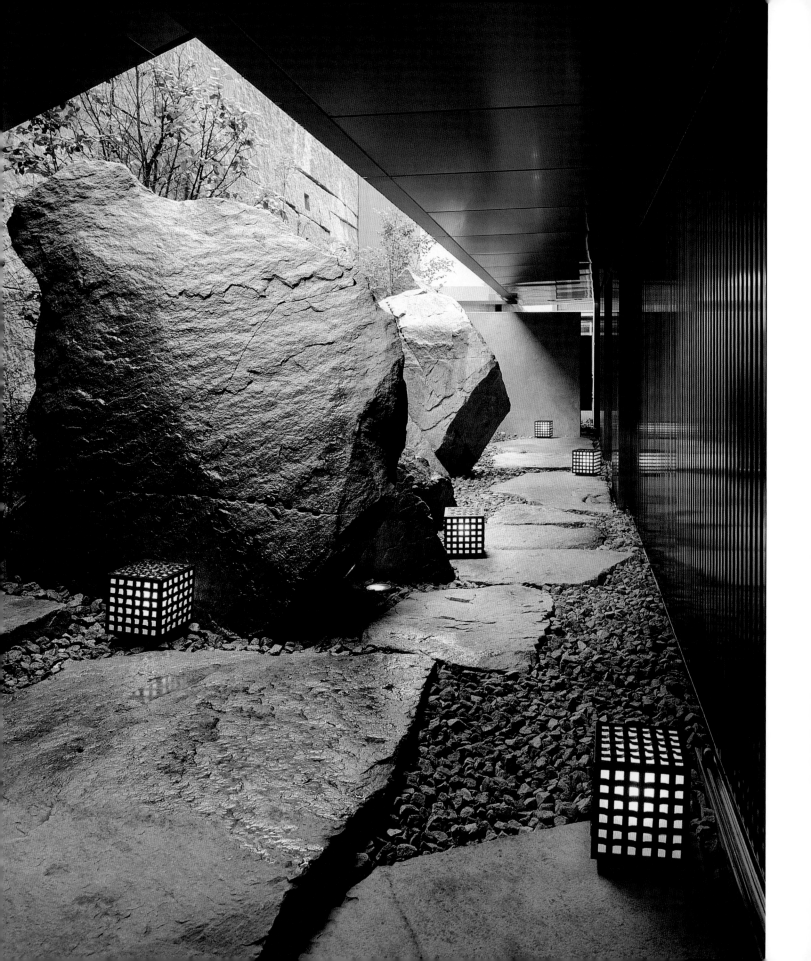

Shunbou

Restaurant / Grand Hyatt Hotel / Roppongi, Tokyo / 2003

Moving from the main hotel space out into the sixth-floor restaurant area, which connects the Grand Hyatt Tokyo Hotel to the West Walk of the Roppongi Hills complex, the ambience changes. The restrained elegance of the hotel gives way to an active yet peaceful semi-outdoor space. A wide stone passageway runs between glass walls, affording views into and through Shunbou and Roku Roku, the restaurants designed by Super Potato. Stone is used extensively in both projects. It all comes from one quarry in Shikoku Island, excavated and cut slowly over a three-year period. It is unusual for an interior designer to have so much lead-time in a project, and Takashi Sugimoto doubts that he will ever be able to repeat such an undertaking. The abundant use of stone is employed as a means to eliminate superficial "information" at a close scale. This superficial visual information would block the ability to understand the totality of the design, and to invoke the feeling of implied rather than actual physical information.

Shunbou is the larger of the two restaurants, and its design greatly emphasizes the power and weight of the stone. The open "show kitchen" is surrounded by a heavy stone counter, and the walls are made of a combination of rough stone and glass. The floor is covered with stone, left roughly finished except for a circle of polished stone surrounding the small glass-enclosed courtyard garden. Seating is provided at the counters or at simple wood tables spread throughout the space. Several small private rooms, with walls covered with textured mud plaster or handmade paper, offer traditional seating on *tatami* mats.

Separated from the main restaurant space by a tight courtyard defined by enormous stones, four private rooms focus views on the courtyard. Heavy wood tables and simple chairs take center stage in the spaces, and floors are covered with *tatami* mats or wood. Floating ceiling planes are made of wood planks interspersed with stainless steel ribs, and walls are surfaced with finely finished mud plaster, creating a strong connection to tradition.

OPPOSITE

Enormous slabs of stone create a path next to rough over-scaled masses of stone in the narrow courtyard between the main restaurant space and the separate private dining area.

ABOVE

A private room with a low table and seating in *horigotatsu* style has a view onto the courtyard. Vertical wood louvers contrast with the horizontal slats of the paper *shoji* screens.

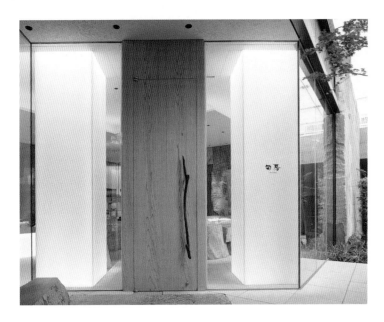

ABOVE

The tall wood entry door with a branch-like handle stands out from the sleek glass wall of the restaurant and the glowing translucent glass wrapping two structural columns.

RIGHT

The open kitchen is defined by a dropped ceiling, thick stone counters, and a back wall composed of rough stone. A small glassed-in courtyard brings nature and light into the restaurant.

BELOW

A narrow corridor leads from the hotel and divides Roku Roku (page 182), in the shaded area on the left, and Shunbou. Shunbou's stone courtyard and separate private dining spaces are on the lower right.

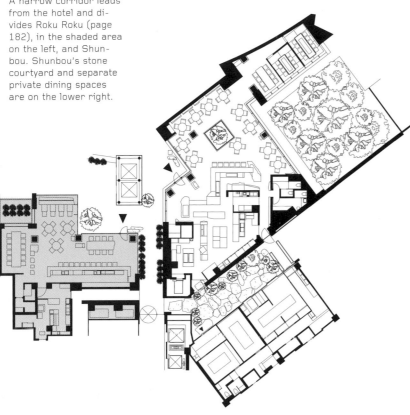

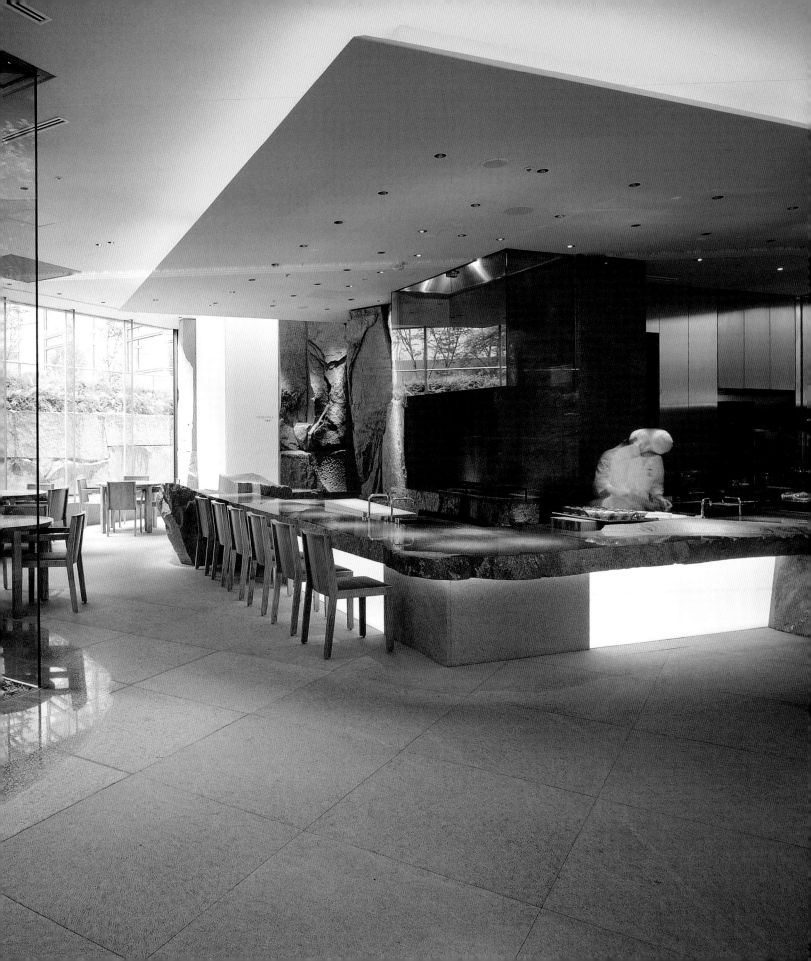

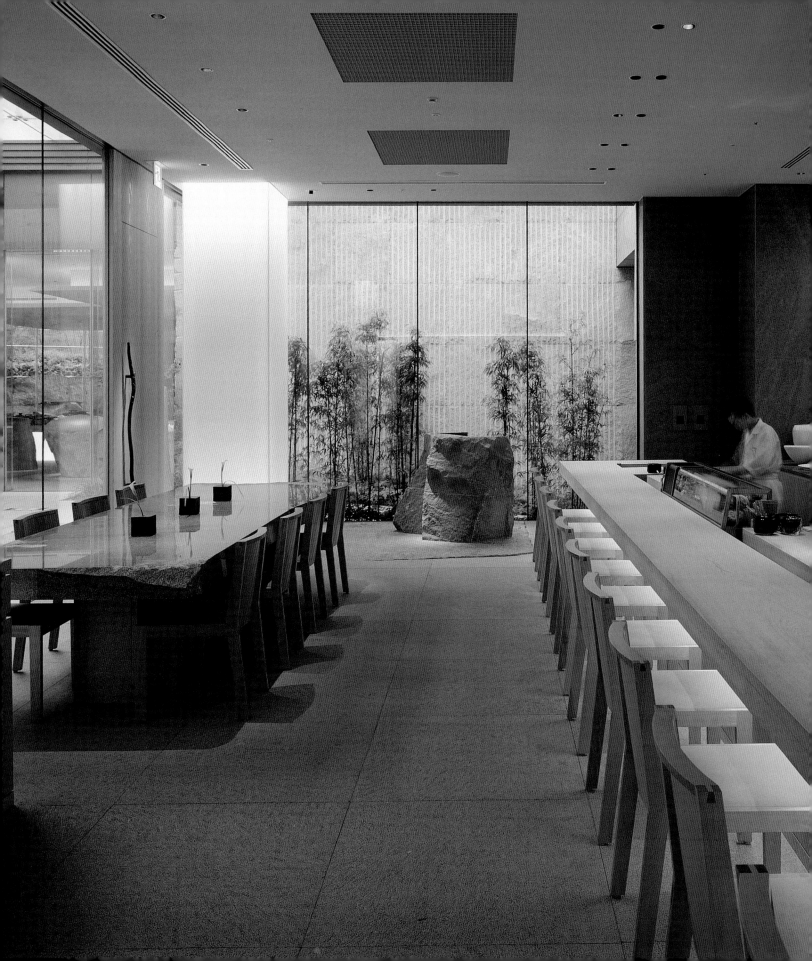

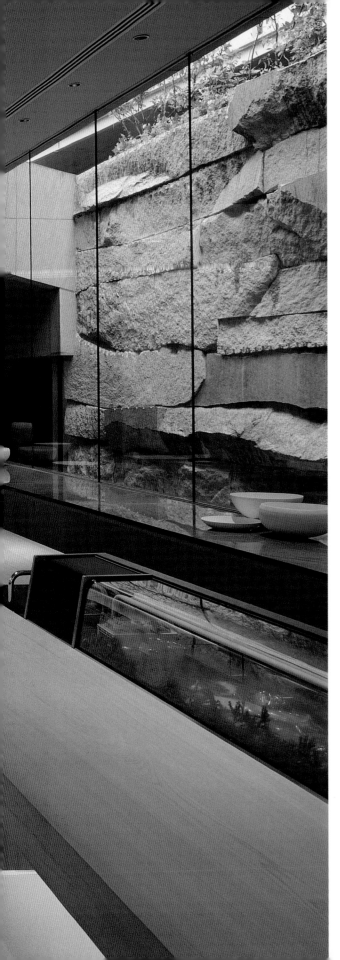

Roku Roku
Restaurant / Grand Hyatt Hotel / Roppongi, Tokyo / 2003

LEFT

A stunning composition of stone, wood, and glass, Roku Roku features seating at a sleek wood sushi counter facing a massive wall of unevenly stacked slabs of rough and polished granite.

The smaller Roku Roku restaurant at the Grand Hyatt Hotel Tokyo features sushi on its menu. The ingredients are part of the design, carefully laid out on beds of ice in glass cases behind the wood counter. The seating is planned to afford specific views of the interior space of the restaurant and beyond. From a seat at the sushi counter, the view is through a vast wall of glass out to a carefully constructed wall of enormous blocks of stone, reminiscent, at first glance, of Japanese castle foundation walls. Careful observation reveals a combination of polished and roughly hewn stones, some showing the drill marks from the quarry – Super Potato's way of reminding us of the information possessed by the stone. Other seats have views through the high glass walls that separate the restaurant from the outside courtyard space. A private room features heavy wood tables and chairs, a bronze sculpture that contrasts with both the handmade *washi* paper on the walls and a glowing back-lit glass wall.

Takashi Sugimoto's concept for the design of the restaurant, similar to that of Shunbou, was to give a material quality to space through the use of light. Light from outside enters through the large expanses of glass used to separate the interior space from the exterior and picks up the texture of the stone on the floor and walls. Pillars of light glow softly through translucent panels covering structural columns, giving visual emphasis and material contrast within the space.

Nagomi
Spa and fitness center / Grand Hyatt Hotel /
Roppongi, Tokyo / 2003

Entering into the space of the Nagomi spa and
fitness center at the Grand Hyatt Tokyo Hotel is
like leaving the outside world behind and enter-
ing a peaceful world of soft forms, cool diffuse
light, and gentle reflections. The space flows, punc-
tuated intermittently with objects made of stone
or wood – familiar materials used as sculptural yet
functional counters and benches. Wide wood stairs
at the entrance move past a silent wall of granite,
the rough finish striated with smooth vertical cuts,
to a wide wooden walk leading to the reception
area. The darkened space of the pool is visible
through a plain glass wall. There the floor surface
changes to cool black granite, which also lines the
entire pool, providing a very subtle transition from
stone to water. The jetted tub, set within a perfect
circle of glowing translucent glass, slightly over-
laps the space of the pool. Its white light produces
a softly glowing reflection on the ceiling. Pairs of
tiny spotlights reflect in the surface of the pool
like a small constellation of stars.

The upper-level fitness room, just visible from
the pool deck, is approached by a simple staircase.
The room is more functional than atmospheric but
is also finely detailed. Wood-paneled walls, an alu-
minum grid ceiling, and wide plank wood floors
define the space.

On the lower level, adjacent to the pool area,
are the spa treatment rooms, designed with diffuse
light and a serene ambience. Various rooms are
available for different types of spa treatments, but
all feature natural materials and refined detailing.
Stone floors, wood walls, teak furniture – even a
bathtub carved out of stone – combine with gentle
lighting to give a refined quality to the carefully
designed spaces.

ABOVE

A small foyer leads to
the reception space with
a diagonal view of the
pool and jetted bath.
Changing rooms and
treatment rooms line the
outer walls. The fitness
area is one floor above,
overlooking the pool.

RIGHT

The luminous jetted
bath, composed of two
perfect circles with their
centers offset, hovers
between the wood plank
floor and the black
granite-lined pool. Star-
like ceiling lights cluster
over the reception area.

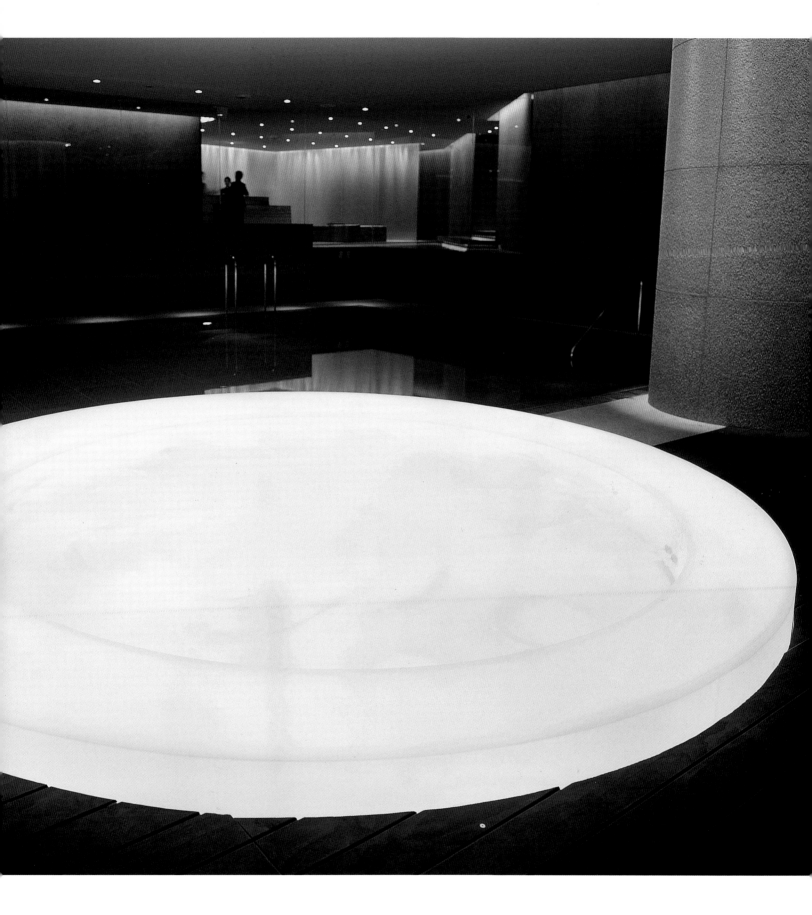

Waketokuyama
Restaurant / Minami Azabu, Tokyo / 2004

A long-time customer of the well-respected Japa-
nese restaurant Waketokuyama, Takashi Sugimoto
enjoys the simply prepared dishes, which do not
try to be unusual or out of the ordinary except
for using only the finest quality ingredients. When
asked by the chef, Hiromitsu Nozaki, to design
his new restaurant, Takashi Sugimoto resolved to
make his design similar to the food prepared at
the restaurant: straightforward and familiar yet
contemporary, using only the best materials.

To design the structure and the important
street front façade of the building, Super Potato
chose to collaborate with the well-known architect
Kengo Kuma. Sited between a long street and a
park in the fashionably cosmopolitan Tokyo neigh-
borhood of Nishi Azabu, the building site provid-
ed an opportunity to address the neighborhood.
The headlights of cars driving by at night formed
blurred lines across the site. This gave the design-
ers the idea of creating a building which expresses
the movement of the street and exposes its inner
workings to the neighborhood, yet feels enclosed
and protected. The result is a façade that appears
to be pierced with many holes, with light both
entering from outside and emanating from inside.
Perforated concrete louvers set into a steel frame
form a screen of horizontal stripes in front of the

OPPOSITE

The interior stair hugs
the outer glass wall
along the front façade,
which reveals glimpses
of the street and the
sky through the exterior
screen of precast perfo-
rated concrete louvers.

LEFT

Designed by architect
Kengo Kuma, the perfo-
rated concrete louvers
float in front of the
street façade and pull
away from the building
to create a protected
entrance area.

BELOW

The section drawing
is cut through the en-
trance and stairs, show-
ing the vertical wood
louvers which run the
full height of the space
and separate the stair
from the dining areas.

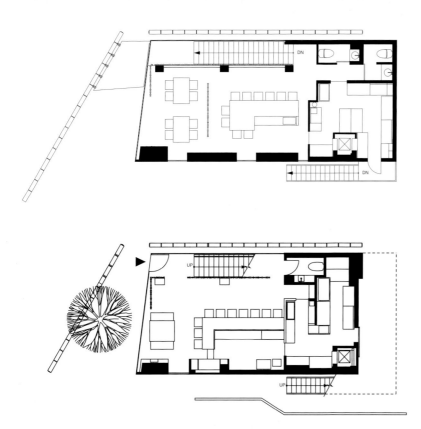

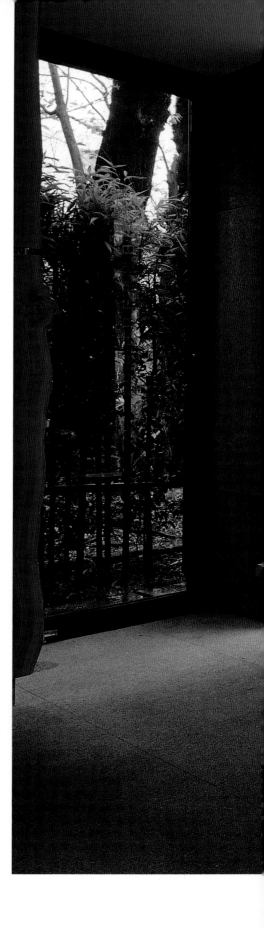

restaurant's two-story glass façade. The louvered screen continues beyond the glass enclosure of the building, extending the feeling of movement while delineating an outdoor stone terrace. A second, shorter screen is set at an angle to the first, signifying the entrance to the restaurant.

Entering the restaurant, the space is characterized by the contrast between the weight of thick walls covered with rough mud plaster and the lightness of thin vertical wood louvers used to further control the light and views through the front façade. The plaster walls, in warm shades of deep orange with a scattering of pottery shards for added texture, are pierced by tall windows looking out to the rear garden. The windows are set back in the wall to reveal its thickness. Stone floors and simple wood counters and chairs finish out the palette of natural materials. Two structural columns, encased in mirrored glass, seem to disappear in the space.

Close to the entry, a staircase leads to the upper floor, where tables and chairs are set up between dividers made of previously used wood. The views through the openings in the plaster wall and the glass side wall reveal the lush greenery of the adjacent park, while the headlamps of cars passing by create moments of softly glowing light.

ABOVE

The seating areas on both floors are pushed to the back corner, opposite the kitchens and bathrooms, to take advantage of the views of the patio and the lush greenery of the rear garden.

RIGHT

Thin wood louvers and expansive glass walls give a feeling of lightness in contrast to the mass and weight of the stone walls and the floor, which continues outside to create a small patio.

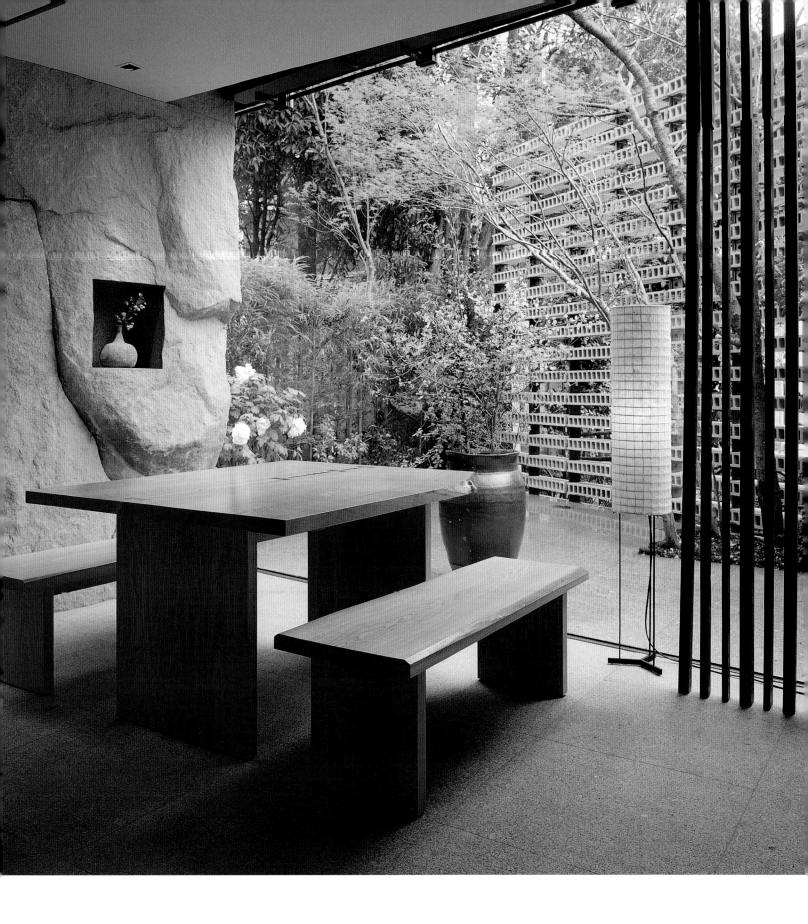

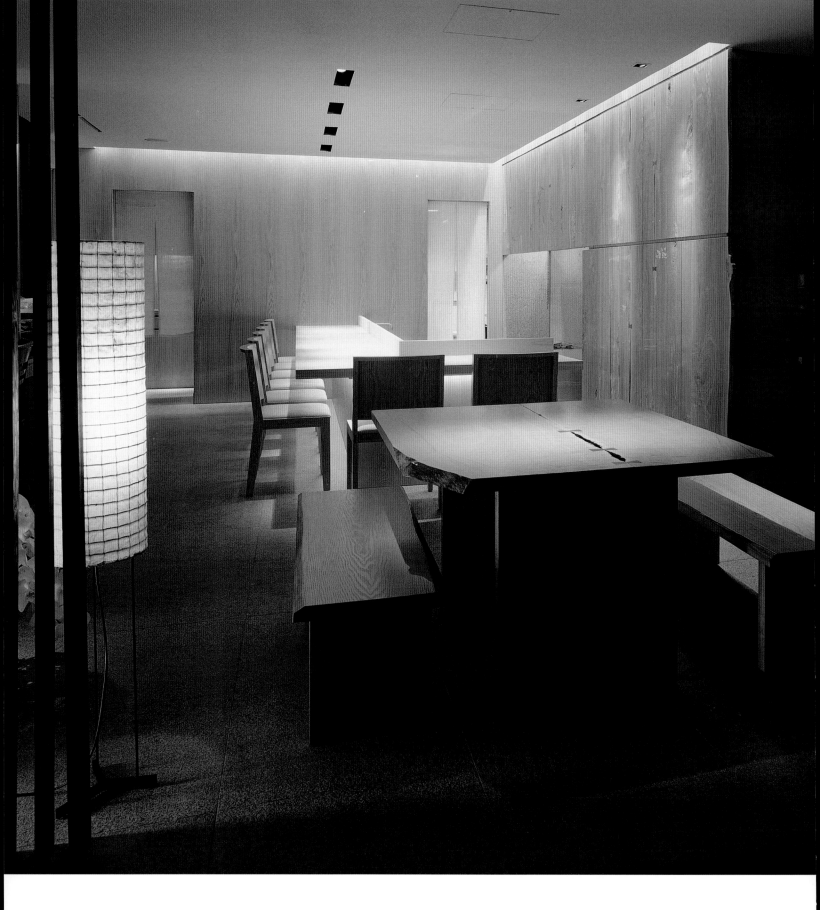

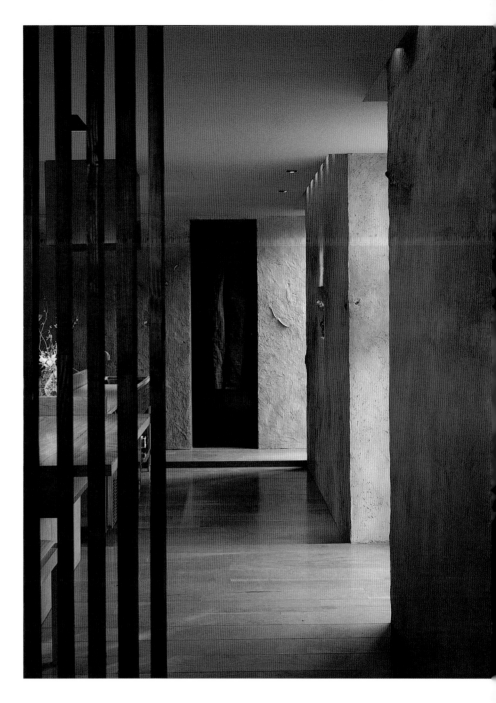

LEFT

Wood is juxtaposed with stone in the first-floor dining area. A single table and counter seating for ten create a place for people to easily talk with one another and with the chef.

ABOVE

Thin vertical slats of salvaged wood and thick walls covered with mud plaster inset with pottery shards alternate with tall windows to define the dining area on the upper level.

Roka and Shochu Lounge
Restaurant and bar / London / 2004

On a corner site in a busy London neighborhood, Roka's quiet façade – broken only by a niche displaying the menu and the beautifully figured wood door – gives only a suggestion of the rich spaces and varied materials within the restaurant. The cool gray of brushed metal panels alternates with large openings filled with glass, offering views in and out of the restaurant. In warm weather, the glass walls open up, tables and chairs spill out from the restaurant onto the sidewalk, and the boundary between the inside of the restaurant and the city is blurred.

The clean lines and pure forms of the exterior continue in the open space of the interior. Here, the simplicity – of the counter wrapping the open kitchen in the center of the space, of the translucent glass hood floating over the *robata* grill, of the sturdy wood tables spread throughout the restaurant, of the wall planes washed gently with warm light – is accented by careful detailing, a great variety of textures, and subtle changes in material and color. Wood, stone, paper, and glass are used in innovative ways and surprising combinations, which alter the way they typically are understood and gives them new meaning. The naturally rippled edge of the wood counter wrapping the open kitchen contrasts with the precision

RIGHT

Jars of fruit in *shochu* dot a wall of salvaged wood. Thick sheets of handmade Japanese paper sandwiched in glass are back-lit to reveal the pattern of the fibers, much like the grain of wood.

BELOW

A tall panel of beautifully figured wood marks the entry and contrasts with the sleek glass and metal of the façade. In the summer, the glass opens to connect the restaurant to the street.

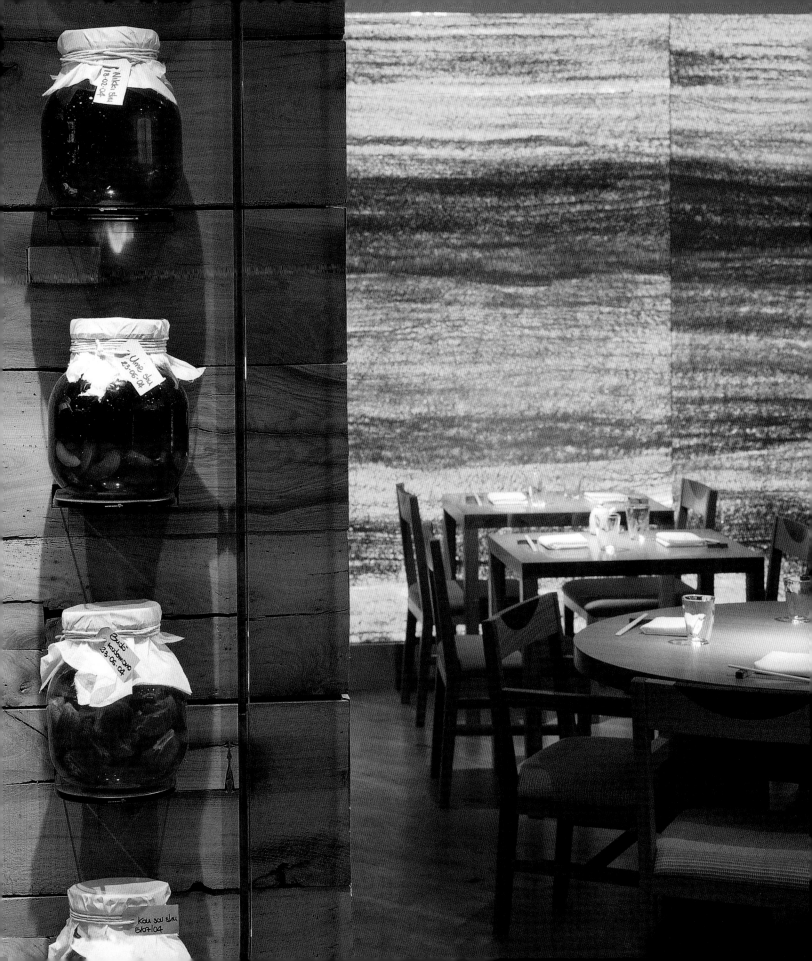

The counter that wraps the open kitchen is crafted from thick planks of a magnificent 270-year-old elm. The story of its life is revealed in its undulating rings and burled knots.

RIGHT

Adjoining a wall of sal-
vaged wood, strips of
thick, brightly colored
paper – stacked from
floor to ceiling with
edges aligned slightly
imperfectly – create
a wall that catches
the light.

BELOW

In the open restaurant
space, the thick gnarled
wood counter surrounds
the central *robata* grill,
with the ingredients
displayed in baskets
and ceramic dishes
on the stone counter.

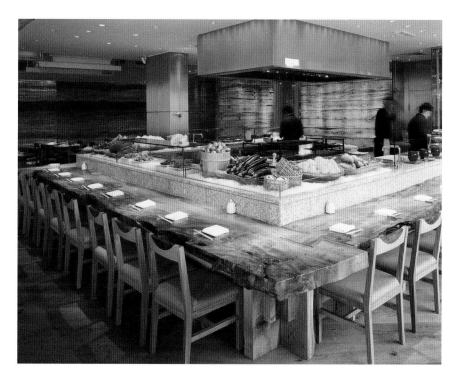

of the inset butterfly joints. Stacked thick oak planks from an abandoned church create a heavy wall, its weight tempered by simple glass shelves holding multiple jars filled with various fruits in liquor – the popular Japanese *shochu* – a hint of what is waiting below.

The stair to the Shochu Lounge has rough mud plaster walls and floors of wide wood planks leading to the shadowy basement bar. The plaster walls continue into the lower space, at times punctuated by inset copper panels resplendent with rivets and at others giving way to a textured collage of old tools and barrels from a defunct Japanese *shochu* brewery or wood shelves full of jars of the specialty drink. The center of the space is defined by the thick dark wood counters of the bar. Soft lighting slowly exposes the depth of the space, accentuated by shots of color in two lounge areas – colorfully upholstered chairs in the larger lounge, two steps above the rest of the space, and a surprising wall of stacked strips of bright red fabric in the smaller lounge, dramatically lit to display the layers and reminiscent of the stacked paper wall upstairs.

The open *robata* grill is
the focus of the restau-
rant (above), with tables
around the edges of the
space. The stair leads
to the central bar of the
Shochu Lounge (below),
with two seating areas.

The dark wood bar
counter, furniture, and
floors create a quiet
atmosphere in the
Shochu Lounge. A wall
composed of pieces of
used barrels and tools
from a *shochu* brewery
gives texture to the bar
space. Beyond the bar,
mud plaster walls define
a raised seating area.

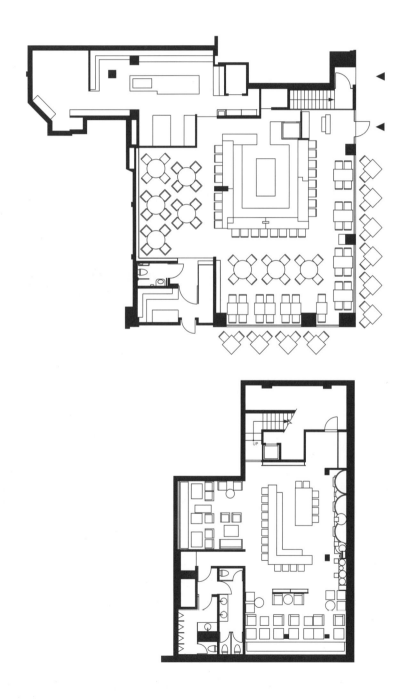

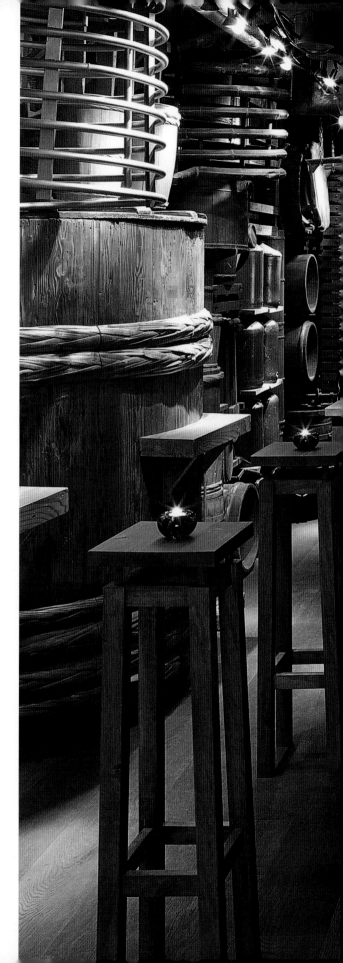

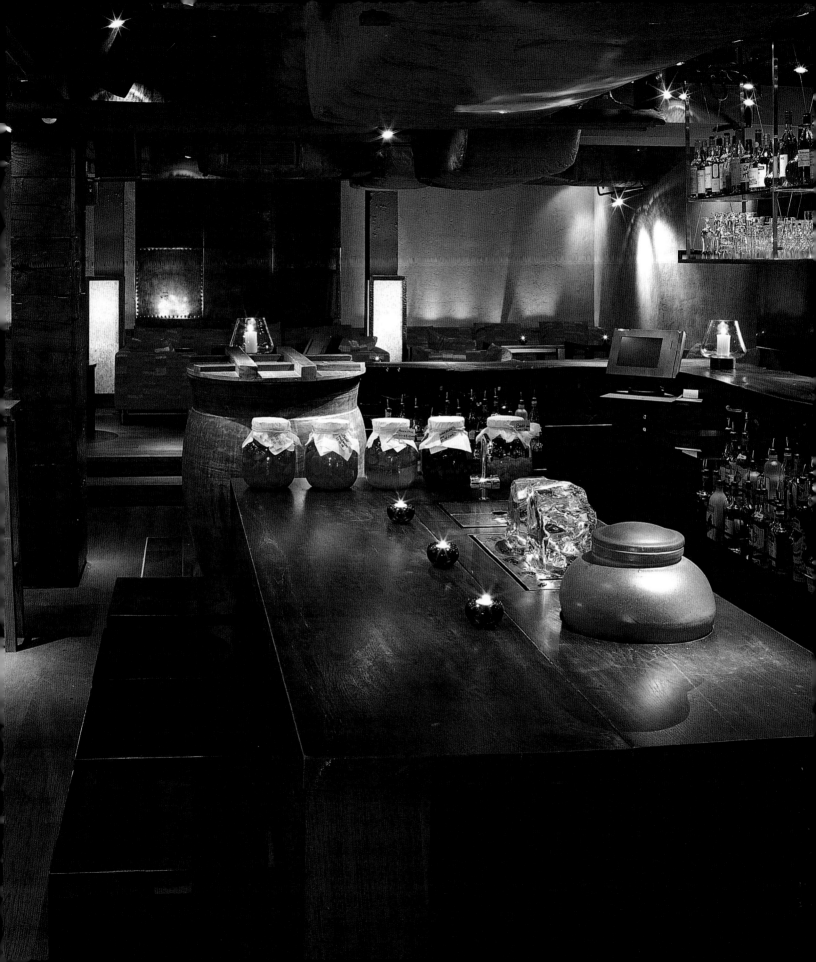

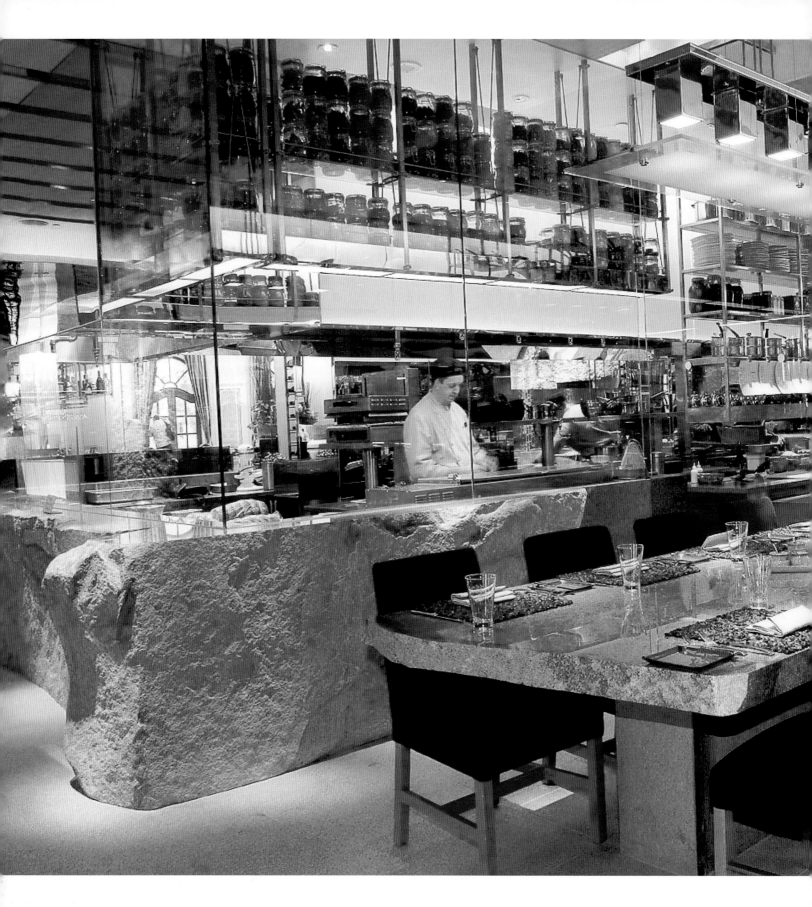

Sensi

Restaurant / Bellagio Hotel / Las Vegas / 2004

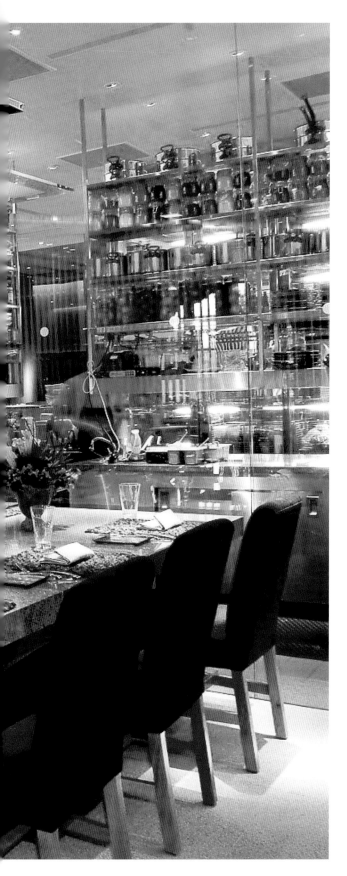

Delineating the space of the open kitchen, massive slabs of rough stone rest heavily on the floor, juxtaposed with hanging glass shelves filled with jars of colorful ingredients.

The name of the restaurant glows brightly from within the cascading wall of water. The tall wood doors beyond mark the entry, and the glass walls give clear views into the restaurant.

Moving from the main lobby of the Bellagio Hotel to the annex, the richly appointed and classically styled interior suddenly gives way to a wall of briskly flowing water framed by gleaming stainless steel. The name "Sensi" glows brightly, floating in the middle of the cascade. The surprising sight and sound entice people to touch the water, but the simple power of the waterfall gives only a slight suggestion of the rich complexity of the restaurant just around the corner.

The restaurant meets the classic interior of the hotel boldly yet subtly with a variety of materials. The waterfall wall yields to an impressive wall of stone. Enormous pieces of Japanese granite are stacked from floor to ceiling, creating a strong texture that contrasts sharply with the adjoining curved glass wall at the entrance. Tall sheets of glass follow the curve of the annex lobby, interrupted only by two enormous wooden doors. The curved glass wall terminates at a glowing square column, wrapped with back-lit translucent glass and capped with stainless steel. A second column marks the outside corner of the restaurant, and between the two is another cascade – water flowing gently over a massive polished stone. The low waterfall is open above and marks the bar area inside the restaurant, creating a clever physical barrier that allows visual access from the lobby. The waterfall wraps around the corner and ends

OPPOSITE

The main dining area is set off by many textures: the rough stone of the pizza oven, the thin wood louvers which offer glimpses outside, and the floating wood panels of the ceiling.

BELOW

A private table, one of two chef's tables which look into the "show" kitchens, is surrounded by activity – glass shelves full of various foods and tanks of live seafood.

RIGHT

The plan shows how the different spaces are slowly revealed. The entry leads first to the corner bar and then the central open kitchens, with the main seating area and corner pastry kitchen beyond, the booths at one side, and the large private rooms in the back.

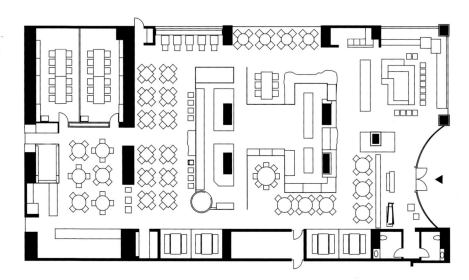

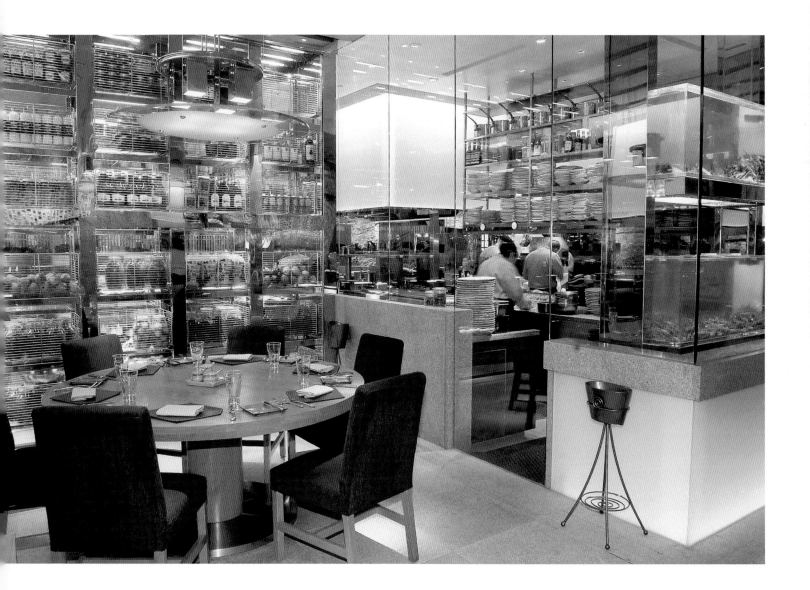

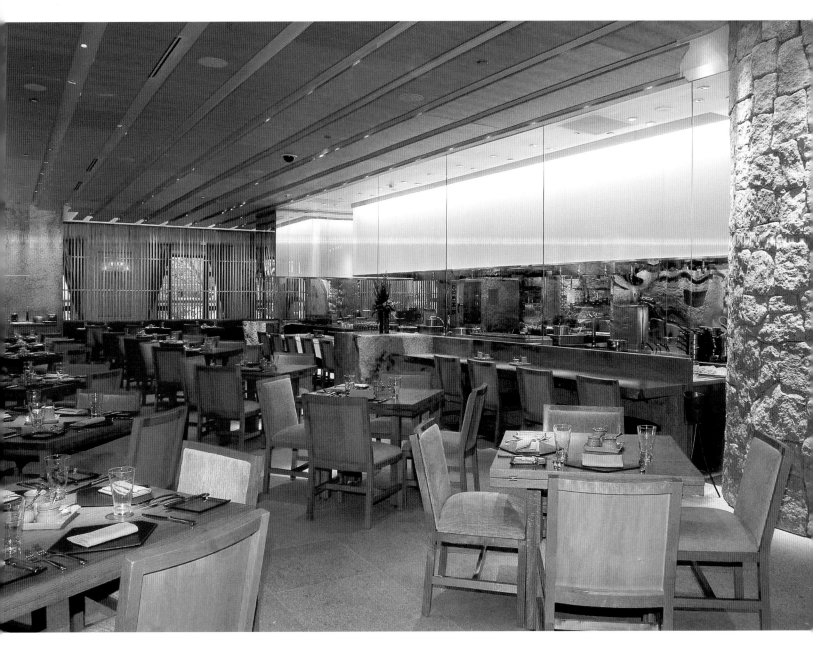

in another wall of stacked stone – partly rough and partly polished in a clever play of textures.

The interior of Sensi reflects the subtle yet bold combination of materials. Thin counters of translucent glass, heavy walls of rough stone, floating wood lattice ceilings, gleaming glass shelves full of jars of colorful preserved foods or bottles of liquor, walls paneled in warm-hued wood, solid stone counters with smoothly finished tops – these elements define different spaces yet work together to create a unified ambience.

The "show" kitchens, placed back-to-back in the center of the restaurant, provide a lively focal point and are surrounded by a variety of dining areas. Counter seating gives a frontline outlook on the culinary action, while dining areas filled with wood tables offer views through the restaurant and glimpses back out into the hotel. Softly lit booths, placed one step above the level of the main dining room, offer an intimate atmosphere. Private rooms tucked away behind the main dining area give customers a chance to experience the changing scenery of Sensi as they move through the varied spaces of the restaurant. The views and materials seem to be constantly in flux and yet somehow always in balance. Not unlike the city of Las Vegas itself, Sensi offers both a quiet intimate escape and a dynamic piece of the action.

Lobby and Lounge
Park Hyatt Hotel / Seoul / 2005

At night, the sleek faceted glass façade of the Park Hyatt Seoul Hotel, crowned by a band of white light from the lobby and lounge on the top floor, is dotted with the yellowish glow of the lights in the guest rooms. At street level, large sculptural boulders of rough Japanese *aji* granite break through the glass front wall, bringing the space of the street into the sparsely furnished gallery-like entrance area. High-speed elevators whisk customers to the 24th floor reception lobby, where the serenely composed museum ambience continues.

Every space in the hotel, each surface and object, is carefully considered to create a tranquil yet intriguing composition. The attention to detail, a hallmark of Super Potato's work, is clearly evident in this project, the largest that the firm has done to date. Super Potato designed every interior

LEFT

Located on an oddly shaped corner site, the hotel takes advantage of the configuration of the property, emphasizing the various angles with a faceted tower of glass and steel.

RIGHT

A sculptural ceiling of folded planes accented with blue lights defines the ground-level lobby. Sheer walls of glass interrupted by massive granite boulders mark the street entrance.

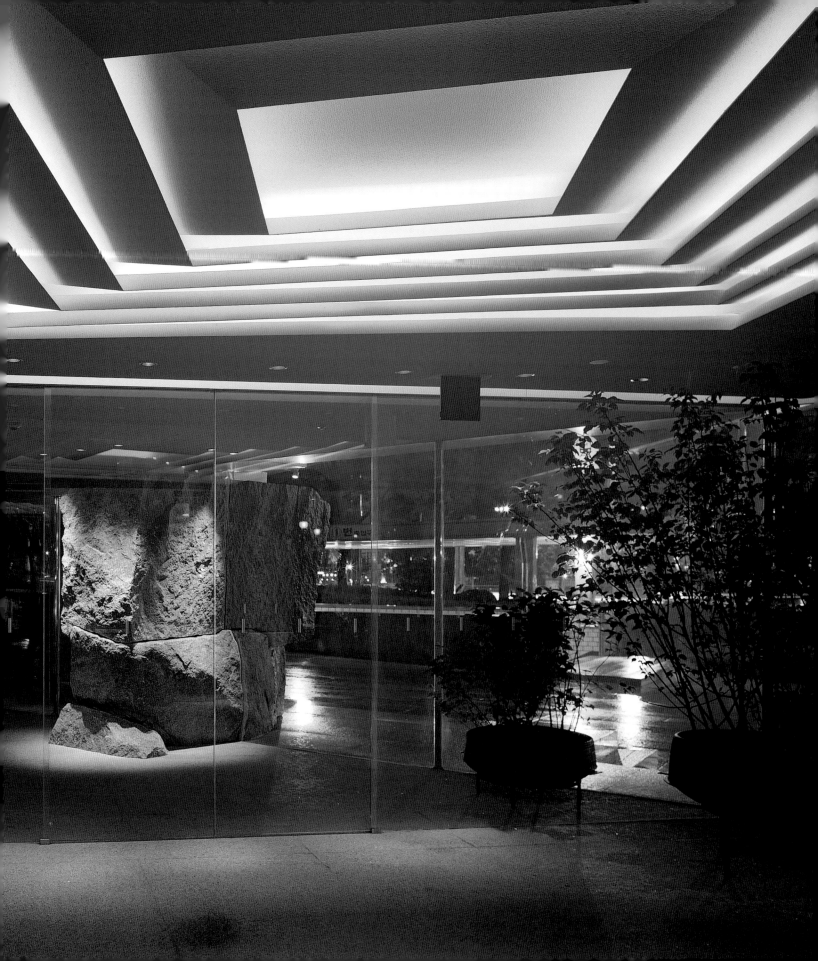

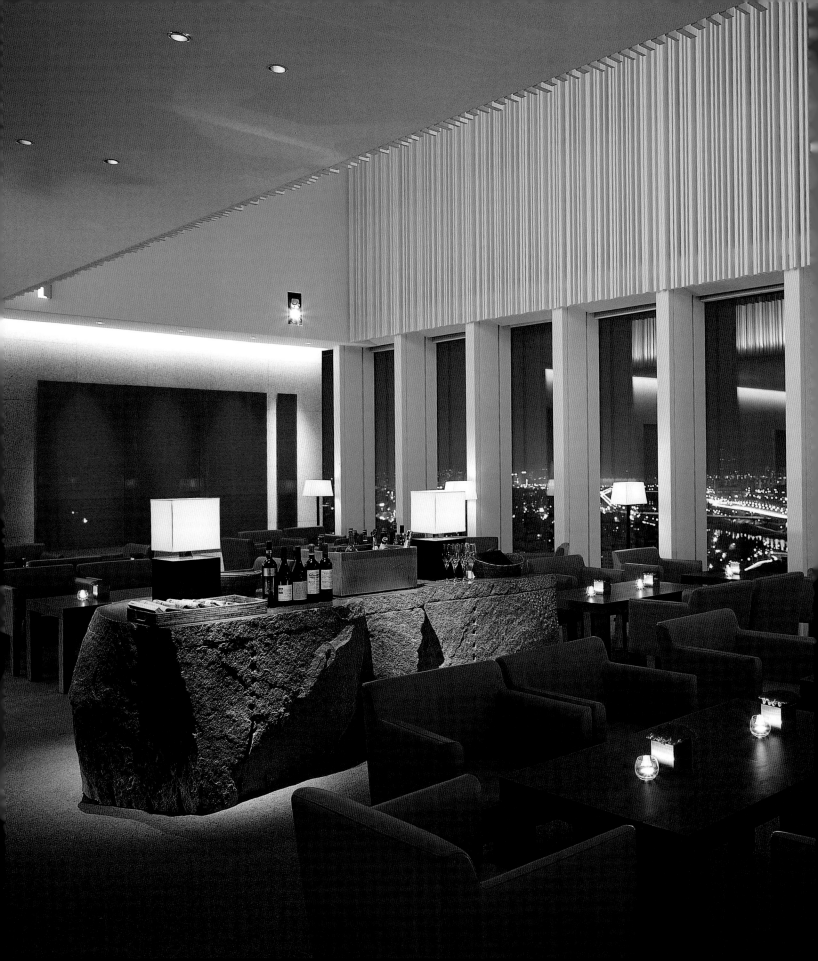

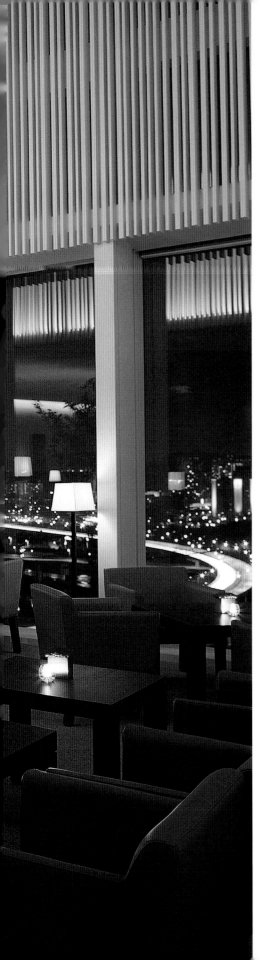

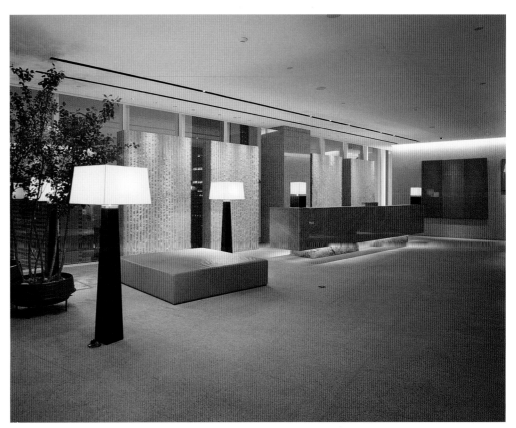

LEFT

Twenty-four stories above the ground, the massive stone bar, comfortable seating, and soothing lighting of the Lounge offer a relaxing place to contemplate the metropolis of Seoul.

ABOVE

The simple bold geometry of the reception desk, seating, and floor lamps is softened by gentle lighting. Large stone panels in front of the glass wall give a sense of enclosure.

BELOW

The elevators open into the sparsely furnished reception area, which connects to the lounge space, with views through glass walls to the swimming pool and the city below.

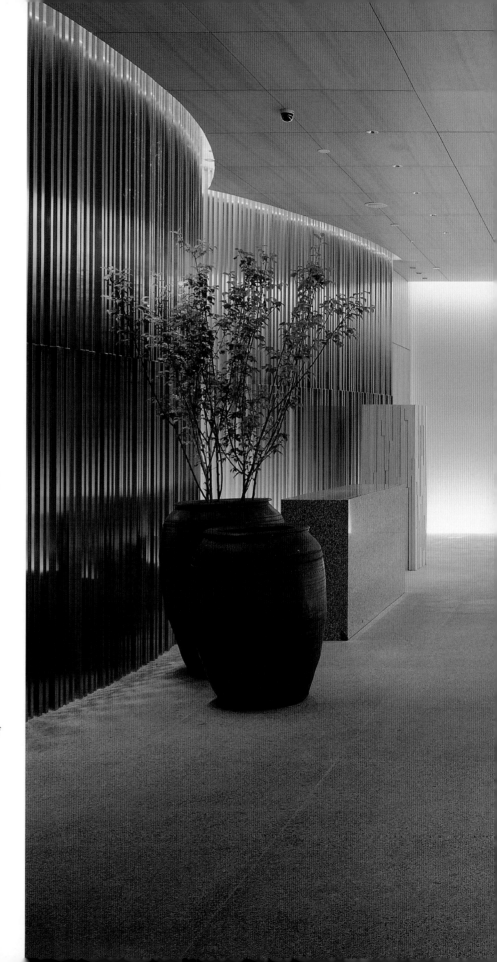

Curving walls faced
with metal slats provide
a backdrop to the pol-
ished granite reception
counter and wood block
installations of the
third-floor business
and meeting center.

space – the 185 guest rooms, six meeting rooms,
restaurant, bar, lounge, pool, fitness center and
spa – as well as advised on the treatment of the
exterior glass surface. From the precisely con-
trolled lighting to the texture of the granite, wood,
and metal used on the floors and walls to the care-
fully chosen works of Korean contemporary and
folk art that provide visual accent throughout the
hotel, the richly designed spaces open up to one
another and to the city, an oasis of design in the
heart of downtown Seoul.

The elevators open into the reception area of
the lobby, where the strongly geometric polished
granite reception counter is lifted off the floor
by two large stones, left naturally rough. The
sleek counter is complemented by vertical slabs
of roughly striated stone, which are set in front
of the windows overlooking the city – giving the
sense of an edge yet daring one to look out over
the city lights. To the side, the lobby lounge fills
the space between two walls of glass, as if floating
over the city. On the far side, six heavy columns of
stone and a transparent wall separate the lounge
from the swimming pool. Pushed to the edge of
the building and entirely surrounded by glass, the
pool is made from dark *aji* granite. Dozens of thin
acrylic cylinders hang from the ceiling for dramat-
ic lighting, reflecting in the water surface like far-
away stars. Everywhere the city is apparent, with
its daytime rush of traffic and night-time bevy of
lights, close but yet a world away.

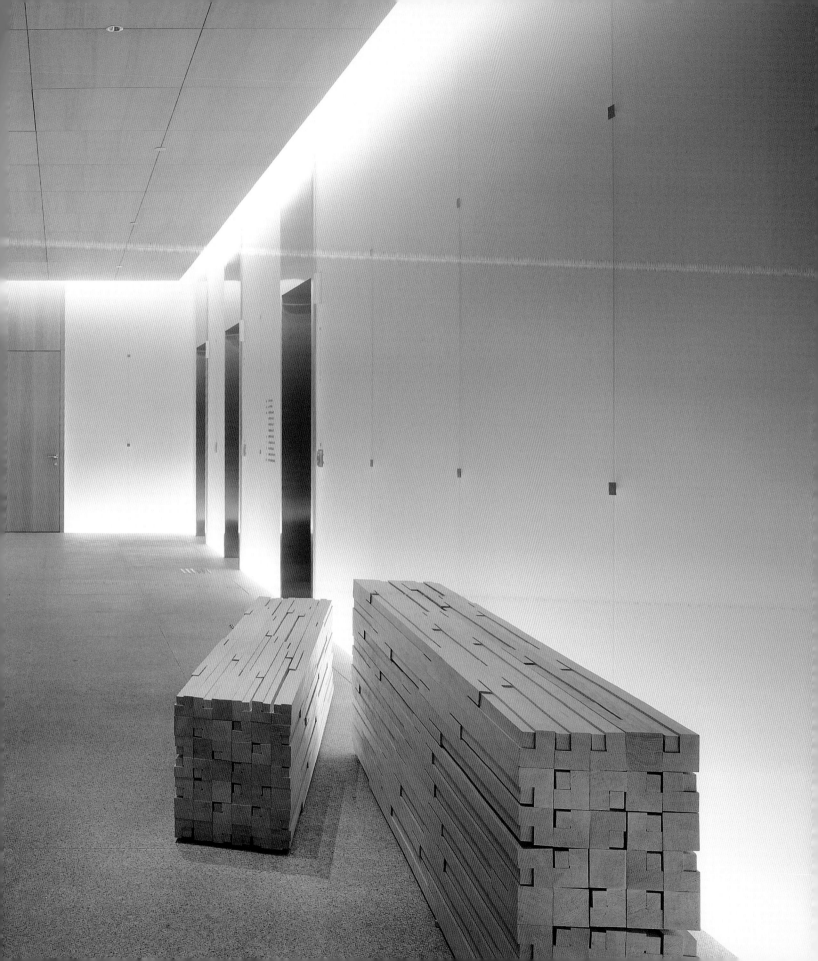

Park Club

Fitness center and spa /
Park Hyatt Hotel / Seoul / 2005

The Park Club fitness center and spa occupies
one end of the 24th floor with its gym, which is
connected to the locker rooms, saunas, and spa
treatment rooms on the floor level below by an
airy internal staircase. Wide-planked wood floors
in warm hues and a smooth ceiling plane covered
with strips of downlights emphasize the horizon-
tality of the gym space, which seems to continue
out into the city sky. With three walls of glass, the
gym has incredible views of downtown Seoul. The
open space is grounded at the perimeter by only
a few columns and the boldly geometric X-shaped
cross-bracing of the building's structure.

A staircase separates the gym from the glass-
enclosed swimming pool and leads to the floor
below. The space of the stair opens up to the cozy
wood-paneled juice bar, Citrus, with just a few
simple wood tables and chairs to accompany the
counter seating. Delicate lighting, just a hint under
the sleek wood counter, and eye-catching down-
lights on the vertical wood panels of the wall
behind the bar give the space a relaxing soft glow.
A rectangular niche cut into the back wall holds
bottles and glasses, the only adornment in the
muted, highly textured space.

In contrast, the locker rooms are full of day-
light and offer filtered views of the city. Materials
are carefully chosen to suggest a sense of weight-
lessness: the lockers are finished in blond wood,
and white ceramic sinks sit on gleaming stainless
steel counters, separated by translucent glass par-
titions. The wood-paneled saunas and stone soak-
ing tubs, with views over the city, are planned
for the utmost in comfort and relaxation. The spa
treatment rooms, elegantly designed with similar
accents of wood, glass, and metal, sophisticated
yet functional, provide a relaxing retreat at the
top of the city of Seoul.

RIGHT

The serene pool is lo-
cated on the 24th floor,
with dramatic views
over Seoul. Thin acrylic
tubes suspended from
the ceiling glow like
stars and reflect on
the pool surface.

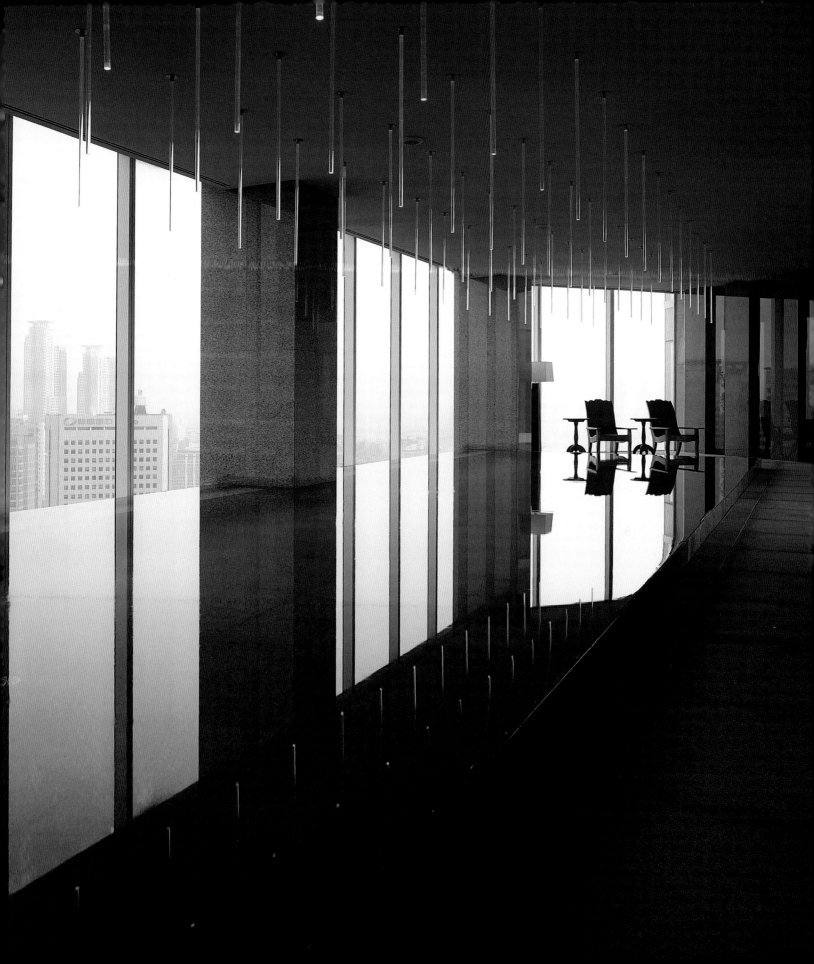

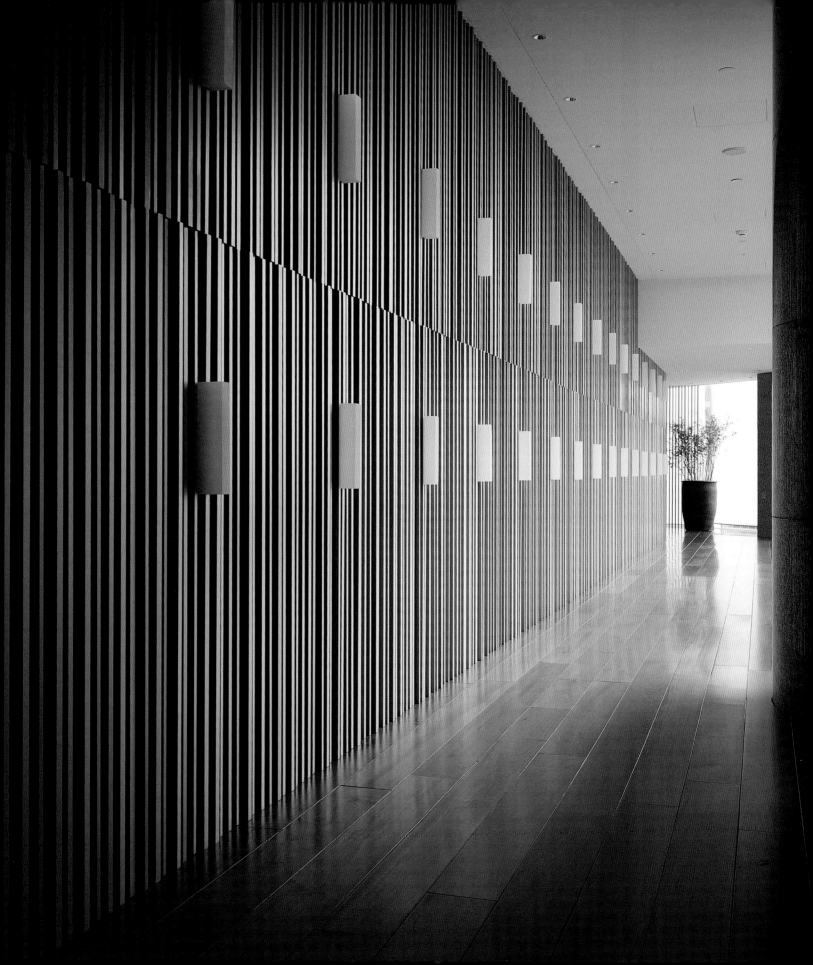

LEFT

Wide wood plank floors lead past a textured wall and a roughly finished column to a view over the city and the entrances to the changing rooms and spa treatment rooms.

RIGHT

Translucent glass partitions with stainless steel bases separate private sink areas in the changing room. The blond wood face of the locker doors is reflected in the mirror.

BELOW

Sculptural lounge chairs have filtered views of the city. Sleek stainless steel and translucent glass shelves contrast with the warm wood floors and paneled walls.

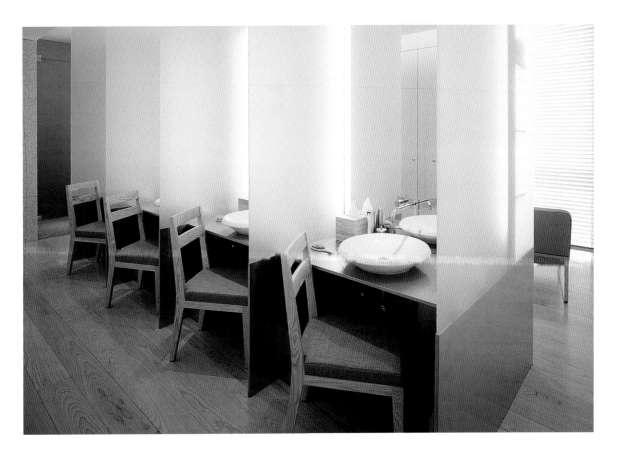

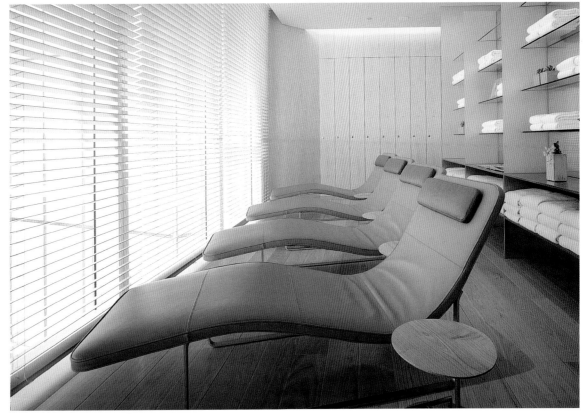

Guest Rooms
Park Hyatt Hotel / Seoul / 2005

The guest room floors feature dramatically lit corridors with glowing display boxes set into the wood-paneled walls. Changing exhibits of artwork by contemporary local artists, as well as Korean antiques and folk art objects, provide visual accents in the space and continue the gallery-like atmosphere of the hotel.

Super Potato designed 11 different types of guest rooms for the hotel. Of a total of 185, 38 are suites, and all take advantage of the long views over the city. Like other spaces in the hotel, the guest rooms are open and minimalist yet carefully designed with comfort in mind. A palette of warm materials in the bedrooms – wood in hues from blonde to amber, roughly textured handmade paper, and walls covered with light gypsum plaster in a ribbed finish – contrast with the stainless steel accents and the weight and texture of the stone used generously in the bathrooms.

A clever sliding wall allows the closet to be accessed from both the bathroom and the bedroom, enhancing the feeling of open, connected spaces. An interior glass wall separates the wet area from the rest of the guest room, yet provides visual connection from the bedroom through the bath area out to the city. The rectangular white porcelain soaking tub is placed near the exterior glass wall. The pure geometry of the bathtub complements the exposed diagonal structural bracing of the building and provides an intriguing juxtaposition to the textured stone floors and walls of the precisely fitted enormous blocks of stone.

The guest rooms are designed with simple elegance, which enhances the specific qualities of the various materials and emphasizes the city views. Every room has a sense of endless space and refined luxury. The most spacious guest room, the sumptuous Presidential Suite, uses accents like antique Korean furniture and wood lattice screens to visually complement the contemporary design. Dramatic lighting and the restrained yet surprising use of color, such as the red headboard of the bed, give the suite a subtle yet fitting flair.

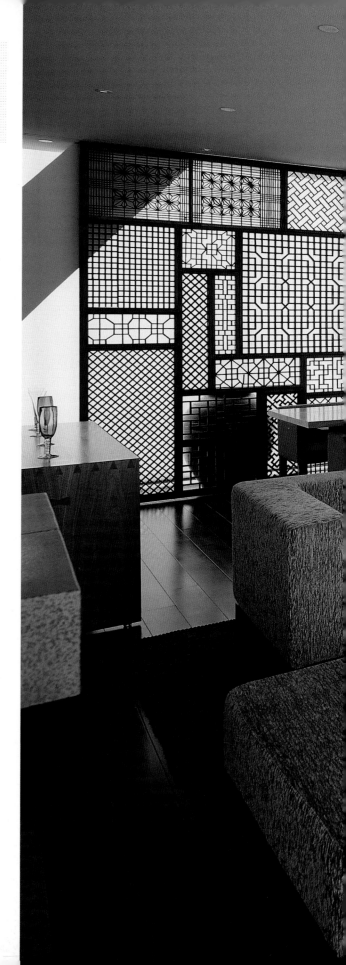

RIGHT

The dining and living areas of the Presidential Suite feature wall panels composed of old Korean wood screens. The structural bracing of the building is visible behind the glass walls.

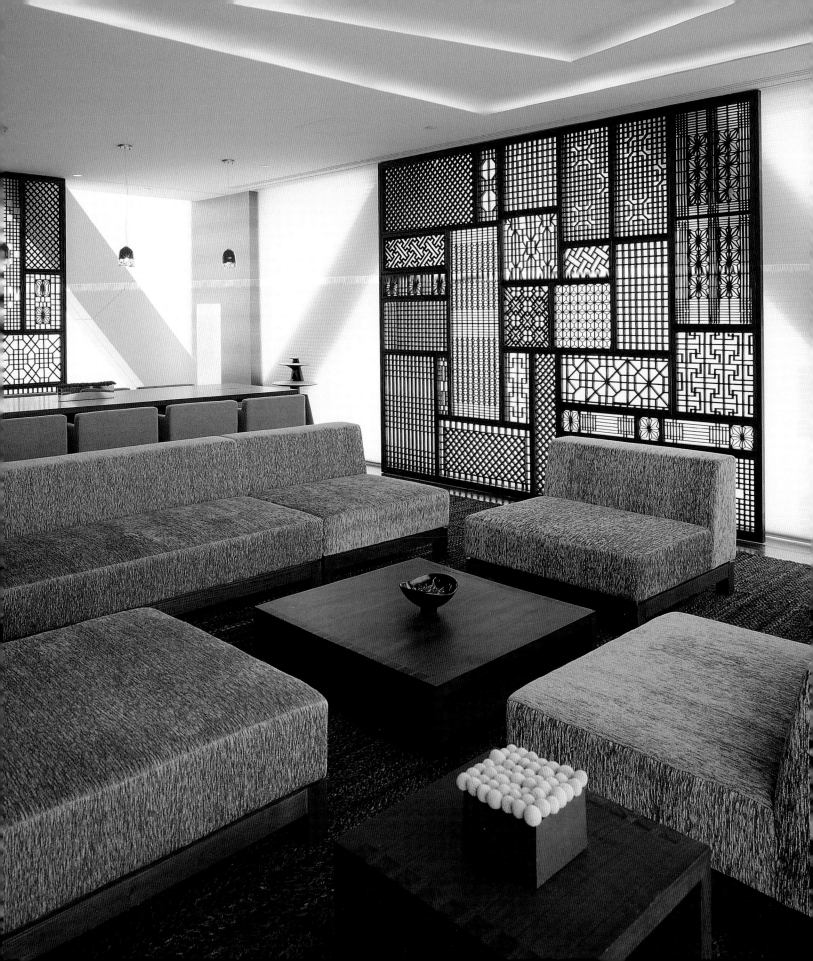

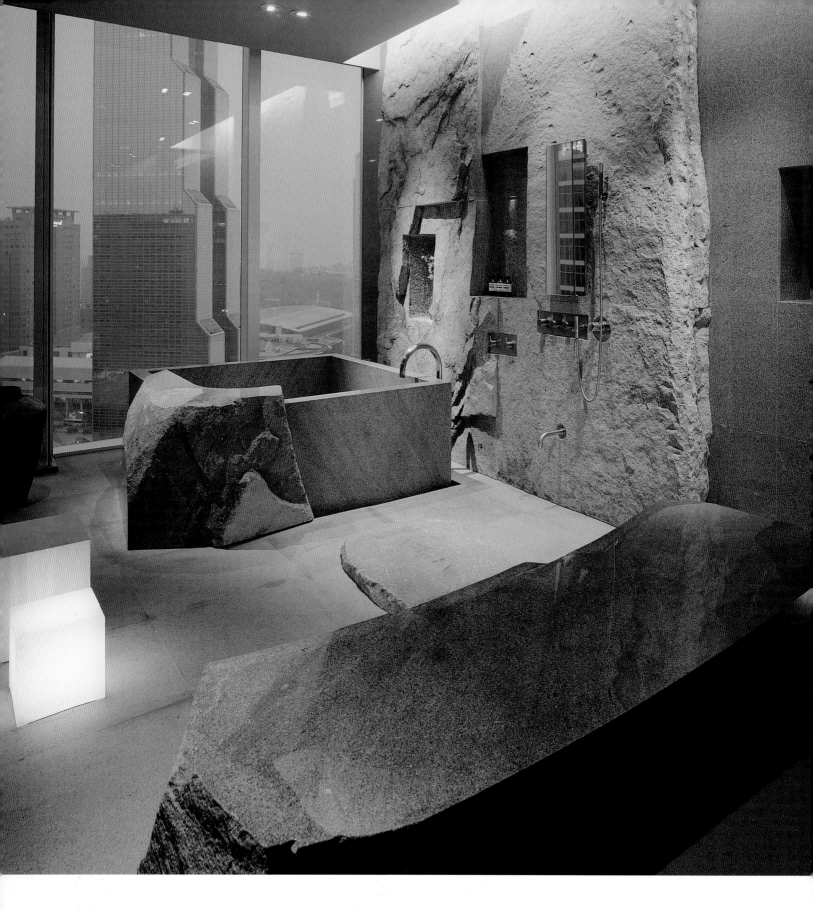

LEFT

The bathroom of the Presidential Suite is a medley of stone surfaces. The bathtub is carved from stone, and a smoothly finished slab of stone serves as a massage table.

BELOW

As elsewhere in the hotel, the Presidential Suite bedroom features bold geometry tempered with gentle lighting and subtle changes in material texture and color.

RIGHT

A typical guest room opens up to views of the city. The bed is set into the wood headboard, which gives warmth to the room, and faces out to the exterior glass wall. An interior glass wall connects the bedroom and bathroom. The pure white rectangular bathtub contrasts with the wall of closely fitted roughly textured stone.

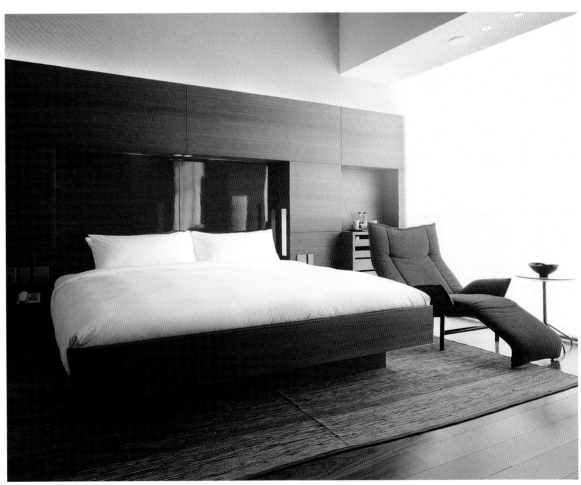

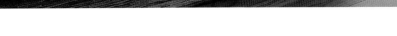

Cornerstone
Restaurant / Park Hyatt Hotel / Seoul / 2005

Making the most of the hotel's sloping site, the main entrance to the Cornerstone restaurant is located on a corner at the high end of the property. The restaurant is laid out parallel to the street, but where the land slopes down, the floor of the restaurant gently slopes up, giving changing views of the street activity and cleverly providing space for the hotel entrance below the restaurant floor at the low part of the site. The sloping floor allows for varied dining spaces on different levels, connected by short runs of stairs. A long ramp connects the main entrance and the hotel elevators, passing the dining areas, the glass-enclosed wine cellar, the private dining room, and the kitchens. The ramp is like an interior street, with its smooth stone floor and wood-louvered ceiling running continuously past varied wall surfaces and glimpses of the dining areas and open kitchens.

The different levels within the restaurant give a sense of privacy in the dining areas, yet with a strong overall sense of spatial connection. Super Potato uses a familiar palette of wood, stone, and glass, accented with stainless steel, throughout the restaurant. The materials are chosen carefully for their textures and colors, and the clean lines of the space allow the cooking and the food to have a strong presence in the design. The granite counters of the open kitchens are smoothly polished and display baskets of breads and bowls of fresh vegetables. Steel and glass shelves hold metal baskets of fruit and subtly separate the bar from the dining space. Square wood boxes filled with tall glass jars of spices hang above the dessert kitchen.

Squares are a subtle theme in the restaurant, predominantly in the wall, which separates the ramp from the dining areas and open kitchens. The wall changes from glass inset with squares of colored light to smoothly polished stone squares in a checkerboard pattern to a patchwork of delicate square black frames containing glass glowing with purplish light. Colored lighting is used to accentuate special walls of contrasting materials or colors and is designed to change color depending on the time of day, suggestive of the changes in light that occur on the street outside from morning to night.

BELOW

Tables line the glass wall facing the street and are interspersed with open kitchens. The ramp runs the length of the restaurant, separating private and open dining areas.

RIGHT

A purple glow emanates from square boxes set into glass walls, which seem to float around a circular table and provide glimpses to the open kitchen and the ramp beyond.

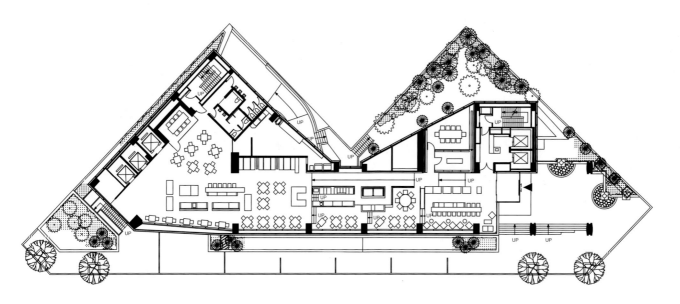

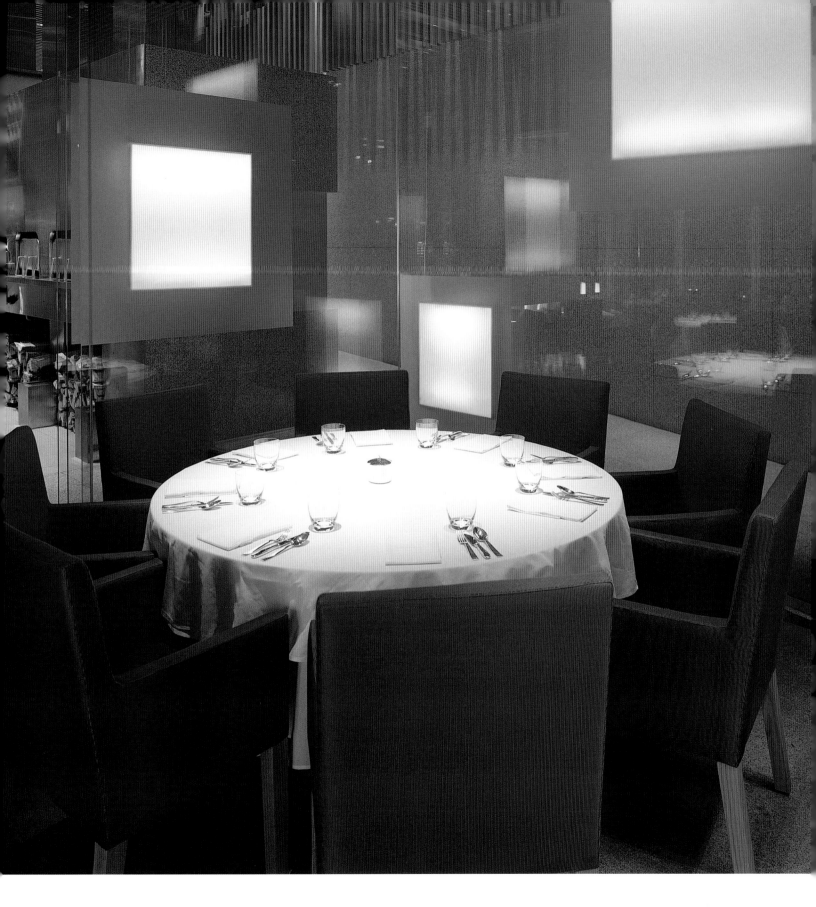

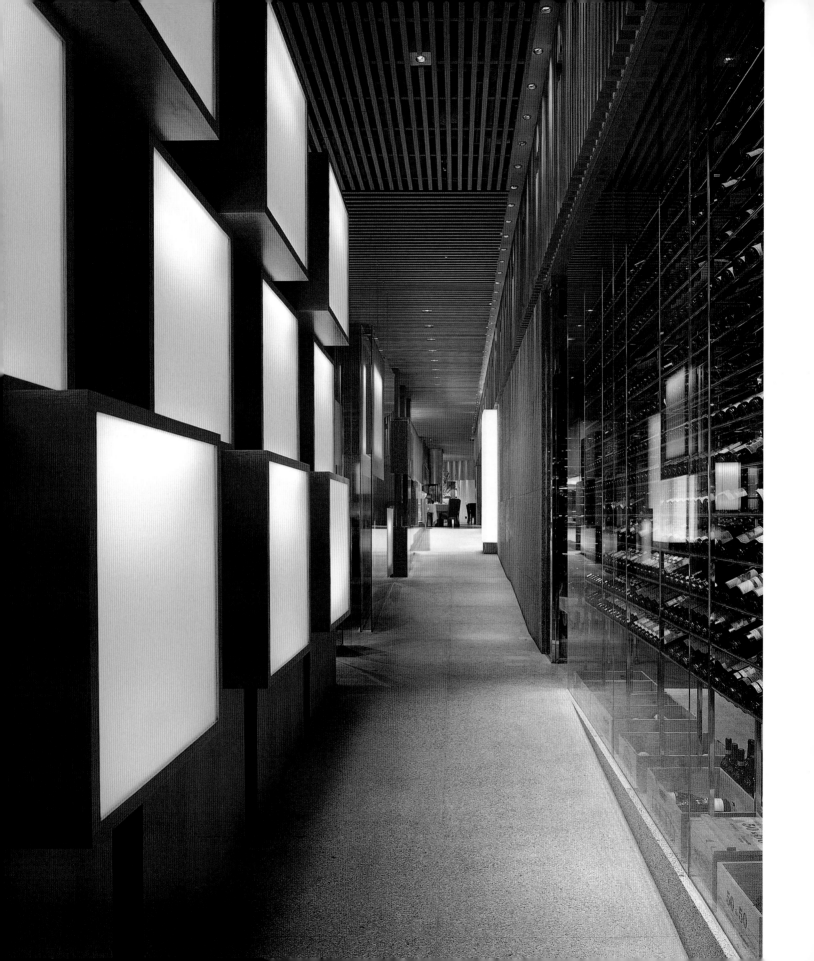

Luminous boxes line one edge of the stone ramp that moves through the restaurant between the main space and the private dining rooms hidden behind the glass-enclosed wine cellar.

RIGHT

The sleek stone counter and bold geometric pattern of stacked boxes of glowing glass shelves give a stylish contemporary feel to the bar area of the restaurant.

BELOW

Counters of polished stone and back-lit translucent glass define the space of the open kitchen. The continuous wood-louvered ceiling draws the eye through the restaurant.

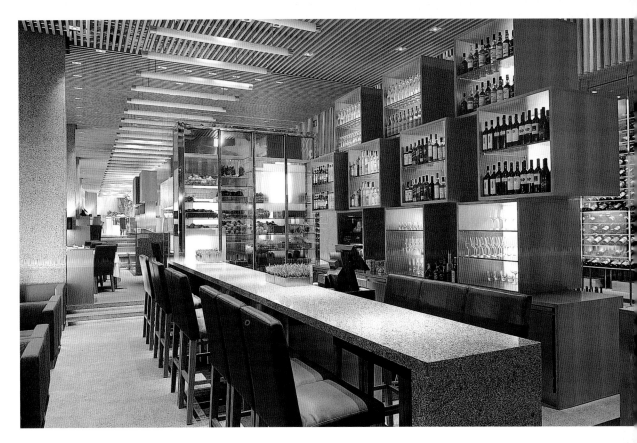

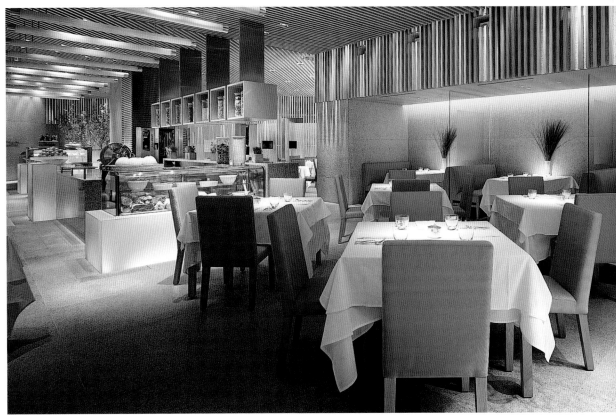

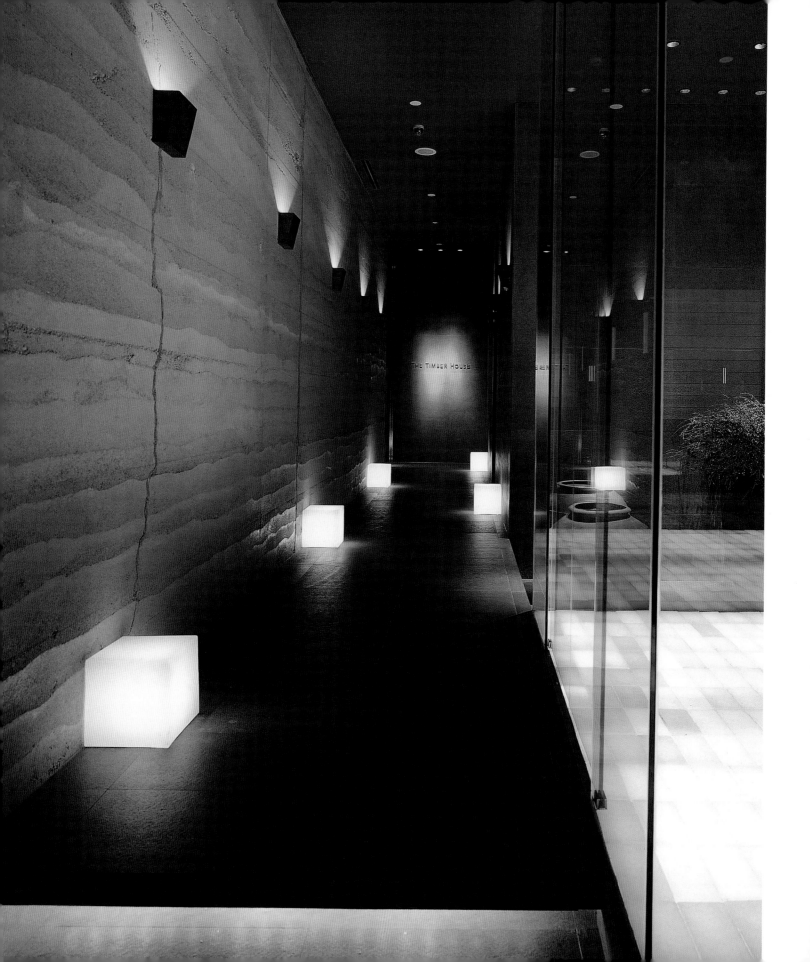

The Timber House

Bar / Park Hyatt Hotel / Seoul / 2005

From the street, an exterior staircase leads to the main entrance of The Timber House bar. Walls finished in layered earthen plaster, gently lit as if by lantern light, subtly hint at the atmosphere of the bar. True to its name, The Timber House takes design cues from traditional South Korean wooden houses, which have central courtyards surrounded by living spaces. Here, the center is a stage, elevated slightly above the level of the "rooms" around it and outfitted for live music. A bar counter made of glowing glass bricks, serving Japanese *saké* and Korean *soju*, accentuates one end of the stage, and the ceiling plane, artfully lit with colored lights, further emphasizes the space. The glow of the counter and the lighted ceiling are reflected in

mirrors placed at the perimeter of the stage, which visually extend and expand the space.

An open framework of old timber columns and beams demarcates the space of the stage and creates a transition to the surrounding private "living rooms." Some of these spaces are cozy sitting areas. Others feature bars specializing in a particular type of drink. Each has a slightly different character, defined by the inventive use of objects from traditional Korean daily life. Familiar materials, like roof tiles, old books, and ceramic plates, are used in unconventional ways to cover walls and create partitions which divide the space. A screen made of pottery shards encased in glass allows views from the stage through

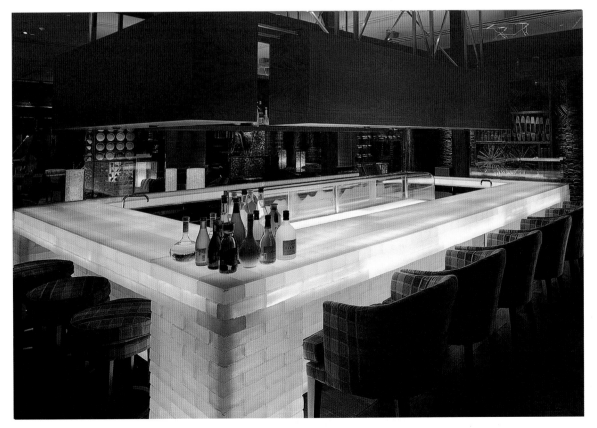

OPPOSITE

Soft cubes of light line the stone path leading to The Timber House, reflecting off the glass and accentuating the texture of the horizontal layers of the earthen plaster wall.

LEFT

Lit from within, glowing glass bricks form the base for the central glass bar counter. Angled metal rods support the dark box hung above the bar and used to store glasses.

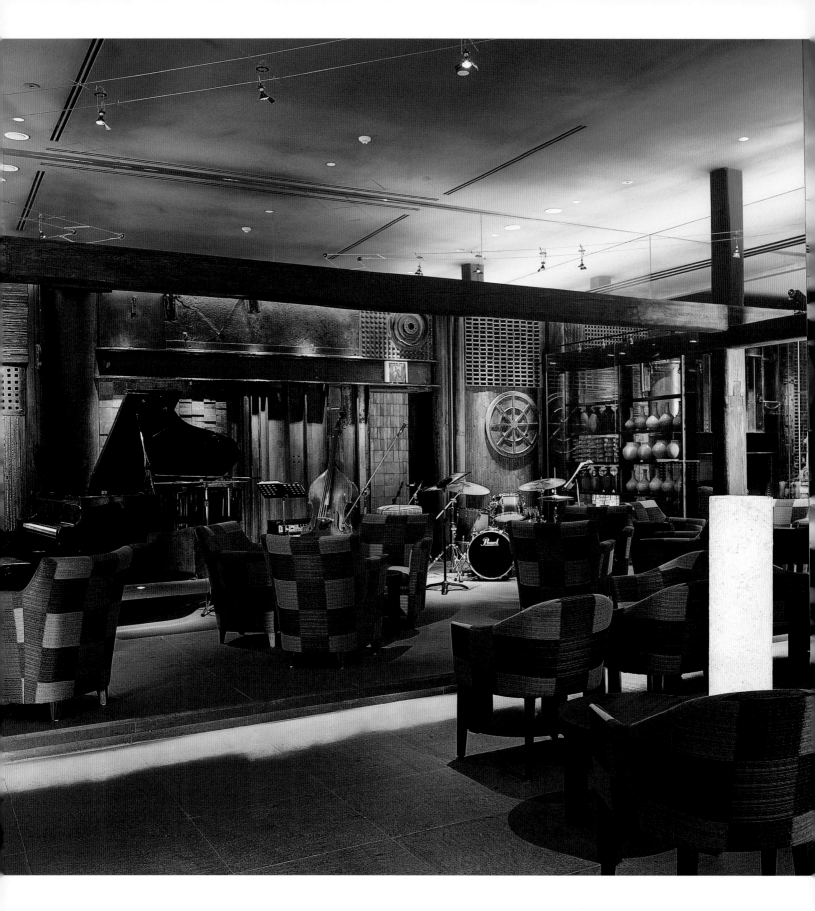

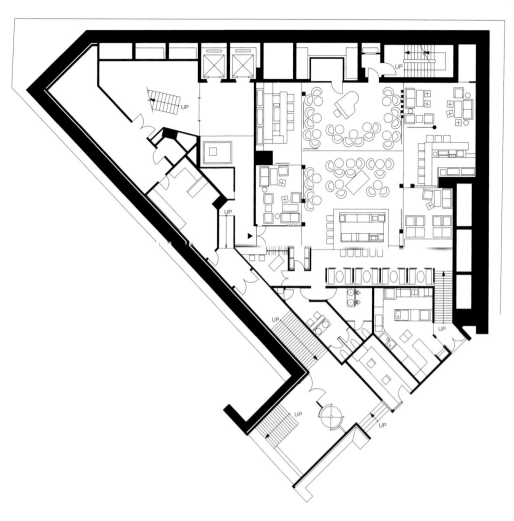

LEFT

Backed by a lively mosa-
ic wall of found objects,
a frame of salvaged
timbers delineates the
space of the stage. A
soft blue glow accents
the ceiling as well as
the glass brick bar.

ABOVE

A wide corridor with a
stair leads to a short
ramp at the entrance to
The Timber House. The
main spaces of the bar
form a square within
the triangular plan of
the building.

to the adjacent sitting area, where one part of the
wall is meticulously covered with old books. Pieces
of salvaged wood become a mosaic on a wall by
the whiskey bar, while previously used wood lat-
tice screens separate the bar from the stage area.
Dozens of old wooden candy molds are strung
on wires to suggest enclosure in one area; and an
earthen plaster wall, lit from above to bring out
the yellow tint of the plaster, sets off the space of
the cocktail bar. Old wood planks, used in varying
patterns, cover the floors of the lower bar spaces,
providing continuity throughout.

Similar to the other areas of the Park Hyatt
Seoul, The Timber House has the spatial quality
and ambience of an art gallery. But rather than
exhibiting art, here the collections are familiar
and common objects, displayed not only as sculp-
ture but as layers of information, which intrigue,
stimulate thought, and suggest a shared common
sense of history and memory.

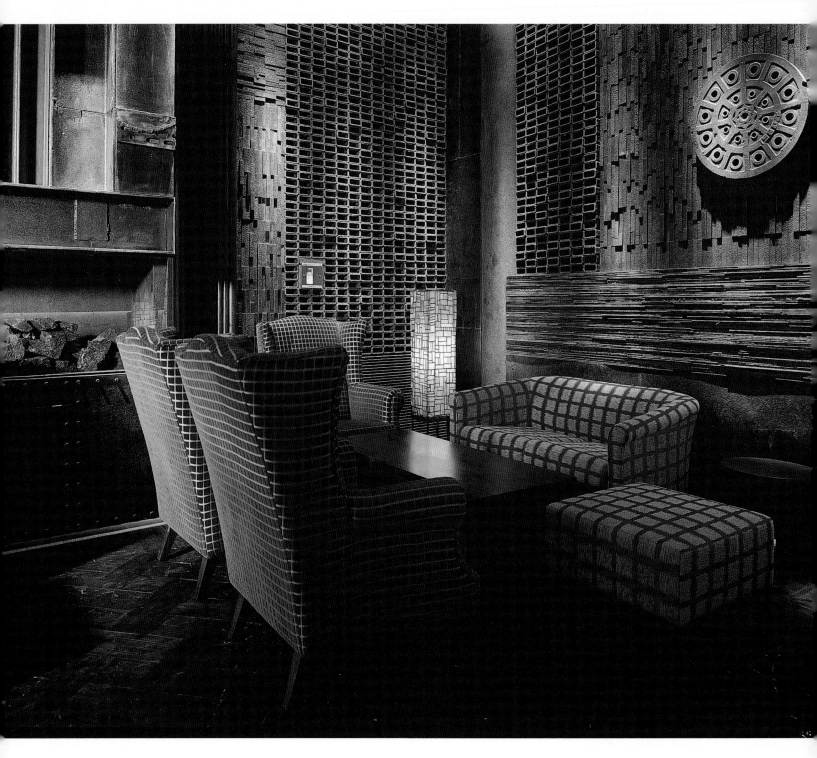

ABOVE

A cozy sitting area is surrounded by texture. Salvaged metal is transformed into tightly composed wall panels, creating new elements that hint of the past.

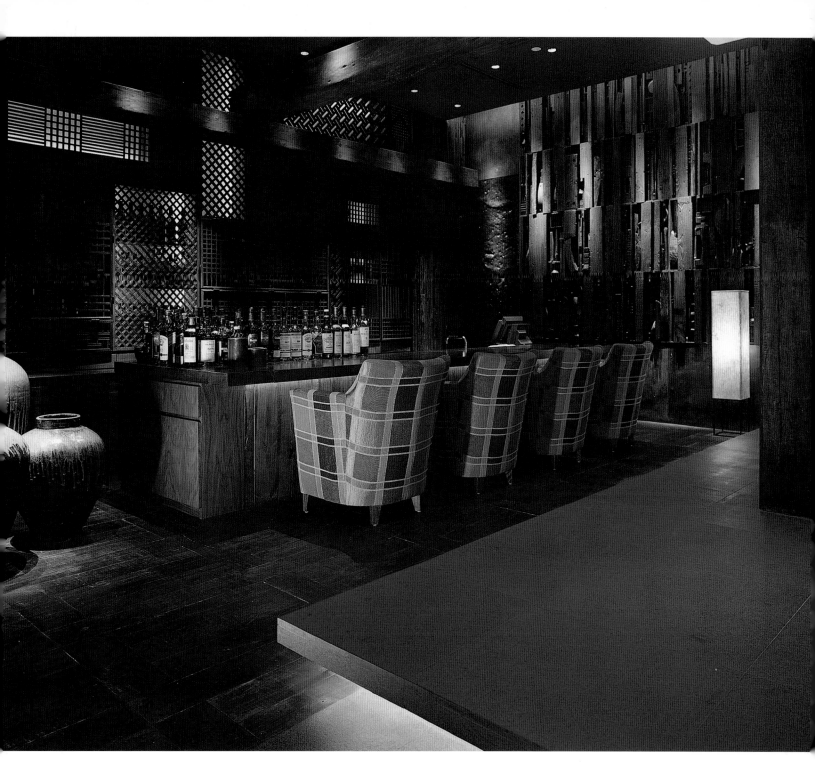

ABOVE

At the side of the stage platform, the whiskey bar is set off by spot-lights on a mosaic wall composed of pieces of salvaged wood and old back-lit lattice screens.

Major Works 1971 – 2006

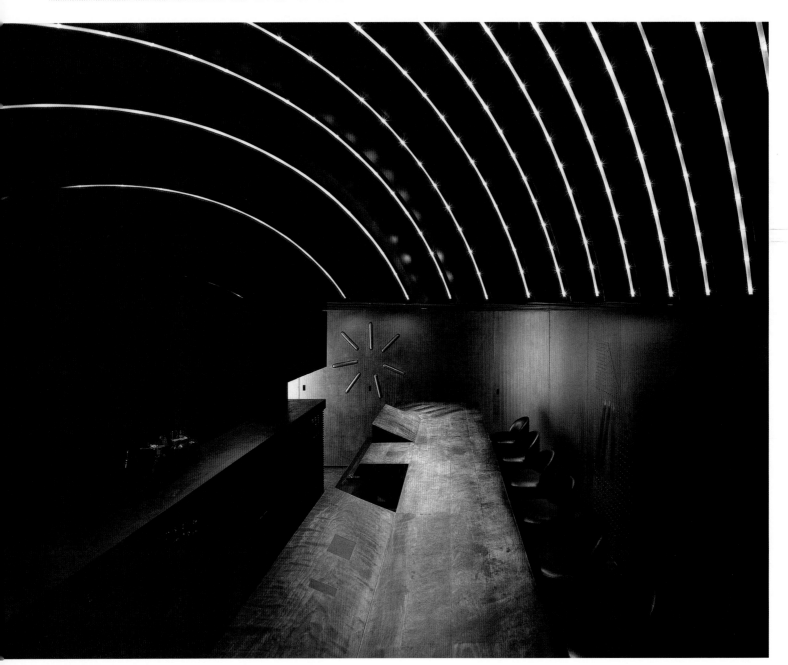

Radio (1982)

1971

Radio: bar, remodeled 1982 / Harajuku, Tokyo
Y's: boutique / Shinjuku, Tokyo

1972

Orange: bar / Shibuya, Tokyo

1973

Naruse Florist: flower shop / Shibuya, Tokyo

1974

Tefu Tefu: bar, with Kunikazu Takatori / Roppongi, Tokyo

1975

Post: bar / Akasaka, Tokyo

1976

Strawberry: café and bar / Shibuya, Tokyo

1977

Marathon Club: live house / Nakano, Tokyo

1978

Maruhachi: bar / Shibuya, Tokyo

1979

Azelia: bar / Aoyoma, Tokyo
Fukuda Motors: automobile showroom / Akasaka, Tokyo
Luna Road: hair salon / Shibuya, Tokyo

1981

KNOX: bar / Akasaka, Tokyo

1982

Radio: bar remodel / Harajuku, Tokyo
Tellus: shoe store / Ginza, Tokyo

1983

5th CLUB: boutique / Aoyama, Tokyo
La Brea: boutique / Harajuku, Tokyo
MUJI Aoyama: retail shop / Aoyama, Tokyo
MUJI Osaka: retail shop / Shinsaibashi, Osaka
OLD-NEW: café and bar / Ikebukuro, Tokyo
Pashu: boutique / Sapporo
Pashu Labo: boutique showroom / Nogizaka, Tokyo
Red Zone: boutique and tea room / Shibuya, Tokyo
Sera: bar, with Ikko Tanaka / Akasaka, Tokyo

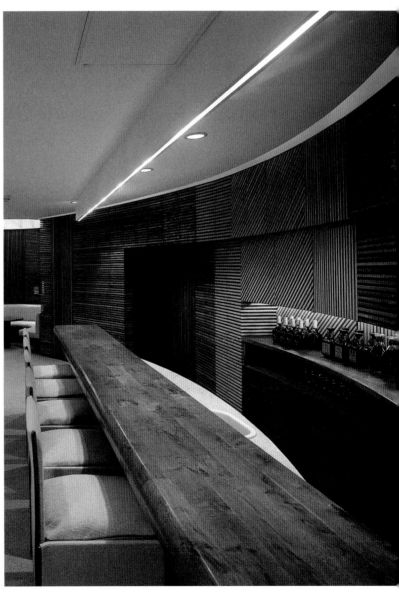

Sera (1983)

1984

Be-in: café and bar / Shinsaibashi, Osaka
Brasserie-EX: café and bar / Shibuya, Tokyo
DAIKO Co. Lighting Laboratory / Hamamatsucho, Tokyo
JUN TO Shinsaibashi: boutique / Shinsaibashi, Osaka
Kageyama: bar / Roppongi, Tokyo
Ki no Hana: bar / Shibuya, Tokyo
OLD-NEW: guest house / Kyoto
Shin Hosokawa: boutique / Harajuku, Tokyo

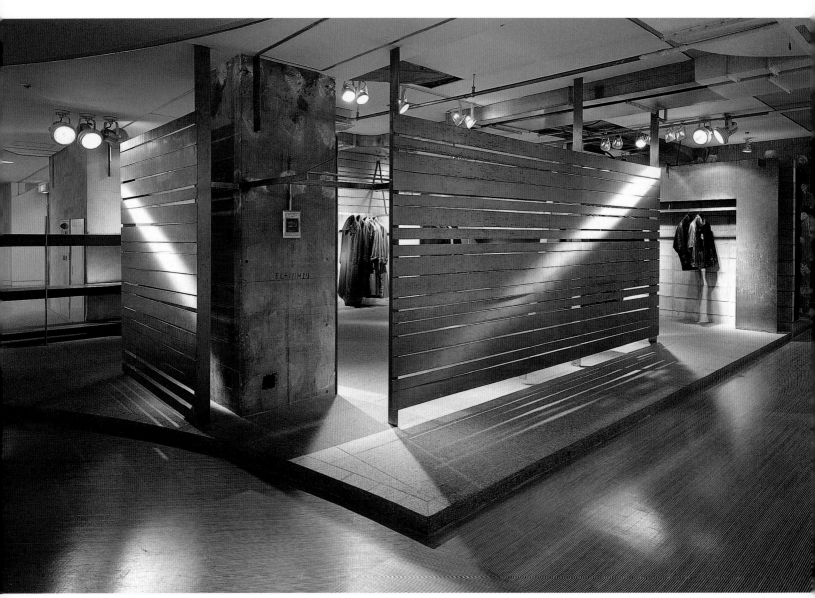

Shin Hosokawa (1984)

1985

Arry's Bar: bar / Yaesu, Tokyo
JUN EX New York: boutique / New York, USA
JUN TO Aoyama: boutique / Aoyama, Tokyo
OLD-NEW Denenchofu: guest house / Denenchofu, Tokyo
OLD-NEW Shibuya: café and bar / Shibuya, Tokyo
RECRUIT Seagull House / Ginza, Tokyo
TOTO Gallery MA: gallery / Nogizaka, Tokyo

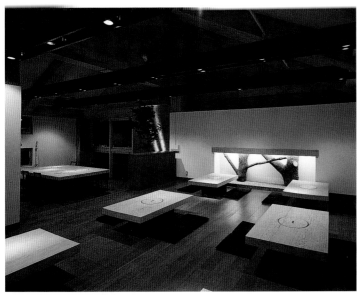

OLD-NEW Denenchofu (1985)

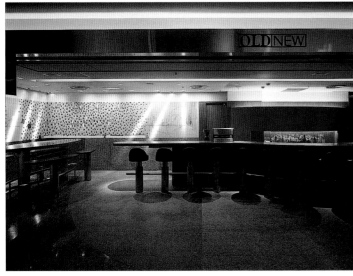

OLD-NEW Shibuya (1985)

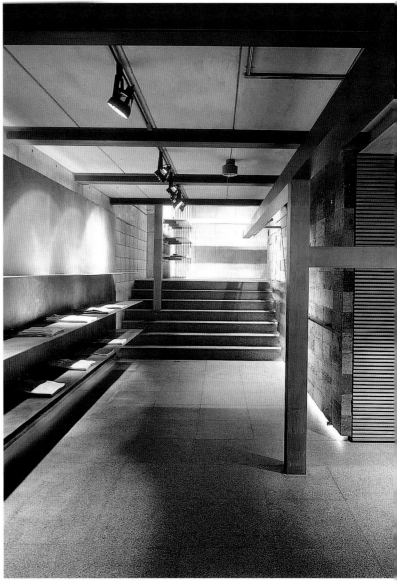

JUN TO Aoyama (1985)

1986

Dainippon Printing Co. Ginza Graphic Gallery GGG: gallery / Ginza, Tokyo
Hiroko Koshino: boutique / Osaka
JUN TO Daiwa Department store: boutique / Kanazawa
JUN TO Ueno: boutique / Ueno, Tokyo
OLD-NEW Rokko: guest house / Kobe
Pen: bar / Ginza, Tokyo
Prego: guest house / Kobe
2nd Radio: bar / Aoyama, Tokyo
SET OFF: bar / Shinjuku, Tokyo
Shunju Mishuku: restaurant / Mishuku, Tokyo

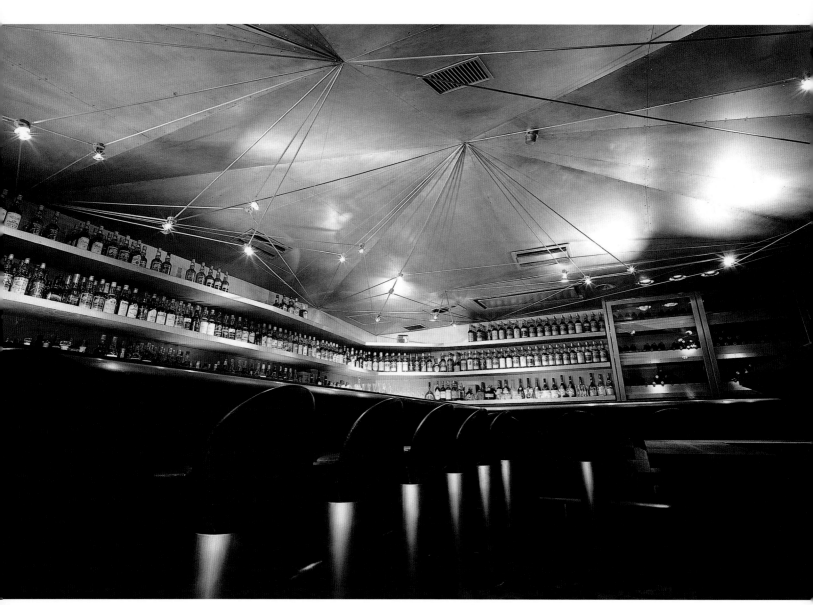

2nd Radio (1986)

1987

Ark by OLD-NEW: café and bar / Shibuya, Tokyo
Meguro-ku Museum: museum / Meguro, Tokyo
MUJI Harajuku: retail shop / Harajuku, Tokyo
OLD-NEW Kichijoji: café and bar / Kichijoji, Tokyo
OLD-NEW Minamitanaka: guest house / Minamitanaka
OLD-NEW Shinjuku: guest house / Shinjuku, Tokyo
Showroom at SONY Building: showroom / Ginza, Tokyo

1988

Haruna: restaurant / Akasaka, Tokyo
LIBRE: beer restaurant / Harajuku, Tokyo
OLD-NEW Akasaka: café and bar / Akasaka, Tokyo
Pew: bar / Yokohama

OLD-NEW Akasaka (1988)

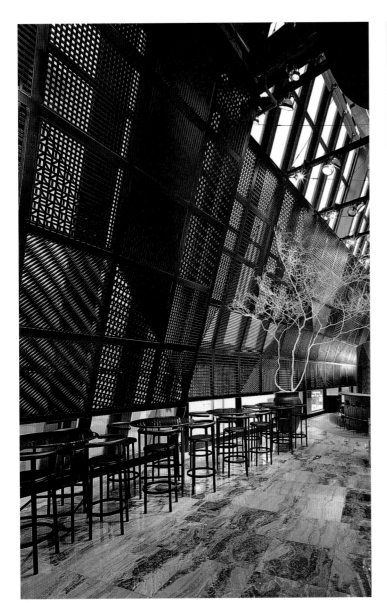

Ark by OLD-NEW (1987)

Libre (1988)

1989

Narita Golf Club: golf club house / Narita
NEO SITE: bar / Kyoto
OLD INN: café / Kyoto
SET OFF/ncy: bar / Shinjuku, Tokyo
Showroom at TOTO Super Space: showroom / Shinjuku, Tokyo
Shunju by Cross Kobe: restaurant / Kobe

1990

Kichi Kichi: Japanese restaurant / Higashi Shinsaibashi, Osaka
OLD-NEW Sapporo: café and bar / Sapporo
Shunju Akasaka: restaurant / Akasaka, Tokyo
Shunju by Cross Fukuoka: restaurant / Fukuoka
Tokuju: restaurant / Shibuya, Tokyo

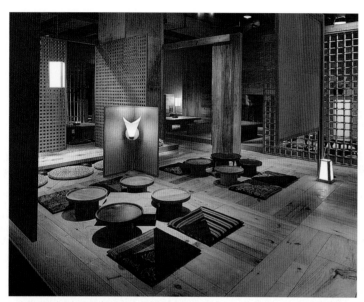

Shunju by Cross (1989)

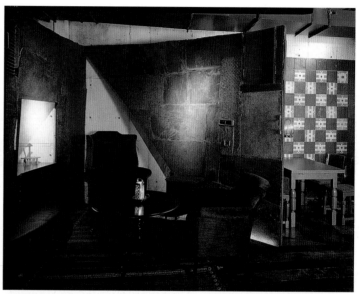

Shunju by Cross (1990)

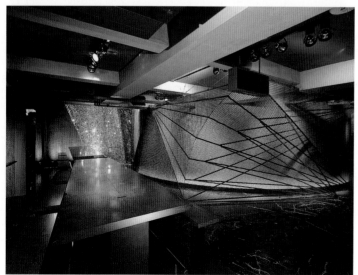

NEO SITE (1989)

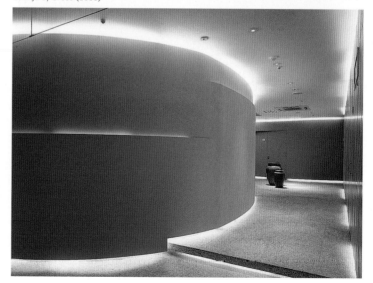

Tokuju (1990)

1991

Kisasa: restaurant / Osaka
PaPa-Milano: restaurant / Ginza, Tokyo

1992

Malt's Club: beer restaurant / Futakotamagawa, Tokyo
Mita: Japanese restaurant / Shinjuku, Tokyo
Mozaic: waterfront market place / Kobe
MUJI Landmark Tower: retail shop / Yokohama
Nihon Itagarasu: showroom / Shibuya, Tokyo
Ryurei: transportable tea ceremony room, Sabie-ZEN Japanese tea
 exhibition / Harajuku, Tokyo
Shunju Hibiki: restaurant / Hiroo, Tokyo

Kisasa (1991)

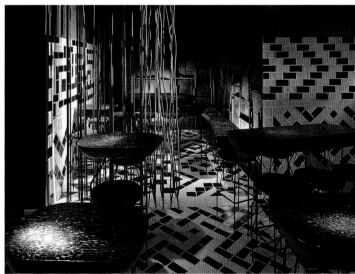
Kisasa (1991)

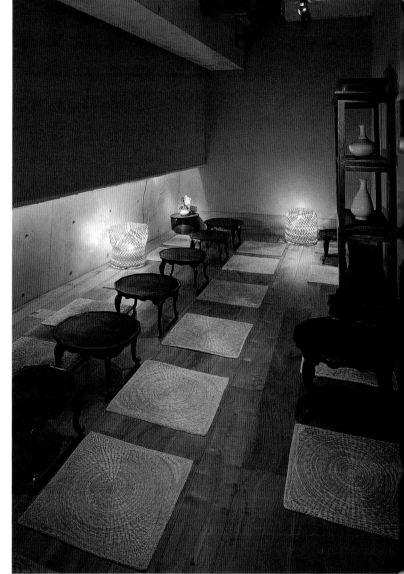
Shunju Hibiki (1992)

1993

Depo: restaurant and bar / Ueno, Tokyo
Komatori: transportable tea ceremony room
MUJI Aoyama-sanchome: retail shop / Aoyama, Tokyo
MUJI Funabashi: retail shop / Funabashi
MUJI Sapporo: retail shop / Sapporo
Sabie-SO: Japanese tea exhibition / Harajuku, Tokyo
Sapporo Wine Cellar: bar / Sapporo
SET OFF mjo: bar / Shinjuku, Tokyo
SONY Showroom "SYNAPS": showroom / Ginza, Tokyo
Tamaya: department store renovation / Kokura

1994

Abiding Club Golf Society: golf club house / Chiba
Fu Fu: open-air stalls / Abeno
Malt's Club: beer restaurant / Kyoto
Malt's Club Heichinro: Chinese restaurant / Yokohama
Sera Trading: showroom / Akasaka, Tokyo
SONY Showroom "SYNAPS": showroom / Osaka

MUJU Sapporo (1993)

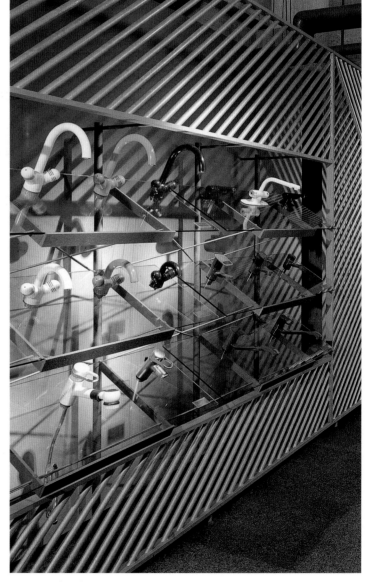

Sera Trading (1994)

1995

Hanshin Umeda: department store renovation, 1F–4F / Osaka
Malt's Club: beer restaurant / Shibuya, Tokyo
MUJI Shinjuku: retail shop / Shinjuku, Tokyo
San: restaurant and bar / Osaka
Shirogane Golf Club: golf club house / Hokkaido
SONY Showroom for Play Station: showroom / Ginza, Tokyo
Yooan: Japanese restaurant / Shinjuku, Tokyo

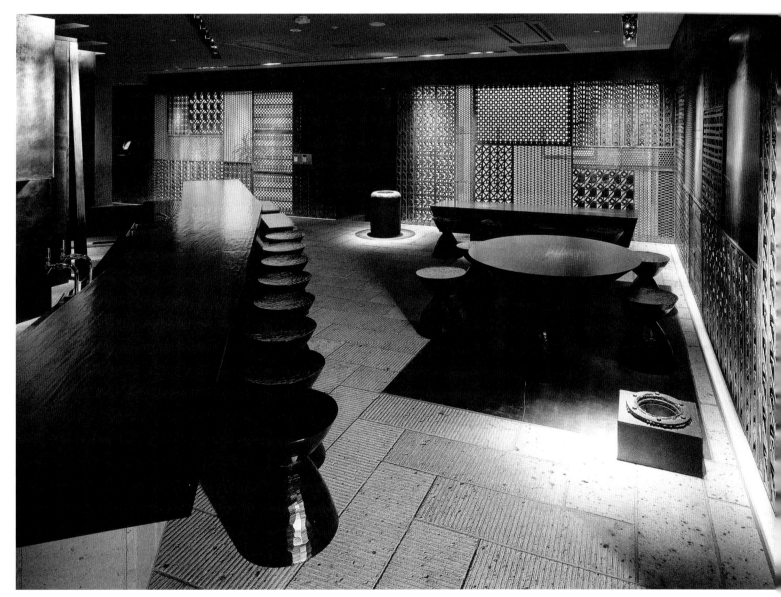

Yooan (1995)

1996

Development and shopping center planning for Tachikawa station area /
 Tachikawa, Tokyo
Five Form: Italian restaurant / Matsumoto
Food Live: restaurant, Grand Hyatt Fukuoka Hotel / Fukuoka
Kintetsu Kichijoji: department store renovation / Kichijoji, Tokyo
MUJI Fukuoka: retail shop / Fukuoka
Residence for the President of SONY: private residence / Tokyo
7 platforms of JR West Tozai Line / Osaka
Shunju Osaka: restaurant / Osaka
Shunju Torizaka: restaurant / Roppongi, Tokyo

1997

Hanshin Umeda: department store renovation, 6F to 9F / Osaka
Hanshin Umeda Food Teria: department store renovation, B2 / Osaka
Kin no Saru: Japanese restaurant / Kichijoji, Tokyo
MUJI Fujisawa: retail shop / Fujisawa
MUJI Kichijoji: retail shop / Kichijoji, Tokyo
MUJI Sun Street: retail shop / Kameido, Tokyo
Niki Club: small luxury hotel / Nasu Shiobara, Tochigi
Shunju Bunkamura: restaurant / Shibuya, Tokyo
TOTO Super Space: showroom / Shinjuku, Tokyo
TOTO Technical Center: Setagaya

Five Form (1996)

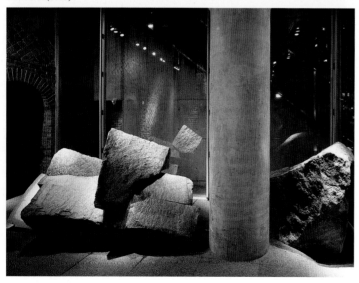

Shunju Torizaka (1996)

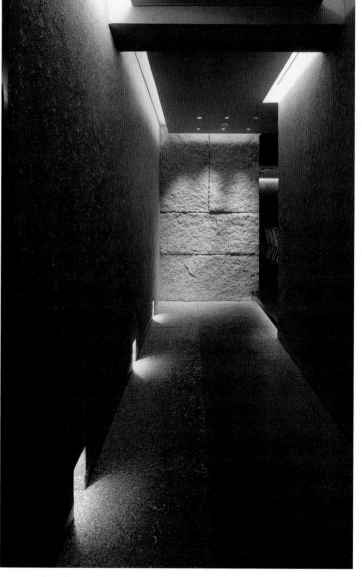

Hotaruzuki (1998)

1998

Atre: wine bar / Kokura
Dynamic Kitchen & Bar Hibiki: restaurant and bar / Shinjuku, Tokyo
Grand Hyatt Singapore Hotel: Singapore
 Entrance and Lobby: 1F
 Mezza9: restaurant, M2F
 BRIX: bar, B1F
Hotaruzuki: *saké* bar / Ikebukuro, Tokyo
MUJI Fuchu: retail shop / Fuchu, Tokyo
MUJI LUMINE: retail shop / Shinjuku, Tokyo
Sarumaru: restaurant and bar / Shibuya, Tokyo
Yooan: Japanese restaurant / Ginza, Tokyo

1999

Niki: restaurant and bar / Roppongi, Tokyo
PU-J's: bar, Grand Hyatt Shanghai Hotel / Shanghai, China
Rokkon: bar / Aomori
Shook!: open dining restaurant / Kuala Lumpur, Malaysia

2000

MUJI Aobadai: retail shop / Aobadai, Tokyo
MUJI Hon-Atsugi: retail shop / Hon-Atsugi, Tokyo
San Dynamic Kitchen: restaurant / Osaka
Shunju Tameike Sanno: restaurant / Tameike Sanno, Tokyo
Shunsui: restaurant and Hanshin department store renovation, 10F / Umeda, Osaka
Zipangu Super Dining by Nadaman: restaurant / Akasaka, Tokyo

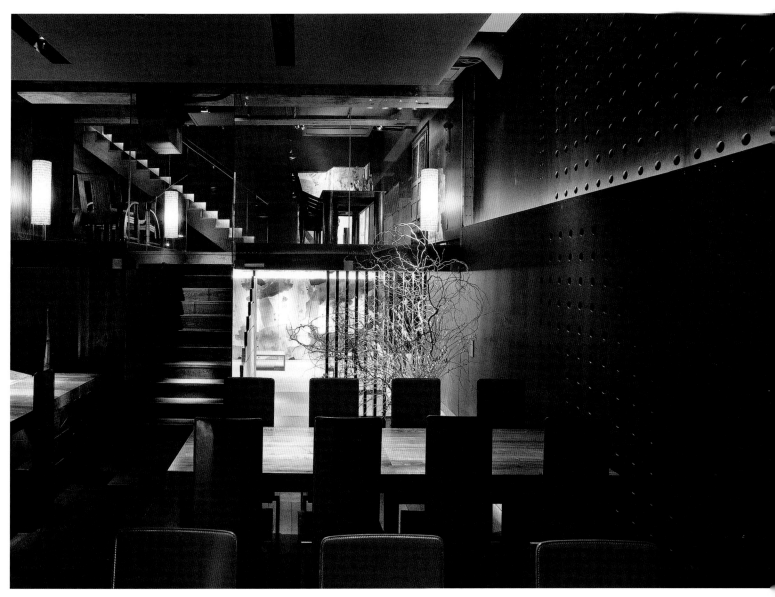

Niki (1999)

2001

Café TOO: restaurant, Shangri-La Island Hotel / Hong Kong
Hibiki Dynamic Kitchen & Bar: restaurant / Ginza 3-chome, Tokyo
Hibiki Dynamic Kitchen & Bar: restaurant / Ginza 7-chome, Tokyo
Hibiki Dynamic Kitchen & Bar: restaurant / Marunouchi, Tokyo
MUJI Yurakucho: retail shop, remodeled 2004 / Yurakucho, Tokyo
Yooan: tofu restaurant / Ebisu, Tokyo

2002

C's: restaurant, Grand Hyatt Jakarta Hotel / Jakarta, Indonesia
Hibiki Dynamic Kitchen & Bar: restaurant / Shiodome, Tokyo
Kitchen Shunju: restaurant / Shinjuku, Tokyo
Matsubaya: restaurant / Akasaka, Tokyo
Nampu: Japanese restaurant, Grand Hyatt Bali Hotel / Bali, Indonesia
Shunkan: My City department store renovation, 7F-8F / Shinjuku, Tokyo
Yooan: delicatessen and restaurant / Meguro, Tokyo
Zipangu: Japanese restaurant, Shangri-La Kuala Lumpur Hotel / Kuala Lumpur, Malaysia
Zipangu Super Dining: restaurant / Shiodome, Tokyo
Zuma: restaurant / London / UK

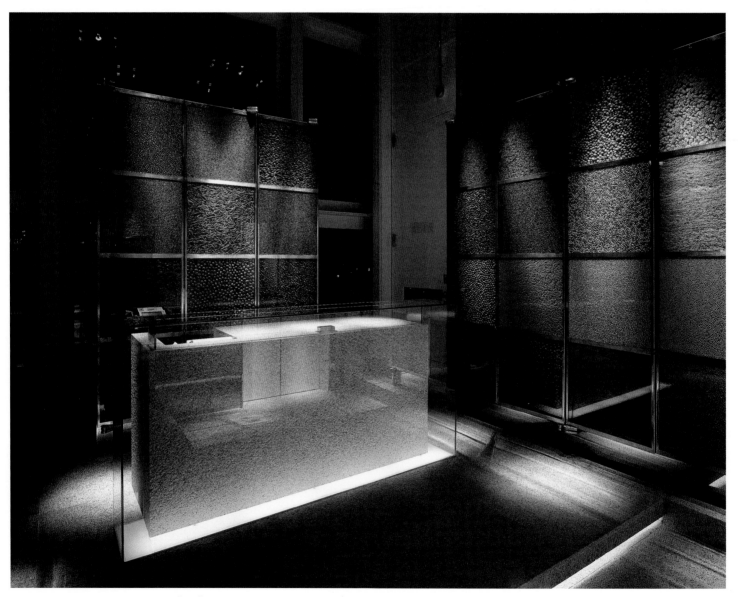

Hibiki Dynamic Kitchen & Bar, Ginza 7-chome (2001)

2003

8: restaurant, Hyatt Regency Incheon Hotel / Incheon, Korea
Grand Hyatt Tokyo Hotel: Roppongi, Tokyo
 The Grand Chapel: 4F
 The Shinto Shrine: 3F
 Shunbou: restaurant, 6F
 Roku Roku: restaurant, 6F
 Nagomi: spa and fitness center, 5F
House+: restaurant / Roppongi, Tokyo
Kitchen Shunju Ginza: restaurant / Ginza, Tokyo
Made in China: restaurant, Grand Hyatt Beijing Hotel / Beijing, China
Mahorama: Japanese restaurant / Marunouchi, Tokyo
Next 2: café and restaurant, Shangri-La Bangkok Hotel / Bangkok, Thailand
Polestar: European restaurant / Marunouchi, Tokyo
Que Sera: French restaurant and bar / Roppongi, Tokyo
Red Moon: bar, Grand Hyatt Beijing Hotel / Beijing, China
Shunmi: restaurant, Novotel Ambassador Gangnan Hotel / Seoul, Korea
Tao ryu: Chinese restaurant / Ginza, Tokyo
Tao ryu: Chinese restaurant / Roppongi, Tokyo
The Future and MUJI: exhibition, Gallery MA / Tokyo
The Future and MUJI: exhibition, Milano Salone / Milan, Italy
The Gaon: restaurant / Seoul, Korea
Vin de Vie: wine bar / Marunouchi, Tokyo
Yooan: Japanese restaurant / Shinagawa, Tokyo

2004

Ent Dining: shopping center restaurant floor development, 5F, and
 restaurant / Osaka
MUJI Ikebukuro Parco: retail shop renovation / Ikebukuro, Tokyo
MUJI Yurakucho: retail shop renovation / Yurakucho, Tokyo
Roka and Shochu Lounge: restaurant and bar / London, UK
Sensi: restaurant, Bellagio Hotel / Las Vegas, USA
Shunju Tetsunabe: Kitchen Shunju Ginza restaurant renovation /
 Ginza, Tokyo
Straits Kitchen: restaurant / Grand Hyatt Singapore Hotel / Singapore
Waketokuyama: restaurant / Minami Azabu, Tokyo

2005

L'Opera: restaurant, Park Hyatt Saigon Hotel / Ho Chi Minh City, Vietnam
Park Hyatt Seoul Hotel: Seoul, Korea
 Lobby and Lounge: 24F
 Park Club: fitness center and spa, 23F and 24F
 Guest Rooms: 4F–22F
 Cornerstone: restaurant, 1F
 The Timber House: bar, B1F
Shunju Tsugihagi: restaurant / Hibiya, Tokyo
Nadaman: restaurant, Shangri-La Shanghai Hotel / Shanghai, China

2006

Hyatt Regency Kyoto Hotel: hotel renovation / Kyoto

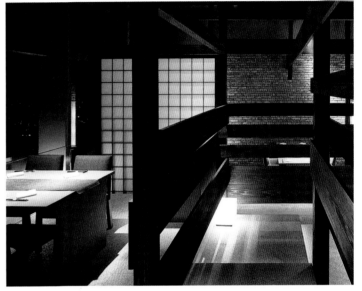

Zipangu Super Dining (2002)

Nagomi (2003)

Acknowledgments

It is with sincere gratitude that I acknowledge a few of the many people who gave freely of their time and knowledge in the making of this book:

Dana Buntrock and Ruri Kawashima for opening doors.

Rainer Becker, Raymond Chan, Laurent Chaudet, Christophe Hazebrouck, Hiromi Imai, Eddie Tan, as well as Yuki Fukasawa of ZOOM! and the staff of Super Potato for generosity and assistance.

Motohisa Arai, Paula Deitz, Joann Gonchar, Zeuler Lima, Noriko Sato, and Noor Azlina Yunus for encouragement and advice.

Saori Yamamoto for unending help and good humor.

Tadao Ando, Kenya Hara, and Kiyoshi Sey Takeyama for energy and insight.

Yoshio Shiratori and Takashi Sugimoto for boundless generosity, wisdom, and friendship.

And Takayuki Murakami for making all things possible.

All photographs have been taken by Yoshio Shiratori of ZOOM! except as noted below.

I would like to thank the following for supplying additional photographs for the book:

Millième for the photographs of Ryurei (page 113) and Komatori (inside front cover and pages 6, 114–15) taken by Takashi Hatakeyama, and for the photograph of Hikari taken by Masaki Miyano (page 116).

Mitsumasa Fujitsuka for the photograph of Maruhachi (page 26).

Niki Resort Inc. for the photographs of Niki Club (pages 126–8).

Ryohin Keikaku Co. Ltd for the photographs of MUJI Aoyama-sanchome (pages 104–7) and The Future and MUJI exhibit (pages 108–11).

Shotenkenchiku-Sha Publishing Co. Ltd for the photographs of Café TOO taken by Shinichi Sato (pages 156–61).

"Books to Span the East and West"